National Geographic

FASHION

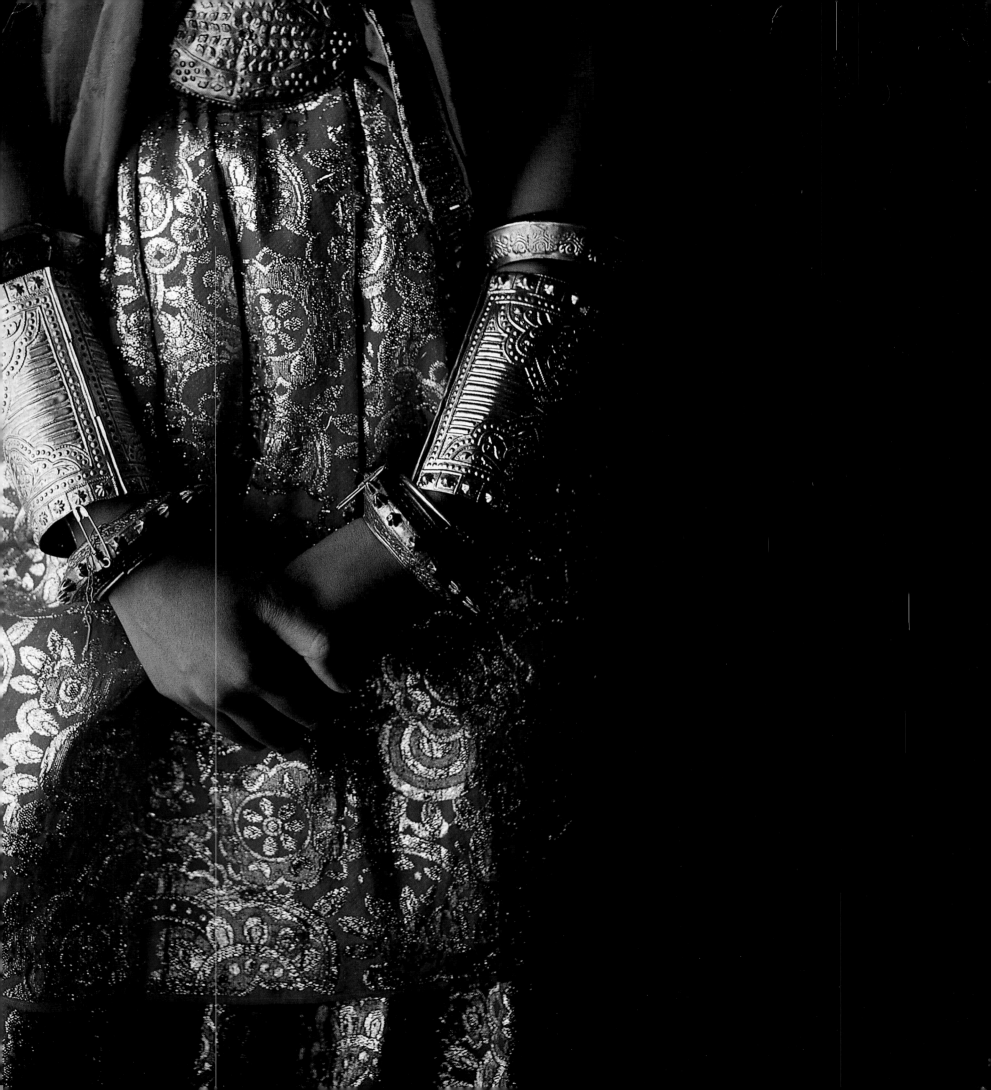

National Geographic

FASHION

By Cathy Newman Introductions by Joanne B. Eicher and Valerie Mendes

☐ NATIONAL GEOGRAPHIC

WASHINGTON, D. C.

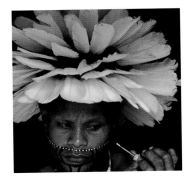

/pages 6–7/ JODI COBB, RUSSIA, 1997: High fashion rules a catwalk in Moscow. */page 8/* ROLAND W. REED, UNITED STATES, 1907: Early morning finds an Ojibwa girl cloaked in a woven blanket. */page 9/* N. ZOGRAPHOS, GREECE, 1930: A sheepskin cape warms the solitude of a shepherd near Athens. */pages 10–11/* WILLIAM ALBERT ALLARD, UNITED STATES, 1998: Jeans, chaps, and boots are hardworking gear for the rodeo. */page 12/* ROBERT W. MADDEN, BRAZIL, 1976: A Yanomami girl wears rain forest decor: *palloitos*, or "little sticks." */page 13/* MICHAEL NICHOLS, BRAZIL, 1990: Father and son wear similar Yanomami markings of plant dyes. */pages 14–15/* WILLIAM ALBERT ALLARD, UNITED STATES, 1986: Pearls grace the form of party-goer in Mississippi.

TABLE OF CONTENTS

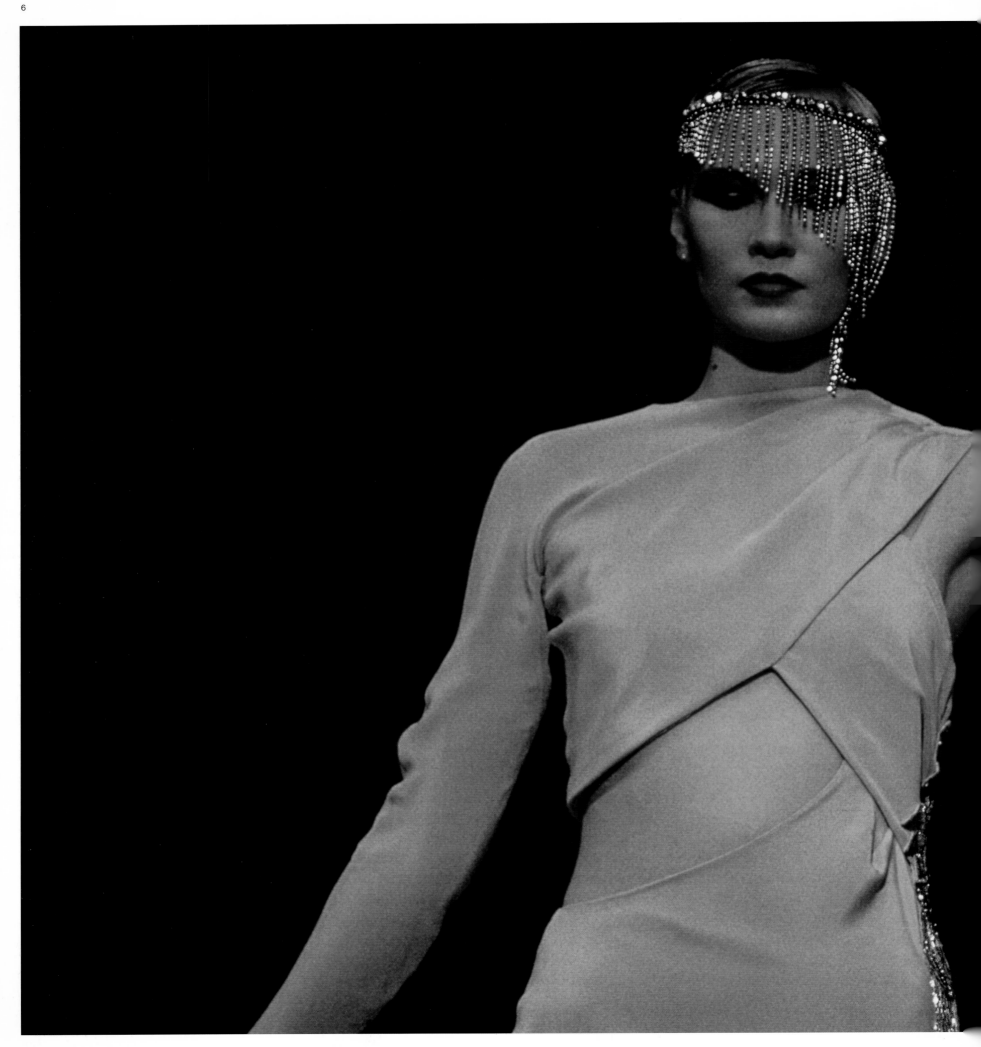

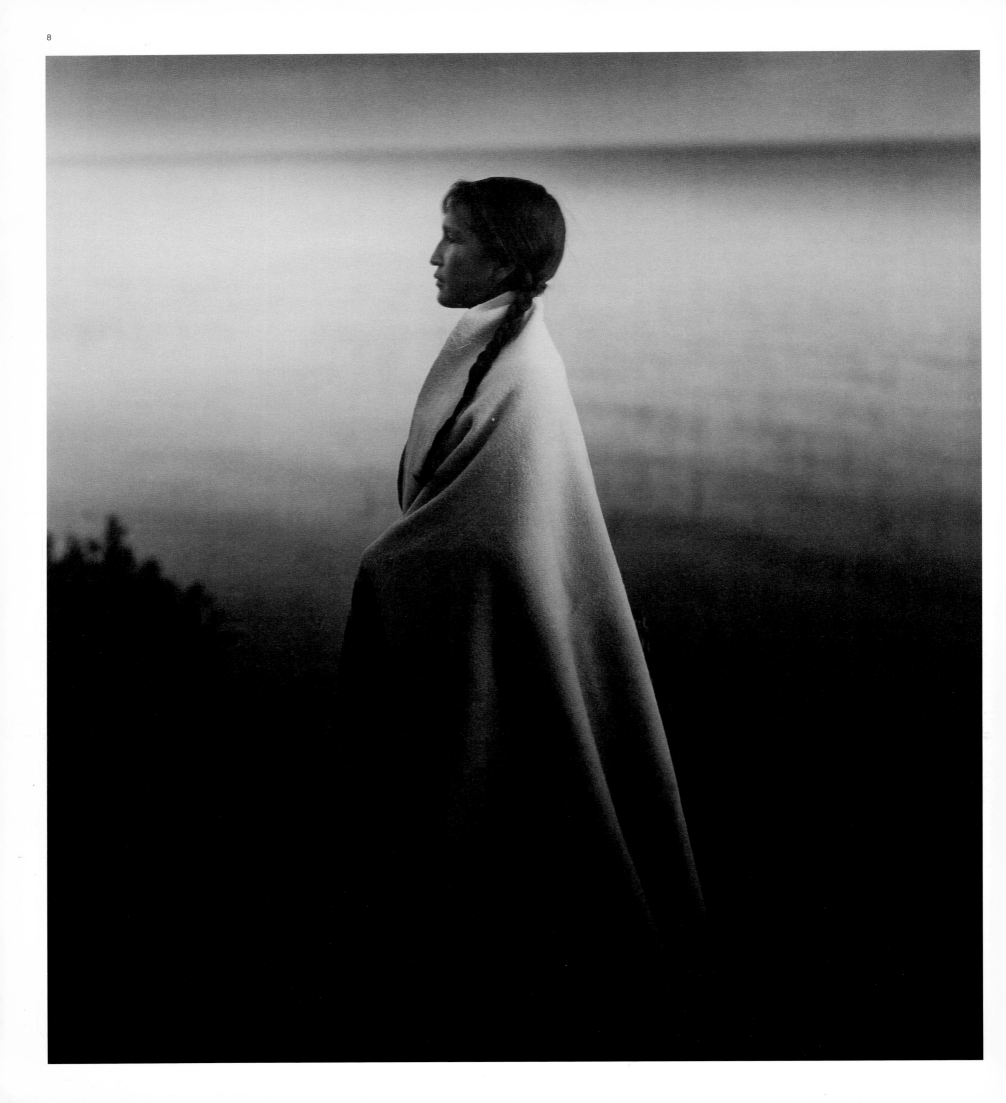

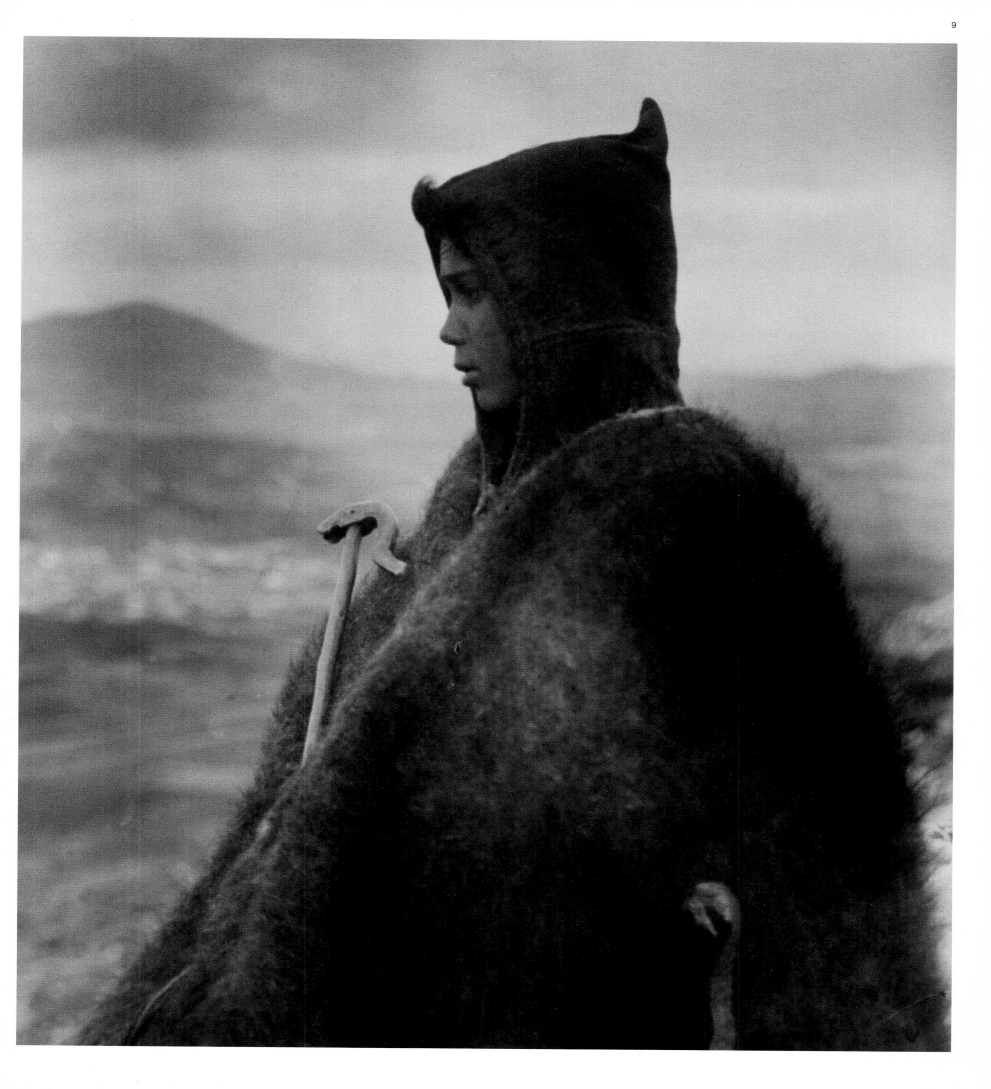

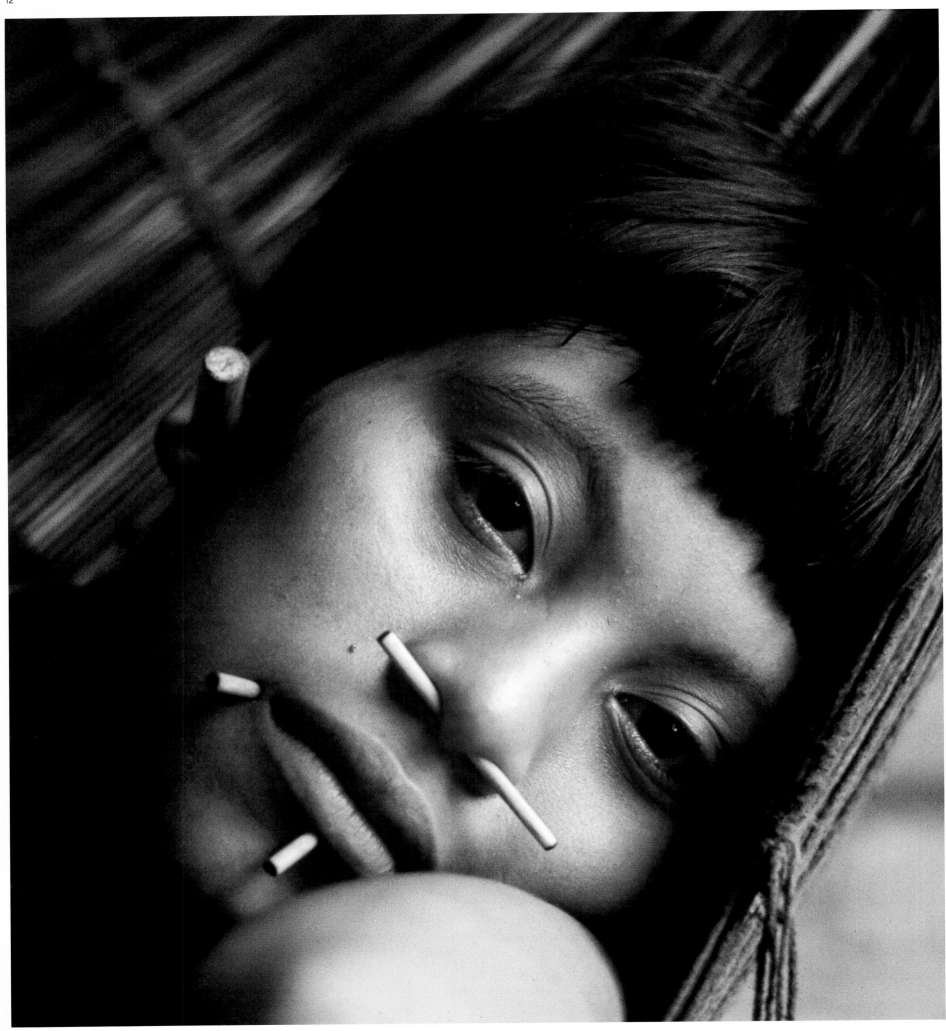

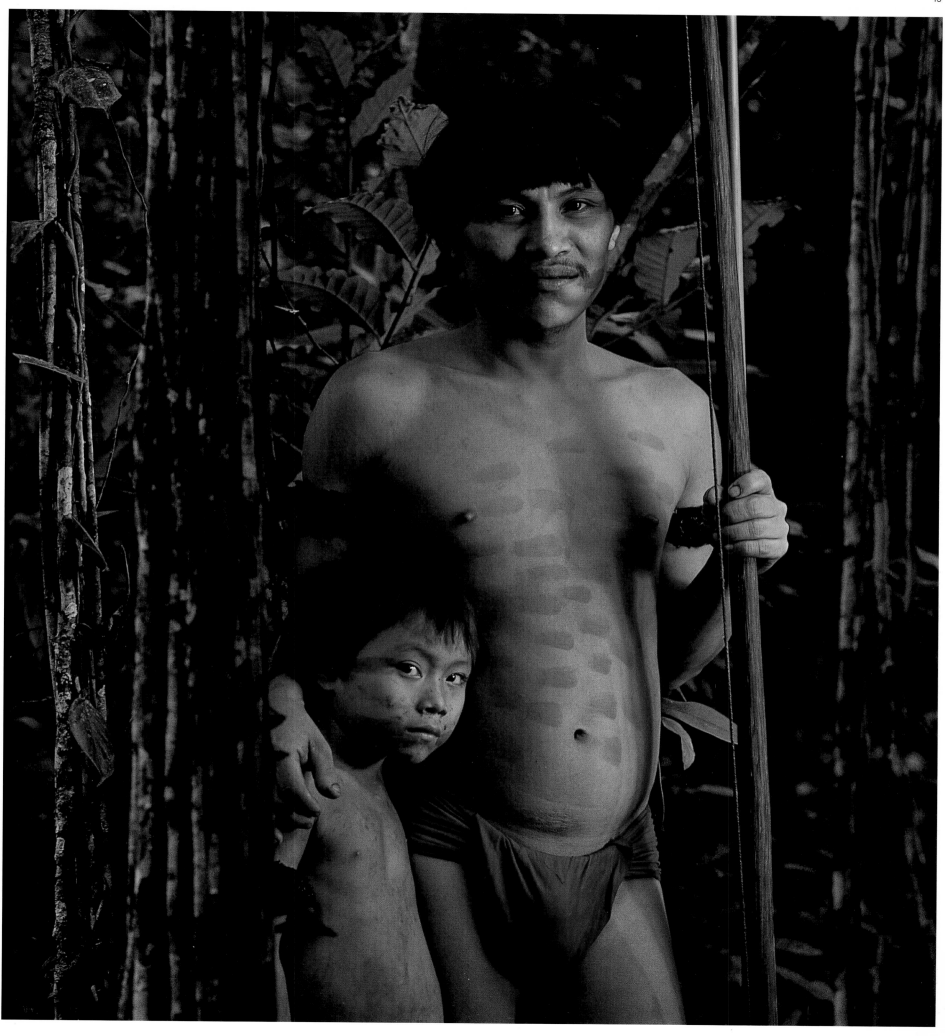

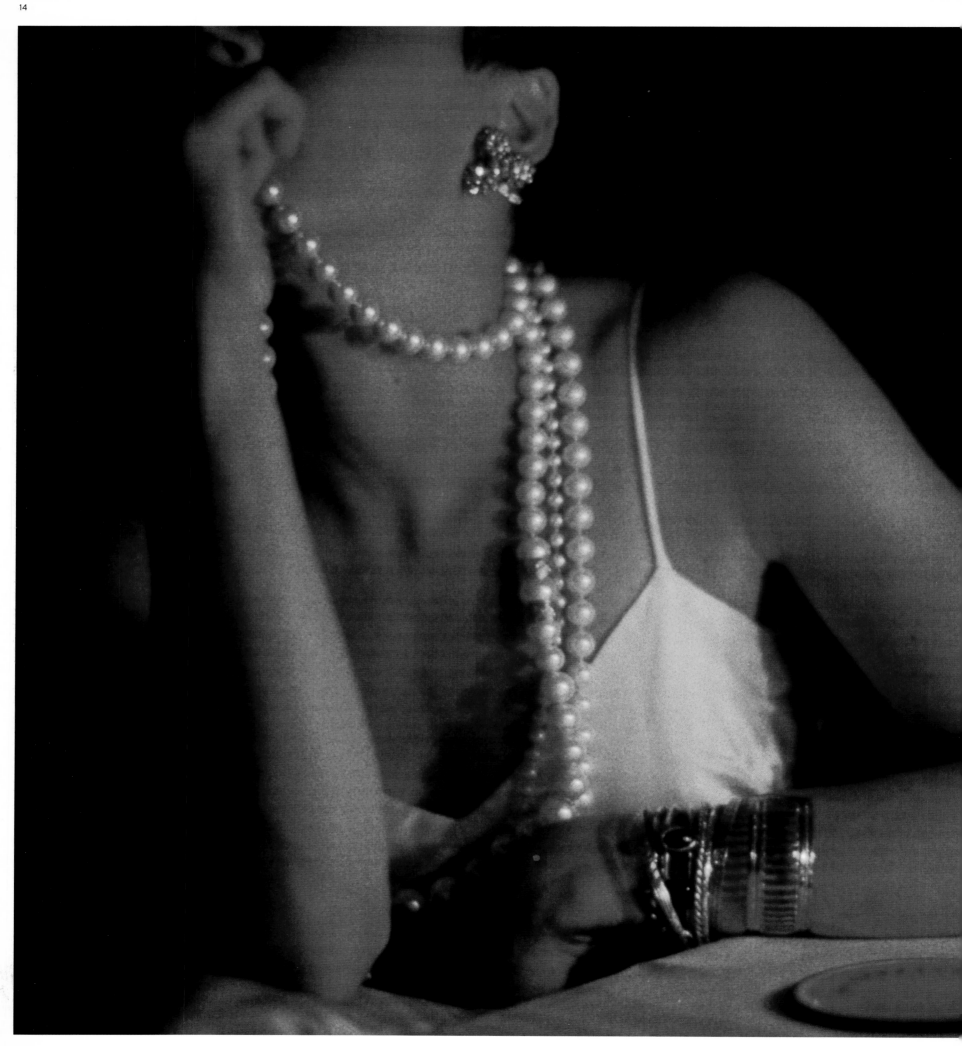

"ELEGANCE
IS NOT THE
PREROGATIVE
OF THOSE WHO
HAVE JUST
ESCAPED FROM
ADOLESCENCE,
BUT OF THOSE
WHO HAVE
ALREADY TAKEN
POSSESSION OF
THEIR FUTURE."

GABRIELLE "COCO" CHANEL

INTRODUCTION **THE FASHION OF DRESS**

BY JOANNE B. EICHER

My teaching and research focus generally on the topic of "dress," not on "fashion." Why then do I applaud the efforts of the National Geographic Society to use their archives of more than 110 years to produce a book on fashion? I do so because the word "fashion" in most people's minds connotes change, and human beings everywhere are capable of, often desire, and do change.

The concept of change varies throughout the world, and open-mindedness is vital in order to appreciate the pace and degree of change in the habits and traditions—and therefore fashion—of other cultures.

No doubt the colonizing efforts of rulers from nations in the late 19th century contributed to ethnocentrism, the belief that "our way" is right, a perspective that many people in "the West" have of "the rest." Early scholars from aggressive nations, which were determined to colonize as much of the world as possible, dedicated themselves to documenting what they believed to be the exotic habits and behaviors of the people unlike themselves—before these people disappeared. These same scholars, and others, believed that such habits and behaviors, which included dress, were fixed in time and thus "traditional" and in direct opposition to the "modern" world of their own lives. Because other people did not change at the accepted modern pace, they did not keep up with the times, the styles. They did not have—fashion.

Following this train of thought leads us to believe that fashion and change are exclusive phenomena of the modern, industrialized world. Not necessarily so. We need to rid ourselves of an ethnocentrism that encourages the belief that we who live in technologically sophisticated cultures are the only ones capable of, or interested in, change. Fashion is, after all, about change, and change happens in every culture because human beings are creative and flexible. However, when we encounter people in other cultures who appear not to be part of our modern world (maybe they don't dress the way we do) and whose past does not include written history, paintings, or drawings, we often categorize them as coming from static worlds. Documenting change becomes a challenge. Instead, we need to find out *how* change has occurred and accept evidence of it, whether from the oral histories of elders that relate to dressing the body, or from the writings about dress by travelers to these areas. In addition, we need to define dress broadly in order to understand the concept of fashion, for fashion in dress involves more than donning and doffing garments.

Dressing the body involves a wide variety of activities that include using all five senses as we prepare for, participate in, and end each day. We bathe, apply scent and cosmetics, comb or fix our hair, put on garments and jewelry, and hear the sounds of shoe cleats, bangle bracelets, rustling taffeta, or the swish of corduroy. In addition, we taste lip pomade or

lipstick, appreciate the colors of our own and others' garments, and feel the texture of many items that we wear—the cool smoothness of silver, the bristle of fur, the sleekness of satin. In the photographs in this book, the visual aspect of dress is primary, but viewing the images may bring other senses to our memories that relate to the fashion and dress depicted.

Although the photographs in the three chapters are organized into the categories of "Look at Me," "Frivolous or Functional," and "Transformations," other ideas also apply. Capturing attention is paramount in "Look at Me," but in some cases, trying not to stand out via one's dress is another option. Some people may want to fit in with the crowd (think of blue jeans and T-shirts), or may be required to blend with the background (think of camouflage uniforms). "Frivolous or Functional" concerns superficiality versus practicality, as in contrasting a debutante's elegant gown with a surgeon's utilitarian scrubs. However, what may seem frivolous to some viewers may be deemed necessary to the wearer, as in the case of the see-through or "barely there" gown worn by an aspiring movie starlet. "Transformations" focuses on the power or emotion an individual feels when wearing particular garments or accessories, such as a black karate belt or a white wedding gown. But often, more than one purpose is expressed through dress. The monarch's crown and ermine-trimmed robe not only capture attention, but also represent centuries of power. The ubiquitous white wedding gown

found throughout the world in the 21st century, as well as the red sari in India, transforms a woman into a bride and also makes her the center of attention. The robe worn at graduation during the academic procession makes each graduate look alike, but separates all graduates from the audience.

Different people have different interpretations of what is fashionable dress. For some, fashion means that only the details of dress change, such as shifting skirt lengths, widening neckties or suit lapels, or altered sleeve styles, as in the blouses called "buba" that Yoruba women of Nigeria wear with their wrapper sets.

For other people, fashion means a dramatic change of silhouette, as when women's garments became miniskirted tunics that skimmed the body after a period of shirtwaist dresses with knee-length (or longer) skirts and fitted bodices. Even similar-looking garments worn in different places in the world at the same time may be interpreted as fashionable in one place and not fashionable in another. For example, young Chinese women in 1990 in Shanghai wore knee-high nylons with the hems of their miniskirts several inches above the bands of the knee-highs. At the same time, American women wore knee-high nylons only under long skirts or trousers, being careful not to display the band at the top.

Many items worn in various parts of the world seem strange to visitors unfamiliar with the local customs of dress. This

occurs especially when garments are borrowed from other cultures and worn in seemingly strange combinations, out of context from the originating culture. Examples include: bowler hats (thought of as men's hats in Europe and America) that are worn by Otavalo women in the Andes with their handwoven skirts; straw boater hats worn with a blazer-style jacket and wrapper by Itsekiri men in Nigeria; and the English-style man's white shirt worn with a sari by some women in India. Rather than viewing borrowed items combined with indigenous ones as ridiculous or humorous, we must understand each instance within its own context and then can interpret it as a creative ensemble. Such new configurations have gone through a process called "cultural authentication," which involves choosing something worn by others outside the culture and incorporating it as an important part of a new combination. These new combinations visibly display human creativity and humans' ability to enjoy change.

A further example of creativity in dress can be found in the life of secondhand clothing that people in Europe and America supply to the rest of the world. Literally tons of cast-off clothes are shipped to other continents. These garments are used in different ways or in different combinations than originally intended in the countries where they originated. One detailed example comes from the anthropological research of Karen Hansen in Zambia, who found that when secondhand garments were reworked, they were hardly frowned upon; in fact, they resulted in new Zambian fashions, much prized within the nation.

If we view other people's dress as exotic and call it "costume," we may offend them. For example, at an academic conference on the topic of "Dressed and Undressed," an African scholar objected when other scholars referred to dress from Africa as "costume," for he declared that African clothing was not esoteric and so should not be called "costume," but dress. Similarly, in a community presentation in St. Paul, Minnesota, on Hmong textiles, the young Hmong lecturer carefully explained that she does not use the word "costume" when talking about the elaborate outfits her people create from the fabrics. These ensembles of embroidered, beaded, and resist-dyed textiles, worn with turbans and necklaces of silver and coins that Hmong people—especially women—covet for celebrating the New Year, are not to be considered "costume," but "Hmong dress."

Few people in the world are completely isolated from some type of mass communication, such as television, movies, computers, or fax machines. Thus technology of the 21st century has an impact on fashion almost everywhere. People in seemingly remote places can easily be "in the know" about current fashion—and they want to have and wear what is in fashion. In the 1970s, when hot pants were at the height of that fashion, *Life* magazine published a photograph of prostitutes wearing hot pants deep in the Brazilian rain forest.

In 1995, Leslie Rabine, a scholar who is conducting research on African and African-inspired fashion in Nairobi, Dakar, and Los Angeles related the following conversation between two 12-year-old Nairobi cousins about baseball caps from the United States, as the caps were being unpacked from suitcases: One cousin solemnly informed the other that "the Bulls is out of fashion." "So what is *in* fashion?" his mother asked. "Lakers," said the other cousin. "Lakers is out," affirmed the first cousin; "White Sox is in." "And Malcolm X?" asked the second cousin, examining the last hat from the suitcase. "Malcolm X will never be out of fashion; Malcolm X will never be out," said the first.

Rabine analyzed the above conversation by pointing out that the loyalty usually represented by the wearer of a baseball cap to the home team was not relevant to these Kenyan boys and their interpretation of fashion. However, the name of Malcolm X on the cap portrayed "the double life of African fashion items," for it acted both as a symbol of an ethnic identity the boy wanted to share with Black Americans, along with his wanting to be fashionable. By stating, "Malcolm X will never be out," he declared that this fashion would endure because he believed that allegiance to Malcolm X represented longstanding allegiance to African Americans.

In savoring the following images from the National Geographic archives, we must exercise caution in assuming that contemporary citizens of a certain area continue to wear the same style and type of dress. The date of the photograph becomes important. The image that delighted the photographer at the time of clicking the shutter may not indicate at all what people are currently wearing in that country. It may not even be an example of what most people wore at that time. For instance, photographers may have a specific purpose in documenting a certain dress, as I did when I began my own in-depth research in the 1980s among the Kalabari people of the Niger Delta in Nigeria. I concentrated on ceremonial and special-occasion dress and avoided photographing people in their everyday clothing such as dresses, skirts and blouses, shirts and trousers, or suits. If observers drew conclusions only from my photographs, they could easily believe that the more specialized outfits were worn every day.

In addition, photographers are artists; as artists, they are entitled to take creative license with their art. For example, although some Inuit in Alaska and Canada still wear fur parkas (although they now use mouton and no longer caribou), many urban women wear printed calico parkas with synthetic fibers as filling, and urban men wear solid-color poplin parkas with synthetic filling. Both have done so for many years. These garments do not provide the same "photo op" for a photographer on location who is seeking the stereotypical image we have of the Inuit wearing fur parka, trousers, and mukluks. Similarly, few Japanese wear

a kimono, except to mark their 20th birthday or their status as bride or groom at a wedding. Instead, Japanese of all ages wear what is commonly called "Western dress," and those who have the resources, often choose to wear designer fashions.

To the eyes of an outsider, whether an armchair traveler, tourist, or merchant, some garments, like the Indian woman's sari, the Korean *hanbok*, or the West African head-tie, may seem unchanging and traditional. But they are not. During a conversation about fashion in Indian saris being related to the width and design of sari borders, an American woman exclaimed, "I never knew there were fashions in saris." Such examples of other people's dress may seem not to change over the years, but the insiders who wear these garments recognize what is in fashion and what is not.

Another example comes from the research of Shelagh Weir, who documented the clothing of Palestinian villagers before that area became known as Israel. She expected to find "that each village or region had only one main style of female dress, and that the village attire fell into two main categories: 'traditional,' that is, relatively static and totally indigenous, and 'modern,' that is, transformed and corrupted by outside, mainly European, influences." Instead, she found that several styles in each village coexisted simultaneously with some features shared across villages. She also found that one particular village was known for being a

leader of fashion in its region, and she confined her research to that location.

Fashion items transfer easily across the globe in all directions, not just from industrialized countries to developing nations or from urban areas to rural towns, but also from East to West, North to South, and from farms to cities. This has happened over the centuries. For example, "Japanism" was a style of leisurewear in America in the early 20th century that showed the clear influence of the Japanese kimono style. The discovery in 1922 of the tomb of King Tutankhamun, the boy pharaoh of Egypt, also had its impact on European and American dress in the 1920s, and subsequently, Egyptian motifs such as scarabs and cobras became the rage and inspiration for many items of Western-style dress.

In the 1960s, young Americans who joined the Peace Corps and were assigned to Nigeria brought back the tunic-style garment called "dashiki" to the United States, where it became a common fashion for a while, died away, and returned again later. By the 1990s in the United States, the handwoven strip cloth from Ghana called "kente," the painted cloth from Mali called "bokolan fini," and the indigo-dyed cloth from Nigeria called "adire" had become signatures in the wardrobes of many African-American men and women.

Often fashion designers of Paris and London use as inspiration the garments or motifs from other countries. Think of

Jean-Paul Gaultier in 1997 drawing ideas for that season's line from Frida Kahlo's wardrobe of her own interpretation of local Mexican dress. Certainly jeans and overalls, clothing items originally worn by rural people in North America for their daily work, have become acceptable and desirable garments to wear in many sophisticated urban circles. Fashion inspiration that derives from developing countries or from rural areas comes not just from designers in the capitals of Europe and America who have discovered these "looks" during their travels or research. Fashion ideas also arise from designers who originate from other continents and who draw from and interpret their own traditions for contemporary fashion. Two such designers are Iwan Tirta from Indonesia, whose fashion house is in Djakarta, and Xuly Bet from Senegal, whose boutiques are in Paris, New York, and Marseilles.

By the 21st century the practice of painting hands with designs of henna, common in North Africa and India, has become a requested fashion in many North American beauty salons. Also, tattoo parlors have sprung up in small towns as well as in larger cities and no longer cater only to a clientele once thought of as primarily male sailors and wrestlers. Both males and females of many ages and professions display the art of the tattooist. A number of designs are inspired by photographs of tattooed people from various cultures who have a tradition of tattooing, such as the Maori of New Zealand and the Japanese.

Living in a modern world does not mean that the traditions of the past as represented by some articles of dress—or even total ensembles—have necessarily disappeared. Instead, treasured articles from the past, such as an academic gown or a cleric's robe, may coexist with and be used at the same time as the latest styles for everyday wear. In addition, some ethnic groups will wear their outfits of traditional dress for special festivals. The examples of traditional outfits may continue to change as those who make them move to new locations and are exposed to different resources for designing and sewing garments.

For instance, the Hmong textile artists who moved from Laos and Thailand to Minnesota began to use sequins, rickrack, and shiny fabrics—indigenous not to their homelands but to their new land—in constructing both men's and women's garments. New fashions developed similar to their older ones, but different in cost and in time needed for a person to don them. One example of an altered style is the ready-made turban—the result of time becoming more of a commodity in the United States. The time-saving turban is placed on a woman's head like a hat instead of an older woman winding yards of cloth around the head of a younger one as she kneels on the floor in front of her.

Still another dimension of considering what is and what is not traditional or fashionable relates to the controversial

topic of Muslim women wearing the veil, and the interpretation of what a veil is. The topic of modesty enters into this controversy, which involves a consideration of what parts and how much of the body (particularly a woman's body) should be hidden. Rather carelessly, from the viewpoint of many Muslim people, headscarves and the more enveloping garments called "chador" and "burqa" are all called "veils," and these clothing items differ in regard to the amount and type of body coverage they provide. Fadwa El Guindi explored various dimensions of meaning attached to the Arabic word "hijab." She prefers it rather than "veil," pointing out that this particular word has many levels of meaning that are much more complex than "veil." The meanings extend beyond the idea of being modest in covering the body to two additional ideas, those of allowing a person privacy and/or allowing resistance. Covering the body permits shielding oneself from being seen by others, and the shielded person has an advantage of controlling her space. In addition, El Guindi declares that many contemporary Islamic women assert that covering the body displays a visible resistance to the values of what they see as the encroaching world of non-Islamic believers.

As you peruse the following pages, I want you as readers to consider two themes: First, the subtleties of fashion as change in dress, and, second, how we interpret change in dress as fashionable. Appreciate these, and you will appreciate the beauty of dressing the body around the world.

JODI COBB **UNITED KINGDOM** 1999
/pages 24-25/ New designers debut during London's Graduate Fashion Week.

ALFRED I. HART **SOUTH AFRICA** 1925
/pages 26-27/ Xhosas don reed outfits for a rite of passage to manhood.

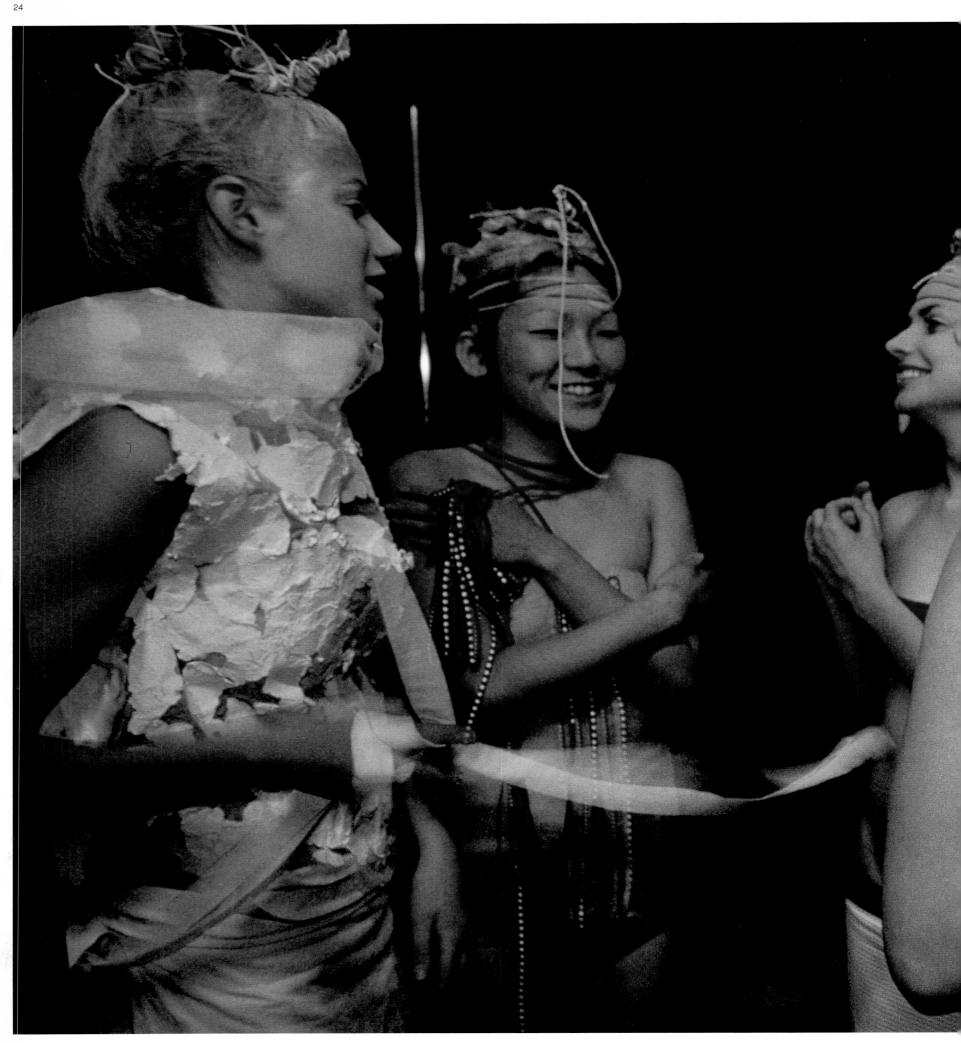

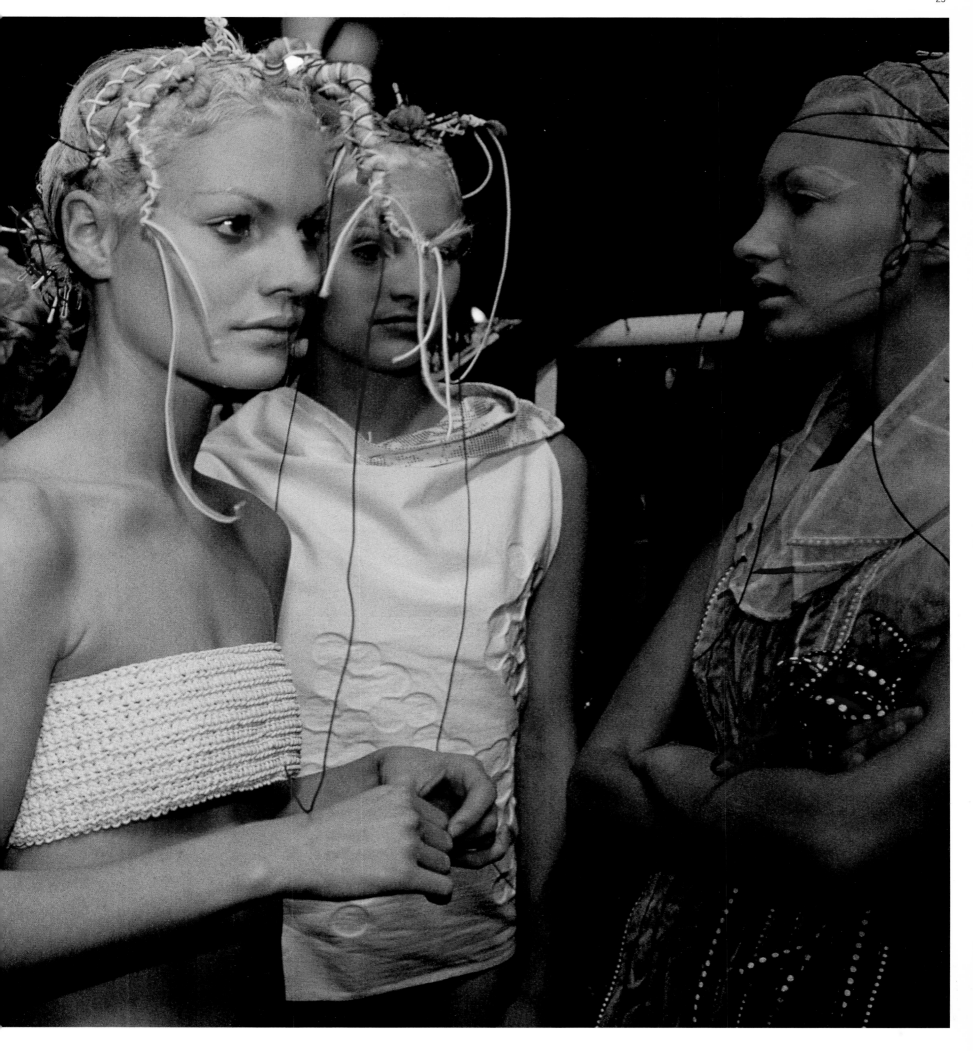

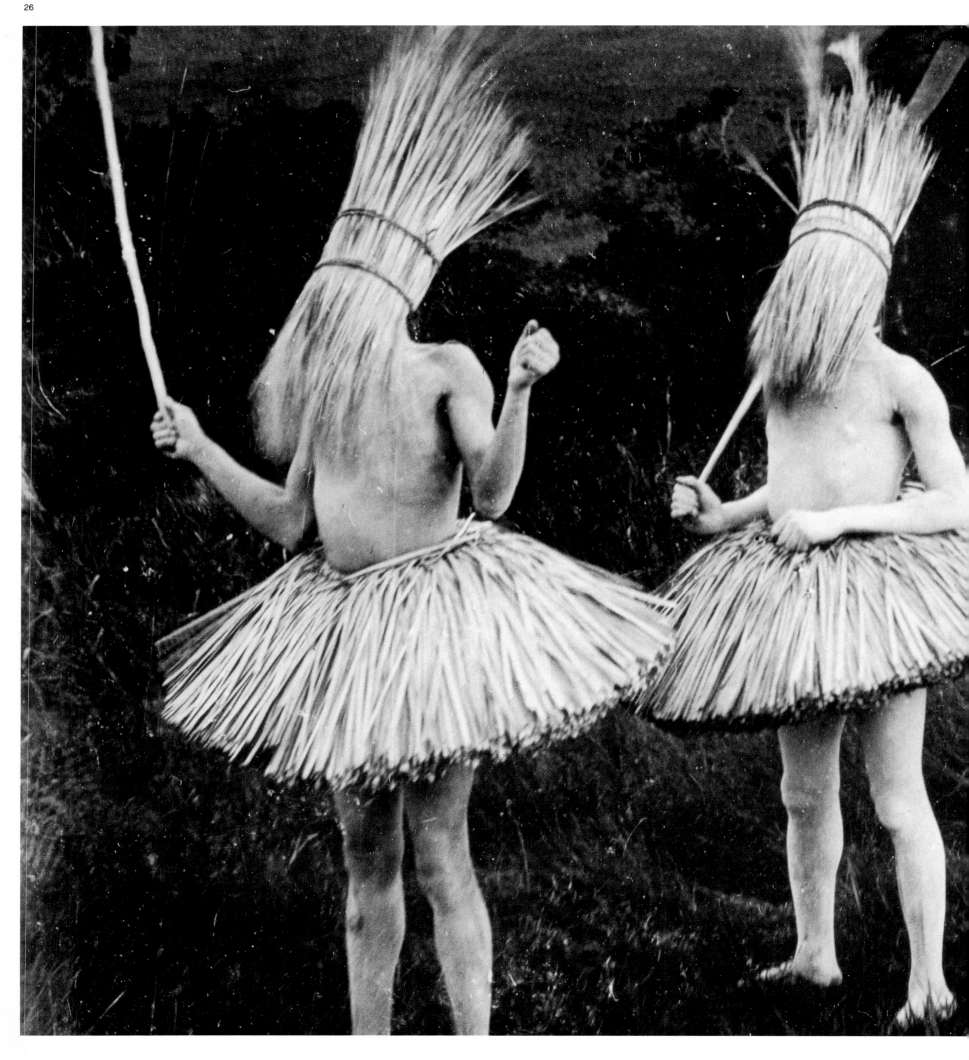

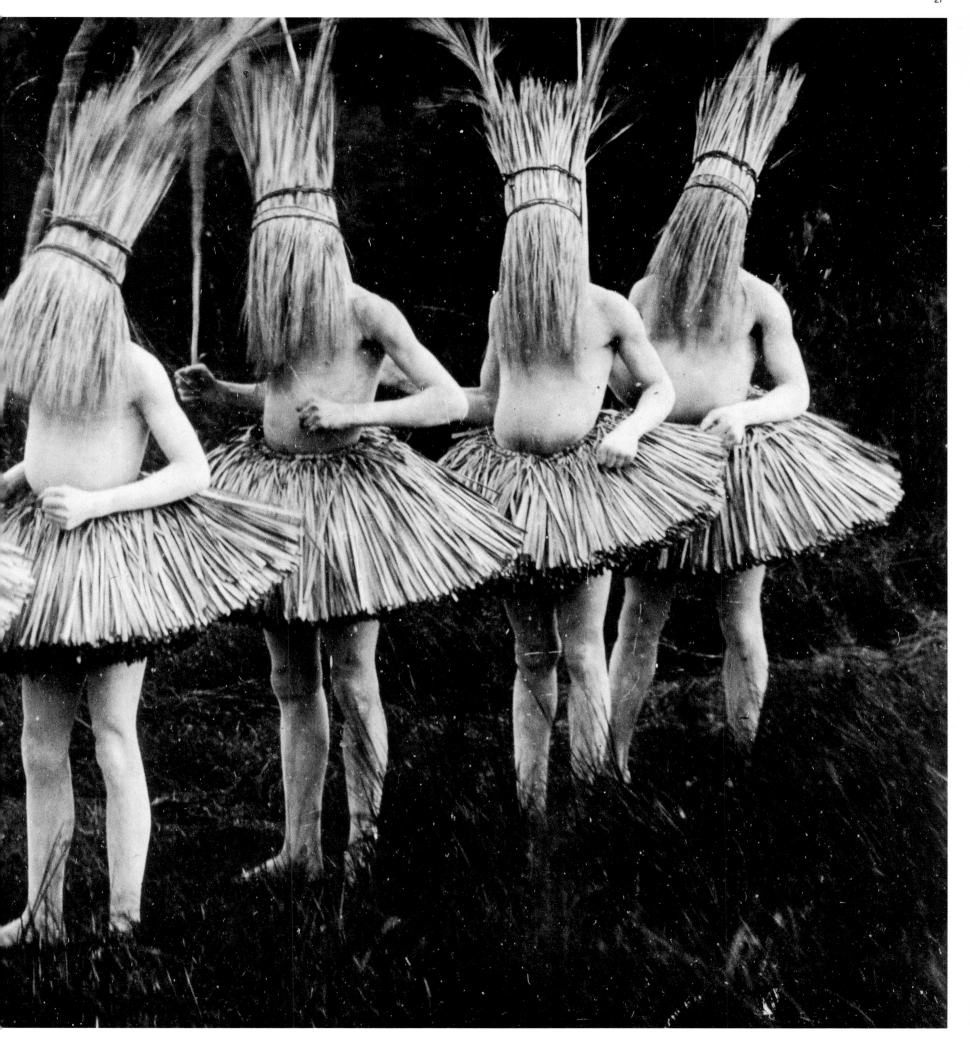

"WE CAN LIE IN
THE LANGUAGE
OF DRESS OR
TRY TO TELL
THE TRUTH;
BUT UNLESS
WE ARE NAKED
AND BALD, IT
IS IMPOSSIBLE
TO BE SILENT."

ALISON LURIE

INTRODUCTION **THE FASHION OF FASHION**

BY VALERIE MENDES

These compelling images, informative, inspirational, have an undeniable strength and diversity. The title *National Geographic FASHION* is an ideal amalgam. As Hilaire Hiler stated in the *Bibliography of Costume*, in 1939, the National Geographic "is too well known to need comment," and though fashion may appear to some to defy purist nomenclature, it best captures the spirit of these remarkable photographs, affirming the creative and changing significance of the clothes as well as the authoritative power of their wearers.

Like it or not, the word "fashion" has a magical ring. It sets pulses racing and, in the museum world, a fashion exhibition acts as a magnet, attracting huge crowds. Indicative of the eternal fascination of clothes (no matter where or when they originate), this popularity is also born of the fact that body and clothes are common denominators, making us comfortable in their presence and confident to comment on them. Scholars have painstakingly dissected what Gilles Lipovetsky in his 1994 *The Empire of Fashion* called "the enigma of fashion," and it still provokes endless opinion and speculation.

Definitions of fashion are numerous, each depending on indisputable facts as well as the bias of each authority. Some common threads are discernible. Fashion is generally characterized by its ephemerality and by incessant stylistic changes that some consider to be imposed dictatorially by the industry and/or designers. Others attribute change to an anti-boredom, restless factor—the near-compulsive desire to

regularly transform one's appearance, or as Doris Langley Moore poetically put it in *The Woman in Fashion* in 1949, this "taste for new fancies, a perpetual succession of new fancies." Common sense concludes that it is a bit of both. The long-held notion that fashion is a Western phenomenon that emerged in the early Renaissance and, Valkyrie-like, galloped through the centuries, growing and accelerating as it went, is rightfully under challenge. The perspicacious Mrs. Langley Moore pinpointed that an "exuberance of fashion" influenced shifts in Greek and Roman clothing, and noted that fashion was not confined to the West, but that untrained European eyes simply were unable to perceive the fashion changes in, for example, Chinese or Japanese clothes.

Webster's Third Edition offers this mercifully uncomplicated, concise definition: that fashion is "the prevailing or accepted style or group of styles in dress or personal decoration established or adopted during a particular time or season." Admirably inclusive, it applies to all periods and all societies.

Fashion exerts a spell as, chimera-like, it fascinates, eludes, and teases. Fashion arouses passionate responses ranging from deep hatred to joyful adoration. That feisty New York designer Elizabeth Hawes came to deplore fashion and wasn't afraid to state, in her 1938 *Fashion is Spinach*, that "I don't know when the word 'fashion' came into being, but it was an evil day." Thirty years later, London-based designer Jean Muir also found the word "fashion" and its associations distasteful

and always insisted on being known as a dressmaker. Conversely, Anna Harvey, deputy editor of British *Vogue*, confided in her 1998 *Fashion: Great Designers Talking*, that "Fashion is the most fickle of Muses, but it is her very capriciousness which has captivated and inspired me. If she is one thing today, tomorrow she will be another." Hawes and Muir were apparently averse to the fashion system in the West, which centers upon production, consumption, and promotion, involving a large and complex network of specialists.

That intimate trio of collective nouns—costume, dress, and clothing—together with their fickle sister, fashion, have accumulated many meanings, each with modifications imposed by user, time, and context. Dictionary definitions of these terms tended to be neglected, and their definitions became increasingly blurred so that today they are often used interchangeably. The virtuous "costume" is popularly associated with stage, film, or historic clothing and, contentiously, with the main focus of this study: non-Western clothing. "Dress" used generically as in men's or children's dress is no longer commonplace and nonspecialists confuse it with "a dress" (as in a woman's garment) that is part of everyday language. Any of the terms world/national/regional/peasant/folk/occupational teamed with "dress," "costume," or "clothes"—rarely "fashion"—are familiar, long-established combinations. While they have a notable pedigree stemming from 9th-century Old English, "clothes" and "clothing" have become the Cinderellas of the story. Clothes, whether fashionable or not, can be spectacular in luxurious fabrics with ornate trimmings, but literature has tended to treat clothes mainly as utilitarian phenomena. The words "dress," "costume," and "fashion" have evolved special auras and connotations, while clothes are frequently referred to as "mere clothes" or "just clothes," and saddest of all, "old clothes." In June 1887 the *Daily News* referred to "That section of the world that 'dresses' in contradistinction to merely wearing clothes." In recent times, old or secondhand clothes have been rescued from their lowly status and given dignity by being part of recycling initiatives, aid programs, retrotrends and, from thrift shops, everyday wear. Book titles incorporating "dress," "costume," or "clothes" imply solemn erudition, but that seductive word "fashion" whets the appetite for accessible texts and striking images.

Museums grapple with terminology. London's Victoria and Albert Museum launched a new Costume Court in the 1960s; after renovation in the 1980s, it was reborn as the Dress Collection. But by the 1990s, dress was démodé, and fashion was waiting in the wings. Kyoto's Costume Institute was established in the 1980s—no doubt inspired by the Costume Institute (née the Museum of Costume Art in 1937) at the Metropolitan Museum of Art in New York. The Smithsonian Institution's National Museum of American History in Washington has a Costume Collection, while the Museum of Fine Arts in Boston has discarded Textiles and Costumes in favor of Textile and Fashion Arts. Paris, the fulcrum of fashion, has two outstanding collections: La Musée de la Mode et du

Textile (formerly Musée des Arts de la Mode) and, embracing all clothing eventualities, La Musée de la Mode et du Costume. The word "fashion," always personified as a female, even a goddess, has an appealing resonance; but France's ultra feminine "La Mode" has that added allure.

The ever-growing literature describing, analyzing, and evaluating what humankind has worn and wears, as well as how and why, abounds with experts' attempts to establish a standard classification. Bringing a diversity of approaches to the task, the long list of authorities includes aestheticians, anthropologists, archaeologists, curators, collectors, designers, economists, ethnologists, historians, manufacturers, philosophers, psychologists, scientists, sociologists, travelers, and, those relative newcomers, semiologists. However, to the fury of some and the delight of others, ever-mutable clothing defies the straitjacket of a universal schema. In his admirable search for order amid the "dazzling gamut of dress throughout the ages and the climes," J. C. Flügel in *The Psychology of Clothes*, 1930, adapted the findings of F. Müller-Lyer and sorted world clothing into two neat categories: the "fixed' and the "modish" or "fashionable." Unfortunately, it would never be so elementary. Indeed Flügel immediately qualified his two megadivisions, explaining that it was a matter of degree. "Fixed" clothing meant that changes were gradual, whereas the very essence of "modish" clothing was rapid change.

Fashion, the forces that drive it, and its dissemination have proved manna to theorists. The psychological theory of fashion —involving a complexity of motives such as self-assertion and self-negation, sexual attraction and competition, conformity and rebellion—has distinguished adherents. Others subscribe to the sociological top-down theory of fashion explored in Thorstein Veblen's 1899 *The Theory of the Leisure Class*, whereby the exclusive clothes of an elite influence the apparel of the general consumer. As the rigid social hierarchies of, say, a hundred years ago came to be replaced by more fluid social structures, a countermovement—the bottom-up sequence—emerged as distinctive looks composed on the cheap by young people began to influence the rarified output of top fashion designers. This trend culminated in the dominance of "street style" in the 1960s and 1970s. So-called "high" fashion, financed by big business with its celebrity designers, seasonal razzmatazz, and glamorous clients defended its position.

The annual catwalk cycle of Paris/Milan/NewYork/London remains high profile but is no longer the almighty force it once was. Still, mass manufacturers continue to take their cues from biannual collections and fill shops with diluted, low-cost versions of designer clothes and "must have" youth-targeted brands. The convergence of a hyperaware clothing industry, fashion icons such as pop and sports stars, rapid communications, and easy travel together with the erosion of cultural traditions, gave rise to new indicators of social status, wealth, and personal creed. The once obvious "leaders and

followers" clothing blueprint, still apparent at ceremonial and formal events, has largely been replaced by more subtle and diverse methods of announcing "this is me and these are my attributes" and of indicating one's place in the pecking order.

Wealth is no longer the insurmountable barrier it once was. The discerning, seriously rich now indicate their affluence by understated nuance rather than overt display, while extroverts flaunt expensive designer logos and lavish gold accoutrements, the latter being favorites of the sporting fraternity.

Conformity is anathema to most, a fact endorsed by observing groups "confined" to corporate, authoritative uniforms. In discreet and sometimes not so discreet ways, they customize their regulation issue, even in the rigorously controlled armed services and police forces. Attorneys, flight attendants, and nurses have ways of adapting their uniform and appearance to express individuality. Perhaps it is only when life itself depends on absolute orthodoxy—as in safety wear for physically dangerous occupations—that humans resist the urge to personalize their clothes.

The democratization of fashion has created a vast potpourri of styles from which to select. There is no doubt that fashion mirrors social formations—not least the present youth-centered "anything goes" dynamic. Refreshingly, this gives a green light to the mixing of all kinds of garments: chain store, couture, secondhand, brand new, occupational, and "ethnic."

In recent years the latter has received much media attention, and it is sometimes forgotten that cross-cultural exchange in fashion has a long history, in which, it can be argued, NATIONAL GEOGRAPHIC magazine has played an important role.

Early adventurer-explorers and traders opened Western eyes to the glories of non-Western artifacts, including the sensuous appeal of silk textiles and clothing. An increasing interest in what people throughout the world wore was fostered in the 16th century by a growing body of illustrated books. Initially these satisfied antiquarian curiosity, but soon they inspired real clothes—especially the escapist costumes, or disguises, of masquerades and pageants. Thus began the Western practice of borrowing and amending elements from clothes of distant cultures.

The habit burgeoned over the next 400 years. By the 19th century, it was fed by texts that varied enormously in content and tone. For example, those in pursuit of ideas "ancient and modern" might turn to the 1846 *Book of Costume* by an anonymous "Lady of Rank," in fact the Countess of Wilton. In 31 intriguing chapters, the book surveyed clothes from selected parts of the world, from "the toilette of England" to "the toilette of Arabia." Huge exhibitions bred of colonialism, such as The Great Exhibition of the Industry of All Nations in London, in 1851, introduced thousands to the rich cultures beyond Europe. The West's artistic repertoire was vastly enhanced—and fashion was not immune.

Throughout the second half of the 19th century, society's preoccupation with "dressing up" led to the proliferation of fancy-dress balls where non-Western clothes and textiles made an impact. Such amusements were aided by handbooks, especially the much reprinted *Fancy Dresses Described or What to Wear at Fancy Balls of 1880* by Ardern Holt. International in scope, the book was published by the London department store Debenham and Freebody which, of course, was prepared to take orders for any of the outfits. The rage for these occasions culminated in the Duchess of Devonshire's famous ball of 1897, when guests were invited to wear "allegorical or historical dress before 1815." Affluent beauties rifled the "Oriental" world for inspiration and had Paris designers create lavish clothes to reflect their chosen characters including a snake charmer, Scheherazade, and Vashti Queen of Persia. The usual favorites the Queen of Sheba and Cleopatra were oversubscribed. Liberty of London, founded in 1875 with emphasis upon imports from India, Japan, China, and North Africa, greatly influenced London bohemia.

Custom-made 19th-century gowns from the prestigious Paris house of Charles Frederick Worth—held to be the first couturier—incorporated notions from India, Japan, and Persia to the delight of his wealthy clientele. Sophisticates in early 1900s Paris were infatuated with interpretations of all things "Oriental"—the costumes and vivid colors for *Scheherazade* performed by Diaghilev's Ballet Russes in 1910 captivated eager audiences. In the realm of fashion, Paul Poiret was the

first to make the exotic so newsworthy. Though clothing of India, Turkey, Japan, China, and Africa had influenced his work since 1907, it was the extraordinary "Oriental" costume with hooped tunic over harem trousers worn by his wife at his lavish Thousand and Second Night Ball in 1911 that caused a stir. Poiret's research into and admiration for world textiles and clothing was serious—he traveled widely, amassing an important personal collection. Study in museums—for example he examined Indian turbans in the Victoria and Albert Museum—satisfied his yearning for authenticity. His multicultural approach to fashion set a pattern for future designers.

As the pace of the fashion business accelerated after World War II, designers increasingly sought stimuli outside their familiar metropolitan ambience. They were aided and abetted in this quest by glossy magazines, which used ever-more distant locations for fashion shoots. Consumers became willing players as the boom in jet travel and vacation packages brought the world to the masses. An impetus came from young people who, disillusioned with what they perceived to be the failings of industrialized society, readily converted to the "drop-out" culture of the 1960s and '70s. Clothes became an outward sign of their rebellion. Their travels, especially on the hippie trail through India and Afghanistan, and South America, introduced them to the practical and decorative appeal of non-Western clothing and adornment, which they instantly adopted. The fashion export potential was soon realized, and specialist shops began catering to urbanites

yearning for a share of the glamour and adventure evoked by these clothes. In London, Inca specialized in "authentic Peruvian knitwear," while Oxus stocked sumptuously embroidered antique dresses and sheepskin coats from Afghanistan. Columns in *Vogue* and *Tatler* frequently depicted socialites clad from head to foot in unconventional garments described as "exotica." Borrowed from distant sources, versions of turbans, smocks, kimonos, djellabas, and caftans became common fashion currency in cities of the West.

Fashion designers have keen eyes and they roam a worldwide visual spectrum, constantly refueling their creative reservoirs. Like Poiret before them, they have a passion for textiles, clothing, and adornment of every kind, irrespective of time and frontiers. Journalists explored the crosscurrents in a succession of collections from Yves Saint Laurent's Russian Designs of 1976-77 to Ralph Lauren's 1994 Vietnamese Collection. Flippant, eye-catching headlines such as "Now and Zen," "Morocco Bound," and "Ever So Sari," brought accusations of irreverence; and some inappropriate "refashioning" of non-Western concepts caused offense. In January 1984 *Vogue* perceived that "Ideas percolating in this brave new fashion world come from all directions, from East, from West, from tribes exotic and urban, and cross-reference dressing is the other great game in town." Exactly ten years later *Marie Claire* announced: "What counts. Global influences. ...inspirational figures range from the rice-paddy worker to the Indian princess."

In contrast to those who are freely inspired by a wealth of clothing traditions outside their heritage, a number of designers have come to prominence who draw specifically on their own cultural backgrounds. For instance, Issey Miyake creates anew from the dynamics of traditional Japanese clothing; London-based Shirin Guild's minimalism is inspired by the cut of Iranian clothes, while the principles of Chinese attire inform the work of Yeohlee in New York. Designers now wrestle with the seemingly limitless opportunities presented by pluralistic fashion in the new millennium. Monographs on designers highlight a hectic, multifaceted creative process—largely driven by the relentless schedule of each fashion year—revealing how ideas gleaned from every corner of the world, together with past and present styles, are redefined to lure and satisfy contemporary consumers.

Designers are discerning collectors who frequently build up personal libraries revolving around fashion and the arts. These provide starting points for their lines and help feed their voracious visual needs. Firm favorites—descendants of encyclopedic classics such as Racinet's *Le costume historique* of 1888—are, in translation, *A Pictorial History of Costume* by Bruhn and Tilke, and its companion *Costume Patterns and Designs*. Together these books provide a treasure trove of nearly 6,000 illustrations of clothing of "all periods and nations from Antiquity to Modern Times." Similarly, for over a hundred years, NATIONAL GEOGRAPHIC magazine has provided a veritable cornucopia of inspirational photographs.

The resurgence of interest in the East/West factor and multi-culturalism in fashion gave rise to key exhibitions in the 1990s. Exhibits revealed the specific emphasis and aim of each of the following: Japanism in Fashion, at the Costume Institute in Kyoto, 1994; Orientalism Vision of the East in Western Dress, at the Metropolitan Museum of Art in New York, 1994; Streetstyle, at London's Victoria and Albert Museum, 1994; Evolution & Revolution, Chinese Dress 1700s-1990s at the Powerhouse Museum in Sydney, 1997; Touches D'exotisme XIV-XX siècles, at the Musée de la Mode et du Textile in Paris, 1998; and China Chic: East Meets West, at the Fashion Institute of Technology in New York, 1999. Throughout the decade, the air was heavy with intimations of what the media dubbed "planet fashion," and these exhibitions coincided with texts on fashion and multiculturalism emerging from universities chiefly in America, Europe, and Australia. From different perspectives, participants overturned the precept that fashion is and has always been confined to the West, and concluded that fashion defies geographic and cultural boundaries. New theories were propounded and old ones revisited, while, most exciting and provocative, antifashion was joined by un-, counter-, contra-, and nonfashion.

Fashion is forever changing, evolving, and being redefined. The debate, like fashion, is without end. *National Geographic FASHION* enters this universal forum, offering us stunning insights into how men and women the world over fashion their bodies and their clothing.

JAMES L. AMOS **LONDON** 1983
/pages 36–37/ Platinum, the noblest metal, is fashioned into an object d'art.

WILLIAM ALBERT ALLARD **PERU** 1996
/pages 38–39/ A safety pin adorns the red felt hat of an Inca descendant.

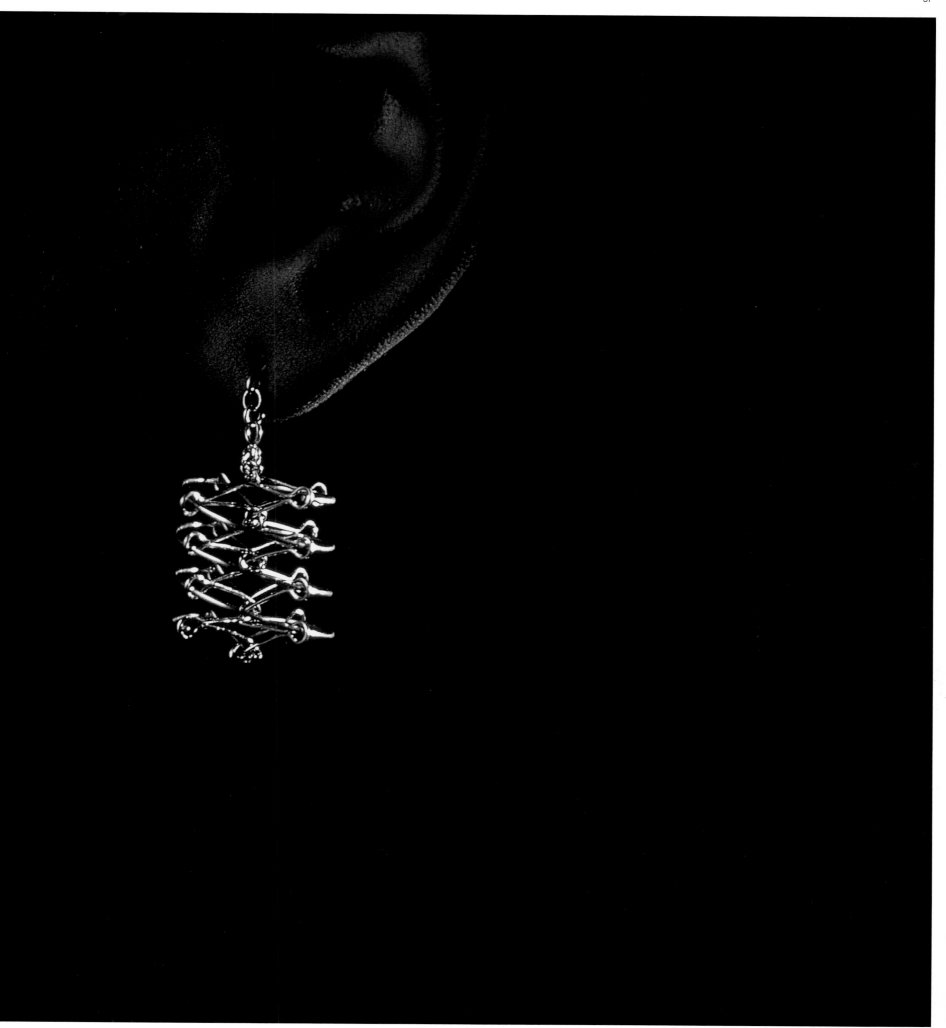

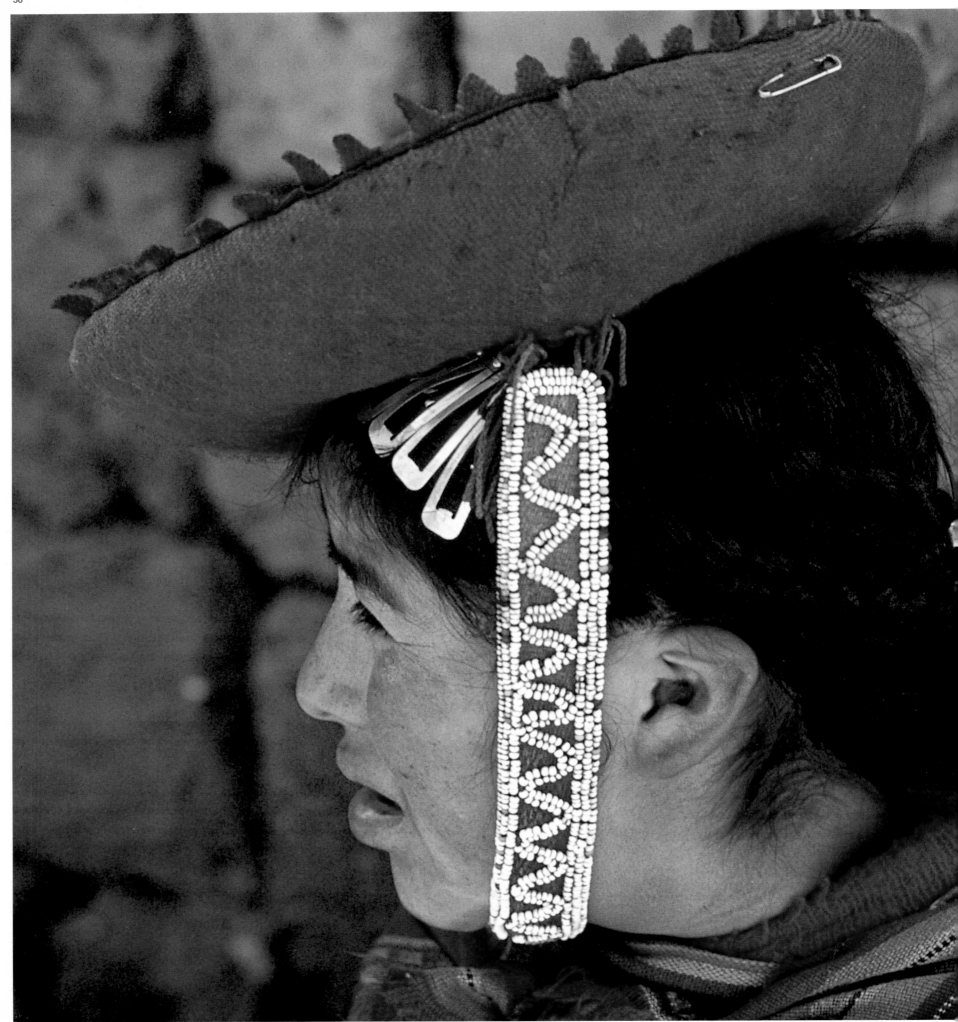

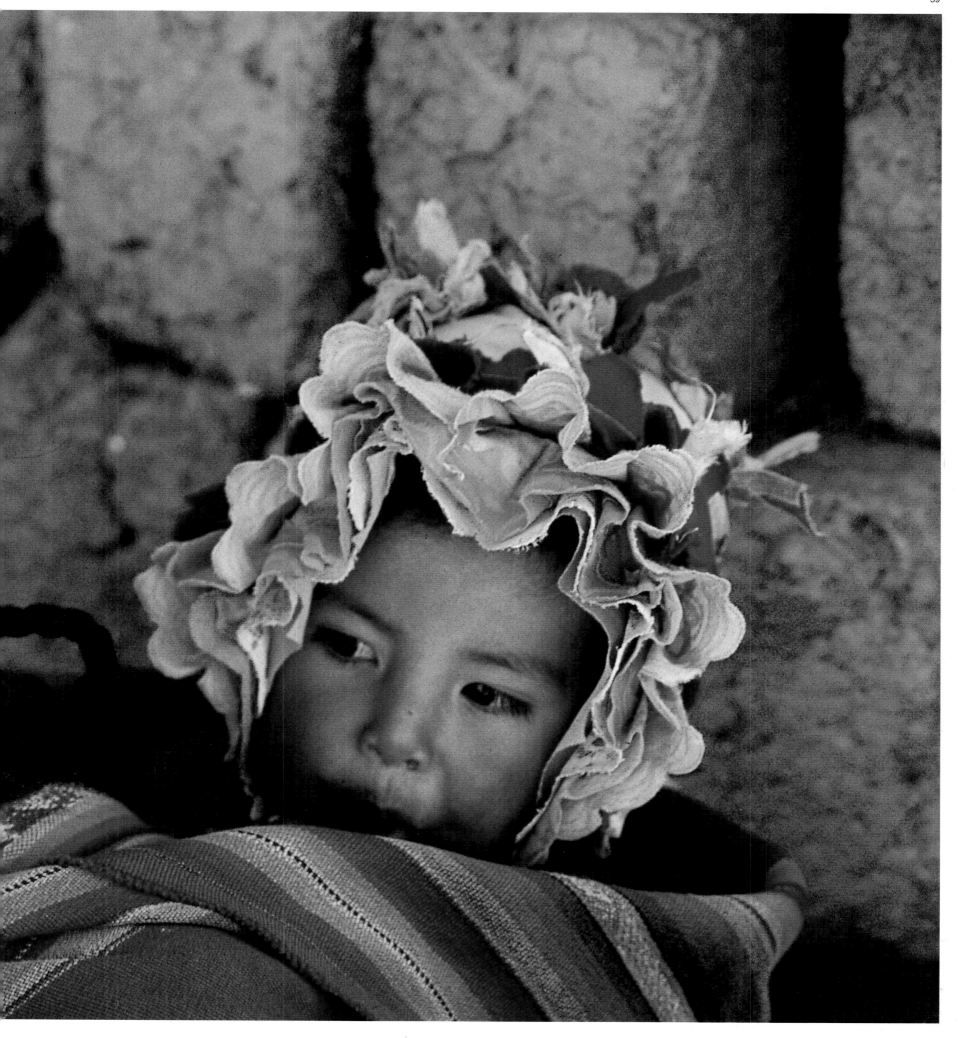

"DOES FASHION
MATTER? ALWAYS—
THOUGH NOT
QUITE AS MUCH
AFTER DEATH."

JOAN RIVERS

CHAPTER 1 **LOOK AT ME**

Melka Treanton is a stylist in Paris, the city where, as Diana Vreeland, the doyenne of fashion editors, once said, "You don't get born to stop thinking of clothes *for a minute*."

A stylist pulls together the clothes for a fashion shoot or runway show, and it is a particular art to arrange a designer's work into an arresting symphony of color, texture, and shape for a photograph or catwalk display. Treanton is good at this; in fact, she is one of the best. As a former editor for the French fashion magazine *Elle*, and now as a freelance stylist, she has, in one way or another, helped nurture the crème de la crème of a younger generation of French designers, among them, Thierry Mugler, Claude Montana, Jean-Paul Gaultier, and has worked with greats in fashion photography like Helmut Newton, Bruce Weber, and Guy Bourdin.

On the day I visit, Treanton is a study in subdued tones. She wears a suede overblouse the color of oak leaves browned by frost, a pair of slim black slacks, and perfectly round tortoise-shell glasses. It is a casual elegance, a perfect example of someone, as the French would say, who is *bien dans sa peau*—comfortable in her skin.

We sit in her apartment on the Avenue Montaigne, directly across the street from the dove-grey façade of Christian Dior and leaf through a sheaf of photographs I have brought along. They are pictures of fashion taken by NATIONAL GEOGRAPHIC photographers on assignment around the world, but they were most pointedly *not* taken as fashion photographs. Nonetheless, Treanton, the fashion expert, is going through them one by one with a critical eye and savoring each one as if it represents a particularly fine vintage that is being passed around for tasting.

She picks up a photograph of a woman from Mozambique Island. The woman wears a scarf of brilliant, in-your-face colors and design. The long swath of cotton fabrics wraps in a graceful swirl around her face, which has been whitened with ground tree-bark. The picture—the bright scarf framing the white powdered face—glows with a ghostly beauty, and Treanton is clearly intrigued. "That scarf—in a French collection would be a hit!" she exclaims in husky-smoky French-inflected English. "It could be Hermès."

The next photograph, of four women in babushka-style head scarves and shearling coats walking down an icy path in Siberia, evokes the murmured words "Saint Laurent," a reference to the French couturier Yves Saint Laurent, whose 1976 "Russian look" collection featured sumptuous fur-trimmed dresses, voluminous greatcoats, and colorful fringed shawls reminiscent of the picture in hand. In truth, nothing in the world of high-style fashion is really new—it is merely reinterpreted and reworked. The "fashions" in the images are real clothes worn by real people, and they are to *haute couture*, or high fashion, what the sound of cannons and church bells are to Tchaikovsky's *1812 Overture:* the raw material that is refined into art, or at least art as western civilization might judge it.

Treanton enthuses over the unposed nature of the photographs—these people *know* they are beautiful she says, pointing to an attractive young Taiwanese woman seated in a boat in the middle of a lake. It is a portrait of serenity made even more gorgeous by the long red skirt and green silk jacket she wears. Treanton lights a slim brown cigarette that smells of incense (from India, she explains), and gets up to pour us a glass of rosé wine. I demur. It is barely 11 a.m. I am supposed to be working, but Treanton, ignoring my protest, glances at

her watch, decrees "It is time," and sets the glass in front of me. Then she sits, leafs through more of the photographs, and pauses to admire the image of a woman and child from the Peruvian highlands. The woman wears a hand-woven wool poncho of brightly colored stripes, and on her head is a red felt hat with a brim and crown not unlike the shape of an oversized citrus juicer.

"Look," she exclaims, and points to a detail I have missed—a large safety pin, boldly affixed to the side of the red hat.

"It has no function," Treanton says of the pin. "It does not hold two pieces of fabric together. It is a decoration. A *jewel*. And the placing of the pin. Just right. Perfect! She wanted to be beautiful, this woman. *Everybody* wants to make themselves more beautiful."

She grinds the cigarette into a crystal ashtray and reaches for another.

"A few years ago when miniskirts were in vogue and I was with *Elle*, I went with a photographer to the street," she says. "It was June and things were slow, but finally we found a young woman in a miniskirt." The young woman, Treanton says, was overweight, but she wore the miniskirt as if it were her birthright.

"Do you like miniskirts?" Treanton asked the young woman.

"I love them," the girl told her, radiant with self-assurance. "I love them because now people notice me."

How we dress, how we look, says many things. "Even when we say nothing, our clothes are talking noisily to everyone who sees us," says writer Alison Lurie in *The Language of Clothes*. "...unless we are naked and bald it is impossible to be silent."

Clothes whisper or shout. They speak of economic, social, and political stature. They elicit learned commentary from anthropologists and sociologists, not to mention analysis from the fashion press, who issue seasonal pronouncements at the drop of a hemline. Clothes provoke, irritate, and seduce. They speak of the ephemeral and of the timeless. They murmur of magic and drone on about the mundane.

But in the language of clothes, there is one sentence that cuts across all cultures and centuries. It is a simple statement, and it is immediately intelligible to anyone and everyone who has ever put on a hat, a dress, or a pair of shoes.

Look at me.

Look at me!

"The origins of clothing are not practical. They are mystical and erotic," the English designer Katharine Hamnett has said. "The primitive man in the wolf pelt was not keeping dry; he was saying: 'Look what I killed. Aren't I the best?'"

Look at me; I'm the best; I'm important; I'm the king!

In every corner of the world, dress has always scribed a line between the privileged and the rest. Whether a crown, a feathered headdress, or the leopard-skin mantle adorned with gold stars found in the tomb of the Egyptian king Tutankhamun, clothes banner status and station. In ancient Crete, Rome, and Egypt the higher your status, the more you wore. "Let clothing

be regulated according to gradations in rank," says the *Book of Guanzi*, a Chinese text from 300 B.C. "Let no one, even if worthy and honored, dare wear clothing that does not befit his rank." Toward the end of the tenth century in Imperial China, a color was assigned each grade in the mandarin hierarchy. Above the third degree, robes must be purple. Above the sixth, vermilion. Ordinary citizens wore black and white.

In the Byzantine Empire, purple dye was restricted to the imperial ranks. It took tens of thousands of mollusks of the species *Murex trunculus* to supply an ounce of the rare, costly dye. The lower, not-so-well-heeled classes promptly set about to imitate the royal style by dyeing red over blue to make a faux purple, thereby setting a precedent for status seekers and a zillion Hong Kong-made Gucci and Prada knockoffs in centuries to follow.

In medieval France, a prince's shoe could boast a 24-inch point, a gentleman's a mere 12 inches. Louis XIV mandated fabrics, colors, and accessories worn by royalty (only high-ranking noblemen could wear silver buttons on their waistcoats) and, on his deathbed, the length of trains ladies could wear to his funeral. For the ruler of the realm, fashion also has the power to add stature. At his 1926 coronation, Emperor Hirohito of Japan stood on 12-inch-high *getas*, wooden clogs.

"When may I have a crinoline?" the great-grandmother of fashion journalist Marie-José Lepicard implored her mother, whose husband worked as a gatekeeper at a railroad crossing in the stratified milieu of mid-19th-century France. "My dear, never," the mother replied. "It is not of your station." A crinoline, or hoopskirt, commanded enormous space and large rooms; it was not a fashion for someone of modest means living in small surroundings.

From high to wide to long: The Russian empress Catherine II may have worn the longest train on record—at least 75 yards—and it required 50 trainbearers to support it. The Empress Elizabeth of Russia had 8,700 dresses, but in the sweepstakes of outrageous excess, consider former Philippines first lady Imelda Marcos. Marcos did not, as rumored, own 3,000 pairs of shoes; it was, a palace inventory revealed, only 1,220 pairs, not to mention 888 handbags, 664 handkerchiefs, and 71 pairs of sunglasses. Surely, Imelda Marcos, who, a United States senator quipped, made Marie Antoinette look like a bag lady, took the "let-them-eat-cake" prize when she explained to a British journalist: "I told myself, if God blesses me with being a VIP, you can be sure I'll dress up for the poor who need a symbol and a given standard to look up to. I am simply allergic to ugliness." The line between regal and crass blurs.

Such extravagant taste can have unforeseen consequences. When France erupted into revolution and Marie Antoinette realized it was time to flee, she wasted precious weeks in ordering a large trousseau of dresses and lingerie for the flight, as well as a *nécessaire de voyage*, an elaborate 18th century version of a makeup case, containing exquisite porcelain jars for toiletries and a gold-plated manicure set.

The queen's delayed exit led to a tragic outcome: a march to the scaffold.

"Know who you are and dress accordingly," said the Greek philosopher Epictetus.

Call it fashion, costume, or dress; what we wear and how we decorate ourselves tells the world who we are, even in less-than-fashionable circumstances. When the English Channel Tunnel—that 31-mile-long, 150-foot-deep tube linking England to France—was under construction from 1987 to 1994, you didn't need a map to tell the British from the French workers. The British wore Day-Glo orange, shapeless coveralls that made them look like sacks of carelessly bagged groceries. The French were outfitted in sleek and chic taupe-colored jumpsuits with electric blue and red racing stripes that ran down the length of the suit.

The Buddhist monk's saffron robe, the Hassidic Jew's black fur hat, called a *shtreimel*, speak to religious devotion. The cardinal's scarlet hat (30 tassels), the archbishop's green hat (20 tassels), the abbott's black hat (6 tassels), signal religious hierarchy. The obscuring veil of the Muslim woman speaks to unavailability, while the exposed nape of the geisha's neck whispers of the erotic. In the Inca kingdom, cloth was both a tribute of military conquest and a significant addition to a dowry. Village dress was distinctive, and to insure that it remained so, state law prohibited any change or variation. The greatest humiliation in that culture was to be stripped naked in public—a punishment doled out to enemies.

"Clothes are just not that important. They're not status symbols any longer. They're for fun," declared the late West Coast designer Rudi Gernreich in a 1967 magazine interview. Gernreich was a true innovator who created the thong, the topless bathing suit (for which he was denounced by the Vatican), the tube dress, and the no-bra bra. But clothes not status symbols? Not quite, Rudi.

Clothes always have been and always will be about status. Even fingernails can send a message that says: *Look at me! I have money. I have power. I have position.* In 10th-century China, the Confucian scholar grew the fingernail of his small digit as long as possible and capped it with a protective silver shield that bannered his unfamiliarity with manual labor. In a similar vein, a 17th-century French aristocratic woman wore embroidered satin slippers, signaling to the world that she never need worry about muddied shoes, and that a sedan chair would be along shortly to whisk her through the streets.

Vanity is global. Nearly every culture has its bad-hair day. In central Australia, balding Aranda Aborigines once wore wigs made of emu feathers. Likewise, the Azande in Sudan wore wigs made of sponge. "Hair has special significance," Rich Alford, a professor of sociology at Oklahoma's East Central University, tells me. "In most societies, short hair means restraint and discipline." Think West Point, Buddhist monks, and prison. "Long hair means freedom and unconventional behavior." Think Lady Godiva and Abbie Hoffman. Alford has made a cross-cultural study of hair and dress in 60 different societies, and so he ticks off a litany of cultural declarations that different hairstyles send. To grow long hair among the Asante of West Africa made one suspect of contemplating murder, while in Brazil the Bororo cut hair as a sign of mourning. In Panama, the Cuna cut their hair short as a sign of marriagibility—while the Iban of Borneo cut their hair short to signal sickness. Among the Hopi people of Arizona, married women traditionally wear two braids coiled on the side, whereas unmarried women wear an elaborate butterfly-shaped hairstyle. Hair is about socialization and civilization. Because it reminds us of our kinship with animals, its removal is often explained as a means of separating us from animals. So, too,

in the Confucian worldview, "people with long, unbound, unkempt hair were barbarians, or were otherwise outside the bounds of normal, civilized society," writes Valerie Steele, a fashion scholar.

From the serious to the semiabsurd: My favorite hair story is about the young English punker with actual spikes—about 20 of them, each five inches long—affixed to his scalp with industrial glue. *(Look at me; I'm a pinhead?)* His employer was not amused and fired him from his job at a Bristol Rolls-Royce plant because his pointy head was judged a safety hazard. "Anyone looking for a scale model of the Statue of Liberty?" saucily inquired the *Toronto Globe and Mail*, which carried the story.

And what about Rich Alford, the sociology professor, himself? I'm talking to him on the phone, so naturally I can't actually see him. I ask how he wears his hair.

"I wear it long," he answers. "Shoulder length. I just like it that way. I went to college in the late 1960s and early 1970s, and I still identify with being a hippie."

"This is what I looked like at age five," Noliwe Rooks, associate director of the African-American Studies program at Princeton University tells me. We're at her dining table drinking tea and talking about hair and how it defines culture, politics, and the tension between generations. The photograph she shows me is of a little girl with a big puffball of an Afro staring up at the camera.

"My mother was a political activist, and so I wore my hair like this until I was 13," Rooks says, smiling at the memory.

"My grandmother had this huge issue with it. I was her only grandchild, and she couldn't stand it. It wasn't cute. It wasn't feminine. You couldn't put little bows in it. Every summer my mother would take me down to Florida to stay with her. As soon as my mother left, my grandmother would take me to Miss Ruby's beauty parlor and straighten my hair. Issues between my mother, my grandmother, and me got worked out around my hair."

While in college Rooks decided to let her hair "lock," or grow into a mass of pencil-thin dreadlocks.

"Before I was able to tell my grandmother, she had a stroke. I found myself on a plane flying to her bedside, rehearsing how I was going to explain the locks. The doctors didn't know the extent of the damage. She hadn't spoken. All she could make were garbled sounds. I couldn't wear a hat to hide my hair. It was Florida. It was a muggy 80 degrees. I walked into her hospital room expecting the worst, when all of a sudden she opened her eyes and looked at me.

"'*What did you do to your hair?*' she said, suddenly regaining the power of speech."

After her grandmother died, Rooks found herself in front of the mirror cutting her hair in a gesture of mourning.

"When my grandmother was in the hospital, I had brushed her hair. I pulled the gray hairs out of the brush, put them in a plastic bag, and put it in front of her picture. That was hair for me. There was so much about it that defined our relationship. It meant closeness, and then, finally, acceptance."

Clothes speak eloquently of politics. Mahatma Gandhi, who had worn a suit with pressed trousers as a young law student in England, took on the cotton loincloth and shawl to align himself with the masses when he became India's nationalist figure and spiritual leader.

"Gatherings were huge...most people who went to see him could not hear him. Even if they could...the English or Hindustani in which he spoke could not be understood by many. Gandhi needed another medium through which to communicate," writes ethnologist Susan Bean.

That other way was his appearance. The sight of Gandhi dressed in the plain, simple clothes of the poor delivered a stunning, powerful, wordless message. "Nothing could match the communicative power of a photograph of Gandhi in loincloth and *chadar* sitting among the formally attired Englishmen. He communicated his disdain for civilization, as it is understood in the West, his disdain for material possessions, his pride in Indian civilization, as well as his power.... By dealing openly with a man in *mahatma* garb, the British accepted his political position and revealed their loss of power."

The politics of fashion has a whimsical side. Before Sir Norman Hartnell, the royal couturier, could get on with the business of designing the gown Princess Elizabeth would wear for her wedding to Philip, the cultural identity of the worms used to make the silk satin had to be definitely established. The year was 1947, Great Britain was still haunted by the horror and pain of World War II, and questions were being asked:

Were they Italian silkworms, or, worse yet, *Japanese?*

"Was I so guilty of treason that I would deliberately use enemy silkworms?" Sir Norman recalled in his autobiography. He telephoned Winterthur, the Scottish supplier of the fabric, to inquire about the provenance of the worms.

The worms, it turned out, were neither Italian or Japanese. They were from China. "Nationalist China, of course," the supplier proudly replied.

In 1940, the Germans tried to steal French fashion. Not content with military victory, the occupying Nazis demanded cultural superiority as well. In an attempt to confiscate creativity, five German officers appeared at the door of the Chambre Syndicale de la Couture Parisienne—the organization of couture designers in Paris—and made it clear that the authorities intended to appropriate and transfer the fashion industry to Berlin and Vienna.

In the face of intense pressure, Lucien Lelong, President of the Chambre Syndicale, stalled and schemed. "You can impose anything on us by force, but Paris couture cannot be transplanted either as a whole or in its elements. It is not in the power of any nation to steal fashion creativity...," he told the Nazis. Despite the bullying, the attempt fizzled. About 60 couture houses remained open during the German Occupation.

But the most pointed resistance to the Germans came from French women themselves, who thumbed their noses at their occupiers by managing to look chic under the most dismal circumstances. They made fantastic hats of rags and newspaper; they stained their legs tan as if to belie the fact that stockings were in short supply, drawing a seam down the back of the leg to complete the illusion.

"They were not about to change," Susan Train, Paris Bureau Chief of *Vogue* tells me. "They would bicycle clear across town to a party clutching their hats and shoes. It drove the Germans crazy. What were they going to do, arrest a woman for wearing a paper hat?" Train, who is tall, thin, and impeccably pulled together in a pewter-gray Saint Laurent pantsuit, has lived in Paris and covered fashion for nearly half a century. Our discussion, which started with lunch at her apartment, continues into early evening; the light in the room softens, and the story of how French fashion survived the occupation becomes increasingly powerful and moving.

The fashion industry in France survived the war—just barely. In the fall of 1944 a group of couturiers decided to put on an exhibit of handmade dolls wearing the latest and finest in clothes that the couturiers could create to deliver the message that French fashion—like France itself—had survived with its creative spirit intact. The project took on a vibrant life of its own. Sculptors and artists created elegant wire-frame dolls with plaster heads; others designed sets evoking a summer garden, an enchanted grotto, a theater. More than 70 couturiers supplied replicas of their fashions—meticulously copied down to tiny pockets that opened and buttons that buttoned. Van Cleef & Arpels and Cartier provided baby jewels.

The *Théâtre de la Mode* opened on March 27, 1945. "An audacious dream," a French artist enthused. "Parisians forgot present or past misery and crowded to see these dazzling little figures. They inhabited their own strange little theater world where penury had no place, where it seemed restrictions had disappeared at full speed."

Having served their purpose, the dolls seemed to vanish. Forty years later, long after they were thought to be destroyed or lost,

Train tracked them down to a small museum in Washington State and set about the business of enlisting the help of the French fashion industry to restore the dolls and sets. In the book she edited, *Théâtre de la Mode*, there is a photograph of a doll dressed in a long-sleeve evening dress by Madame Grès, one of the era's most gifted couturiers. The skirt is a lush waterfall of black silk organdy. It splits in front to flaunt a cascade of underskirt the color of a Colombian emerald. There is an eerie beauty to the doll and her exquisite, mute companions. "It is not difficult to imagine that when the lights go out, they come to life as if in some childhood fairy tale," Train says.

When it was shown at the Louvre in Paris in 1945, the *Théâtre de la Mode* attracted nearly a hundred thousand visitors. The fashion show in miniature with its proclamation of hope traveled, among other places, to London, New York, Stockholm, Copenhagen, and Vienna.

Beauty endures; creativity is renewed; life goes on. To enable us to forget the misery of the past, to allow us to look to the hope of the future, is the artistry of fashion at its most brilliant.

Look at me. I will survive. I have survived.

In celebrating fashion, we celebrate our culture; we celebrate our spirit; we celebrate ourselves.

DAVID EDWARDS **CHINA** 1999
/**page 48**/ A Kazakh falconer wears spoils of his hunt: a fox-fur hat.

JODI COBB **SAUDI ARABIA** 1986
/**page 49**/ The veil of Islamic custom conceals a Bedouin woman's features.

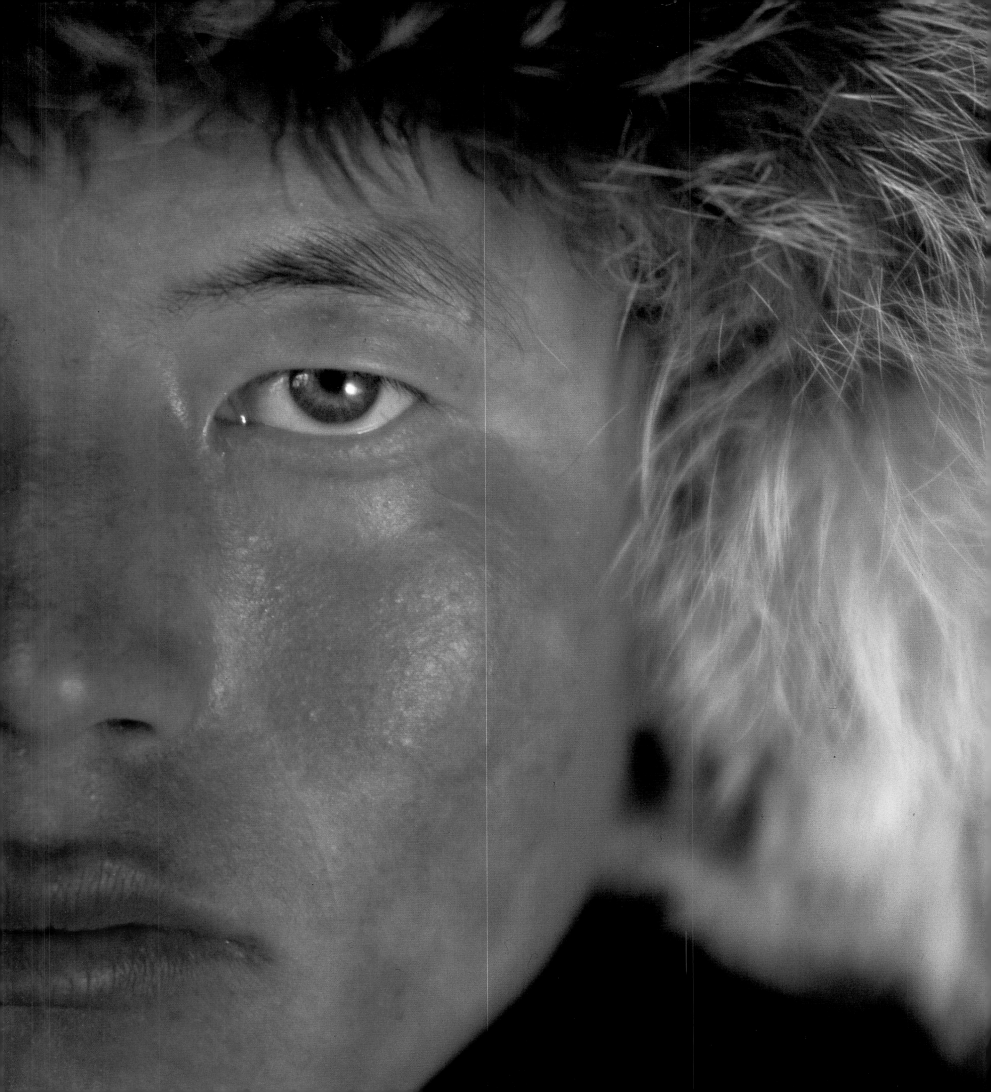

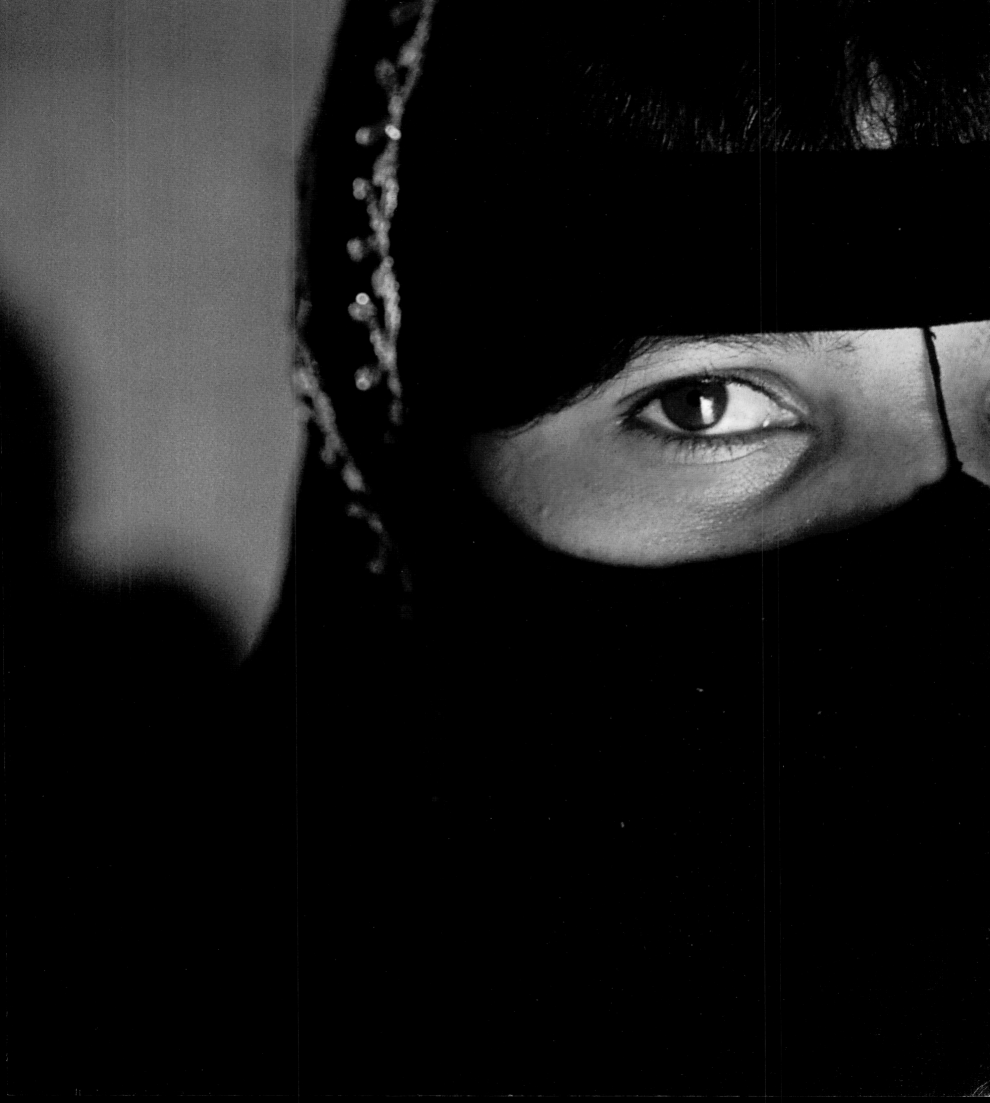

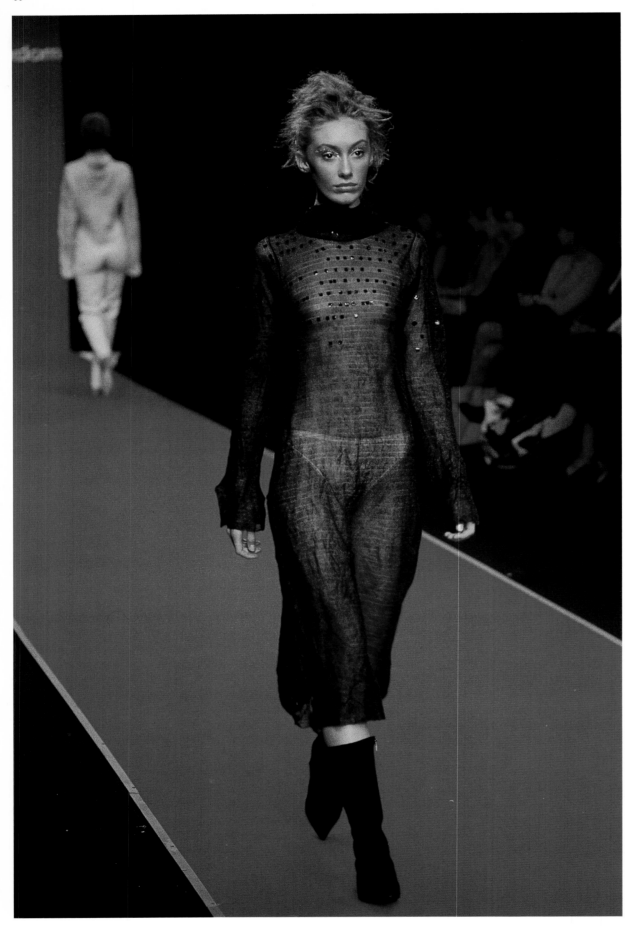

JODI COBB **ENGLAND** 1999

Her body veiled but revealed by nearly transparent cloth, a model
parades down the runway during Graduate Fashion Week in London.

CARY WOLINSKY **INDIA** 1983

A cascade of silk conceals the face of a silk dyer's wife, who presents
herself for a portrait in her home, wearing traditional purdah.

YVETTE BORUP ANDREWS **MONGOLIA** 1933

/**pages 52-53**/ A monk fingers prayer beads while three women wait for
the doors of a Buddhist temple to open. Their best clothes include dis-
tinctive headdresses and boots with upturned toes for ease in riding.

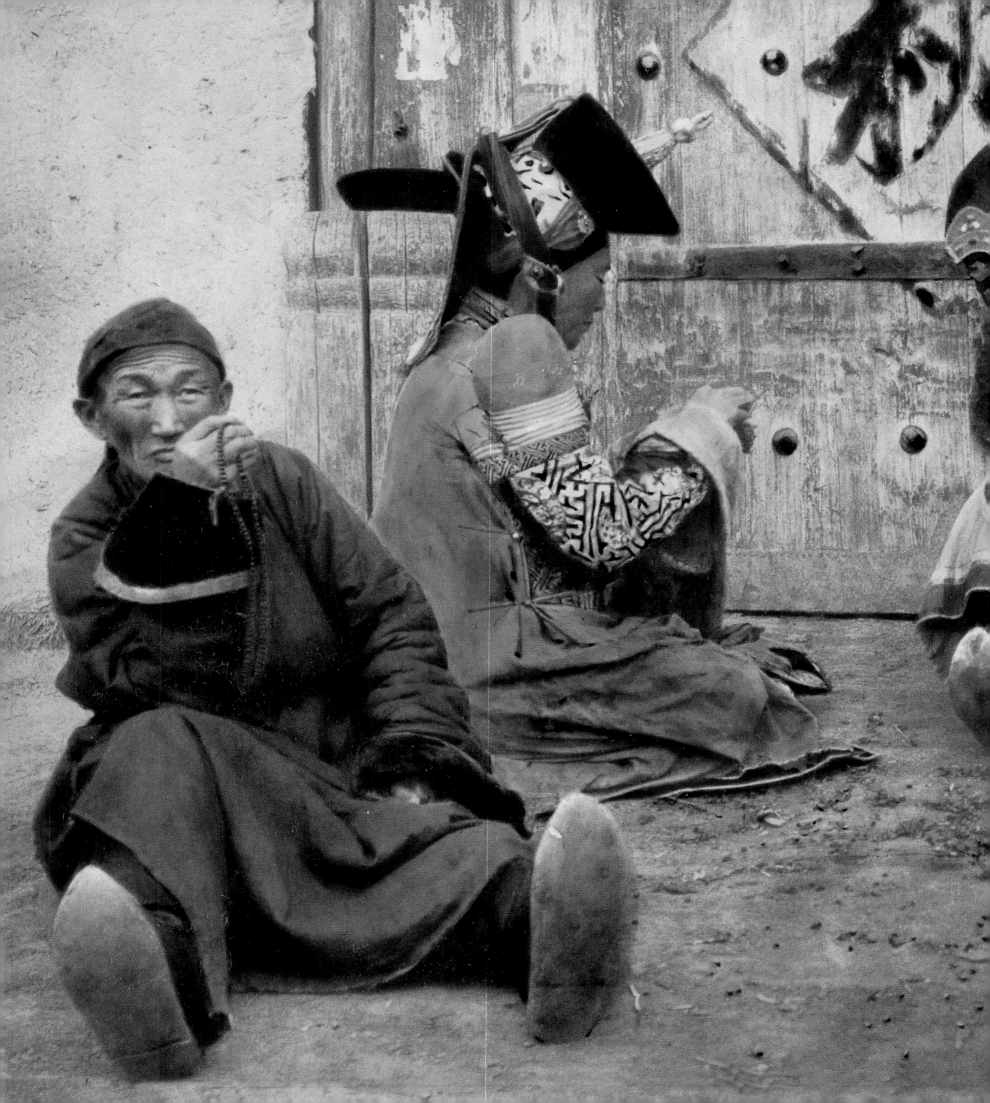

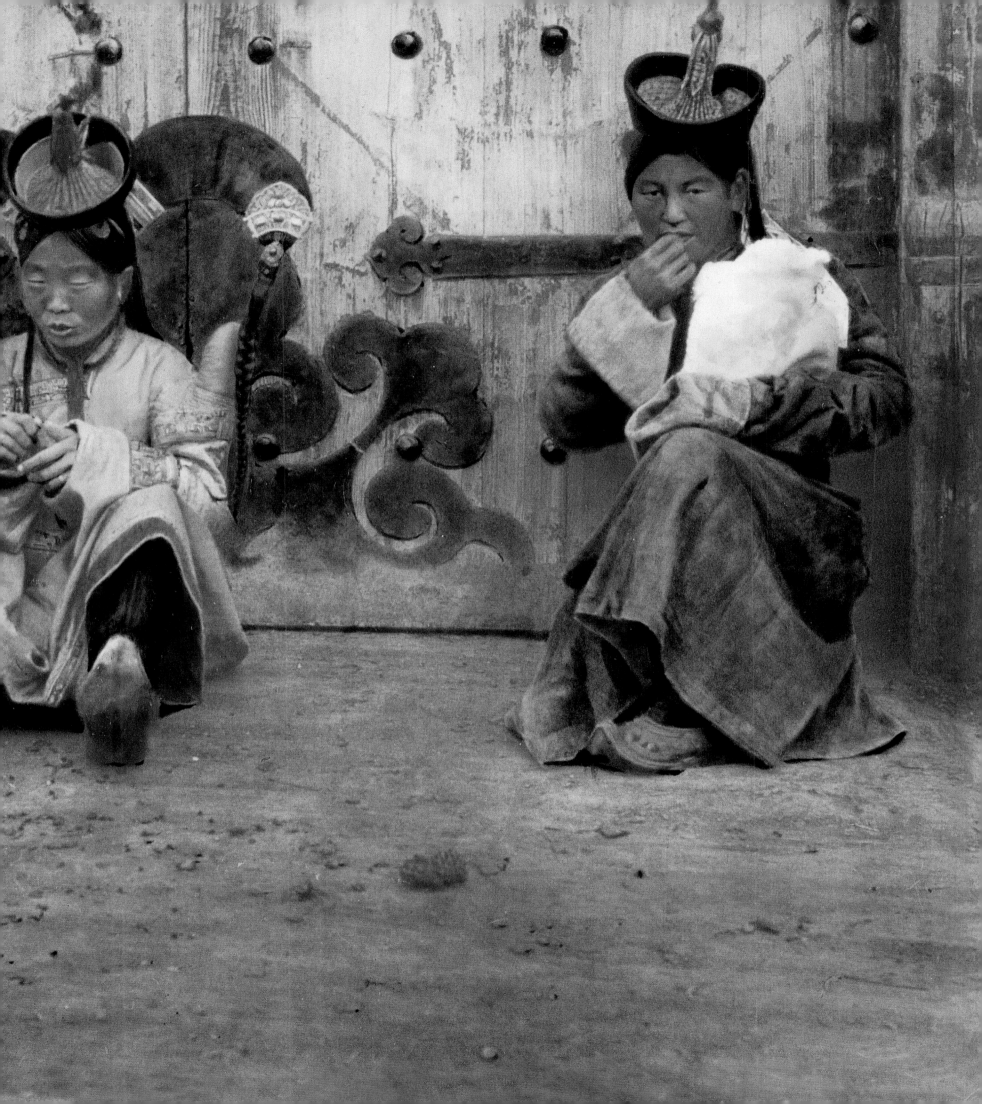

"FASHION IS
SOMETHING
BARBAROUS,
FOR IT
PRODUCES
INNOVATION
WITHOUT
REASON AND
IMITATION
WITHOUT
BENEFIT."

GEORGE SANTAYANA

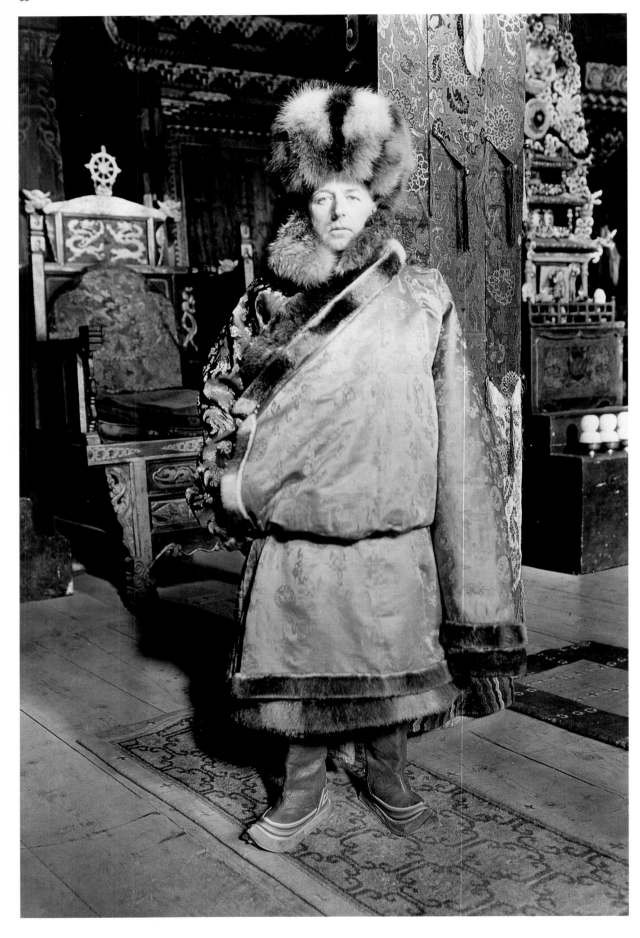

HANS HILDEBRAND **AUSTRIA** 1929

/**page 54**/ The photographer used Autochrome processing to capture the colors worn by these Austrian matrons, whose dress was little changed from the time of their grandmothers.

DR. JOSEPH F. ROCK **CHINA** 1928

National Geographic explorer Joseph Rock adopted the fur hat, padded silk coat, and boots of his hosts in China and Tibet, as seen in this self-portrait. He believed in dressing grandly to earn respect.

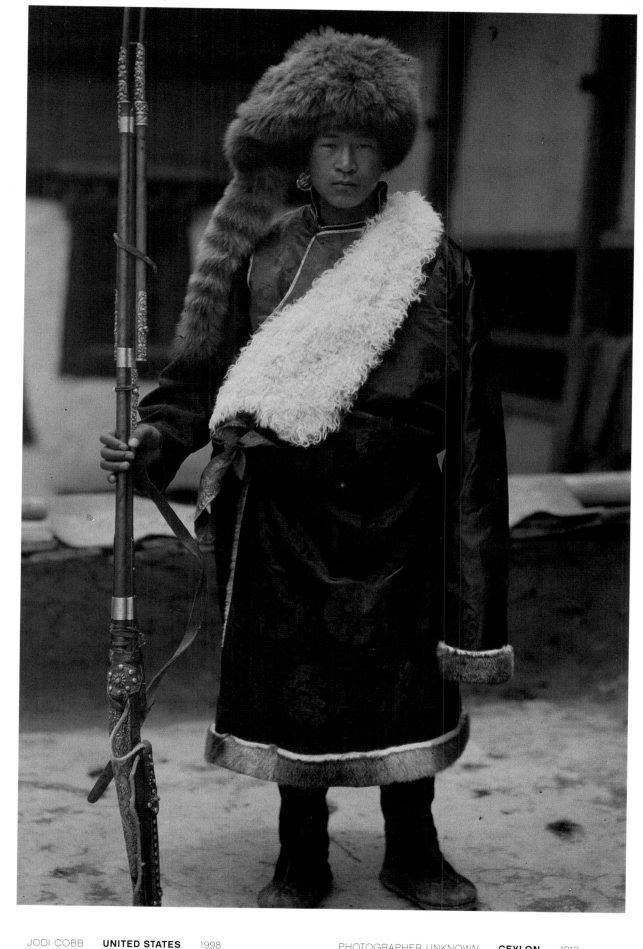

"THE PRIMITIVE
MAN IN THE
WOLF PELT WAS
NOT KEEPING
DRY; HE WAS
SAYING: 'LOOK
WHAT I KILLED.
AREN'T I THE
BEST?'"

KATHARINE HAMNETT

DR. JOSEPH F. ROCK **CHINA** 1929

A guard on a Rock expedition in Sichuan province grips the musket he used against bandits. The tail of his lesser-panda hat falls to his elbow. He wears his coat over one shoulder for ease in firing.

JODI COBB **UNITED STATES** 1998

/**page 58**/ Law student Wendy Fitzwilliam of Trinidad adjusts an earring before performing in the Miss Universe Pageant. Her dynamic act in a feathered Carnival costume helped her win the crown.

PHOTOGRAPHER UNKNOWN **CEYLON** 1912

/**page 59**/ Palm fronds fan out like a peacock's tail around the form of a Tamil girl from Ceylon, now Sri Lanka. This image is part of a collection given to National Geographic by Alexander Graham Bell.

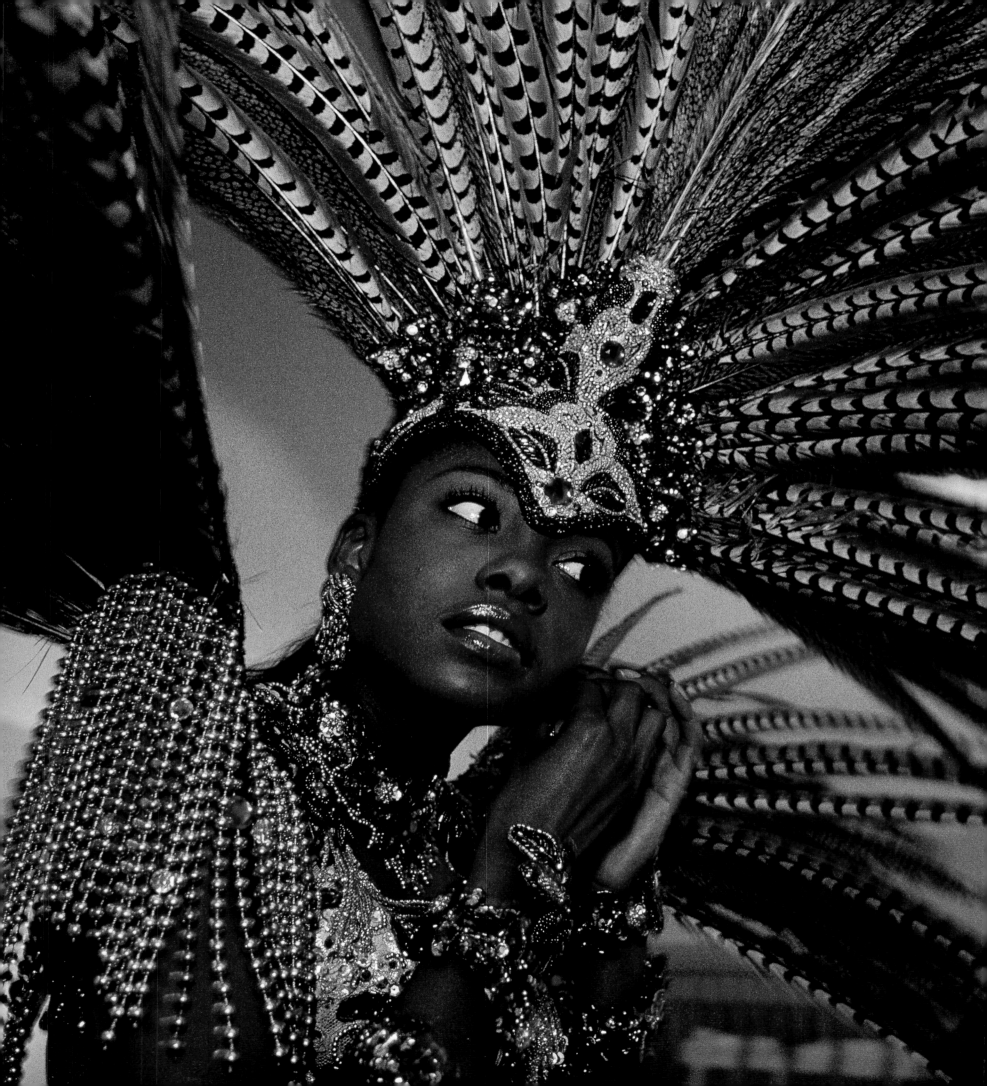

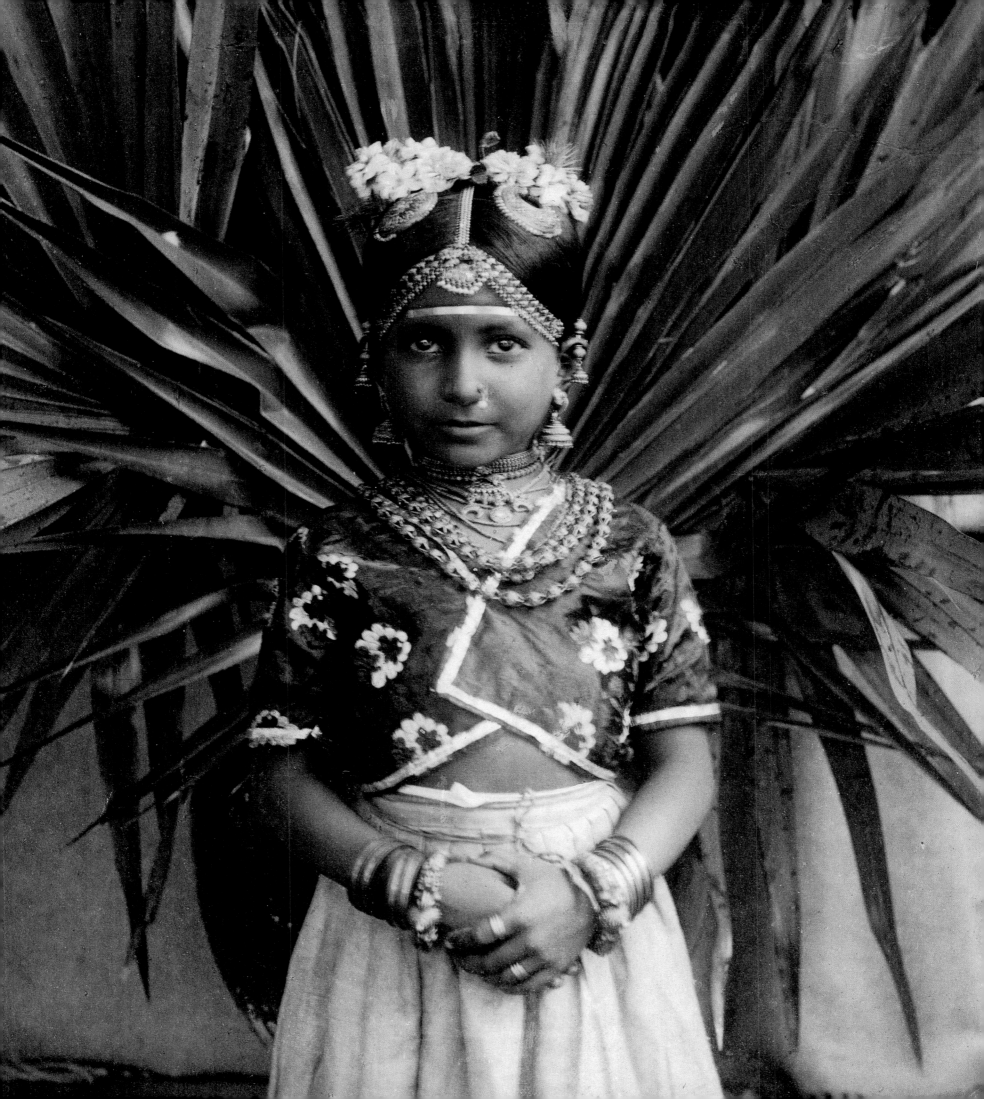

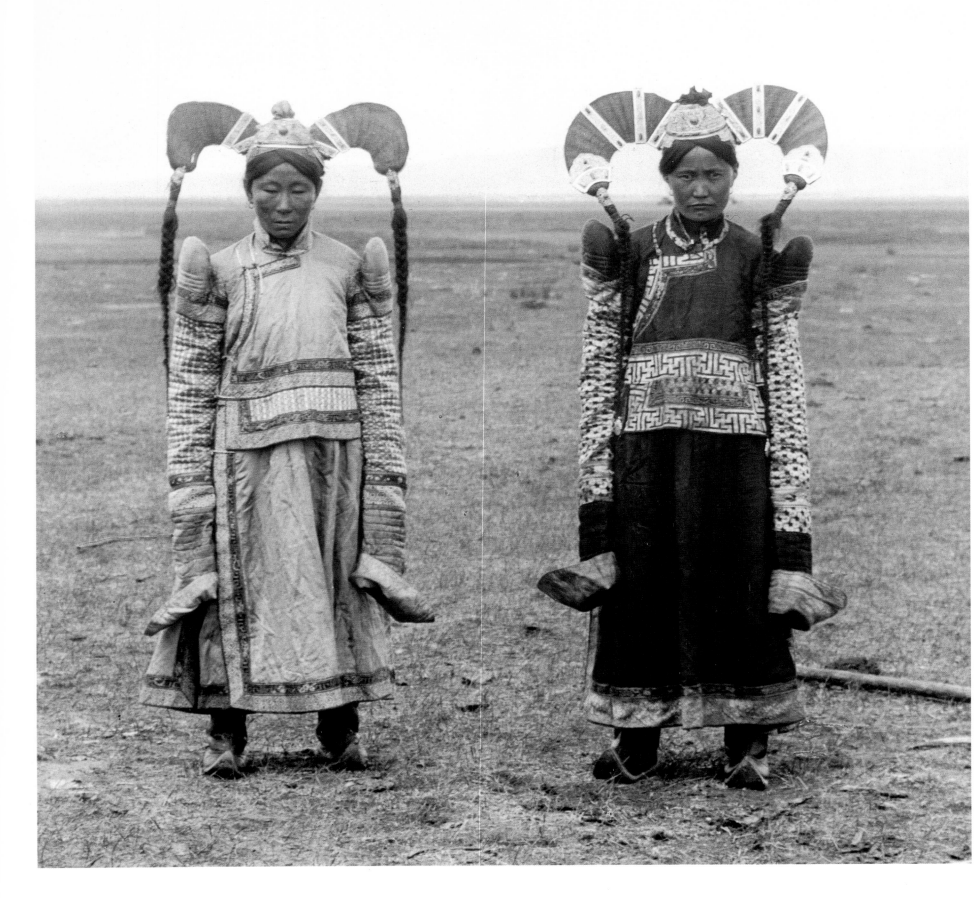

HORACE BRODZKY **MONGOLIA** 1921

Brodzky was intrigued by the headgear of Mongolian women: Their hair was arranged over a framework resembling the horns of mountain sheep, and ended in a braid sometimes encased in gold or silver. These wear the typical Mongolian boot, with upturned toe.

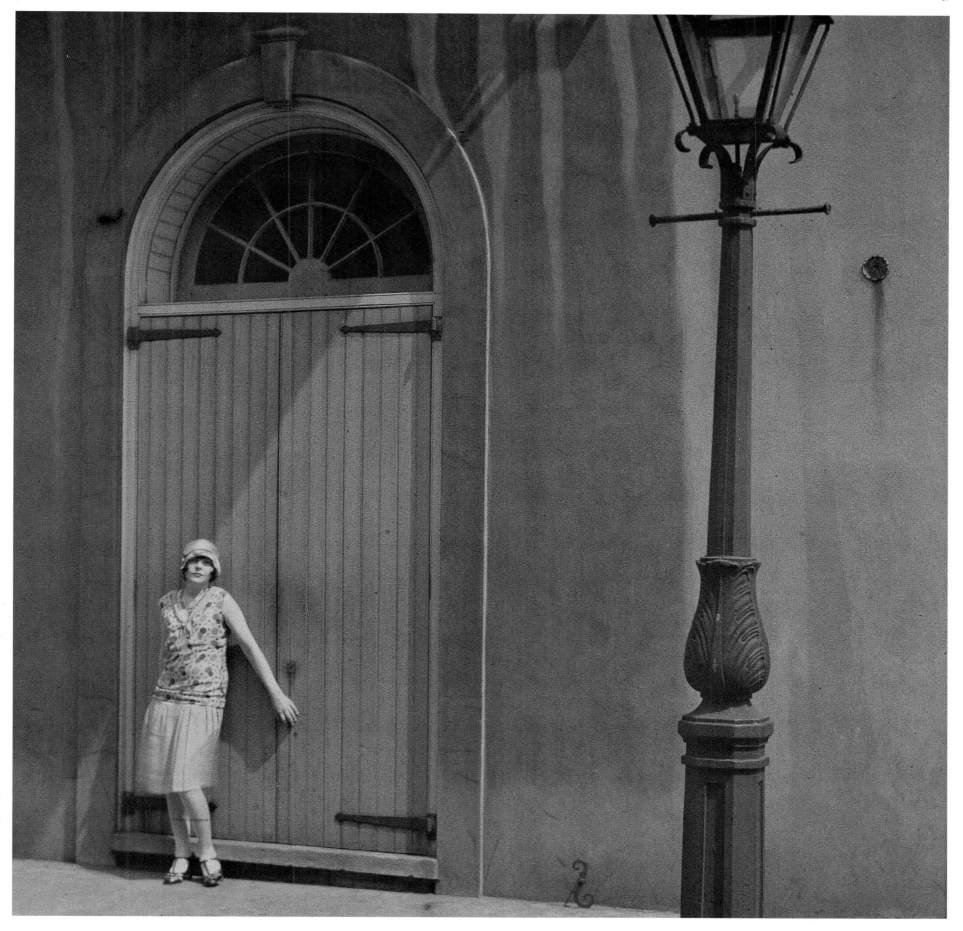

EDWIN L. WISHERD **UNITED STATES** 1929

The snug cloche hat, bobbed hair, short skirt, and low waistline were characteristic of the 1920s flapper style, when women seeking careers outside the home demanded more functional, comfortable clothing than the Victorian styles their mothers had worn.

STEVE RAYMER **JAPAN** 1981

/**page 62**/ A Japanese bride in a heavy white silk kimono distinctly fashioned for her landmark event wears a hairpiece ornamented with traditional combs carved from the shell of the endangered hawksbill turtle.

THOMAS J. ABERCROMBIE **INDIA** 1978

/**page 63**/ Rough-cut turquoise stones adorn the headdress, or *peyrak*, of a young government worker in Ladakh, in the Himalaya— once a key crossroads for Asia's caravans. Long, heavy sashed robes of wool are worn by men and women alike.

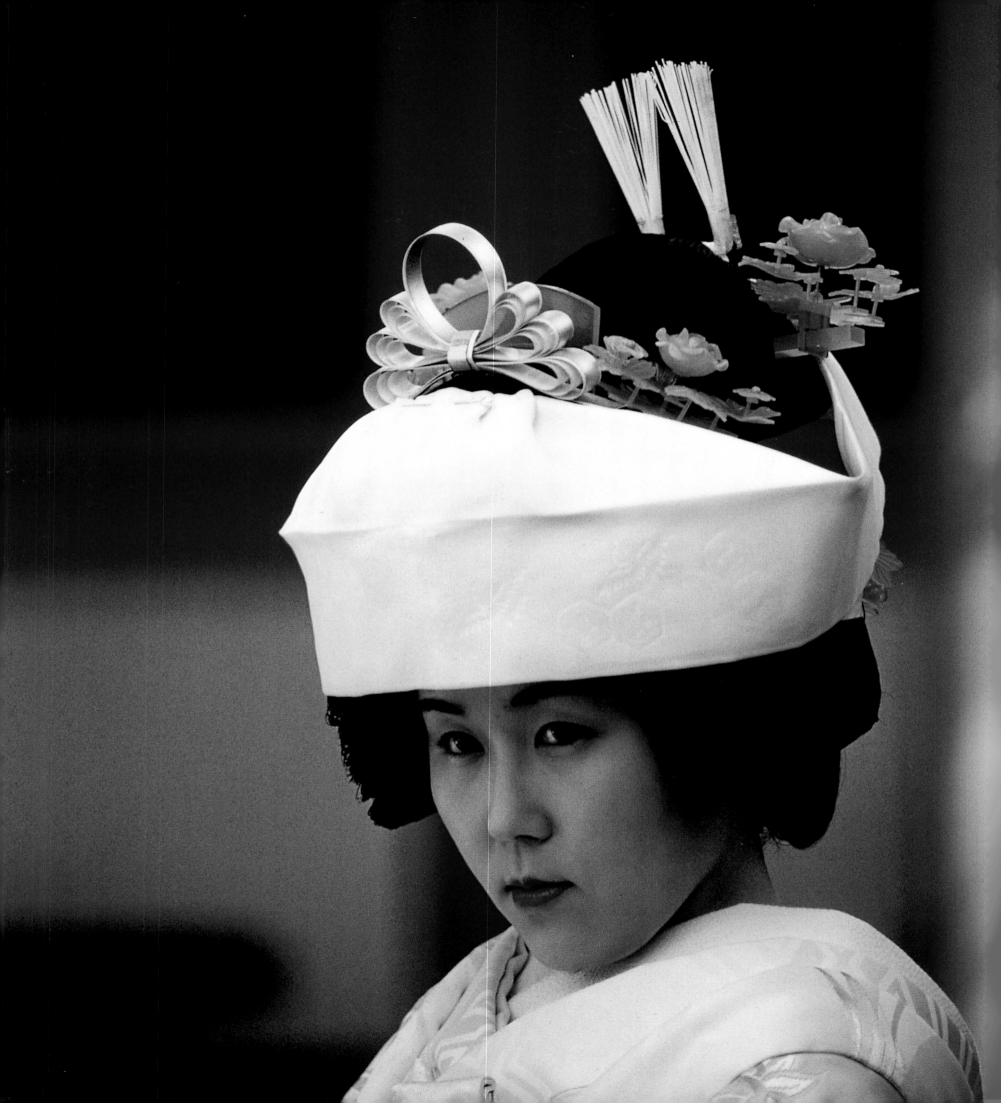

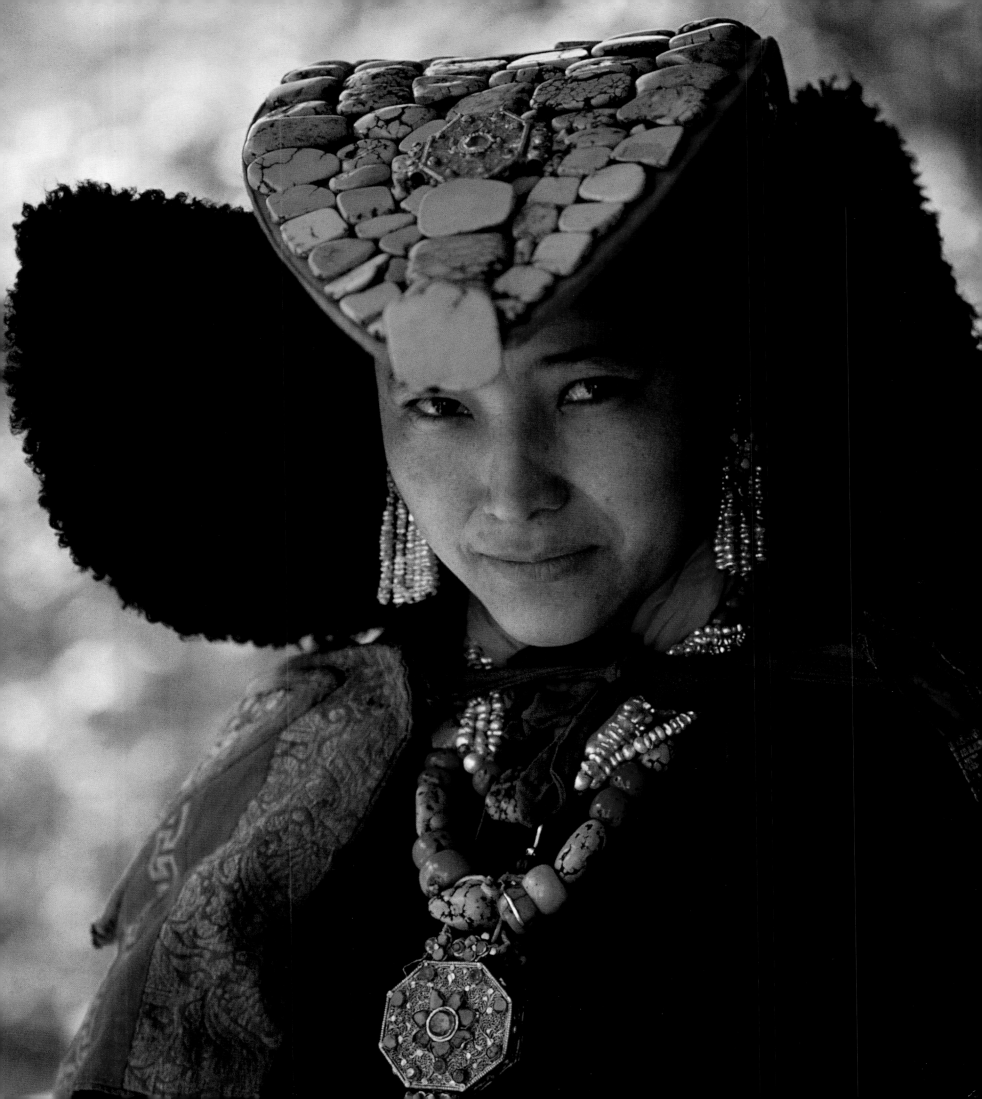

"I HAVE NEVER
KNOWN A
REALLY CHIC
WOMAN WHOSE
APPEARANCE
WAS NOT, IN
LARGE PART,
AN OUTWARD
REFLECTION
OF HER
INNER SELF."

MAINBOCHER

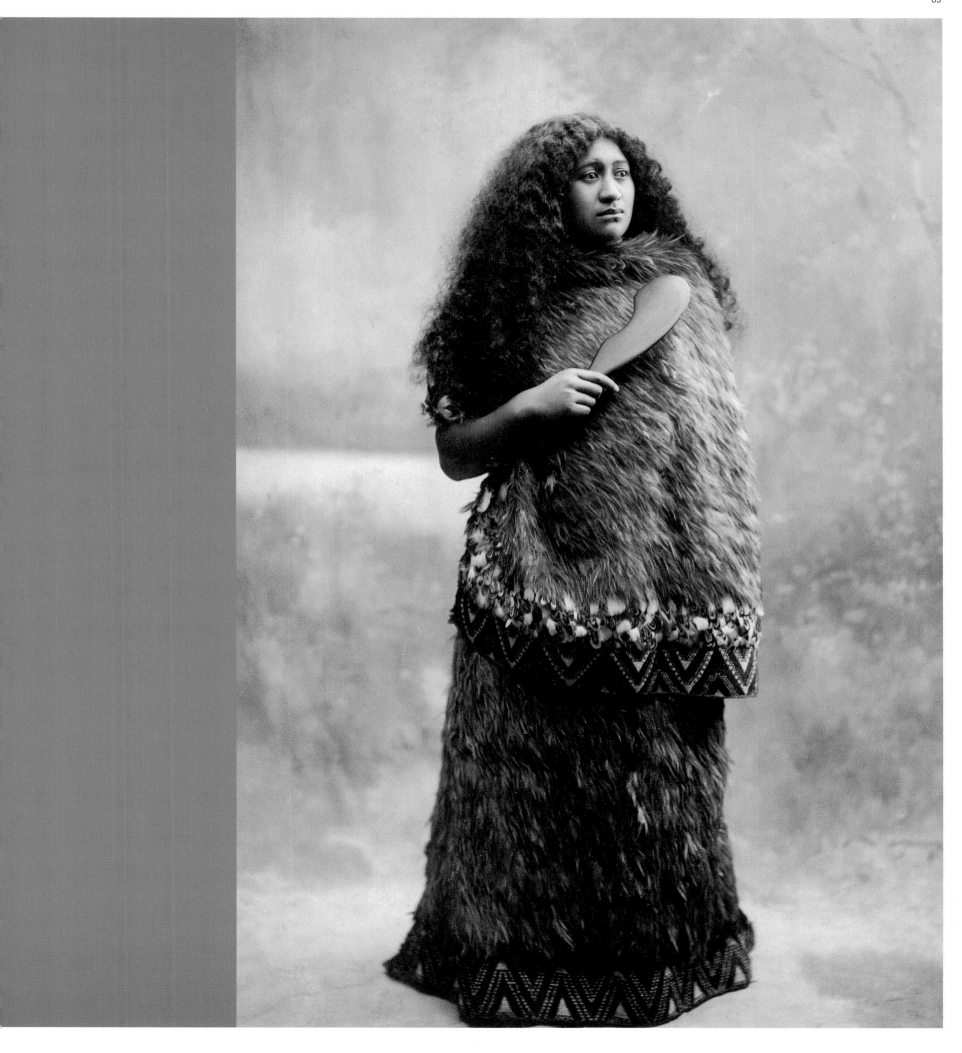

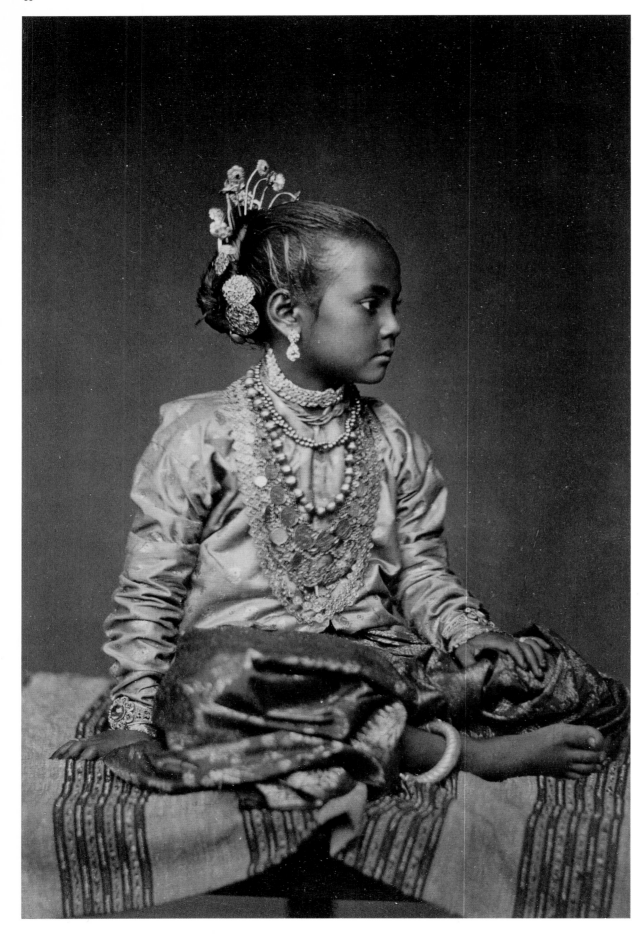

THE TESLA STUDIOS **NEW ZEALAND** 1921

/**page 65**/ A Maori woman models the prized feather cloak worn by persons of rank. Made from the plumage of red parrots and other birds, it is bordered with *taniko* work, a woven geometrical pattern. The weapon she holds of nephrite, or greenstone, was used in war.

ELIZA R. SCIDMORE **INDIA** 1907

Of this young girl's dress, Scidmore wrote: "the Hindu...ornaments his women with tangible riches..... For weddings, the jewels are often hired by both families, and children of the slums wear...jewels of a temple idol for one day."

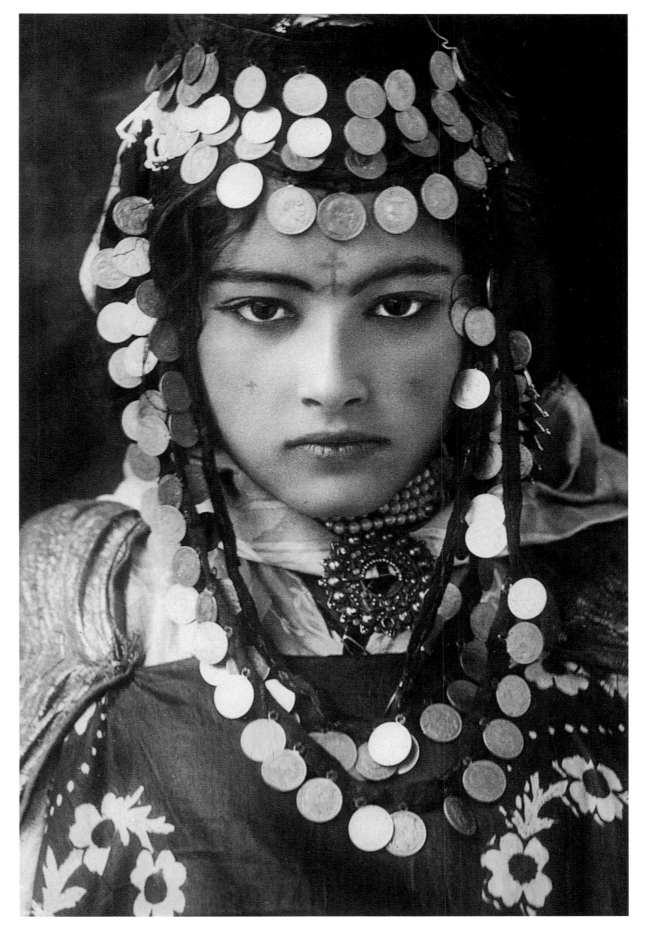

LEHNERT & LANDROCK **ALGERIA** ca 1905

Girls from the desert tribe Ouled Nails often left home to work as dancers in Mediterranean ports. The coins they earned were worn as decorative dowry until they acquired enough money to go home and marry.

JODI COBB **UNITED KINGDOM** 1998

/**pages 68-69**/ Some of the most surprising fashions emerge from graduating design students during London's Graduate Fashion Week, where professionals often scout for new talent.

"TO CALL
A FASHION
WEARABLE
IS THE KISS
OF DEATH. NO
NEW FASHION
WORTH ITS
SALT IS EVER
WEARABLE."

New York Herald Tribune

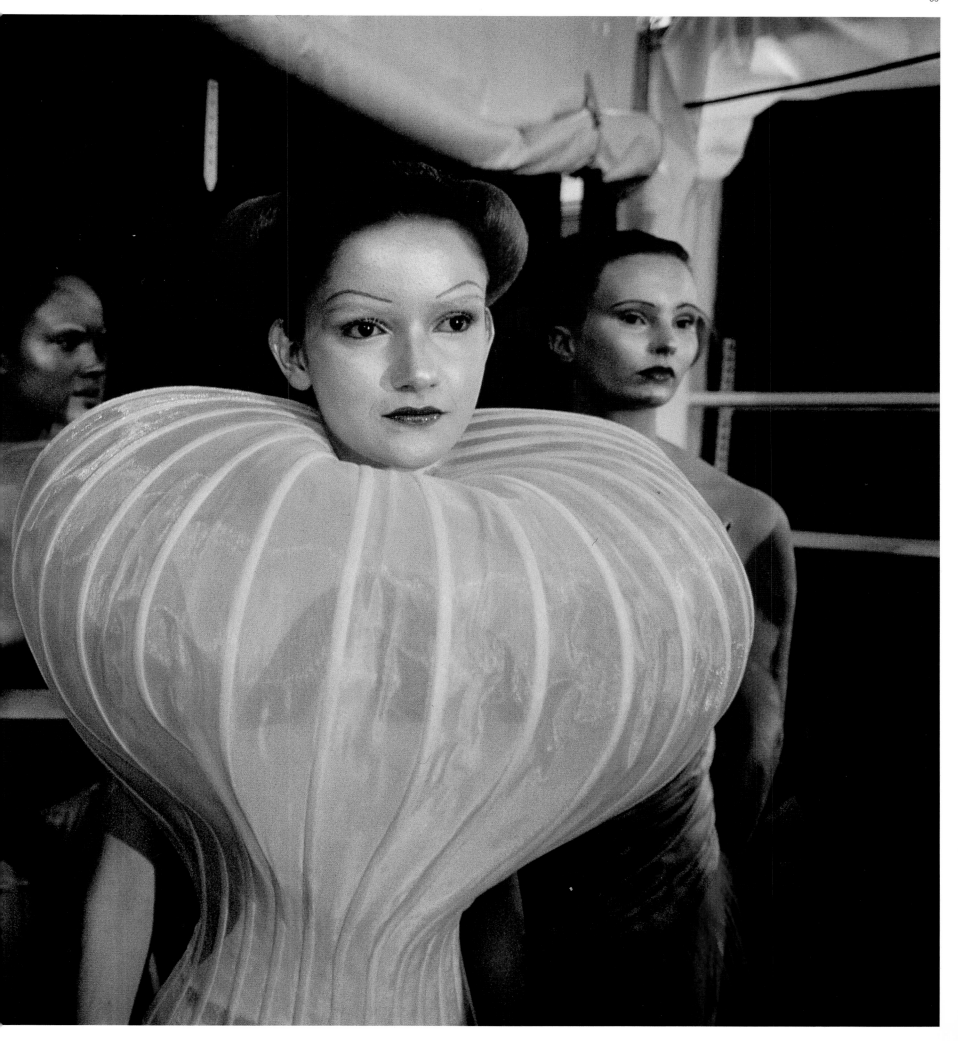

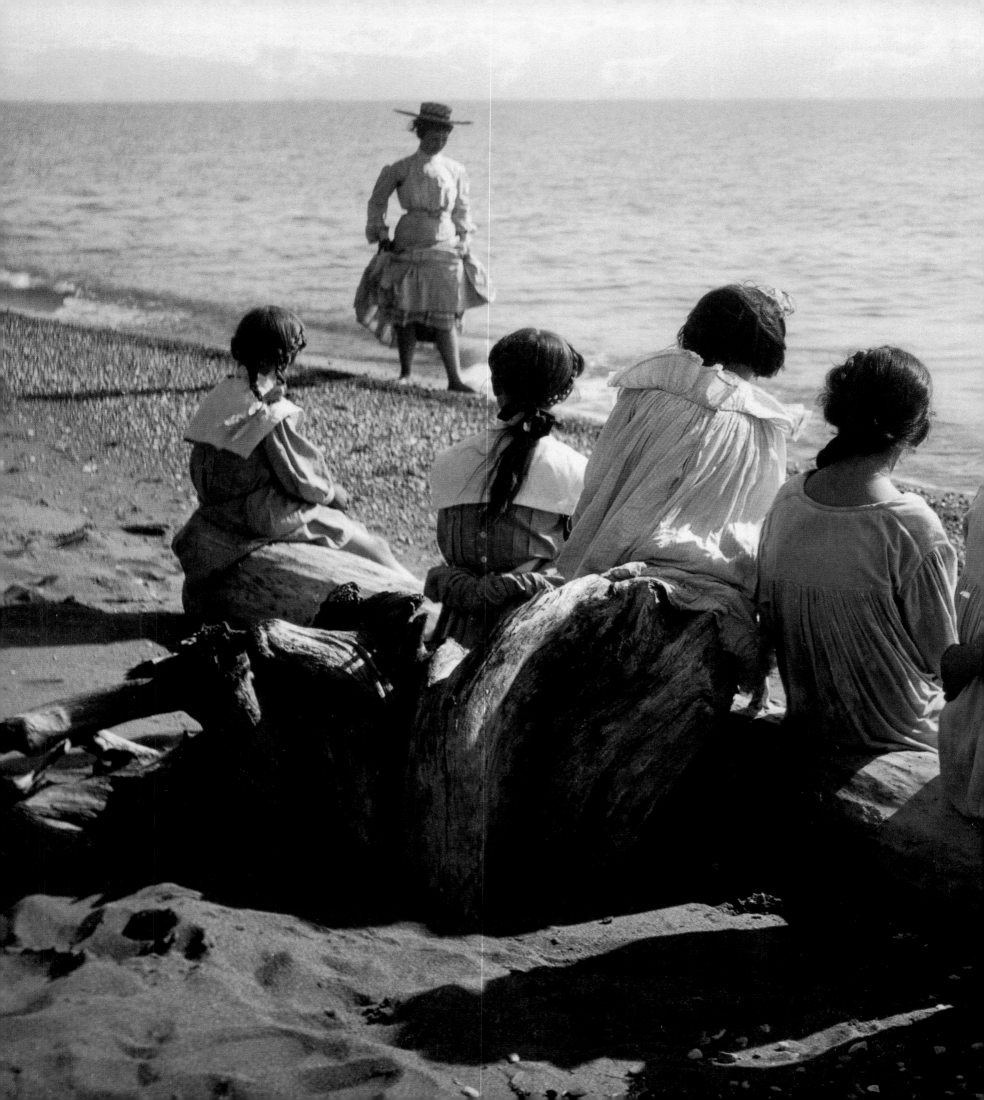

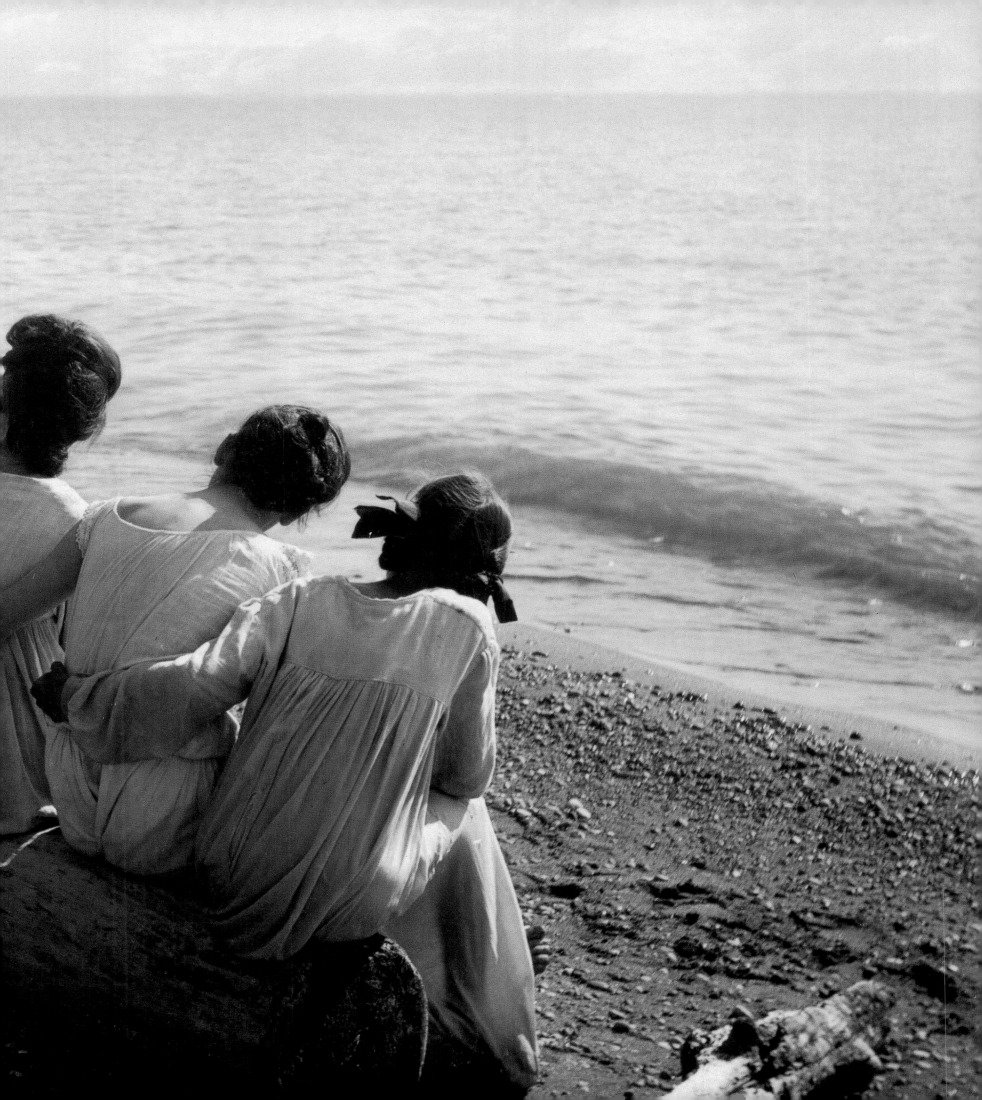

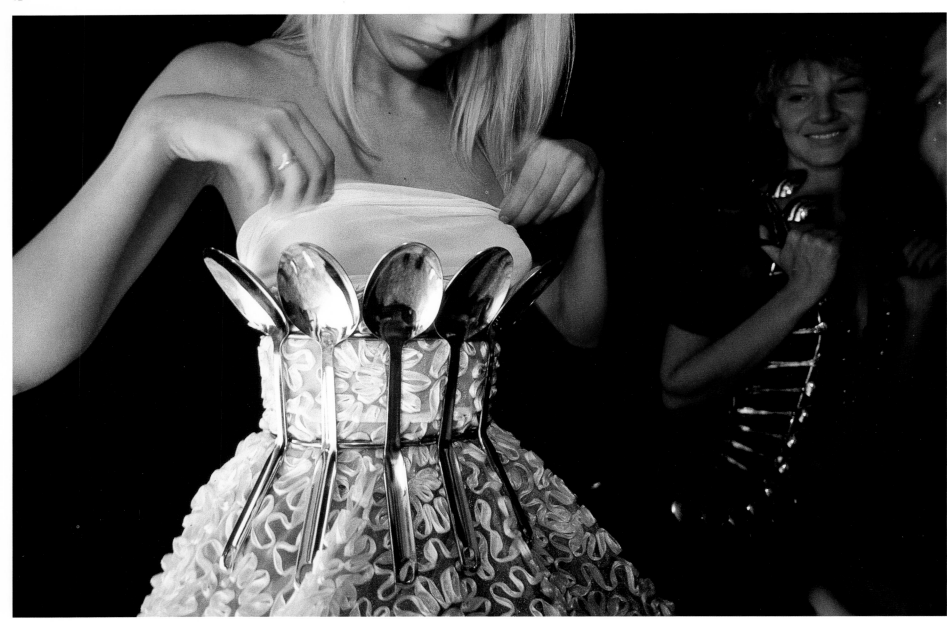

R.R. SALLOWS **CANADA** 1905

/**pages 70-71**/ A properly hatted and corsetted matron bares her calves and ankles during a walk on the beach at Lake Huron, capturing the attention of the younger generation.

JODI COBB **RUSSIA** 1997

Before a fashion show, a model in Moscow adjusts her avant-garde outfit ornamented with large spoons.

WILLIAM ALBERT ALLARD **FRANCE** 1999

At the Ballet du Conservatoire d'Avignon in Provence, students in petal-like tulle skirts prepare for a performance.

THOMAS J. ABERCROMBIE **JAPAN** 1969

/page 74/ Under the protection of a glazed-paper umbrella, a carefully made-up geisha waits outside a building in Kyoto, her hair ornamented with a flourish of flowers.

EDWARD S. CURTIS **UNITED STATES** ca 1910

/page 75/ A Hopi girl in Arizona models the "squash-blossom" hairstyle of unmarried women: The hair was wound in a figure-eight pattern around a willow frame into blossom-like whorls.

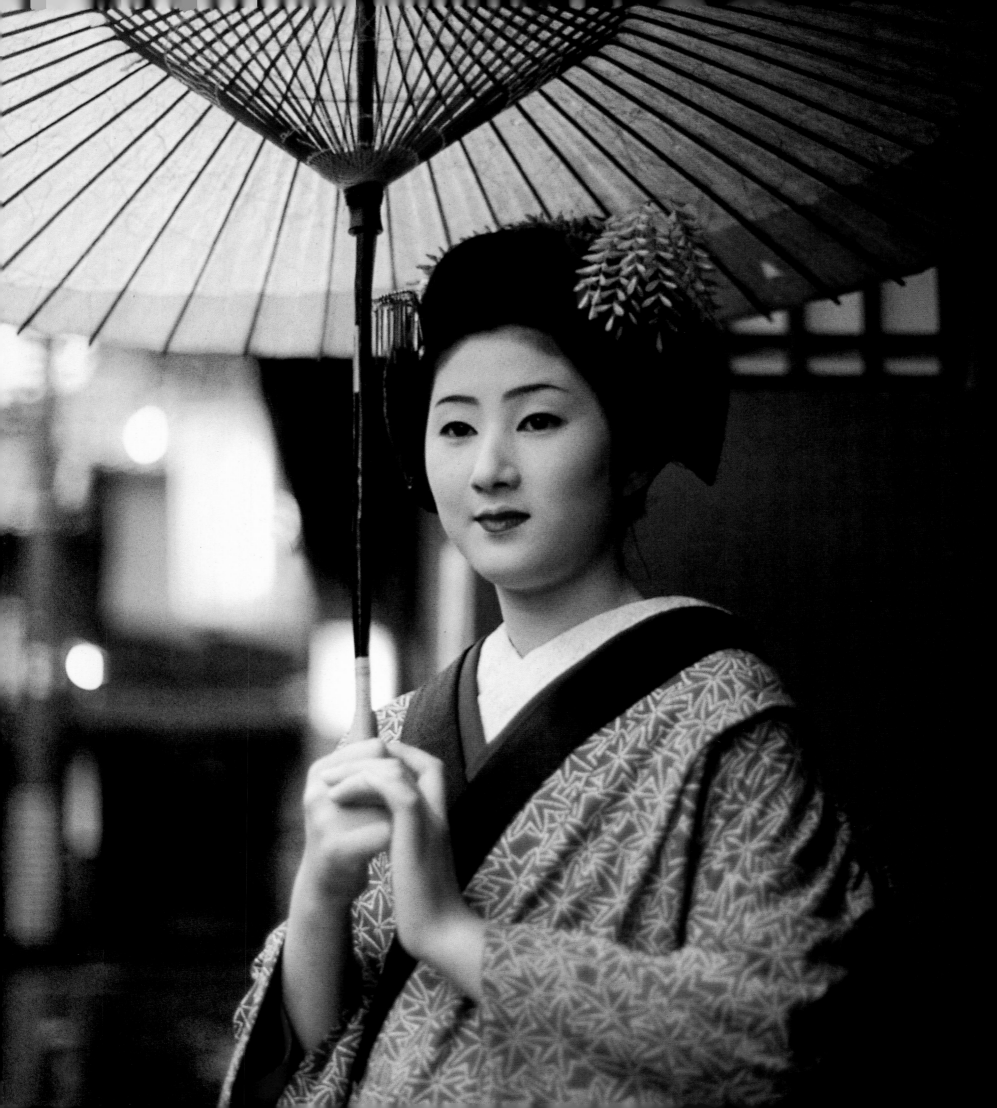

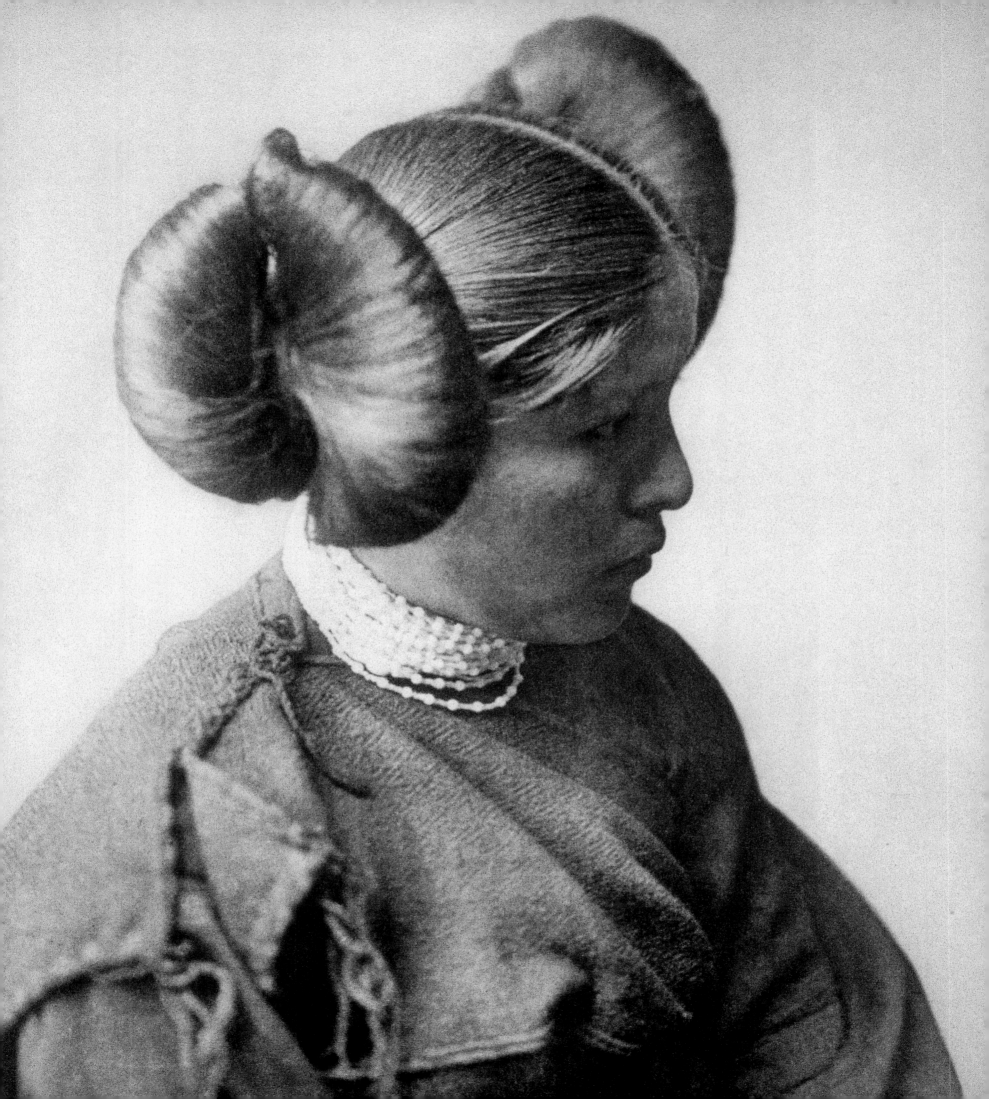

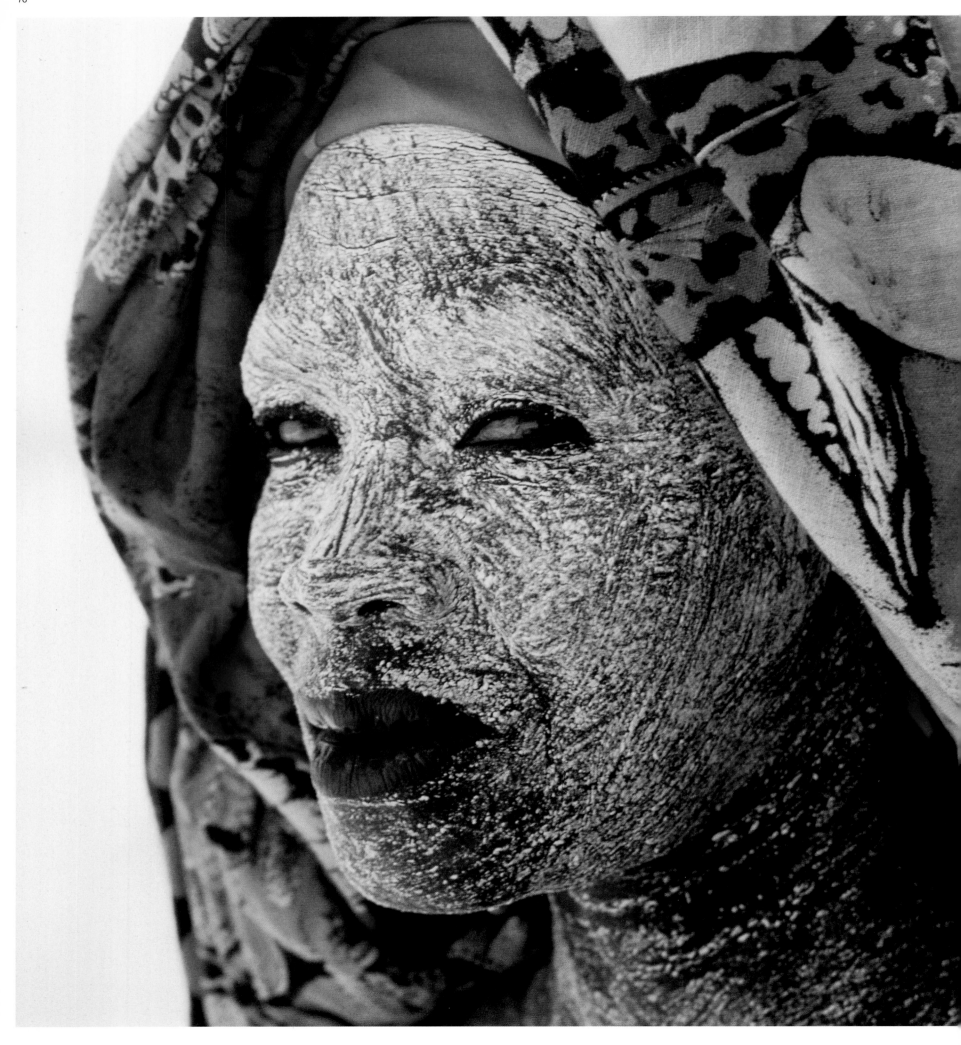

"IT IS THE UNSEEN, UNFORGETTABLE, ULTIMATE ACCESSORY OF FASHION...THAT HERALDS YOUR ARRIVAL AND PROLONGS YOUR DEPARTURE."

GABRIELLE "COCO" CHANEL

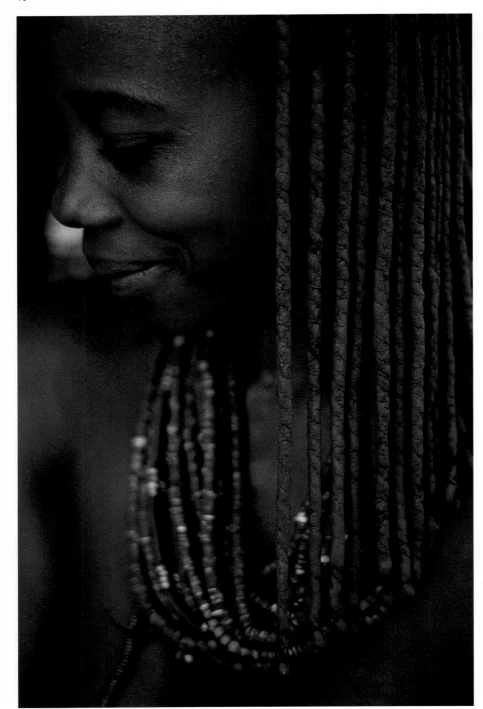

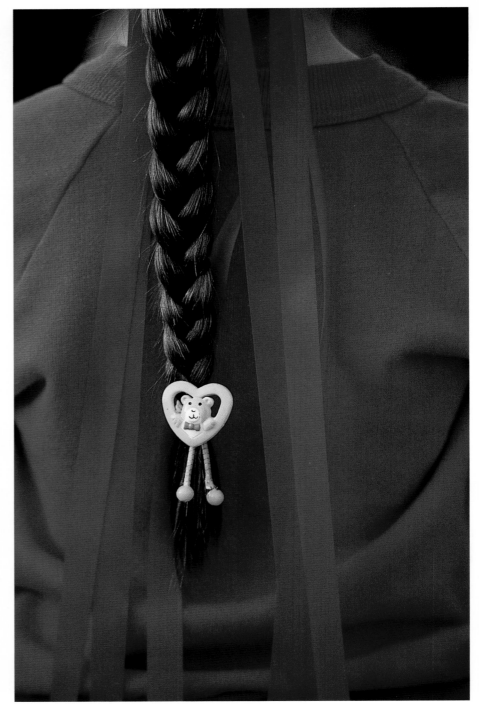

JAMES L. STANFIELD **MOZAMBIQUE** 1992

/**pages 76-77**/ A woman from the coastal city of Mozambique protects her face from the harsh equatorial sun with a cream made from ground bark. A scarf printed with a colorful fish motif covers her head and shoulders.

JIM BRANDENBURG **NAMIBIA** 1982

At puberty, a woman of the cattle-raising Himba people shaves off the hair on the front of her head, then braids the rest with strands of plant fiber. When she marries, she weaves in locks of hair from her husband and brothers.

GEORGE F. MOBLEY **CANADA** 1986

Speaking subtly of love, a heart-shaped ornament hangs from the single braid of a woman in Manitoba.

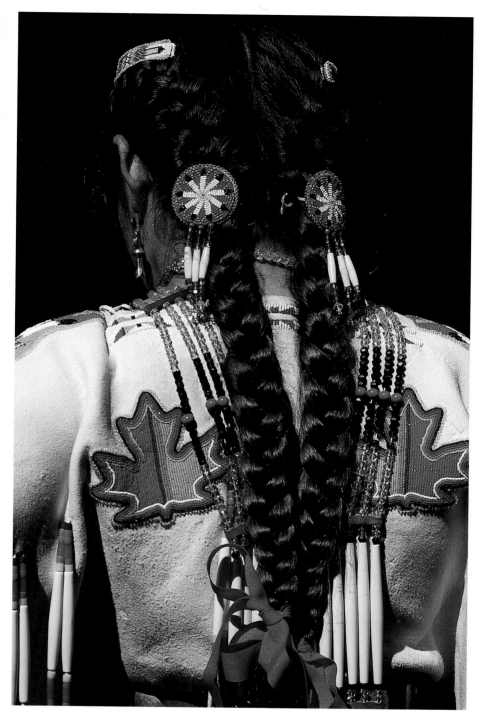

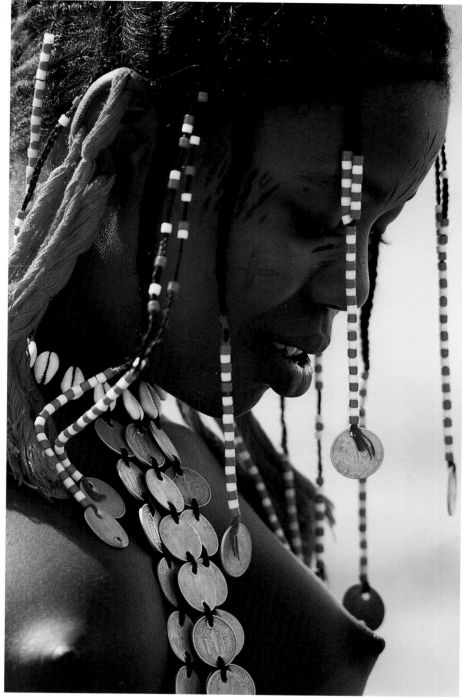

OTIS IMBODEN **UNITED STATES** 1980

To create a hairstyle as elaborate as her ceremonial dress, a Native American in Santa Fe, New Mexico, adorned her braids with beaded starbursts and linked the plaits with ribbon.

CAROLE DEVILLERS **UPPER VOLTA** 1980

Beads and coins ornament the braids of this young woman, whose tribal scars identify her as a member of the Jelgobe Fulani people.

J. BAYLOR ROBERTS **UNITED STATES** 1944

/page 80-81/ In a mime to apply lipstick underwater, two stunt swimmers performing at Wakulla Springs near Tallahassee, Florida, display the fitted bathing-suit style of the 1940s.

"EVERY GENERATION
LAUGHS AT THE OLD
FASHIONS, BUT FOLLOWS
RELIGIOUSLY THE NEW."

HENRY DAVID THOREAU

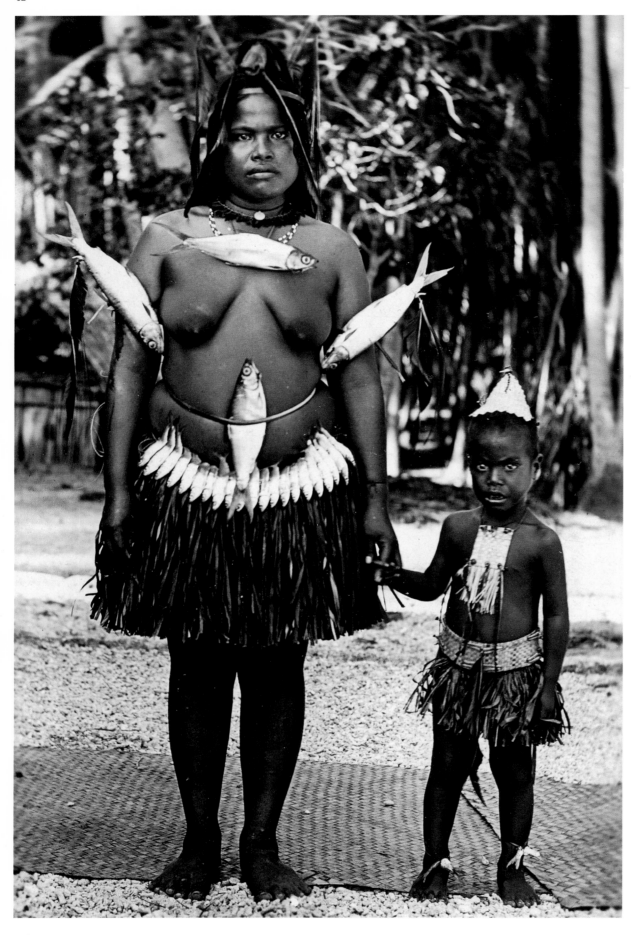

ROSAMOND DODSON RHONE **NAURU ISLAND** 1921

To participate in the Fish Dance, Nauru Islanders of the South Pacific
wear fish from a freshwater lagoon as part of their costume. After the
ceremony, dancers eat the fish.

"OH, NEVER
MIND THE
FASHION.
WHEN ONE
HAS A STYLE
OF ONE'S
OWN, IT IS
ALWAYS
TWENTY
TIMES
BETTER."

MARGARET OLIPHANT

ANGELA FISHER **CAMEROON** 1984

A woman from the remote northern region of Cameroon wears a dec-
orative apron of forged iron pendants. At the time this photo was
taken, the government was discouraging women from wearing
this fashion.

DR. JOSEPH F. ROCK **CHINA** 1935

/page 84/ Splendid in brocade ceremonial robes and seated on
a tiger skin, this oracle was said to have become possessed by
a demon who caused him to groan, spit, and shake uncontrollably;
other demons he banished with his bow and arrow.

N. ZOGRAPHOS **GREECE** 1930

/page 85/ An officer of the Evzones, or Greek Presidential Guard,
wears the embroidered vest, wide-sleeved white blouse, and pleated
fustanella, or kilt, that still distingush these elite military men today.

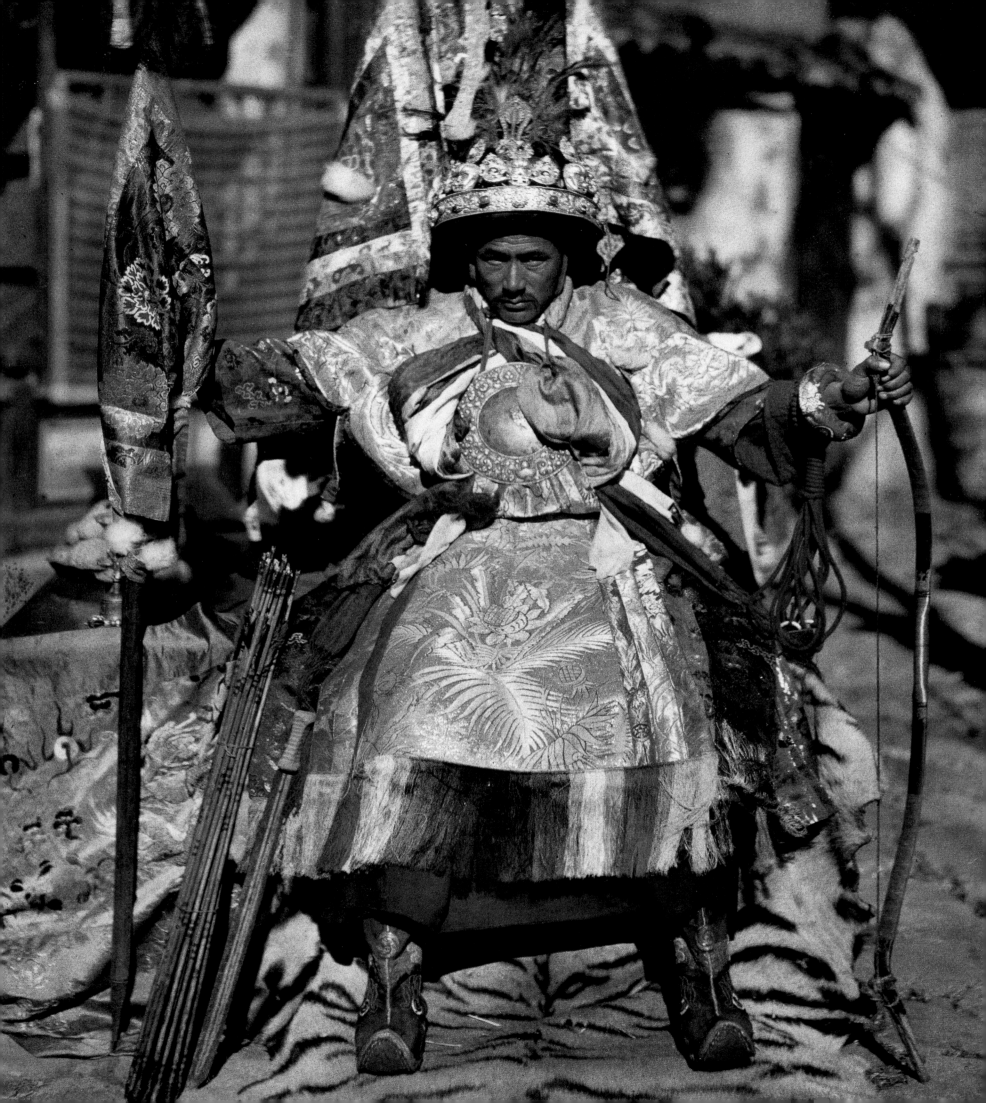

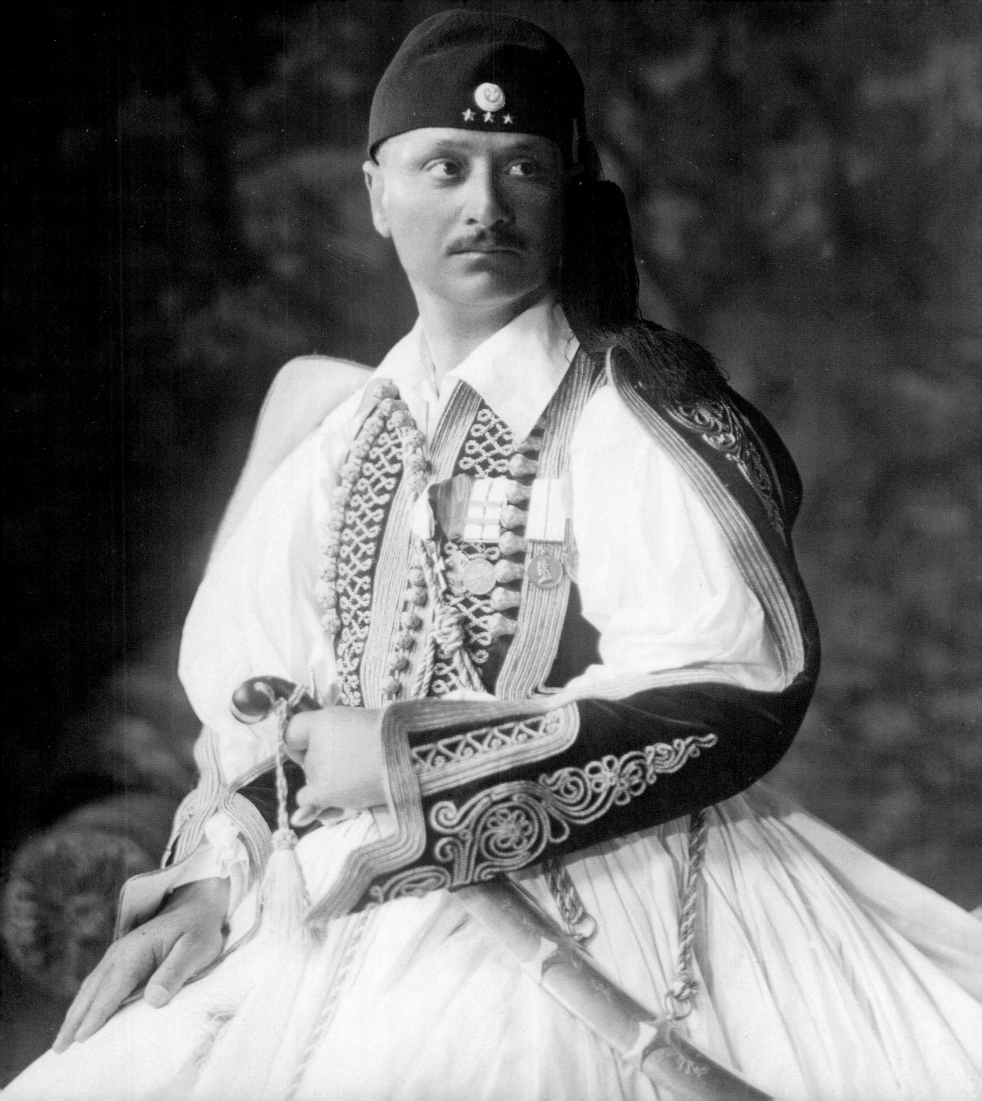

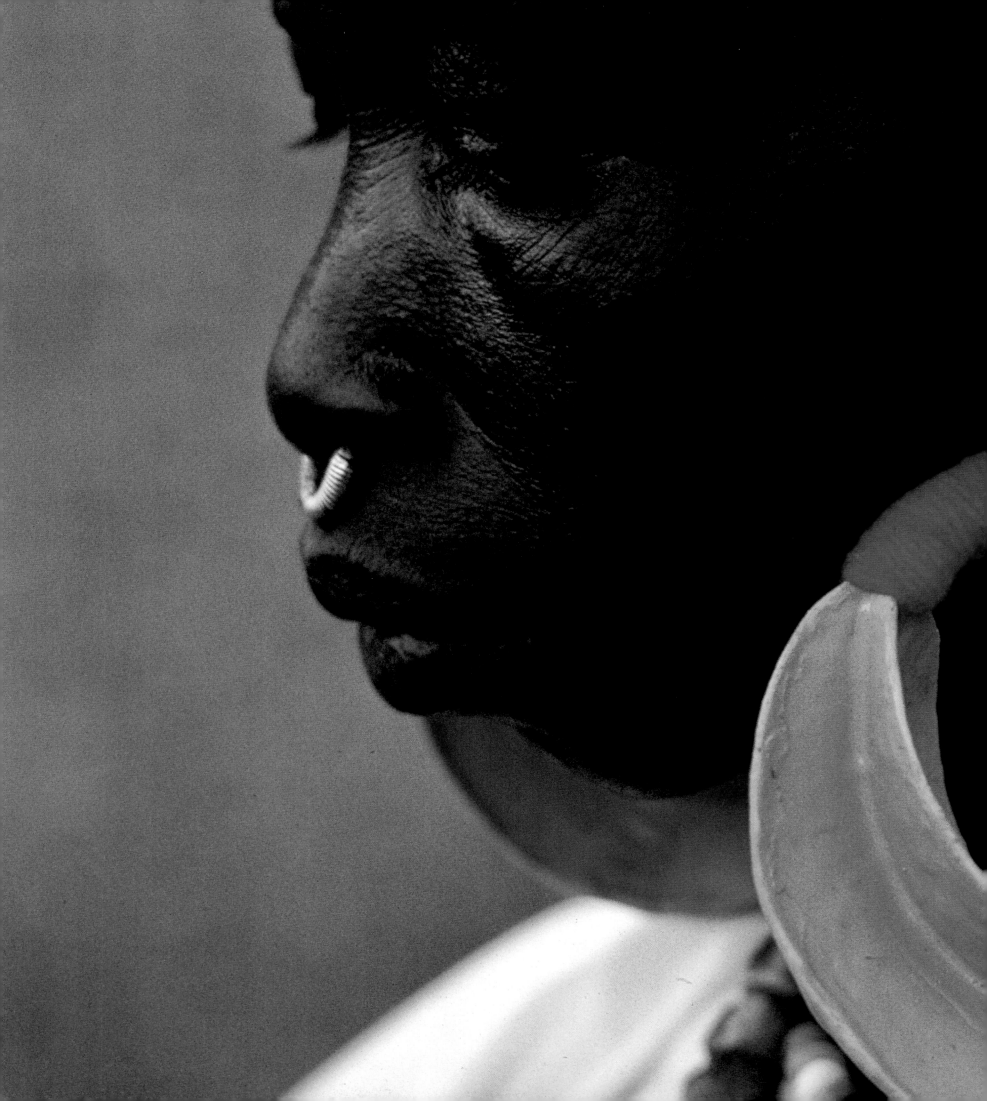

88

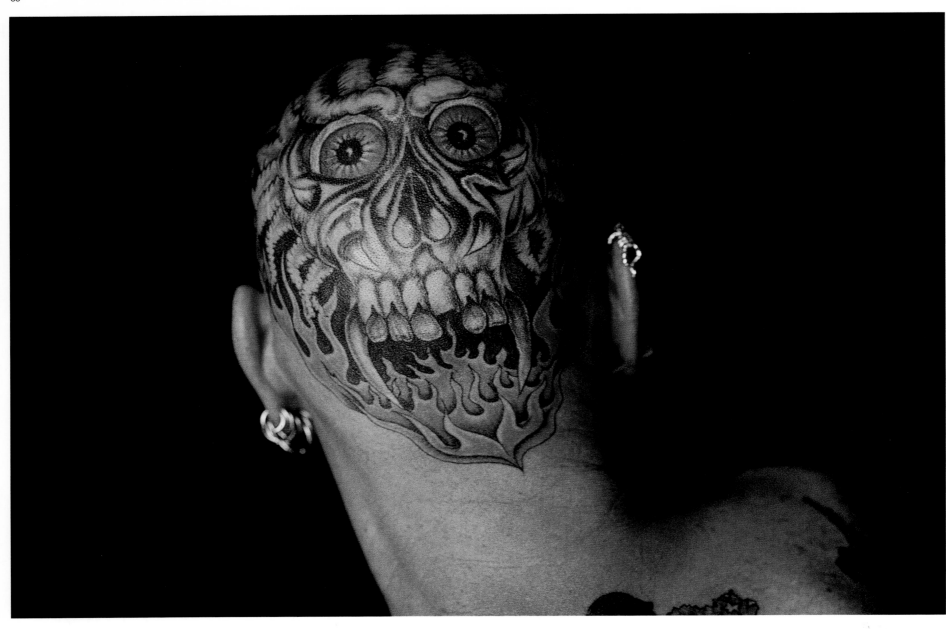

JAMES L. STANFIELD **MALI** 1990

/**pages 86-87**/ Sutura Landure from the village of Nyala displays the oversize earrings favored by her people and described by Muslim explorer Ibn Battuta in his travels more than 600 years ago.

JODI COBB **UNITED KINGDOM** 1999

The word "tattoo" comes from the Tahitian *taitau,* meaning "to mark." To display this tattoo, the wearer must keep his head shaved.

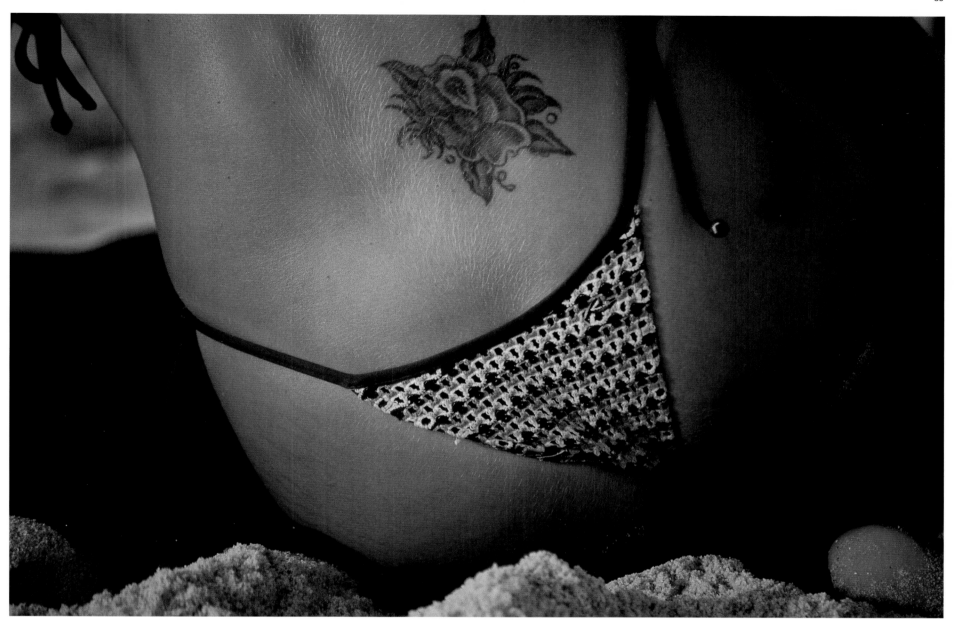

JODI COBB **UNITED KINGDOM** 1999

Once shunned by most Western women, tattooing has become more acceptable and widespread in recent years as a way to permanently ornament the body.

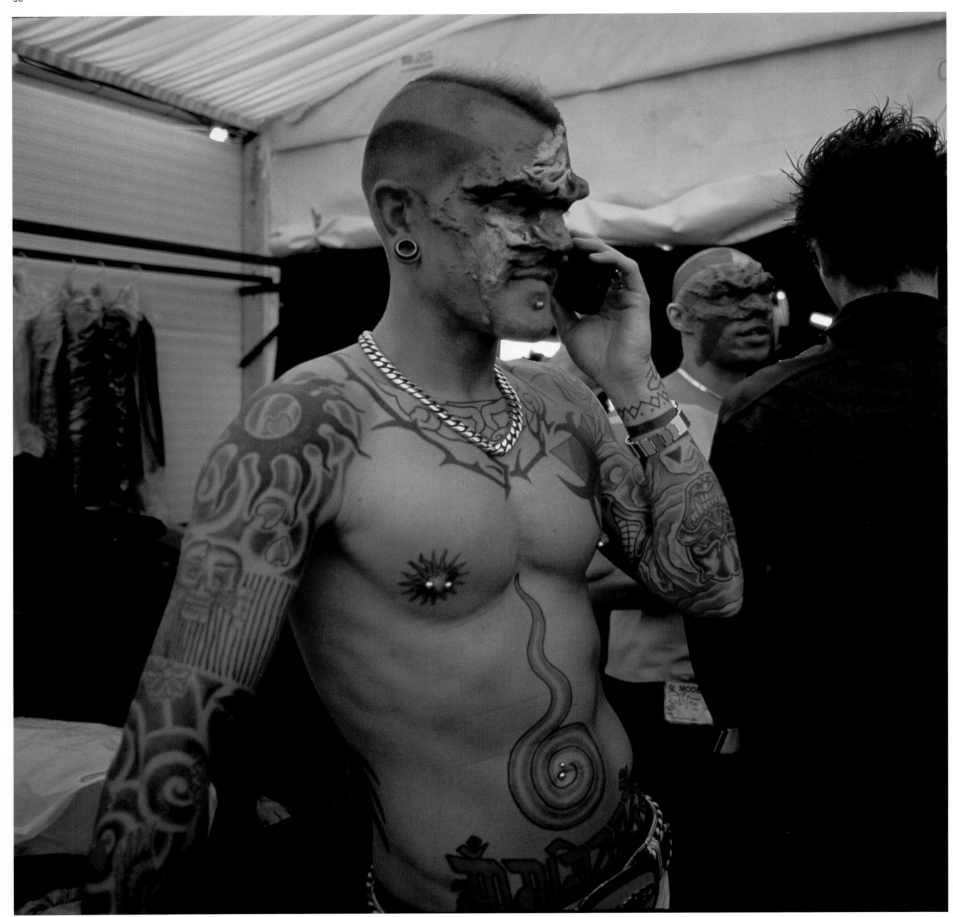

JODI COBB **UNITED KINGDOM** 1999

To display his collection for a runway show, one London designer recruited models like this young man who had real tattoos and body piercings. The facial markings are created by makeup.

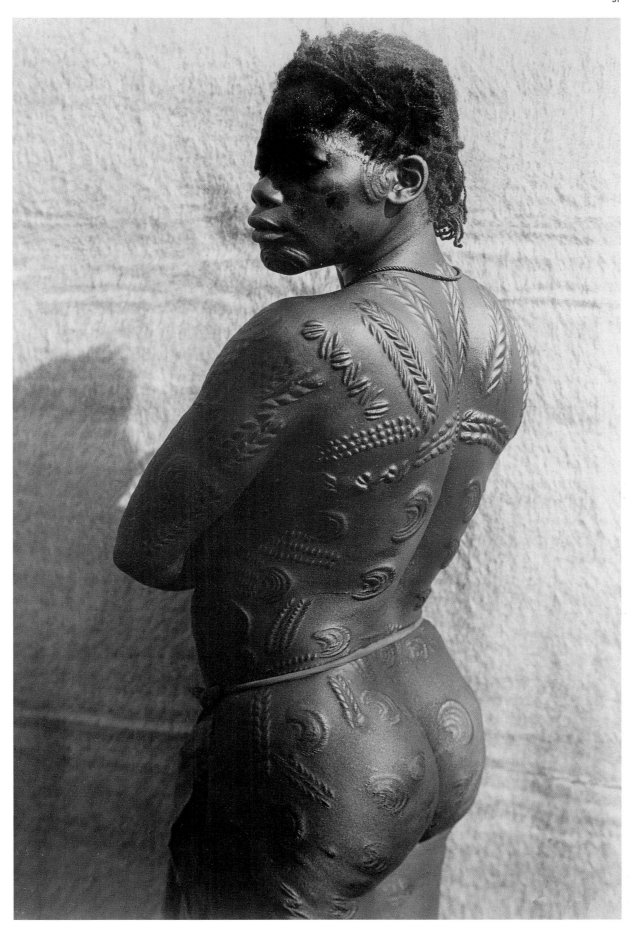

ALBERT COUTURIAUX **CONGO** 1926

The pattern of raised scars, or *cicatrices*, that adorn this woman's body were considered a sign of beauty by her people. The marks were created by inserting charcoal and ashes into incisions in the skin and allowing them to fester.

WILBUR E. GARRETT **CAMBODIA** 1968

/pages 92-93/ Surrounded by ghostly stone faces, two Buddhist monks wearing saffron robes sit in a window of the grand and mysterious Bayon, the main temple of Angkor Thom built hundreds of years ago by the Khmer kings.

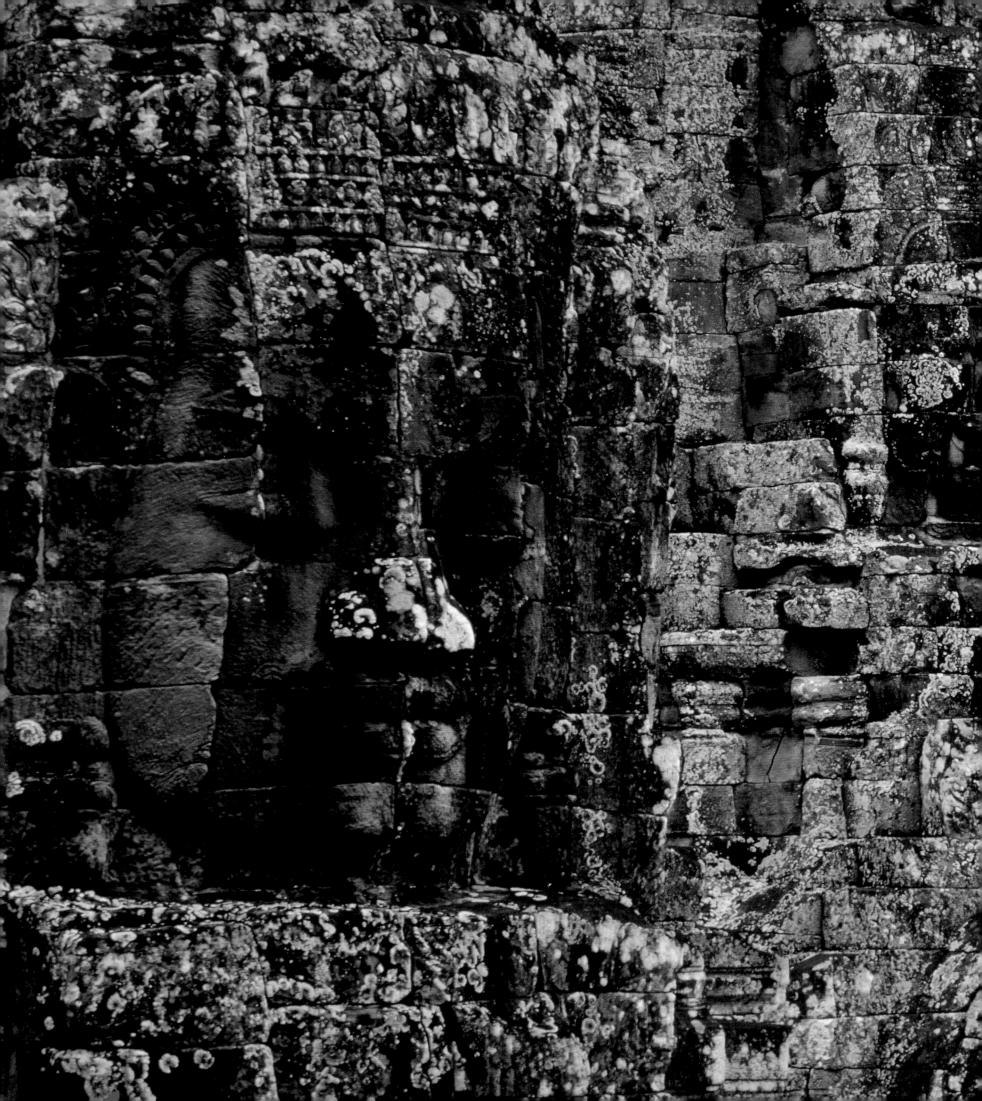

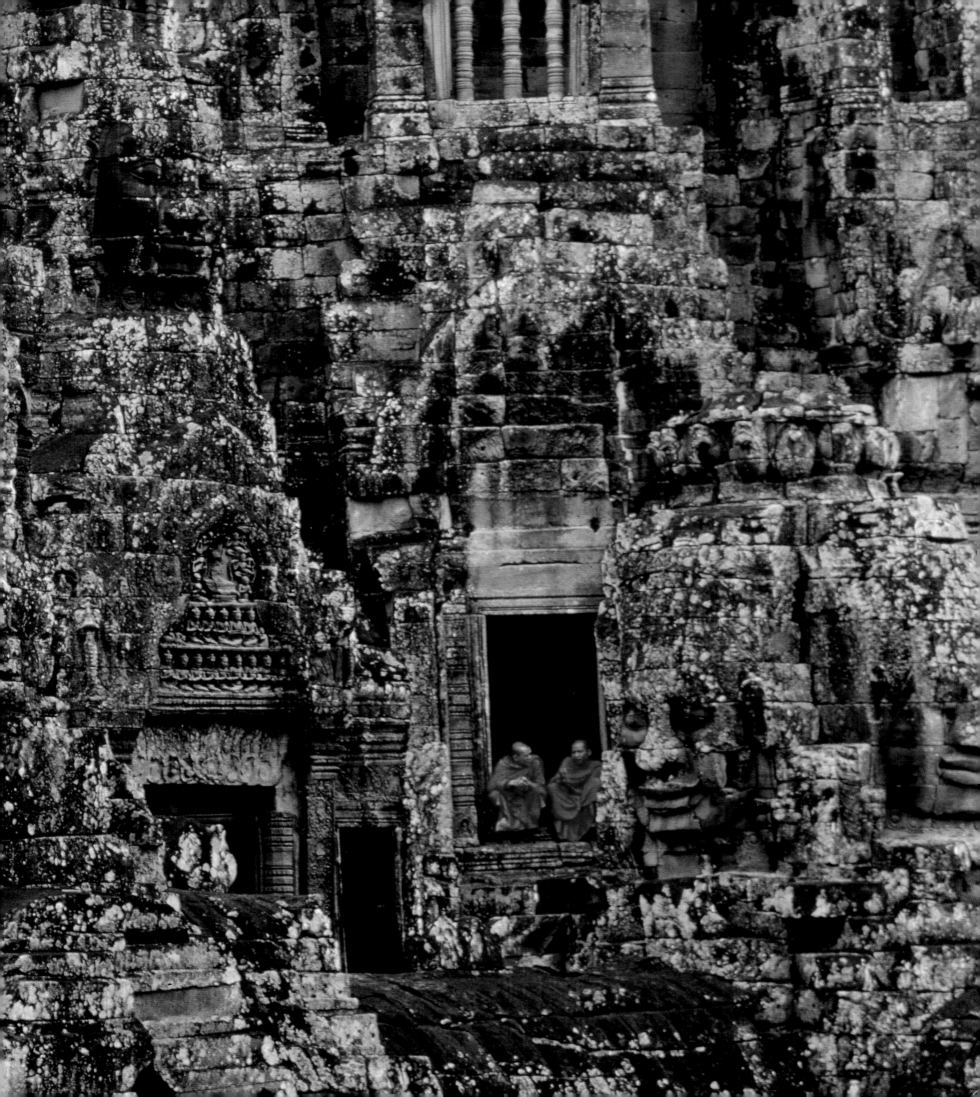

"ELEGANCE
IS GOOD
TASTE PLUS
A DASH
OF DARING."

CARMEL SNOW

JOHN SLEEZER　**GHANA**　1985

/page 95/ Old fashion meets new. Wearing headphones with his traditional robes, a Ghanaian man creates his own individual style.

JAMES L. AMOS　**UNITED STATES**　1987

A mannequin's red garter and high-heel silver shoes advertise a chilidog and souvenir stand that a century earlier may have been a bordello in Silverton, Colorado.

DILIP MEHTA **INDIA** 1993

In Rajasthan, a woman calls further attention to her silver-bangled feet by painting her toenails red.

WILLIAM ALBERT ALLARD **FRANCE** 1989

/**pages 98-99**/ From the age of the pharaohs to the wave of futuristic Paris design, fashion is about draping the human form in interesting ways, as these runway models in a Thierry Mugler show demonstrate.

R. SENZ & COMPANY **SIAM (THAILAND)** 1911

/**page 101**/ In a photographer's studio in Bangkok, a girl pours water over her sleeveless blouse and sarong skirt, revealing the curve of her body.

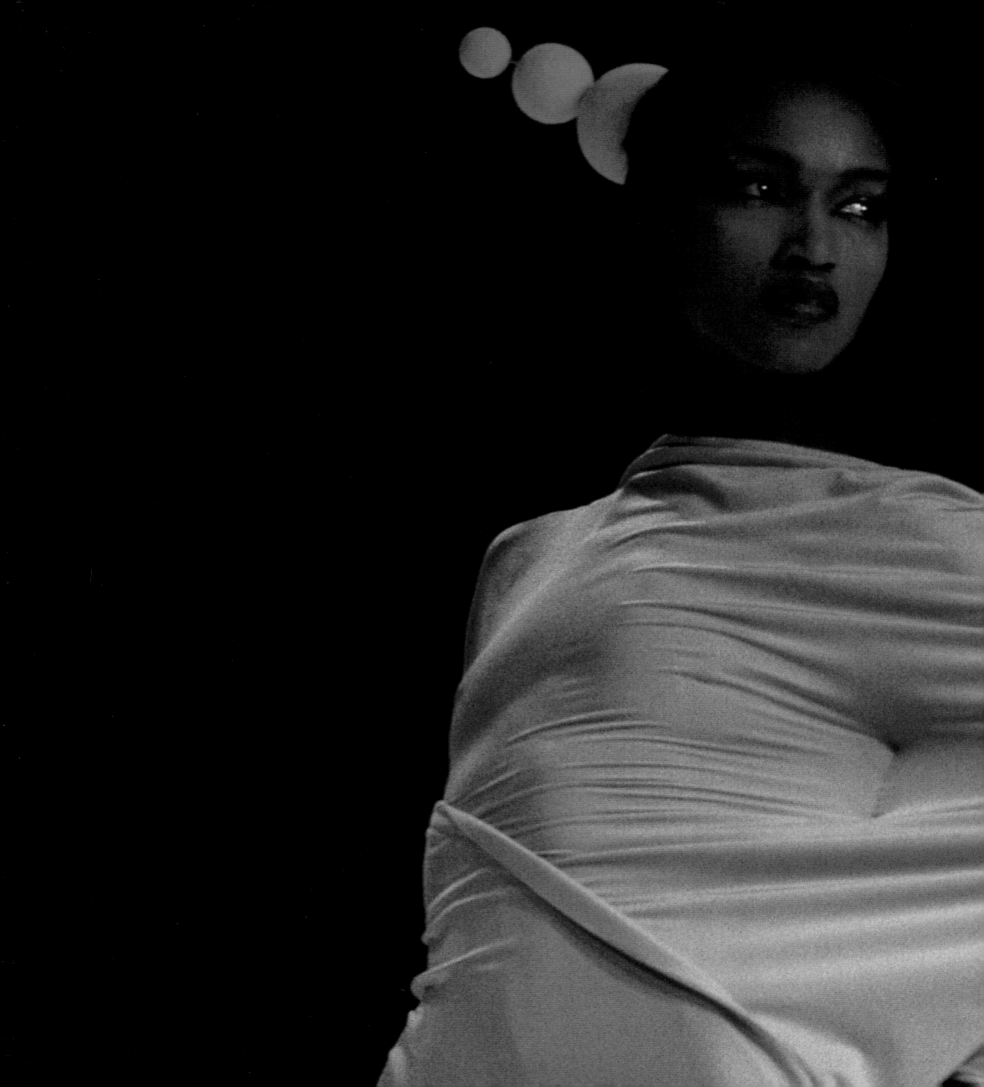

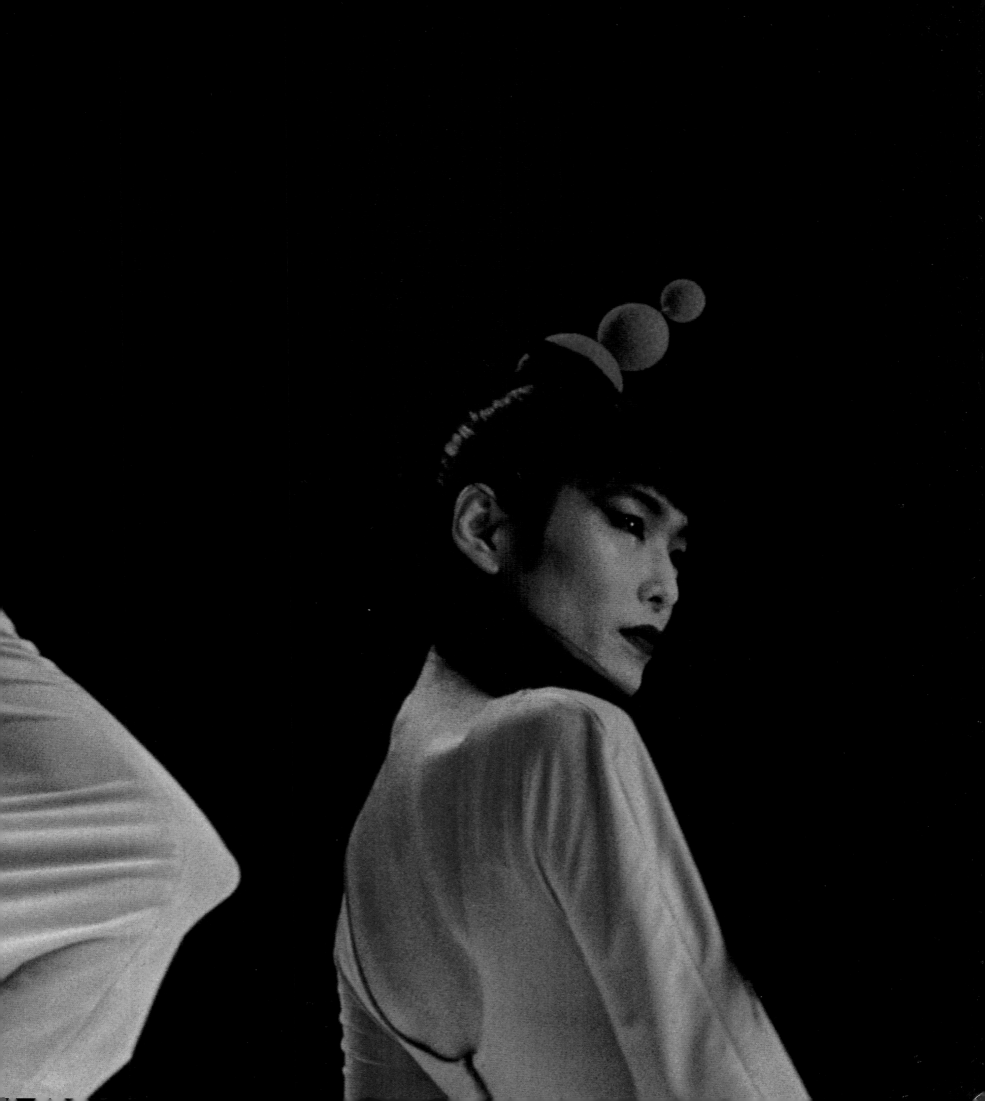

"TO WASH ONE'S
HAIR, MAKE ONE'S
TOILET, AND PUT ON
SCENTED ROBES;
EVEN IF NOT A SOUL
SEES ONE, THESE
PREPARATIONS STILL
PRODUCE AN
INNER PLEASURE."

SEI SHONAGON

"GARMENTS
INTENDED
TO DEFLECT
THE POINT OF
A LANCE, FLYING
ARROWS, OR
SOLAR RADIATION
POSSESS A
STRANGE KIND
OF INSTANT
CHIC."

RACHEL KEMPER

CHAPTER 2 **FRIVOLOUS OR FUNCTIONAL?**

"Isn't fashion frivolous?" I ask Vivienne Westwood.

For the past hour, Westwood, a prominent British designer, has been careening from one random thought to another, uttering haiku-esque pronouncements like "I don't believe in progress," and "Comfort is a perception," and "A man in a pearl necklace is much more interesting than a man in a skirt."

Talking with Westwood is like trying to gain a toehold on a cloud. A wild card pops up at every turn. She unapologetically lights a cigarette. "I don't care if you mind that I smoke," she says, daring me to object. There's something eerie about her, too. Westwood, with her parchment-like alabaster skin and tangerine curls is reminiscent of those iconographic 16th-century portraits of Elizabeth I in masklike pallor. Not surprisingly, her 1997 collection, called "Five Centuries Ago," borrowed heavily from that era. She wears a pair of beaded fur moccasins, plaid knee-highs (one has a run in it), and a sleeveless bottle green dress with shoulders that slip low enough to show a ruby red bra strap. To add to the vibrating patterns in the room, she sits in a plaid upholstered chair on a plaid rug—plaids being a Westwood trademark—while an armchair upholstered in yet a third plaid stands in the corner of her office in South London. She is trying to help the interview move along, but clearly her mind does not run in linear mode. It works more like a broadband scanner radio, jumping between frequency bands with little or no warning.

Finally I ask a simple question about whether fashion *really* matters, in hopes of getting a simple answer. Fashion is frivolous, I prod. Hadn't Samuel Johnson, the English lexicographer, said, "A man who cannot get to heaven in a green coat will not find his way thither the sooner in a grey one" ? In Texas, a man

of no substance is said to be "all hat and no cattle." Even Carmel Snow, the notable editor of *Harper's Bazaar*, called fashion "...light—lighter than air."

Now in her late 50s, Westwood is Britain's bad-girl genius of fashion, who—among other achievements—spawned the safety-pin-rubber-leather-zipper punk look in the early 1970s, before evolving into the head of a fashion empire that shows on the runways of Paris. Though she has made it in the crème de la crème world of Paris and London fashion, she is subversive to the last, as when she vamped royalty by sending out as accessories crowns and orbs set with paste jewels. After receiving an Order of the British Empire in 1992, she celebrated by twirling in a full tartan skirt *sans* underwear outside Buckingham Palace; and she once sent supermodel Naomi Campbell down the runway in a pair of platform shoes so skyscraper-tall that Campell stumbled and fell to her knees.

Even so, there's a vulnerable streak. She wants to be sure I know she was named British Designer of the Year for two years running. She seems piqued that expatriate British designers like Alexander McQueen, now working for Gucci, and John Galliano of Christian Dior get so much attention. She wants to be *understood*. Don't we all?

"Of *course*, fashion is frivolous. It *should* be," Westwood says, with the kind of look nannies must reserve for their more thickheaded young charges. "It has to be to be seductive. A woman's power lies in coquetry."

If there is anything Westwood understands, it's coquetry. Her clothes overflow with sexual charge. She is famous for bosoms pouring out of cinched, corseted waists, for peek-a-boob

T-shirts printed with feminine cleavage, and for putting a model in opaque tights with a fig leaf strategically sewn you-know-where. Her perfume—named Boudoir—is touted by a suggestive ad featuring a voluptuous nude wearing nothing more than a few wisps of sheer material; her collections bear names like "Vive la Cocotte" and "Erotic Zones."

Well, and why not? Fashion, which serves in the court of beauty, is in no small way about sex, which is not so frivolous after all. "If no one wore clothes, no one would ever get laid," Katharine Hamnett, another British designer who specializes in the irreverent, says. The human body—in all its glorious shapes and sizes and with all its fleshly protuberances—does have the air of the comical about it, Hamnett seems to be saying.

Biologists theorize that birds with brighter plumage, swallows with longer tails, elk with larger, more intricate racks are more successful at mating than their more ordinary-attired counterparts; and it requires little leap of the imagination to suggest that the same goes for the human species. Small wonder, as naturalist Charles Darwin observed, "man admires and often tries to exaggerate whatever characteristics nature may have given him." Clothes amplify what nature bestows or supplies what nature does not. High heels extend legs. Belts and corsets diminish waists. Wonderbras enlarge breasts. Padded jackets broaden shoulders and chests, much as the breast-plate of a Roman warrior did in the pre-Armani era.

"It has been manifest to all serious students of dress that of all the motives for the wearing of clothes, those connected with the sexual life have an altogether predominant position," writes J.C. Flügel, a British psychologist. "…clothing and deco-ration (like their antecedents, tattooing, painting, etc.) start anatomically at or near the genital region, and have very frequently some definite reference to a sexual occasion (puberty, marriage, etc.)." String skirts carved on stone-and-bone Venus figures from the Stone Age—and probably worn by women themselves—had nothing to do with warmth or modesty. Their function, suggests Elizabeth Barber, a Professor of Archaeology at Occidental College, who specializes in ancient textiles, probably had more to do with drawing the eye toward the focal point of feminine reproduction.

Scientists and social historians are only repeating a principle Hollywood has capitalized on for years. Five years before she died at the age of 94, I interviewed Edith Head, the grande dame of Hollywood costume design with more than a thousand films to her credit, including such classics as *All About Eve*, *Butch Cassidy and the Sundance Kid*, and *Sunset Boulevard*. In the course of conversation, she recalled a director who demanded that she put the westward-bound heroine in a low-cut dress. "I pointed out that the story locale was the wilderness," the designer said. "The last thing our heroine would be wearing in such tough and desolate surroundings would be a long gown with a dipping décolleté."

"'My dear Edith,'" the director replied. 'If ladies didn't show their busts, *you* wouldn't be here today. There wouldn't be any civilization.'" End of conversation. Head, who by the end of her career had accumulated a cache of eight Oscars for costume design, fussed, fumed, and complied. As directed, she put the lady in a ball gown and sent her galloping into the sunset. Hollywood knew best. As the French novelist Françoise Sagan observed: "A dress has no meaning unless it makes a man want to take it off."

"I'm mad about armor," Diana Vreeland, the legendary editor of *Vogue*, once effused, as if one could zip into Bloomingdale's for the latest in halberds and helmets. Which is not to say that in its time, armor wasn't the ultimately functional outerwear—allowing one to endure the slings and arrows of war with impunity. In the 14th century, even horses stepped out in their own armor—a well-trained horse being considered every bit as worthy of protection as its knightly rider. In modern times, armor still has its uses. When the deposed Philippines President Ferdinand Marcos and his wife Imelda abruptly exited Manila in 1986, among the extravagant flotsam and jetsam left hanging in the palace closets were these telling relics: a dress made of swan feathers and several pairs of bulletproof vests.

Surely Vreeland with her exquisite sensibility was responding more to the glitter and splendor of armor than its function. "I always have armor in my Metropolitan shows," wrote Vreeland, who was special consultant to the Costume Institute at New York's Metropolitan Museum of Art from 1971 until her death in 1989. "I had a gold breastplate," she said of one exhibit, "...and out of the neck poured *point de Bruxelles*, the most beautiful lace in the world. The combination of gold and steel and lace!—no combination is as beautiful."

As historian Rachel Kemper points out: "Garments intended to deflect the point of a lance, flying arrows, or solar radiation possess a strange kind of instant chic, [such as the] ubiquitous aviator glasses that line the rails of fashionable singles bars, perforated racing gloves that grip the wheels of sedate family cars, impressively complicated scuba divers' watches that will never be immersed in any body of water more challenging than the country-club pool."

The modern-day knight on a motorcycle can roar off into the sunset wearing a crash helmet designed by Fendi or Louis Vuitton, or a Trussardi helmet in blue, beige, or burgundy python skin. (A mere six hundred dollars, to order, from the chic London store Harvey Nichols.) But Rafael Misher, a bicycle messenger in Washington, D.C., swears by his own cobbled-together-at-home protective gear. After falling from his bike a few years ago and suffering a broken femur, Misher decided it was time to seriously armor himself against the hazards of the street. These days, he never wheels off without putting on the following: a pair of soccer shin guards, four pairs of knee pads sewn together, a pair of thigh pads, a pair of roller-blading hip pads, a padded downhill biking vest, a pair of shoulder pads, a pair of elbow pads, padded gloves, and, finally, a high-impact-resistant bike helmet.

"They call us the last cowboys," Misher tells me, and describes his typical ten-hour day as an obstacle course of darting cars, inattentive pedestrians, and slick, rain-coated streets—made even more perilous by the relentlessness of a ticking clock. (Time literally is money. Misher gets paid by the number of packages he delivers.) "I'm one of the best and fastest riders," he says, exuding confidence. Other riders teasingly call Misher "Gadget Man," because of the Power Ranger look of his armor, but Misher has the last laugh. A few months ago a car cut him off, smacked into his bike, and sent him soaring seven feet into the air. Misher landed on his back, got up, and dusted himself off. He escaped without a scratch, thanks to his protective gear.

"I'm glad to see you're OK," the shaken driver observed. "Me too," Misher told him.

"Of course, clothing as protection is such a tiny point of it," observes Rebecca Stevens, a curator at the Textile Museum in

Washington, D.C. "In some cold climates, people paint themselves and that's all there is to it. Consider chaps and cowboy boots, which start out as completely functional articles of clothing, then become something else altogether."

According to retailer Stanley Marcus, it wasn't until the French couturier Jacques Fath adapted Western wear into his couture collection of 1950 and showed a cowboy shirt made in satin with rhinestone buttons, that American manufacturers recognized the potential of a fashion style that grew up in its own backyard.

Take the cowboy boot in its original stolid, solid brown cowhide incarnation, functional down to its toes and perfectly designed for the Western saddle. The narrow toe slipped easily *into* the stirrup. The high, underslung heel kept the foot from slipping *through* the stirrup. The high leather boot top protected legs from chafing, while the stitching kept the top from sagging and slipping.

As the footwear of the ultimate American fantasy, it was inevitable that boots would make the step from functional to frivolous. First came intricate stitching, tooling, and inlays; then exotic skins like ostrich, anteater, and python. Before you knew it the only branding going on (Tony Lama, Lucchese) had absolutely nothing to do with cows, and the pointy-toe boot was pounding big-city pavement thousands of miles from the nearest longhorn herd.

So, too, with blue jeans, once the work pants of choice among miners of the California gold rush, and now an American fashion icon and multibillion-dollar business. ("I wish I had invented blue jeans," the French designer Yves Saint Laurent commented, wistfully.) Another example of the migratory patterns of chic, cargo pants turned up in 1938 as part of the British Army battle-dress uniform and ended up appearing on United States Army paratroopers in World War II. That was more than a half-century before they became, in one observer's words, "the sports utility vehicle of the fashion world." From there, it wasn't long before the pants started bearing sports utility vehicle prices. A few years ago, the American designer Ralph Lauren showed a $2,295 version in suede.

The slide from functional to frivolous is not limited to our own culture. Once upon a time Copper Eskimo women wore a type of boot that let in snow, but was attractive to men because of the waddle it inflicted on the wearer—a fashion statement not unlike the ancient Chinese custom of foot-binding or the 20th-century high-heel shoe.

For fashion at its most cruel and magnificent, I visit Christopher Ross, a retired investment banker who lives in New York City. Ross is a collector of military costume, specifically English and Continental regalia of the 19th century.

"Just think," Ross tells me. "The British had 135,000 troops in India and controlled a population of 250 million. Whereas, we had a half a million troops in Vietnam and controlled nothing."

I am in the living room of his town house, which holds a parade of uniforms and accoutrements each more magnificent than the next. Ross collects only the best of the best. There are gilded helmets with flowing horsehair tails, and silver helmets with plumes of swan feathers, and the rich black sheen of high-top, calf-leather boots. There are the wool tartan kilt and crimson jacket of a Scottish officer's uniform and a Hungarian

officer's mink and velvet uniform, not to mention jackets encrusted with gilded silver-wire braid and damascened sabers with inlaid pearl handles. There are sublime colors: French pewter gray, rich Prussian blue, vivid crimson, and a Russian uniform with woolen sleeves of a hue best described as luminescent coral.

The men who wore these clothes were dressed to kill. Literally. In England, Ross tells me, an officer would have gone to a Saville Row tailor for his uniform fitting. Such elegance was pricey. Ross fingers the intricate braided jacket of a colonel of the Tenth Regiment. "A uniform like this cost 5,000 guineas," he notes. "You could have bought a house for that."

"A lot of people are turned off by this," he says, with a slight smile, then quotes Mark Twain. "We love heraldry, but we mock it with our lips."

The uniforms evoke an era, he explains, when war was a profession and soldiers were motivated by a sense of honor. "Life is Military," Ross says, in the words of the Roman statesman Seneca. When I ask him to explain, he adds: "Life is victory; life is defeat. Life is struggle."

He goes on to say that there is function to these clothes, and it has to do with a shared symbolism and an aestheticism tied to purpose. These men fought under the King's colors. The eight-inch plumes rising from helmets that glinted in the sun made the approaching soldiers seem taller than they were. The patterns of skeletal-like braiding on the front of the Brandenberg jackets intimidated the enemy. Epaulets helped protect the collarbone from a sword blow. The high, stiff jacket collars held the head erect. In short, these are serious

clothes for a serious purpose. "War is death and there is nothing more serious than that," Ross says.

Ross opens a drawer, pulls out a red leather box, and from it carefully lifts out a model of a silver skull the size of a Damson plum. It is a garniture for a horse blanket that belonged to an officer of the 17th Lancers—an English regiment—and the piece is so constructed that when you touch the jaw, it clacks against the upper skull. A death rattle incarnate, I think, and imagine the terrible metallic clattering as the cavalrymen of the 17th English Lancers charged into battle.

"These uniforms are a metaphor of a coherent society based on the acceptance of inequality," Ross says. What is more hierarchical than uniform—the general's braid; the lieutenant's sword; the corporal's stripes? "Discipline and order is what people want," he says, then extends the thought. "The essence of collecting is order. I walk into this room and all is in order. I select it. I control it."

There is yet another layer to the metaphor. It's about sex again. It is la petite guerre, the war between men and women. In the animal kingdom, the female always gravitates to the strongest and handsomest of the males. Think of the male peacock in its extravagant feathered glory. "This," Ross says looking at the golden regalia of war around the room, "is the male in full plumage."

"What is it about the men who wore these uniforms that you find most appealing?" I ask.

His response is immediate. "They owned themselves," he says, with a smile of satisfaction. "They knew who they were and what they were there for."

When it comes to frivolity, nothing beats the ruffles and flourishes of 18th-century Europe. Love of appearance was paramount among the aristocracy of 18th-century France. "There is nothing more serious than the goings on in the morning when Madame is about her toilet," wrote Montesquieu, the French essayist. Monsieur in his wig of cascading curls, scented gloves, and rouge was equally obsessed. "They have their color, toilet, powder puffs, pomades and perfumes," noted one lady socialite, "and it occupies them just as much as or even more than us."

The English dandy Beau Brummell, London's premier clotheshorse in the 19th century, was so fussy that he was said to have had his coat made by one tailor, his waistcoats by a second, and his breeches by a third. Brummell popularized and refined the idea of close-fitting, finely tailored jacket and pants, as opposed to the loose, sloppy English country squire or flashy French courtier looks then in vogue. It is recorded that the Prince of Wales (the future King George IV) burst into tears because Brummel criticized the cut of his new coat. Later on, Brummell and the prince had a falling out. It is not surprising, considering he asked a mutual acquaintance: "Who is your fat friend?" in reference to the prince. But then, arrogance was a specialty. At Eton, he taunted his headmaster by calling into question the symmetry of his neckcloth, and often greeted acquaintances with lines like "Do you call that thing a coat?" Such behavior did not endear him to friends. He gambled away his fortune and died penniless in an asylum for the poor, but his name lives on as a synonym for a dandy and for the astute observation that if someone on the street turns to observe your appearance, you are not well dressed.

Is everything a fashion statement? Aren't clothes ever functional in the utilitarian sense these days? Of course they are.

Clothes for outdoor pursuits are clothes that are not only truly functional, but downright lifesaving. Take the wet suit, the down jacket of the ocean. It allows a diver to stay under in an environment that wants you to be cold, and also provides protection from sunburn, stinging cells, and abrasion.

Diving suits started out as shapeless canvas and rubber garments that were bulky and leaked easily. Appropriately enough, the Italian Navy was first to produce thin suits that were not only fashionable but also functional. Now referred to as "thermal regulating garments," wet suits are generally made of neoprene, a synthetic rubber invented in the 1930s, which traps water in sponge-like cells next to the body and warms it.

In the late 1950s, actor Lloyd Bridges had a gray wet suit in the television show Sea Hunt to distinguish him from the bad guys in black. Wet suits in colors appeared at the end of the 1960s, when women started taking up the sport. "Yellow was the first color you could buy," remembers David Doubilet, undoubtedly the foremost underwater photographer working today. "Next came blue wetsuits, then blue and black, and then in the 1980s you had purple and white. The late 80s and 90s saw the rise of lime green and orange. Occasionally," he adds, "you'll see a white suit. They're lovely except for the dirt."

"Of course," Doubilet adds, "Basic black has never gone out of fashion." And how many diving suits does he own? There's a silence on the phone as he mentally goes through his closets. "About 23," he says. "Of course, half of them don't fit anymore, and should be thrown out."

From deep sea to deep space. Space is a vacuum. In addition to oxygen, those who would float among the stars have

urgent need of a pressurized suit. "Otherwise the gases in your blood would literally boil," explains Bill Ayrey, manager of quality testing at ILC Dover. ILC (formerly International Latex Corporation), which is located at One Moonwalker Road near Dover, Delaware, manufactures space suits. They made the suits Apollo mission astronauts wore and those currently worn for the Shuttle program. These days they are working on designing suits for trips to Mars. There's no couture like space couture. Apollo mission flyers like Buzz Aldrin had their space suits fitted with the same attention and care as a bespoke suit.

These days it's more of an off-the-rack business, although gloves are still custom-fitted and require some hand sewing. In fact, says, Michelle Guzniczak, project engineer for ILC, 50 people are involved in fabricating a set of gloves. She handed me the newest model, known as a Phase VI Glove. I put it on, a sensation, I imagine, not unlike pulling on a gauntlet. The glove, though bulky, is surprisingly flexible. The palm has silicon rubber tread ridges to help with gripping, and a fingertip heater for those cold mornings in space. It is space armor, made of high-tech materials. The inner layer is an airtight bladder, followed by a restraint layer which absorbs the wear and tear of motion, then a TMG (thermal micro-meteoroid garment) which contains five layers of Mylar to withstand temperatures that range from 280°F to minus 180°F, and finally a protective Teflon-like shell that provides additional thermal protection and is resistant to abrasion and micro-meteoroids. At 18,000 miles an hour, even a particle of dust can cause a sizable dent.

The pattern pieces of material for the space suit are cut out by laser, then stitched together by women using heavy-duty sewing machines in a scene reminiscent of a factory in New York's garment district. Instead of sportswear separates, though, it's space suits. "It's really not much of a fashion statement," Bill Ayrey said apologetically, as we watched a suit being pieced together in the assembly room.

But it is. Space suits inspired the Spanish designer Paco Rabanne and the French designer Pierre Cardin, among others. Cardin produced a felted helmet with a futuristic shape for a collection called "Cosmos," delighted in the silver and white associated with space travel, and occasionally teamed designs with inverted-goldfish-bowl-like Perspex helmets. "Many years ago, Cardin, a powerful, persuasive man, managed to get Smithsonian curators to let him try on an archive suit from the Apollo program," reports Valerie Mendes, Fashion Research Fellow at the Victoria and Albert Museum in London. "And there are photographs in the Cardin archives to prove it."

Space suits are yet another statement about how clothes define the wearer. They epitomize exquisitely well-thought-out and functional design. They are, as well, a statement of time and place that defines the wearer as a citizen of Earth in the 21st century: a fashion statement that transcends ethnicity, race, or gender.

"You want frivolous. I'll show you frivolous," promises Elizabeth Ann Coleman, curator of Textile and Fashion Arts at the Museum of Fine Arts in Boston, as we head for the basement-level room where the collections are stored. In spite of—or perhaps rather, in addition to—her standing in the curatorial world, Coleman maintains a sense of humor about the subject and has little patience for those who would put fashion in an academic straitjacket. The department she heads at the Boston Museum used to be called Textiles, Arts, and Costume, until Coleman pointed out to the Museum board that, among

other things, the word "costume" had the whiff of the derogatory about it, as if what people from non-Western cultures wore didn't count as *fashion.*

In Coleman's generous view, what anyone wears, anywhere, anytime, can be defined as fashion. This includes the wide world of clothing from Indian saris to Japanese kimonos to Inuit anoraks to the djellaba worn by Moroccan men. You could call this apparel "regional fashion," she says, but it is fashion nonetheless.

What is fashion? "A word," Coleman replies with an airy wave as she unlocks the door to the collections room. In response to my wish to see something purely frivolous, Coleman walks over to a cabinet, pulls open a drawer, and points out a dozen or so hair ornaments from the 18th and 19th centuries. It is easy to dismiss these artifacts of vanity as pure fluff; they are, after all, little more than bits of brightly embroidered ribbon, feather, and lace that provided neither warmth nor protection from rain. They provided nothing except the pleasure of adornment.

She pulls open another drawer to reveal several pairs of leather and velvet *chopines* the 16th- and 17th-century equivalent of the platform shoe, worn by high-class Venetian courtesans. As walking shoes, chopines were an utter failure. They stood six inches or more off the ground. Each step was a disaster waiting to happen. To make the journey from point A to point B, the lady in chopines had to be supported by servants. Practical? No. Emblematic of indolence and conspicuous consumption? Indisputably. "High heels," a fashion writer once said, "are for those who pay other people to do their walking for them—to the dry cleaner, to fetch a cab, to pick up lunch." Perhaps it is the function of fashion to be frivolous. What bet-

ter way to catch the eye and, hopefully, the heart, than with the dazzle of gold threads in a silk sari or the languid drape of a paisley shawl. Fashion has a great deal to do with sex—which is, after all, how we go about ensuring the continuity of the species, and it has been that way for a very long time.

"In that sense, fashion is about survival," Elizabeth Ann Coleman says. There is nothing frivolous about that.

ELIZA R. SCIDMORE **JAVA** 1907
/**page 112**/ In a sling of batik, an Indonesian handprint, mother cradles child.

BARBARA CUSHMAN ROWELL **PAKISTAN** 1987
/**page 113**/ The Balti mountain people dress as they have for centuries.

"MEN'S FASHIONS
ALL START AS
SPORTS CLOTHES
AND PROGRESS TO
GREAT OCCASIONS
OF STATE. THE TAIL
COAT, WHICH STARTED
AS A HUNTING COAT,
IS FINISHING SUCH
A JOURNEY. THE
TRACK SUIT IS JUST
BEGINNING ONE."

ANGUS McGILL

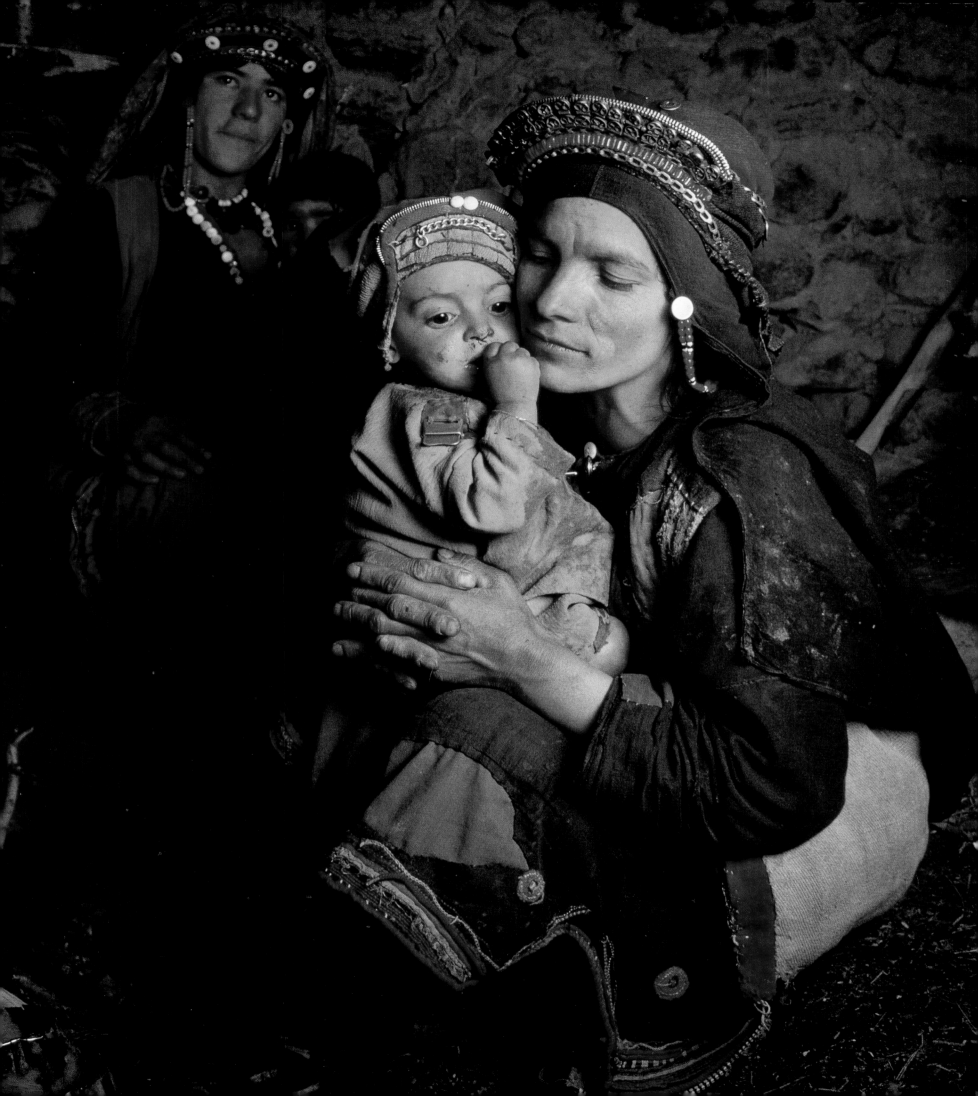

"ISN'T
ELEGANCE
FORGETTING
WHAT ONE IS
WEARING?"

YVES SAINT LAURENT

JOSÉ AZEL **MALI** 1990

/pages 114–115/ This Dogon woman keeps her child close as she grinds millet, a staple for the people of Mali. The fabric that secures her baby is an integral part of her dress, just as children are an integral part of their parents' working life.

DAVID ALAN HARVEY **UNITED STATES** 1993

At the annual September powwow in White Swan, Washington, James Winterhawk Seymour emits a yawn. Whenever he stirs, the beads suspended above his cradle board make a gentle tinkling sound, alerting his parents and lulling him back to sleep.

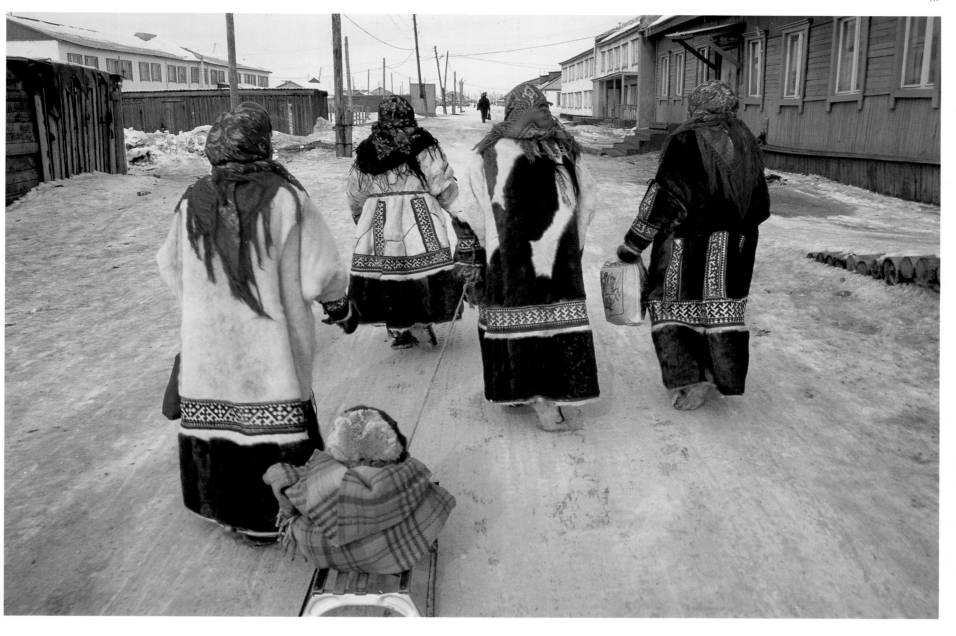

MARIA STENZEL **RUSSIA** 1996

Trudging down a snowy street in Siberia, residents of the town Yar
Sale face the cold in style. The intricate and painstaking embroidery
on their coats indicates their love for decor, as well as the clan or
family to which each belongs.

GEORGE R. KING **NETHERLANDS** 1914

/**pages 118–119**/ Surrounded by the Zuider Zee, this Dutch farming
family on the island of Marken wear clogs to protect their feet from
damp soil. Father and son are clad in the distinctive "Dutchman's
breeches," for which a wildflower was named.

"IN DIFFICULT
TIMES FASHION
IS ALWAYS
OUTRAGEOUS."

ELSA SCHIAPARELLI

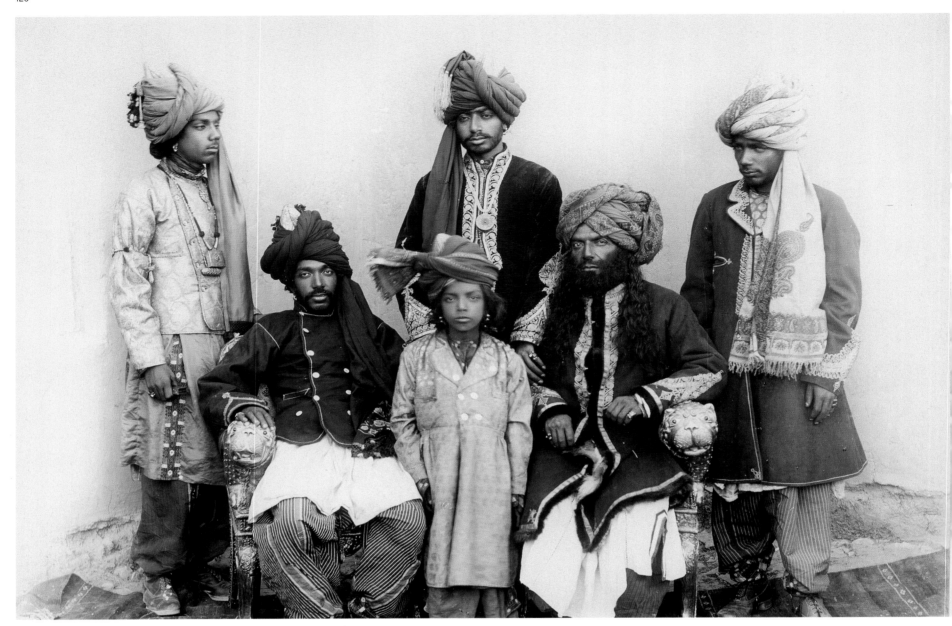

FRED BREMNER **PAKISTAN** 1922

On a bench bearing tiger-head armrests, the Khan of Kalat (left) sits with his father, the former Khan (right), amid his brothers. Along with their traditional turbans, earrings, and robes, a few wear Western-style coats.

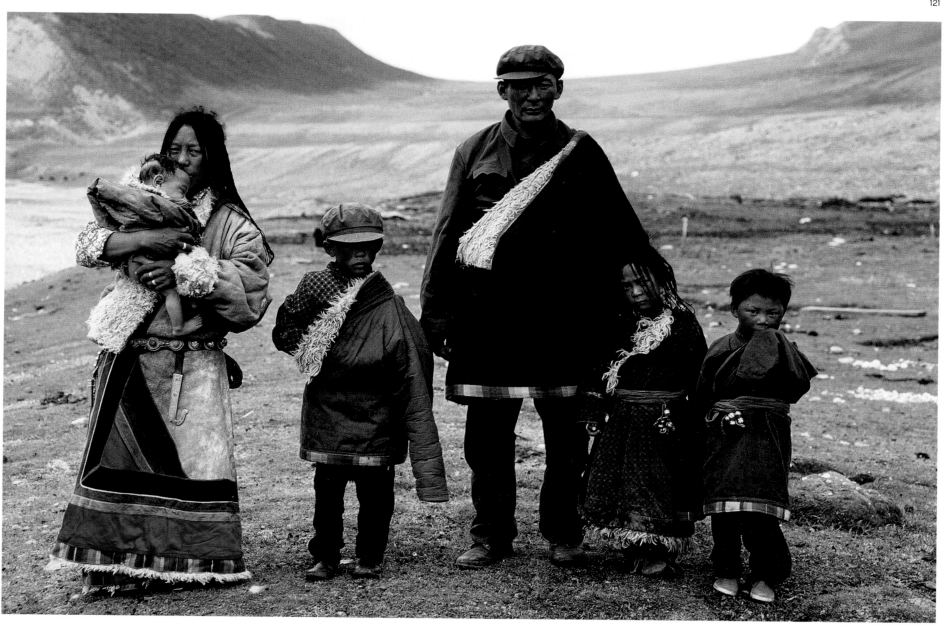

HAROLD A. KNUTSON **TIBET** 1982

A Golog family may wear basic communist-style clothing, but their Tibetan heritage prevails. Known for their independence and defiance of authority, Golog people wear jackets to cover their left shoulder only, leaving their right arm free to fight.

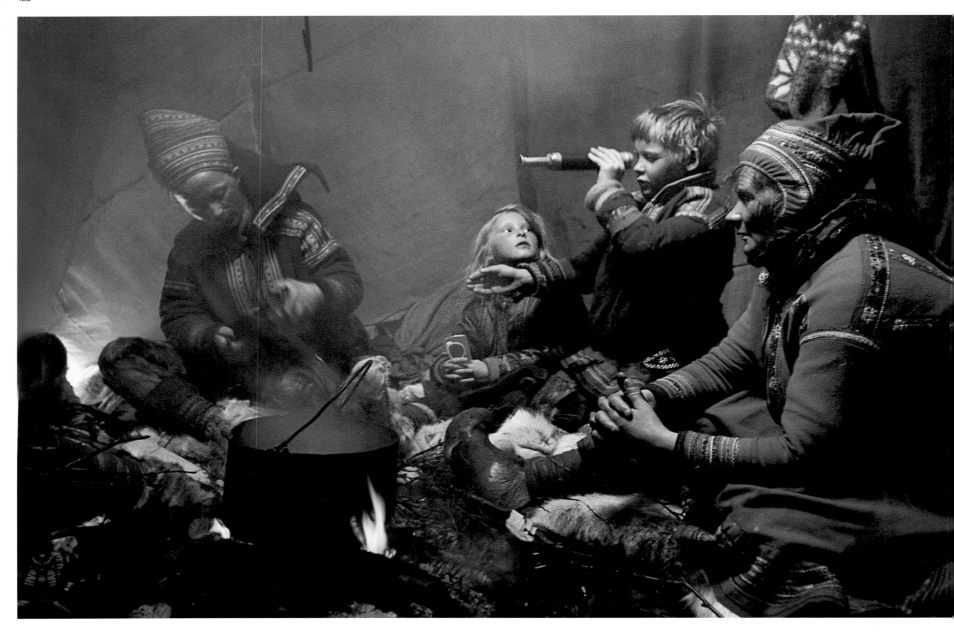

GEORGE F. MOBLEY **NORWAY** 1971

Dinner pot steaming, a tentbound Sami, or Lapp, family waits out a
storm before moving their reindeer herd. Sami are known for their
brightly embroidered clothing and seminomadic lifestyle. The father
fixes a broken harness; the son's telescope will spot stray reindeer.

PHOTOGRAPHER UNKNOWN **FRANCE** 1911

Two young girls in northern France may wear aprons as their mother
and grandmother do while performing domestic chores. To don the
frilly white caps, however, the girls must wait until they are married.

J. BAYLOR ROBERTS **UNITED STATES** 1937

/**pages 124–125**/ Four Amish youngsters in Lancaster, Pennsylvania,
dress as their ancestors did, in dark brimmed hats and suspenders
for the boys, and long dresses for the girls. Older children wear shoes
and stockings, while the younger ones go barefoot.

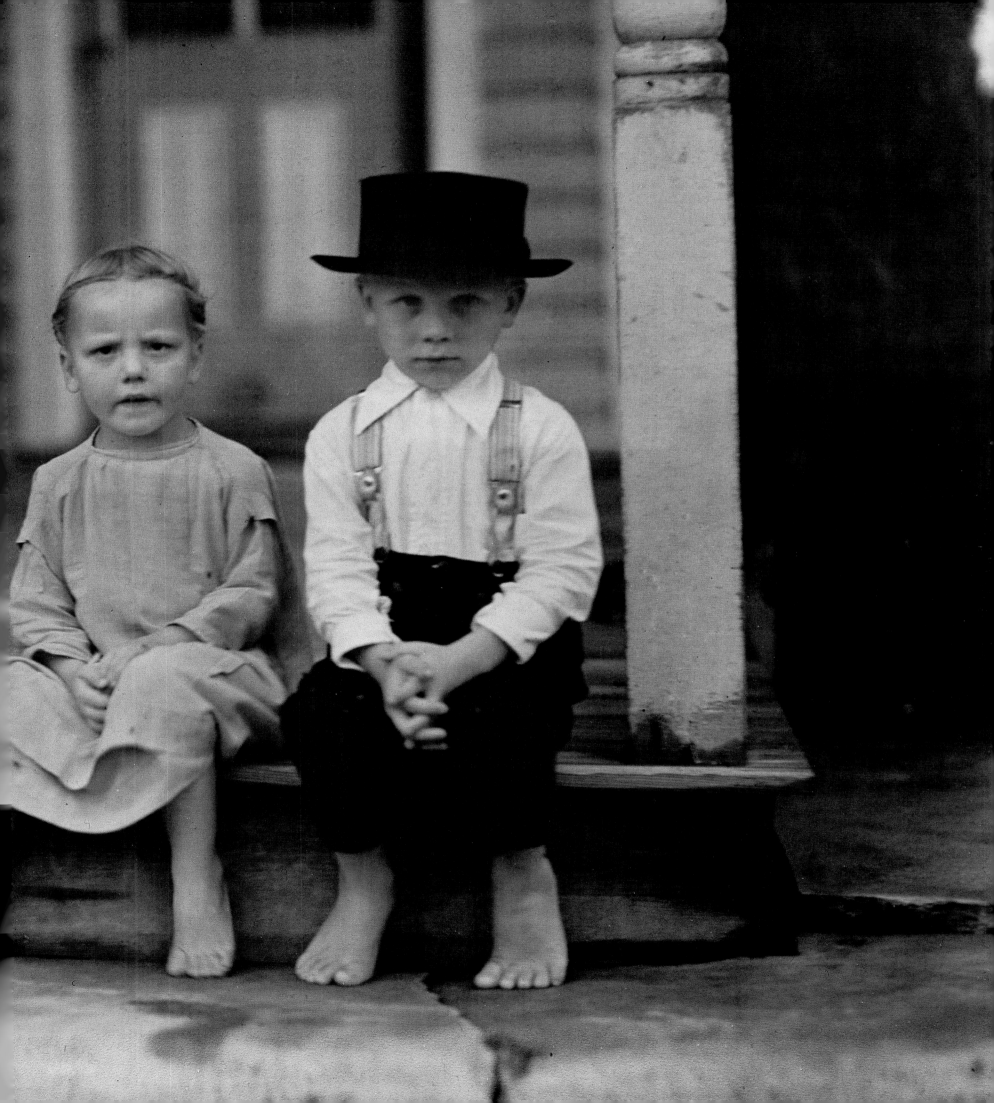

126

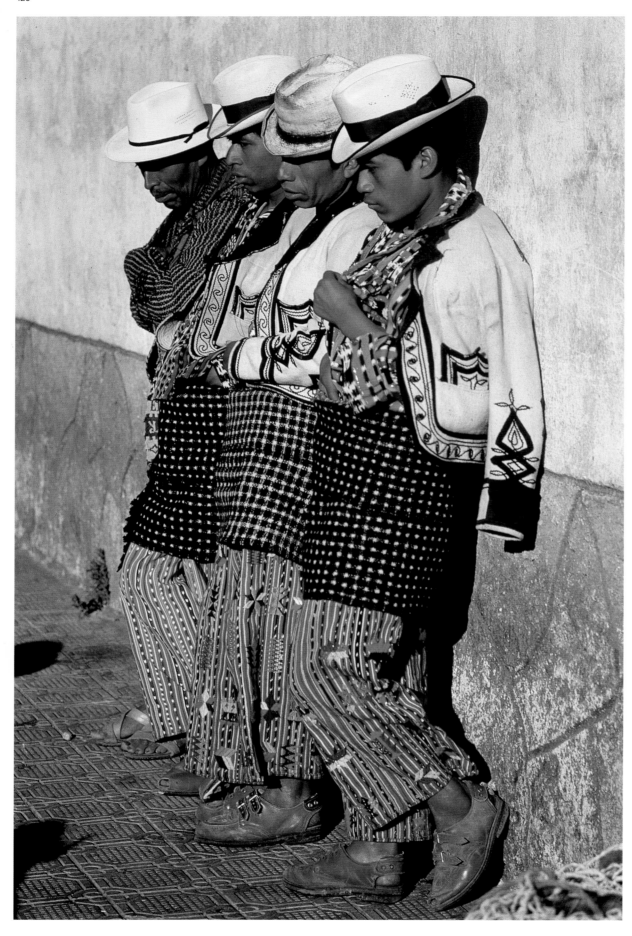

DAVID ALAN HARVEY **GUATEMALA** 1975

In the mountain village of Solola, Maya descendants exemplify the
blend of past and present: The ancient Mayan skill of weaving fine,
brightly-colored fabrics and motifs joins the more modern influence of
brimmed hats and tailored jackets.

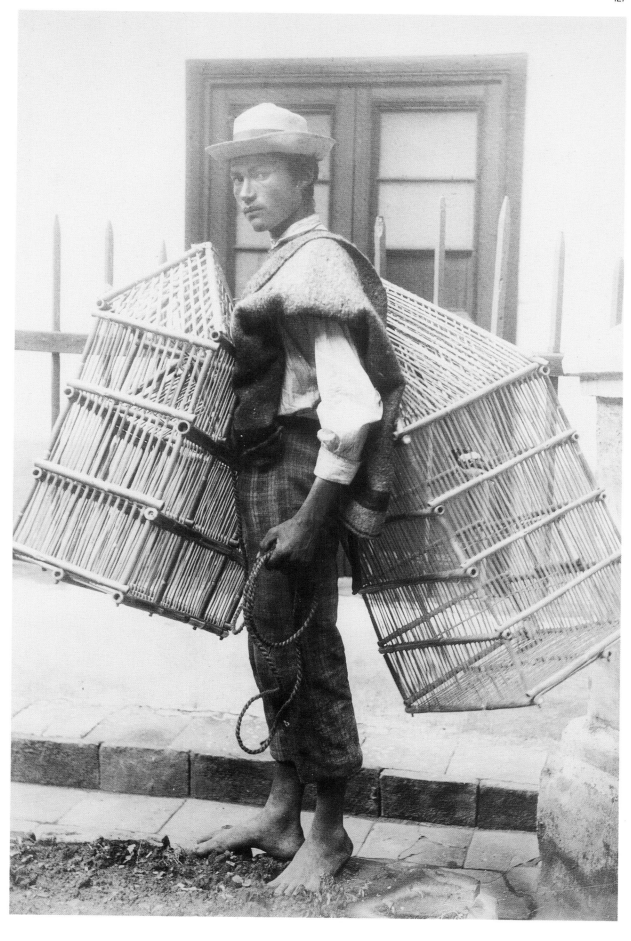

HENRY R. LEMLY **SOUTH AMERICA** ca 1900

Bird cages strapped to his front and back, a young man pauses before the camera of Henry Lemly, an Army major who spent his retired years documenting the world and its cultures.

WILLIAM ALBERT ALLARD **UNITED STATES** 1986

/pages 128–129/ A convict at the State Penitentiary in Louisiana wears cotton and carries a cotton bag as he harvests cotton. The fiber is popular for its exceptional resilience and ability to take dye; the spiky-edged pod makes picking difficult.

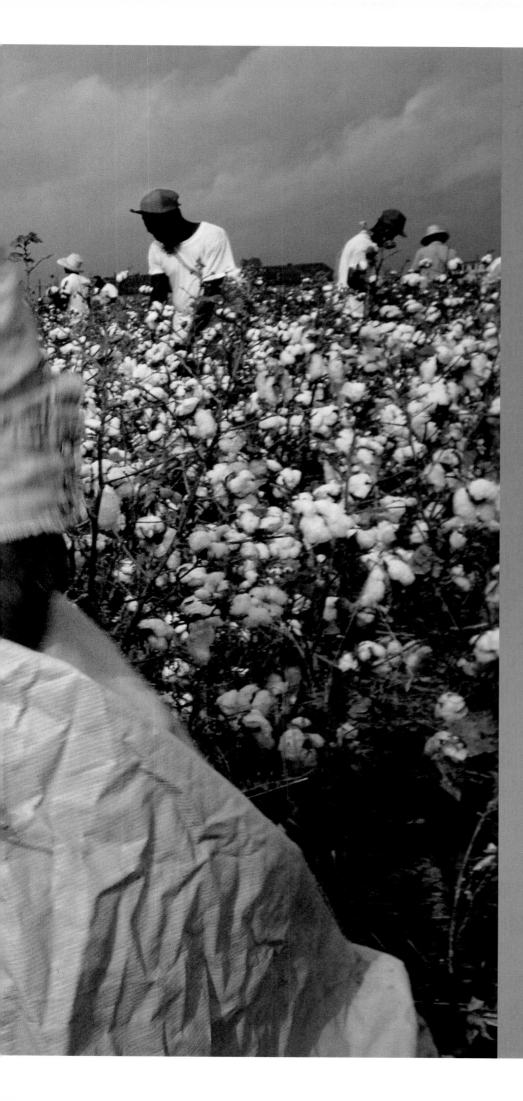

"CLOTHES STAND
FOR KNOWLEDGE,
LANGUAGE, ART
AND LOVE, TIME
AND DEATH,
THE CREATIVE,
STRUGGLING
STATE OF MAN."

ANNE HOLLANDER

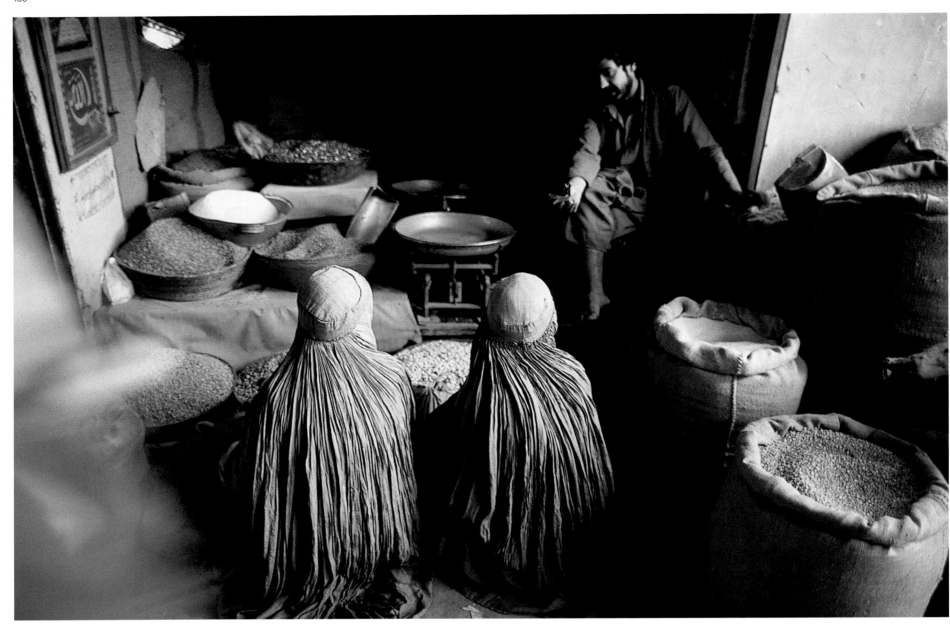

STEVE RAYMER **AFGHANISTAN** 1985

Women wearing the traditional head-to-toe garment called the chadri bargain with a grain merchant in Kabul. In the late 20th century Afghan women were permitted to wear modern clothing in public; today, they would be beaten for doing so.

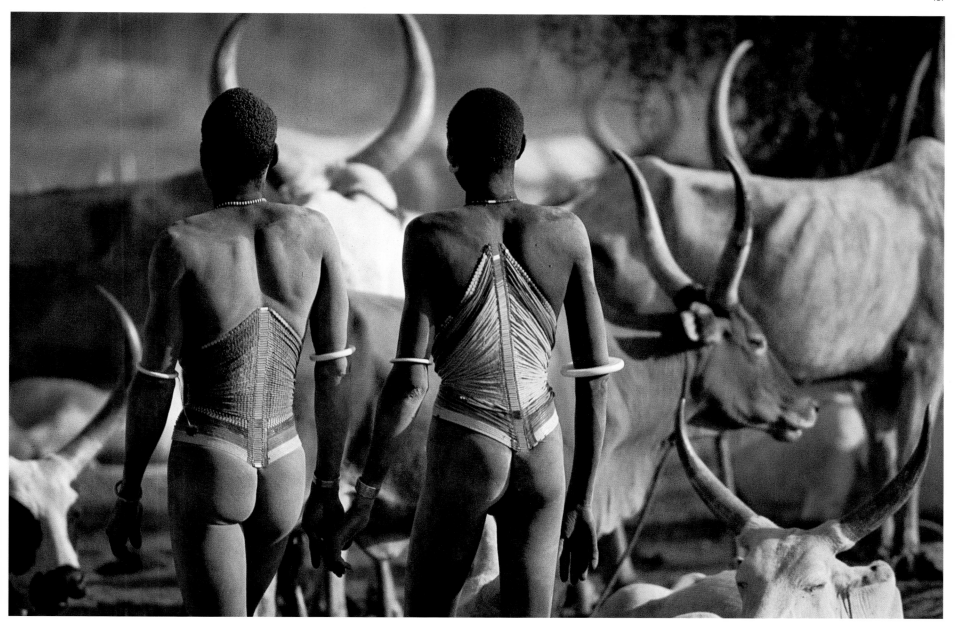

FABBY K.J. NIELSEN **SUDAN** 1984

Dinka men wear beaded corsets indicating their age group: red and black for age 15 to 25; pink and purple for 25 to 30; and predominantly yellow for those past 30. The corsets fit so tightly that they must be cut off when their owners change age groups.

JONATHAN BLAIR **ALGERIA** 1967

/**page 132**/ Swathed in fabric that shelters her from the desiccating winds of the Sahara, a woman of the nomadic Reguibat people wears the brilliant blue favored by her tribe. It sets off their Arab-Berber features.

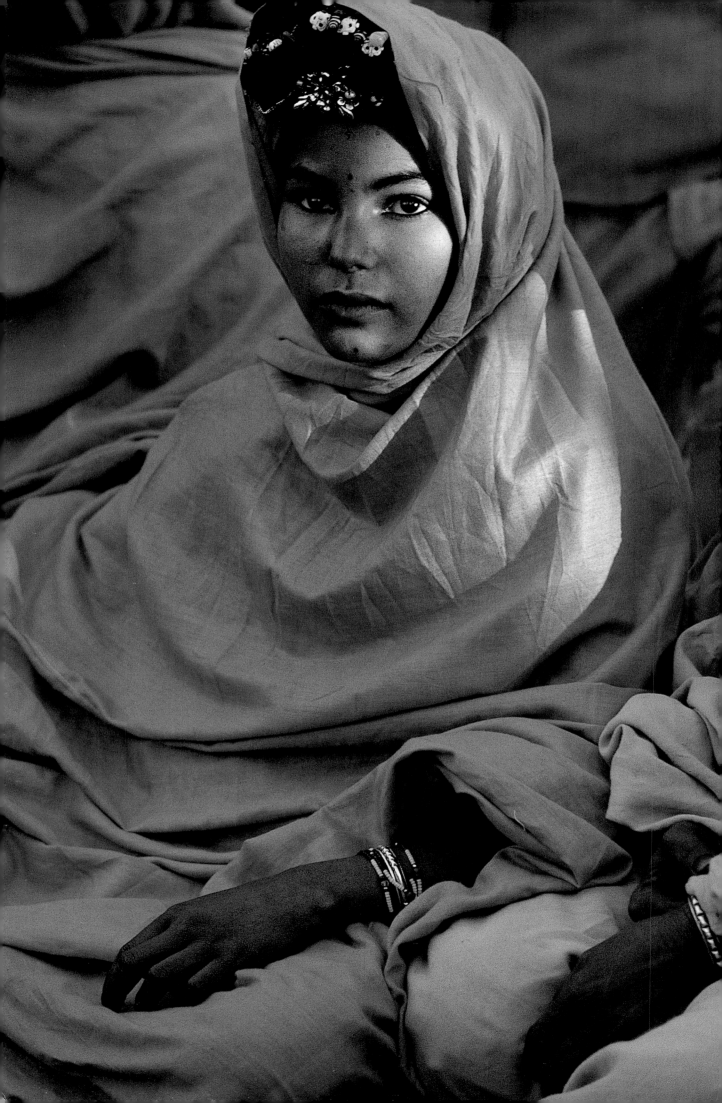

"THE ORIGINS
OF CLOTHING
ARE NOT
PRACTICAL.
THEY ARE
MYSTICAL
AND EROTIC."

KATHARINE HAMNETT

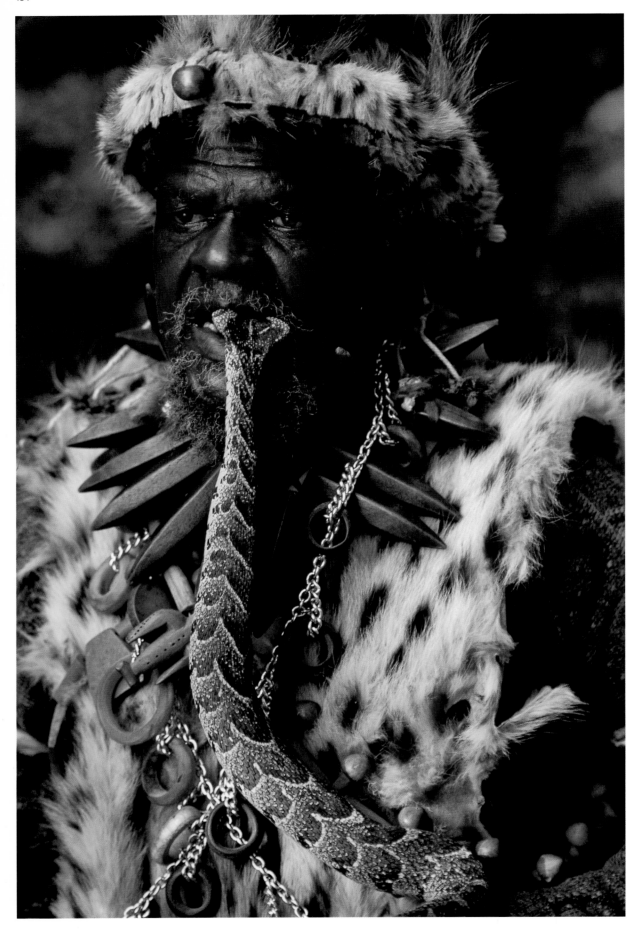

CHRIS JOHNS **SOUTH AFRICA** 1996

The deadly venom of a puff adder does not deter a high-ranking Zulu
medicine man from clamping the snake's skull between his teeth.
This skill gives him power over his people. Gold chains and a chee-
tah vest and headdress enhance his awesome appearance.

"FASHION IS AS
PROFOUND AND
CRITICAL A PART
OF THE SOCIAL
LIFE OF MAN AS
SEX, AND IT IS
MADE UP OF THE
SAME AMBIVALENT
MIXTURE OF IRRE-
SISTIBLE URGES
AND INEVITABLE
TABOOS."

RENÉ KONIG

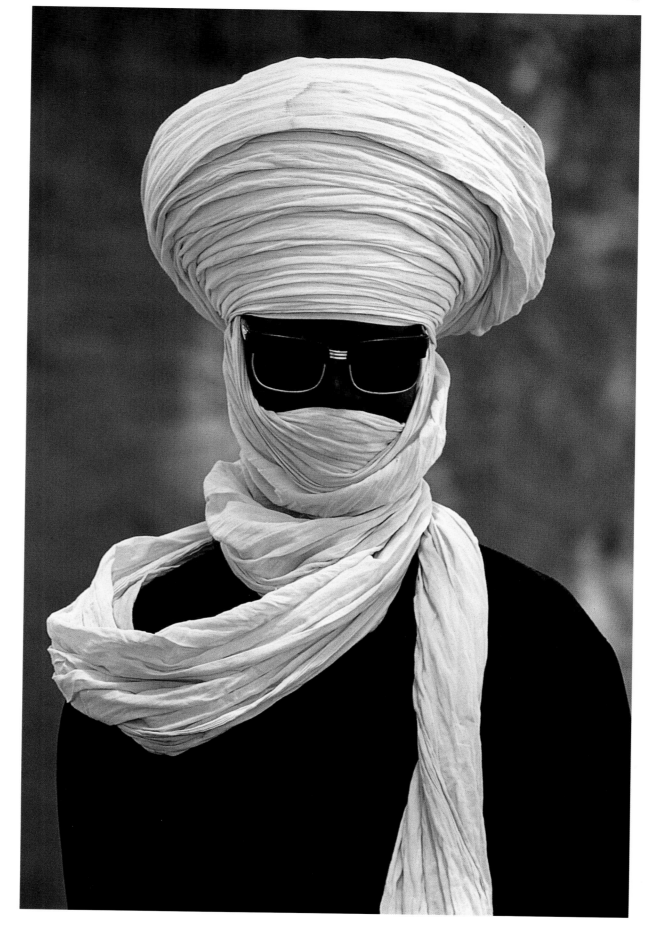

GEORG GERSTER **BURKINA FASO** 1979

Yards of fabric draped from neck to nose, then wound up into a tow-ering turban shield a Bella tribesman against desert sun and sand. A practical invention from the modern world completes his protective screen: sunglasses.

J.W. BEATTIE **SOLOMON ISLANDS** 1916

/**page 136**/ The humid South Pacific requires little in the way of cloth-ing, but a visor woven from plant material provides protection from the sun for this resident of Vella Lavella Island.

ROBERT E. PEARY **UNITED STATES** ca 1910

/**page 137**/ Explorer Matthew A. Henson, who joined Peary on six attempts to reach the North Pole, met the challenge of Arctic life: He wore fur clothing made by the Inuits, learned their language, and became an expert dogsled driver.

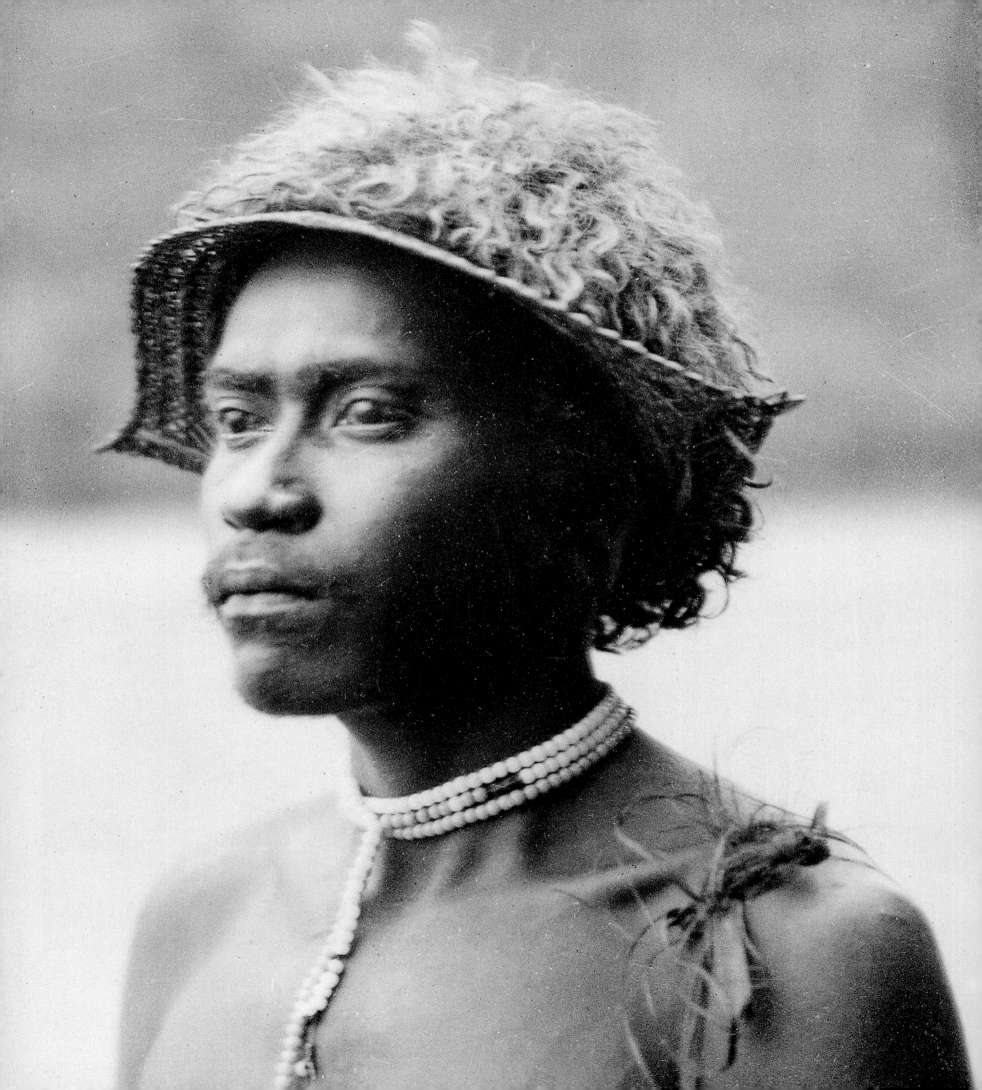

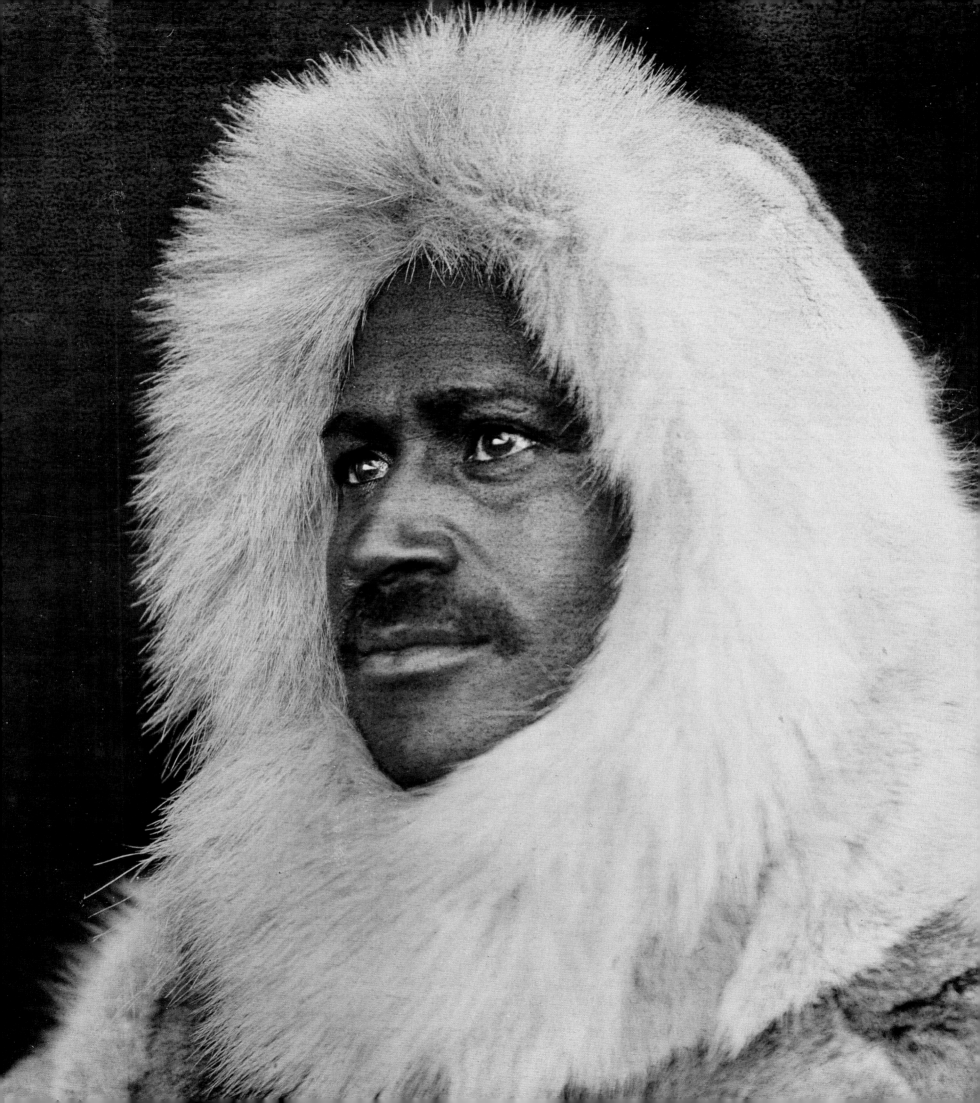

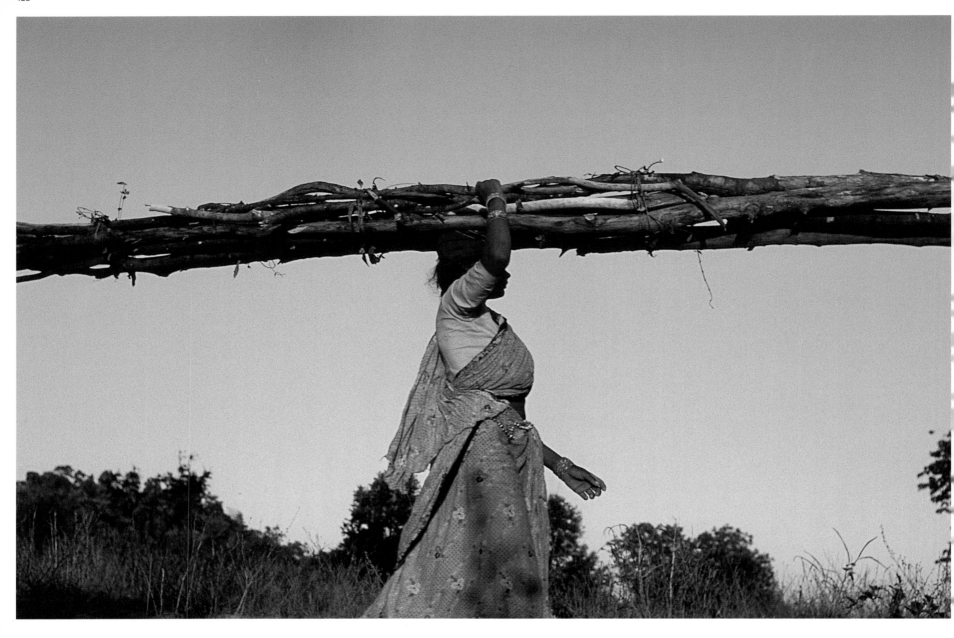

MICHAEL NICHOLS **INDIA** 1995

With astonishing skill and balance, a woman in Bandhavgarh National
Park carries her load with grace, her sari as ephemeral as her
strength is tangible.

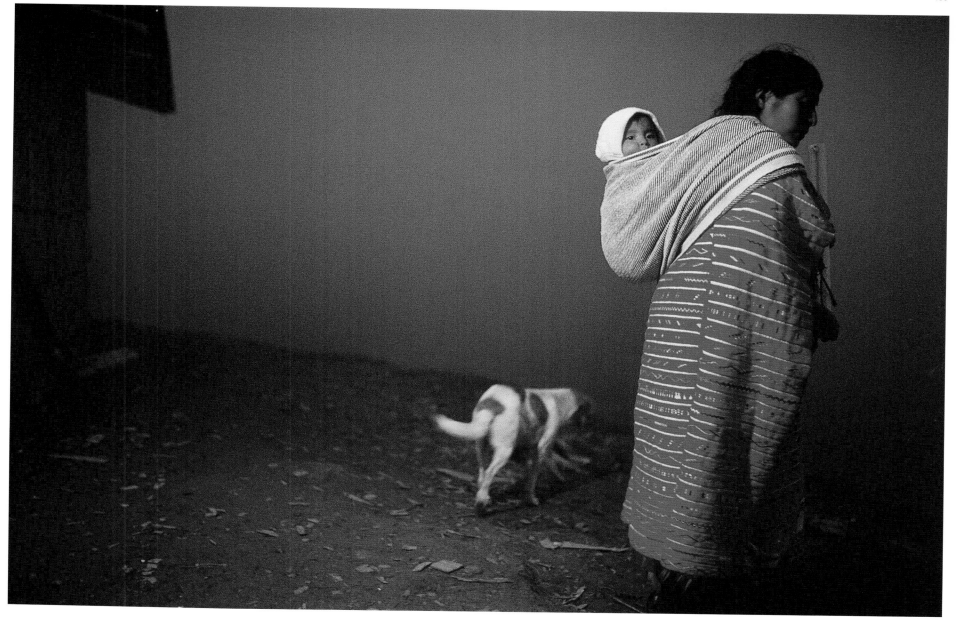

DAVID ALAN HARVEY **MEXICO** 1992

A street in Oaxaca brightens as a mother and her child pass by cloaked in richly-colored, handwoven textiles.

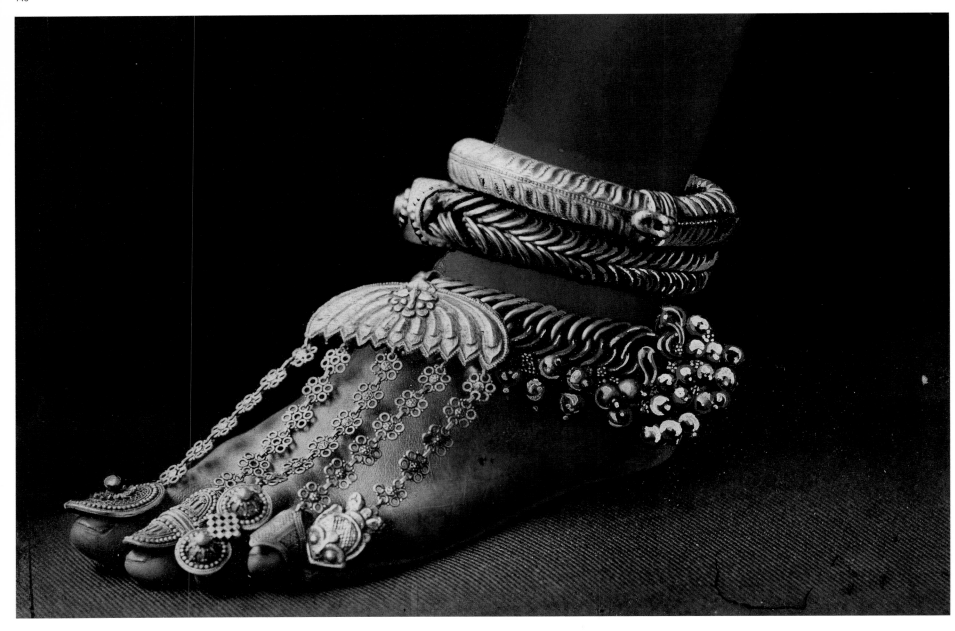

ELIZA R. SCIDMORE **INDIA** 1907

The silver bells, rings, bracelets, and chains that ornament the foot of
this Tamil girl serve no practical function, except, perhaps, to make
music as she walks.

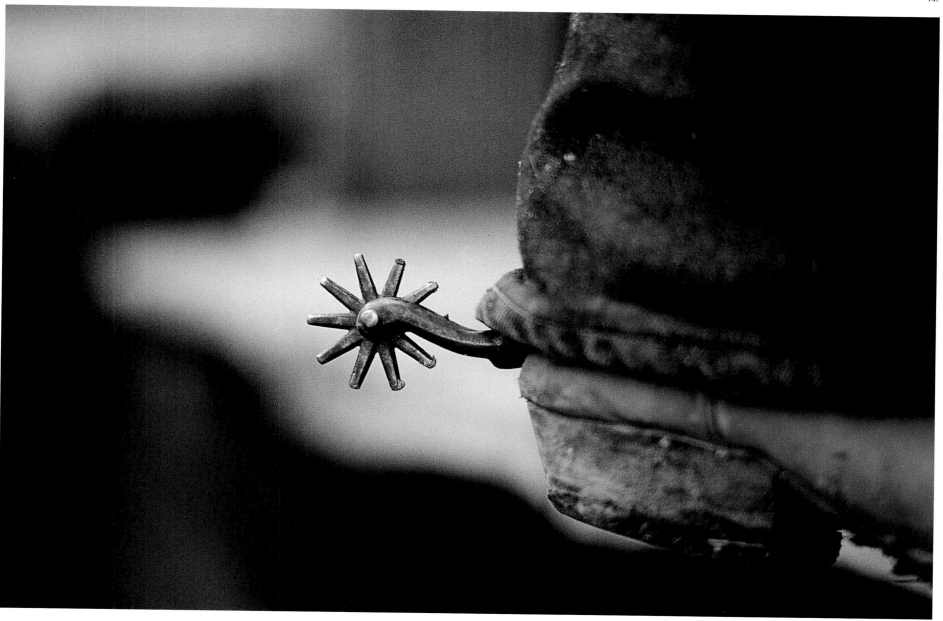

STEVE RAYMER **UNITED STATES** 1979

Decorative as well as functional, silver spurs enhance the boots
of a ranch hand on Alaska's lonely Kodiak Island, where cowboys and
cattle alike contend with cold weather and grizzlies.

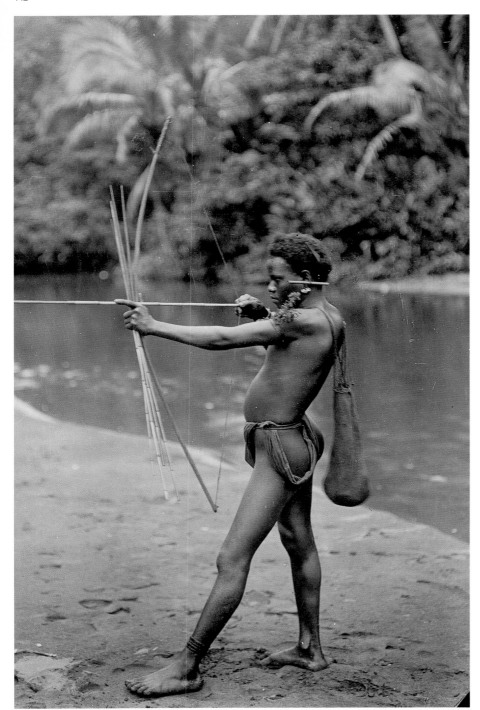

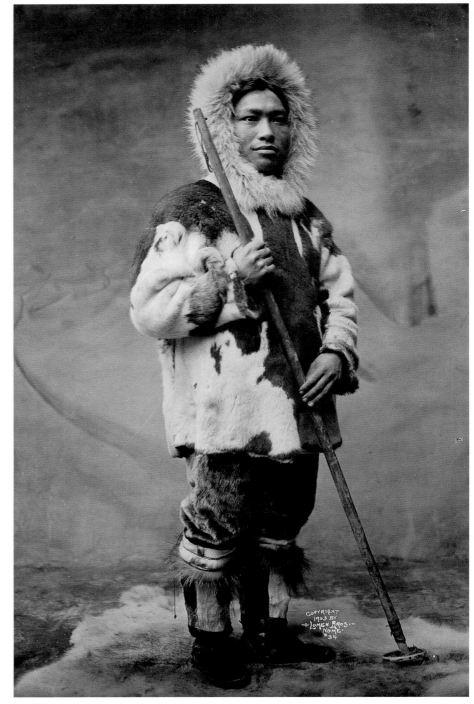

J.W. BEATTIE **SOLOMON ISLANDS** 1916

A Malaita Islander practices hunting skills. Pocketless, he carries his pipe, tobacco, and supply of betel nuts for chewing in a bag woven from plants. By slinging it backward around his neck, his aim is unencumbered.

CARL J. LOMEN **UNITED STATES** 1903

Furred from head to toe, Thommie Illayok demonstrates the art of staying warm in Alaska, where he worked for years as an interpreter on government ships. Daily he stuffed his fur-lined leather boots with moss or leaves to absorb moisture.

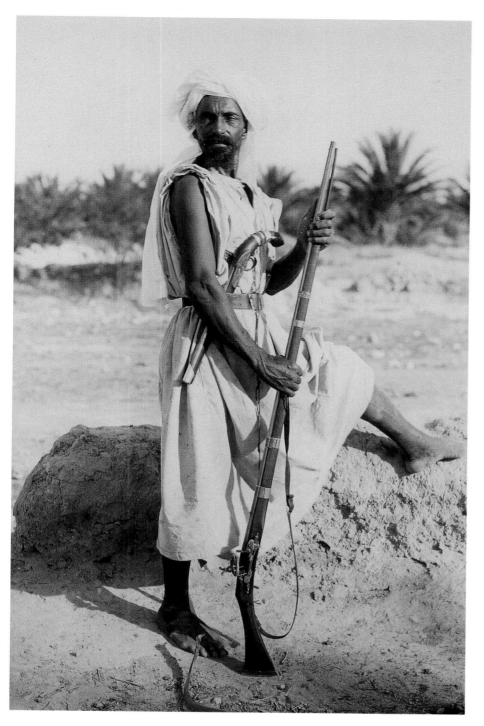

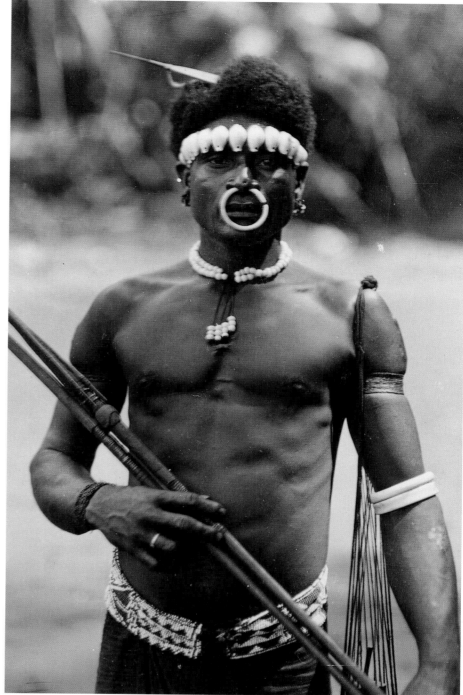

LEVASSEUR **ALGERIA** 1928

A belt doubles as a holster for a warrior from the Bou-Azid tribe in the Sahara. He wears no sandals, but a turban protects his head from the desert heat and shields his face during sandstorms.

J.W. BEATTIE **SOLOMON ISLANDS** 1916

A Malaita Islander displays his hunting spears and garb, including a cowrie-shell headband, a belt of shell money, and a nose ring and armbands cut from giant clamshells.

ROBERT REID **UNITED KINGDOM** 1928

/pages 144–145/ Fisherwomen pose on the beach at Banffshire, Scotland, in their work gear: kerchiefs, rubber boots, and waterproof aprons.

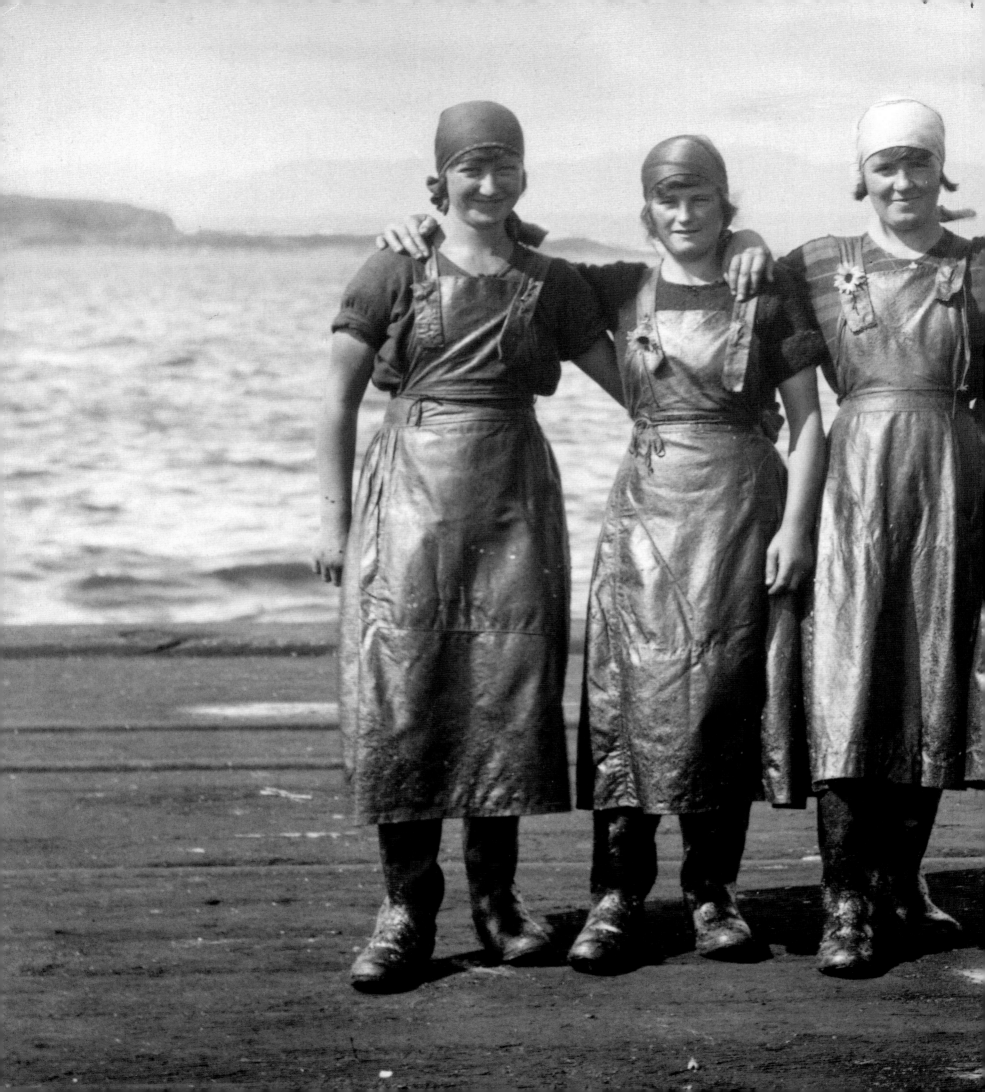

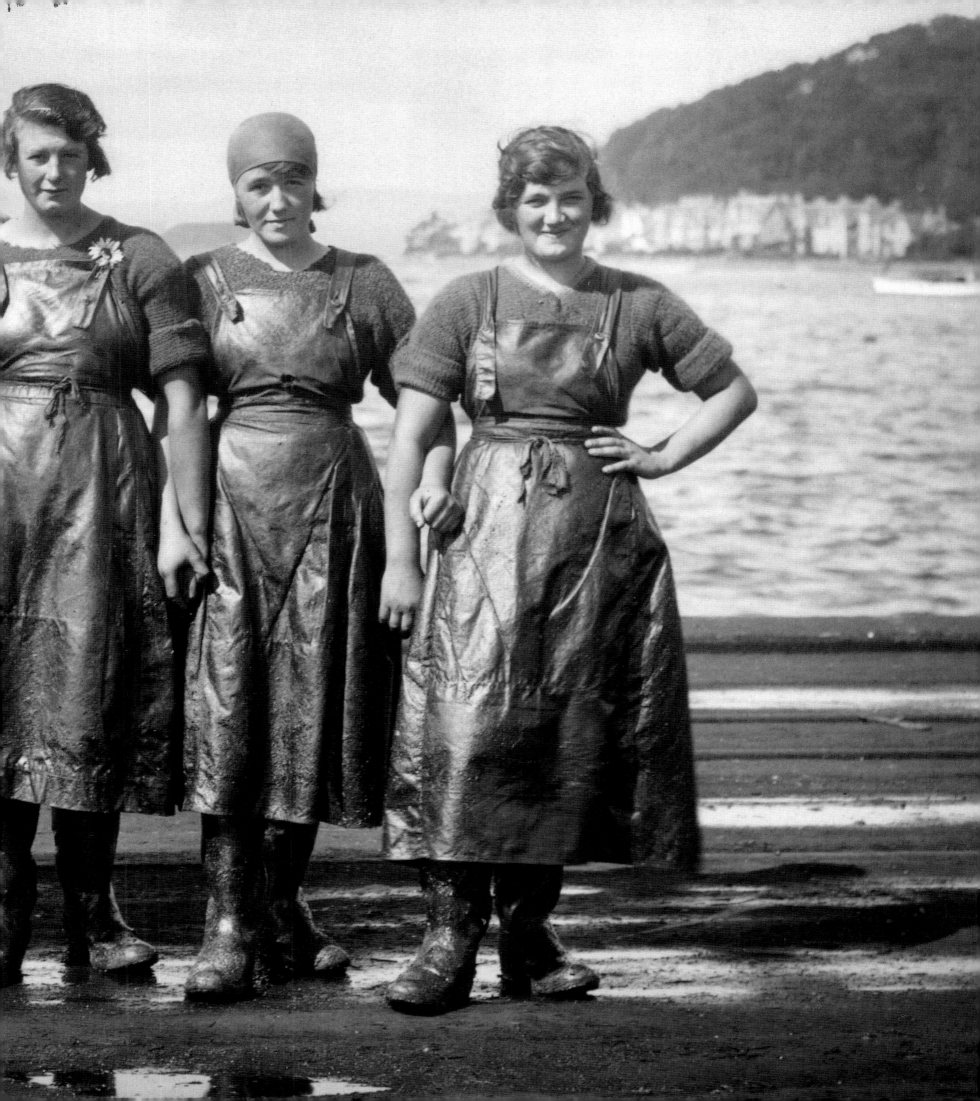

"THE FASHIONABLE WOMAN WEARS CLOTHES. THE CLOTHES DON'T WEAR HER."

MARY QUANT

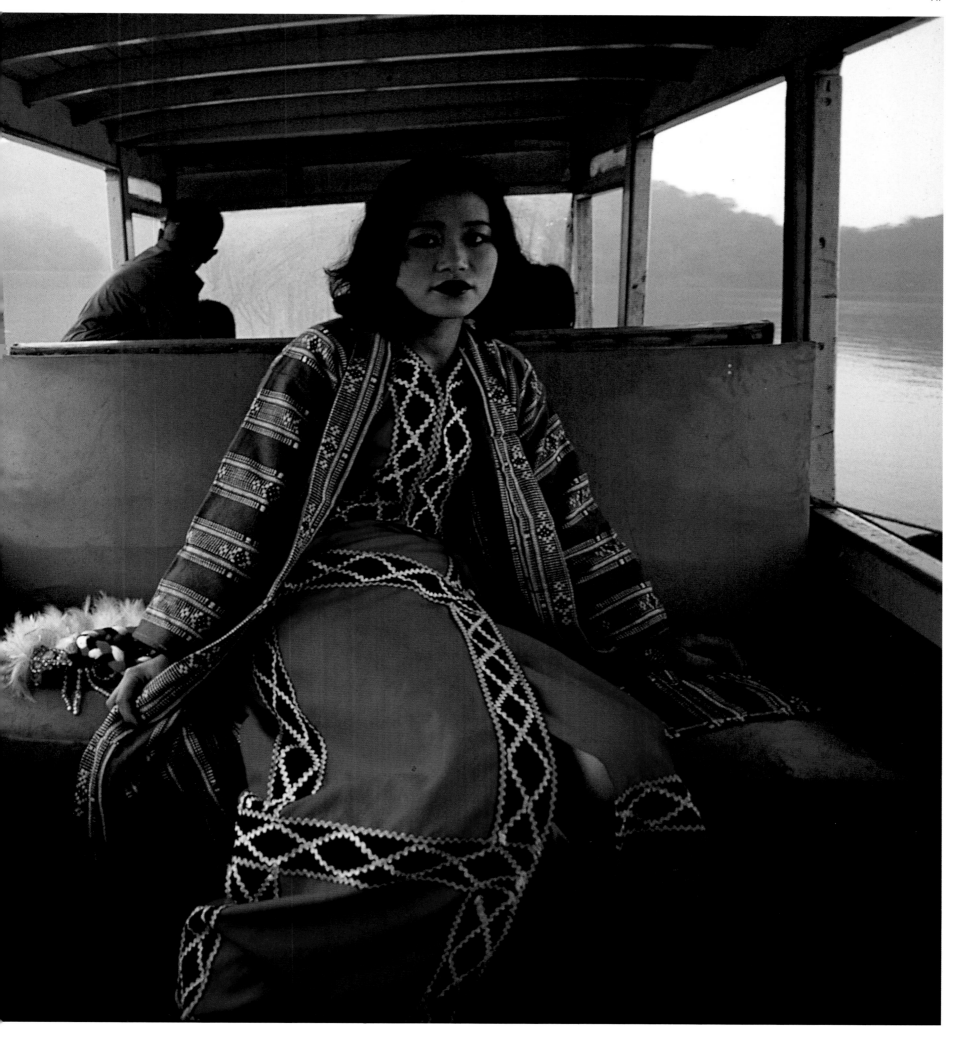

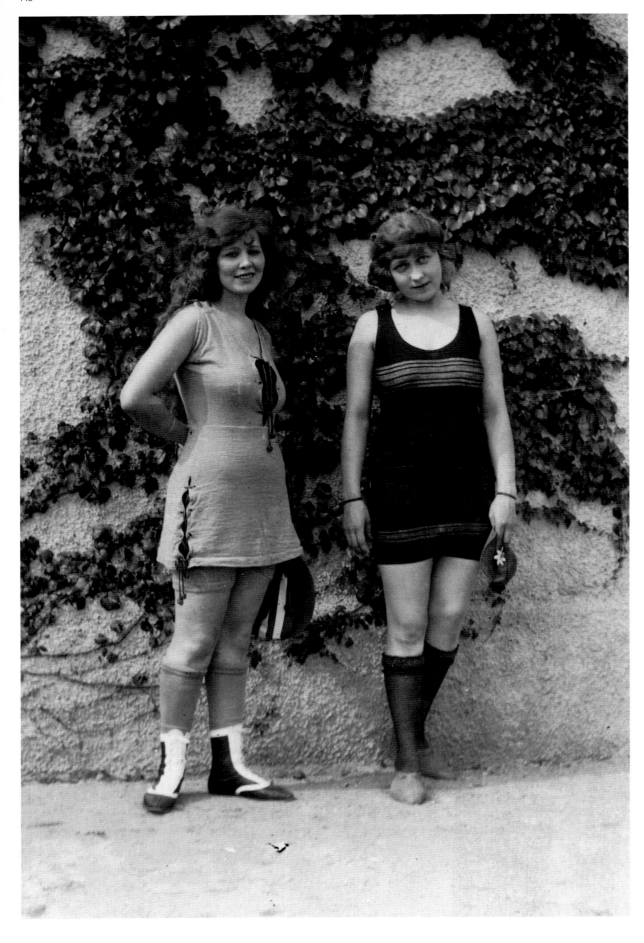

JOHN CHAO **TAIWAN** 1982

/pages 146-147/ After performing at a resort on Sun Moon Lake, a dancer relaxes on the return home. Her brilliantly decorated dress and jacket are typical of her people, the Atayal, one of nine tribes who inhabited Taiwan before the Chinese arrived.

MAYNARD OWEN WILLIAMS **UNITED STATES** 1922

Summer in Washington, D.C., finds the bathing beach at the Tidal Basin frequented by women in the latest swimwear. The styles fit snugly, making swimming—and a view of the female form—easy to achieve.

"ALL WOMEN'S DRESSES ARE MERELY VARIATIONS ON THE ETERNAL STRUGGLE BETWEEN THE ADMITTED DESIRE TO DRESS AND THE UNADMITTED DESIRE TO UNDRESS."

LIN YUTANG

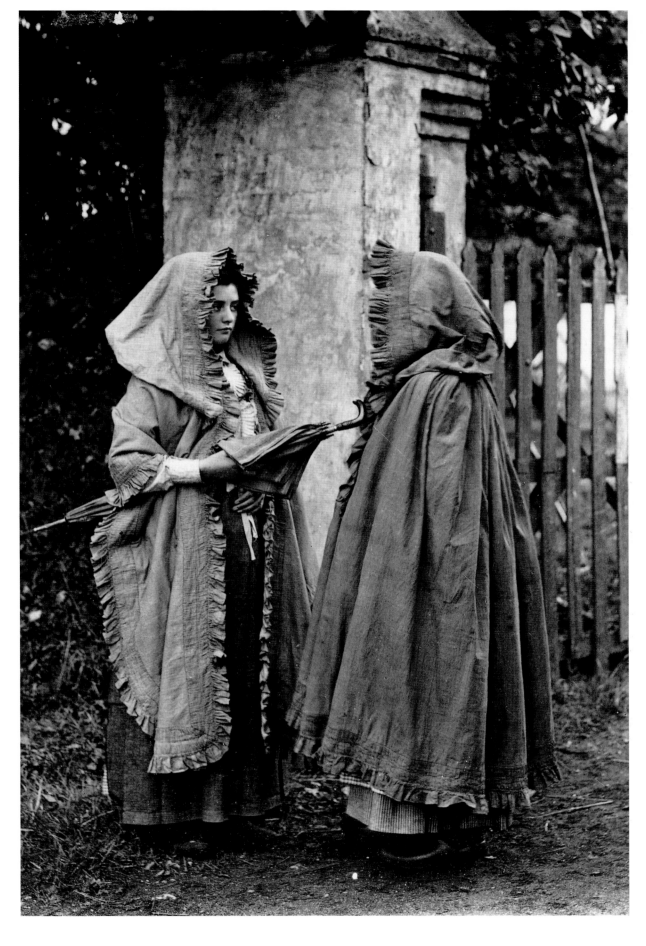

CRÉTÉ **FRANCE** 1920

Although the season is summer, young women of the Normandy countryside drape themselves in ruffled capes. The photographer traveled through France documenting the dress of the people.

WILLIAM ALBERT ALLARD **FRANCE** 1996

/page 150/ As if the subject of a painting, a young woman, her scarf echoing the colors of the curtains around her, strikes a pose before a window in Arles, the home of artist Vincent Van Gogh.

WILLIAM ALBERT ALLARD **PERU** 1995

/page 151/ A bullfighter since the age of 14, Ronald Azpur of Ayacucho, Peru, readies for a performance. His "suit of lights," is the age-old style of Spanish origin. He fights bulls only on occasion; his main occupation is raising and selling cattle.

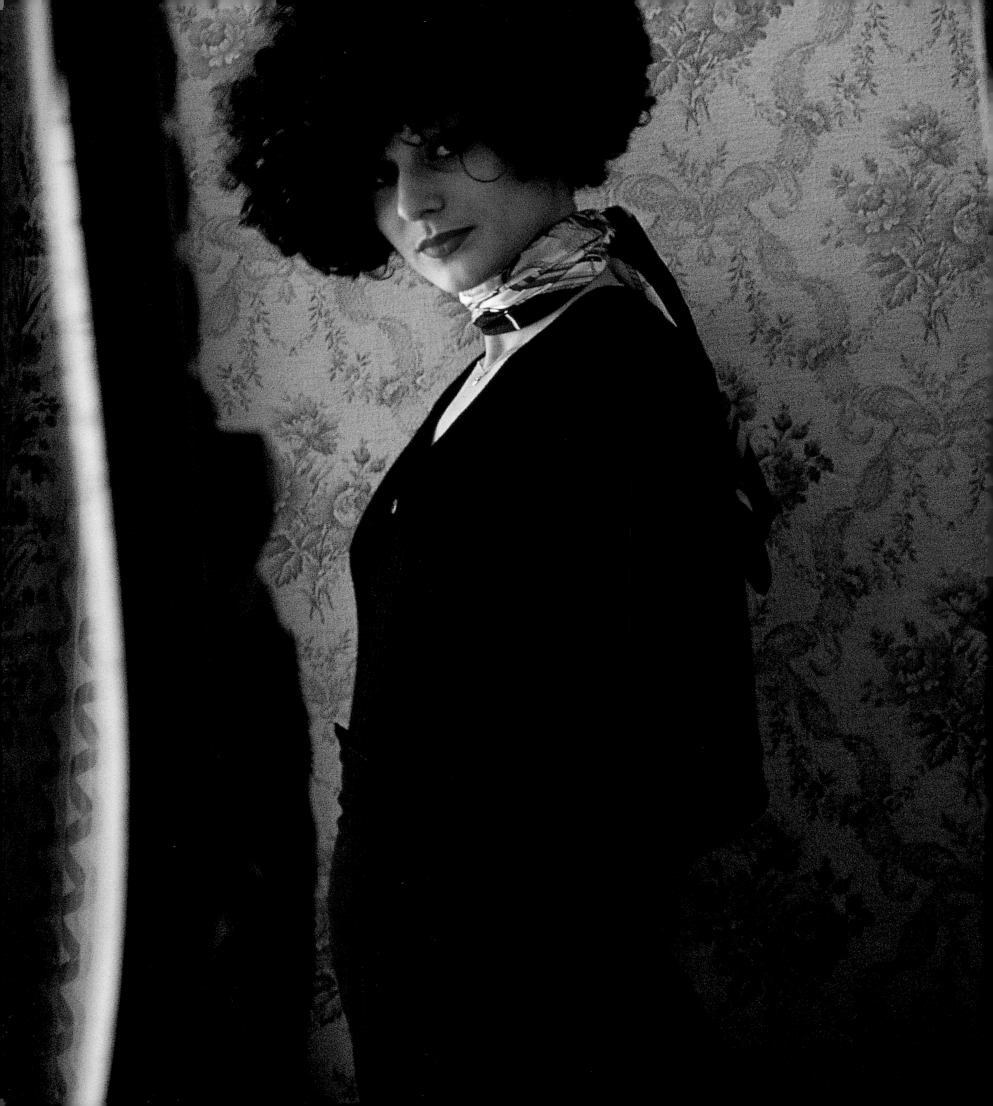

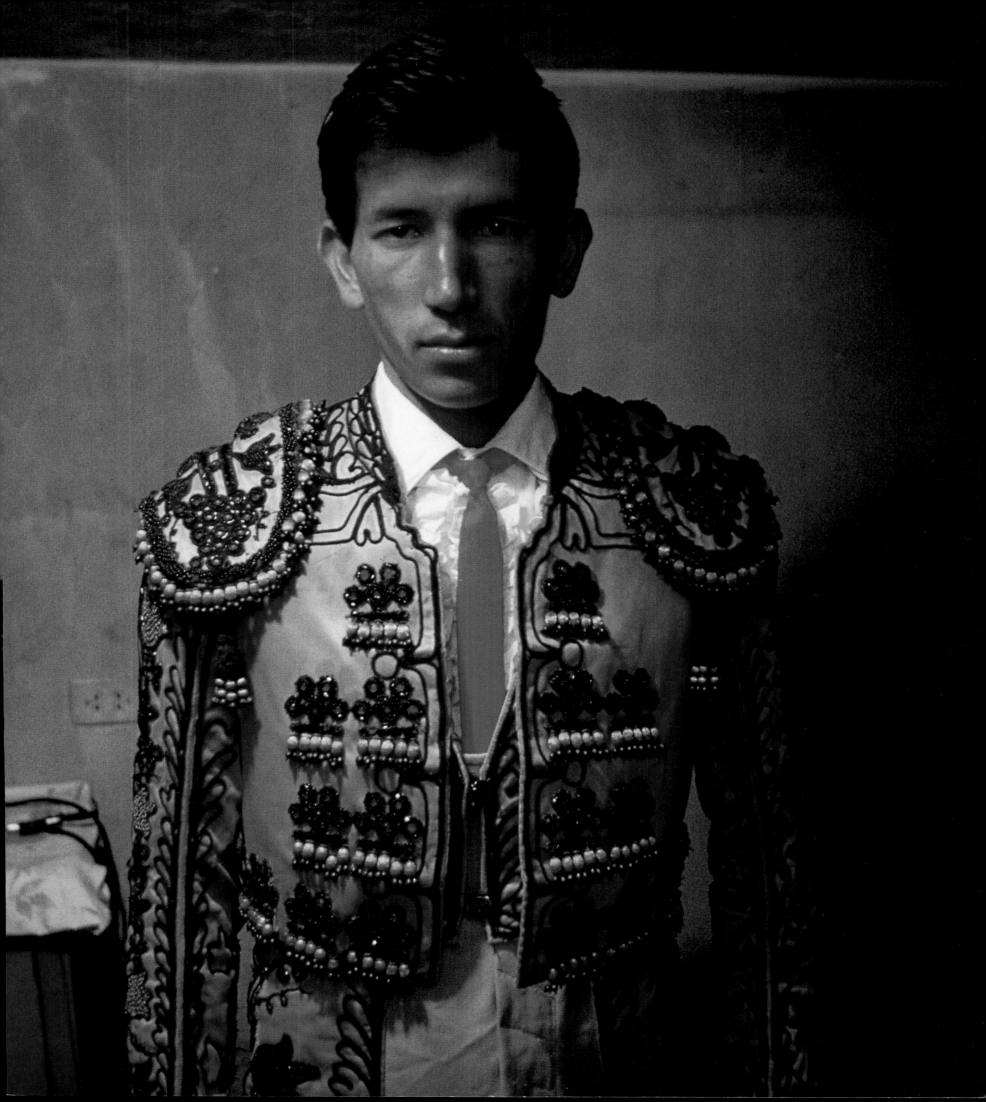

"MAN ADMIRES
AND OFTEN TRIES
TO EXAGGERATE
WHATEVER
CHARACTERISTICS
NATURE MAY
HAVE GIVEN HIM."

CHARLES DARWIN

WILLIAM ALBERT ALLARD **FRANCE** 1991

/page 152-153/ Matadors in Provence arrange their capes before the beginning of a *corrida,* or bullfight. The event starts with a procession across the arena, in which the fighters prepare to unfurl the capes to test the bull's movements.

THOMAS NEBBIA **MEXICO** 1977

Sombreroed and uniformed, the remaining members of Emiliano Zapata's revolutionary forces of the early 1900s come together for a photograph in 1977. The former guerillas grasp rifles and sling cartridge belts across their chests as in the old days.

JODI COBB **TAHITI** 1997

White straw hats and white dresses are de rigueur for women at Sunday services in Tahiti, where women and men sit separately.

RICHARD NOWITZ **UNITED STATES** 1991

/**page 156**/ Preserving the image of the Wild West, actors A. J. Kalanich (left) and Peter Walther dress as gun-toting cowboys in the tourist mecca of Nevada City, Montana, where they reenact its days as a boomtown.

E.C. ERDIS **PERU** 1912

/**page 157**/ National Geographic explorer Hiram Bingham pauses at Machu Picchu, the ancient Inca city he introduced to the world. From vest pockets for collecting to thorn- and insect-proof pants, his clothes were made for discovery.

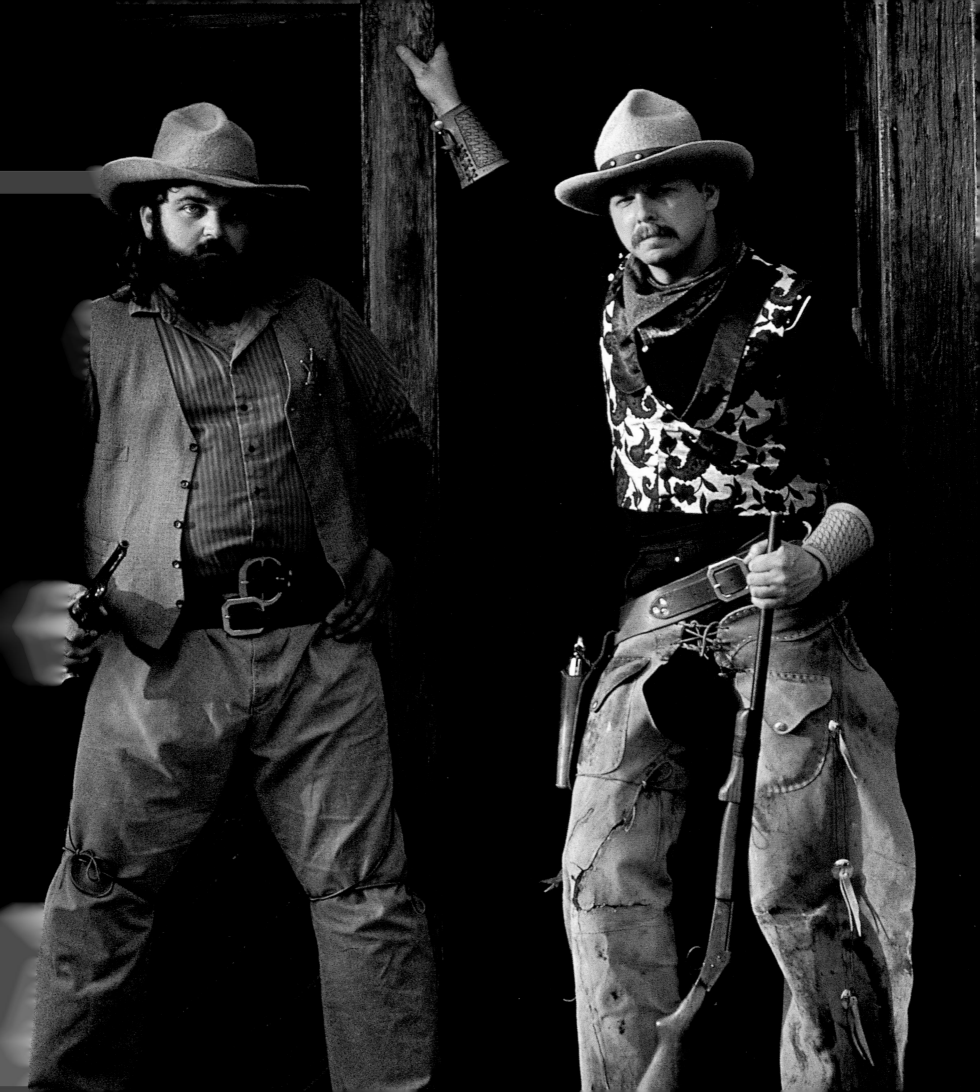

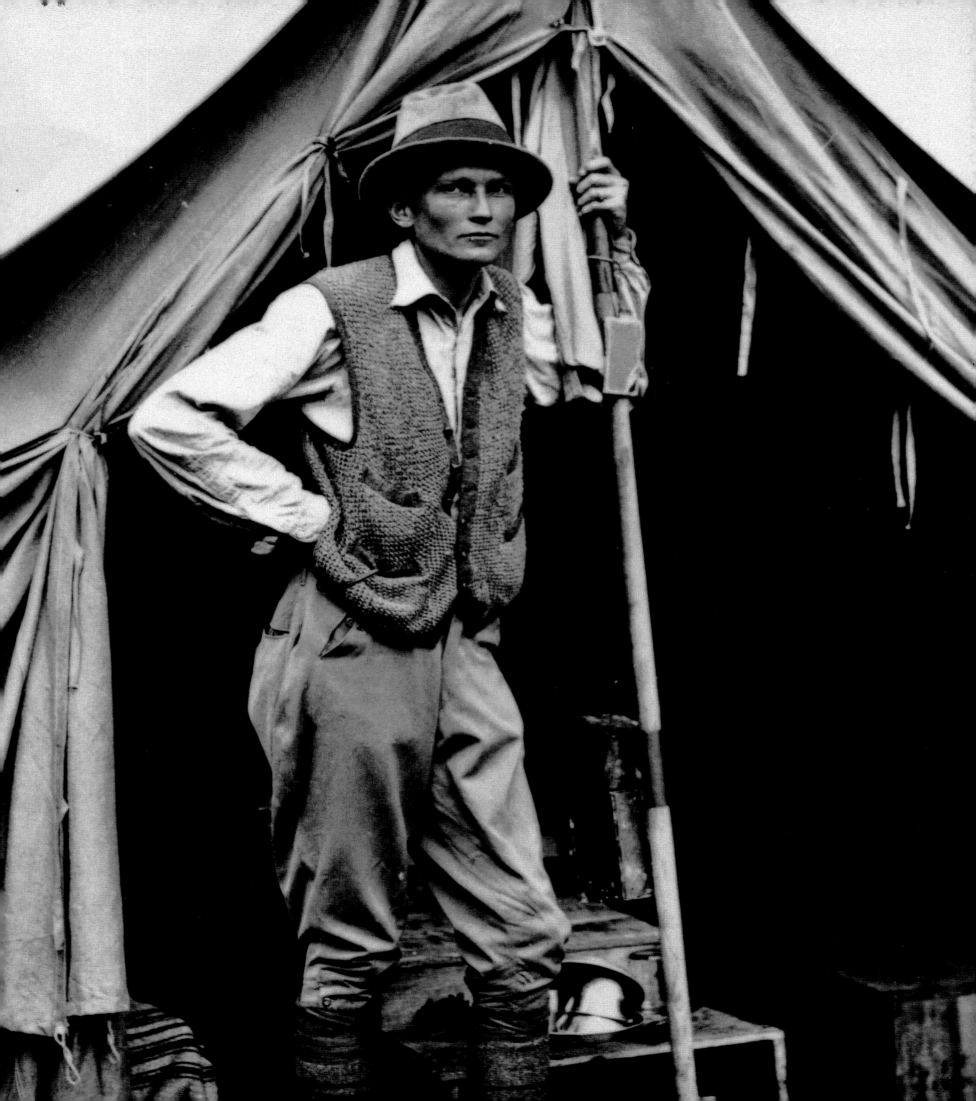

"I THINK THERE'S
SOMETHING
INCREDIBLY SEXY
ABOUT A WOMAN
WEARING HER
BOYFRIEND'S
T-SHIRT AND
UNDERWEAR."

CALVIN KLEIN

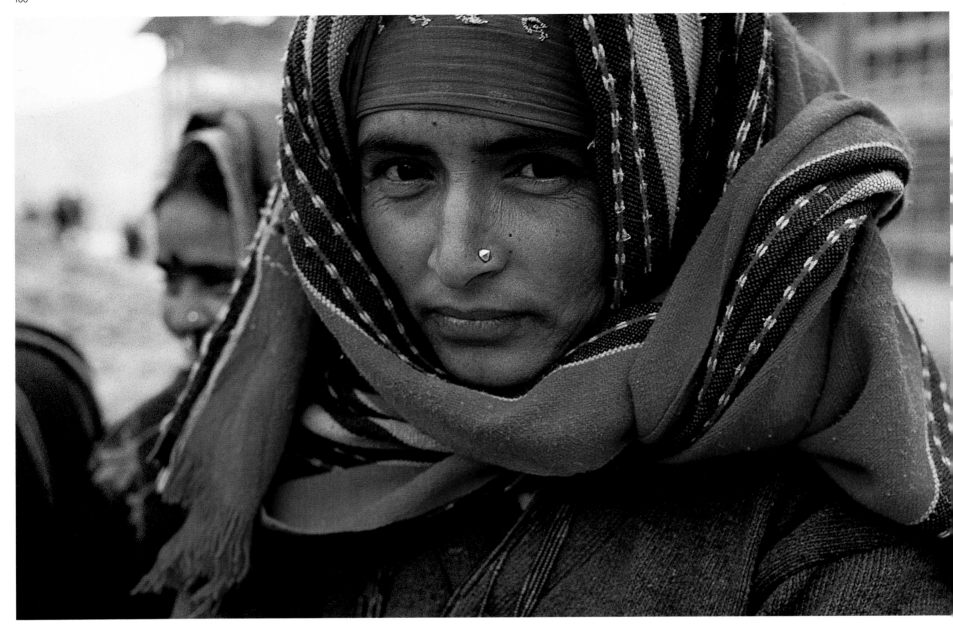

CLIFTON R. ADAMS **UNITED STATES** ca 1928

/pages 158–159/ On a dude ranch in Arizona guests gather at the water jar, or olla, for a drink. The woman at left wears Western-style chaps and cowboy boots; her partner wears the Eastern counterpart: jodhpurs and riding boots.

JAMES L. STANFIELD **BHUTAN** 1991

A woven scarf frames the face of a woman bundled against the cold in the kingdom of Bhutan, high in the Himalaya. A single gold nose stud offsets the simplicity of her dress.

FLIP SCHULKE **PERU** 1970

Bowlers have long been popular with women in the Andes, as with this resident of Puno, near Lake Titicaca. Her combination of bowler and bright scarf make a fashion statement that is as much about warmth as it is about style.

JAMES L. STANFIELD **PAKISTAN** 2000

GEORGE F. MOBLEY **PAKISTAN** 1985

/**top**/ Embroidery adorns the clothing of Nasreen Bibi and her class-
mates of the Kalash people in the remote Hindu Kush. They claim to
descend from the troops of Alexander the Great, and follow ancient
practices of worship, winemaking, and animal sacrifice.

Kalash dancers wearing headdresses of black cloth replete with
cowrie shells and buttons will perform during the autumn grape and
walnut harvest festival. Cowrie shells are rare and therefore prized in
the Hindu Kush mountains.

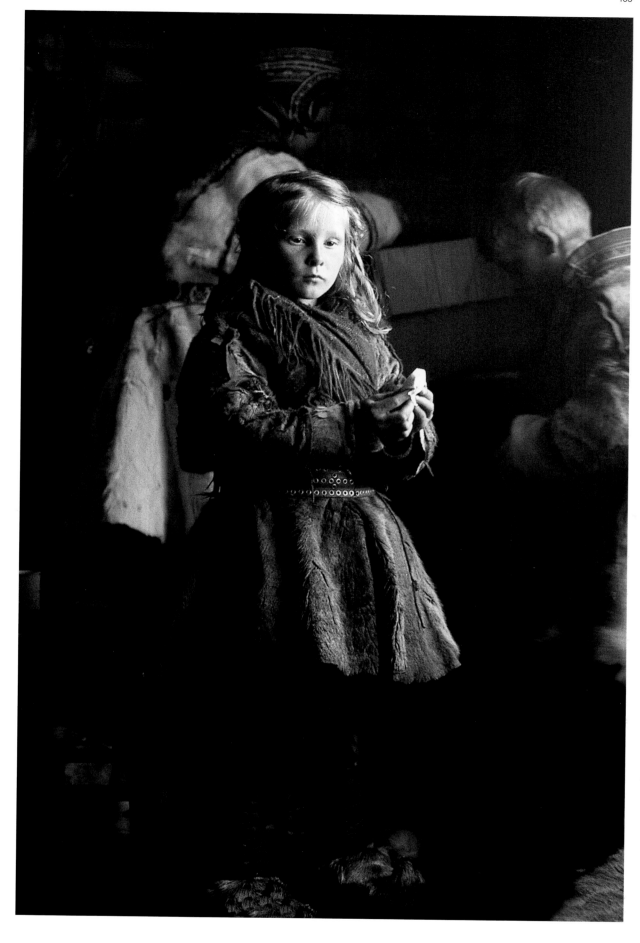

GEORGE F. MOBLEY **NORWAY** 1967

JODI COBB **ETHIOPIA** 1998

To stay warm, even indoors, a Sami girl wears a reindeer coat, leggings, leather shoes, and a fringed woolen shawl. People in cold climates tend to wear clothing made of animal skins, while warm-weather dwellers make clothes mainly from plants.

/**pages 164-165**/ To enhance her appearance, a Hamar woman has rubbed her skin and hair with cowfat and ocher—the cosmetics of her region. Below her tightly-coiled hair, beads and cowrie shells lace her neck; a gourd carries her lunch.

"THAT'S WHAT
THE RUNWAY IS—
IT'S SIMPLY AN
EXTENSION OF
THE IDEA OF THE
TRADER COMING
INTO TOWN."

ELIZABETH ANN COLEMAN

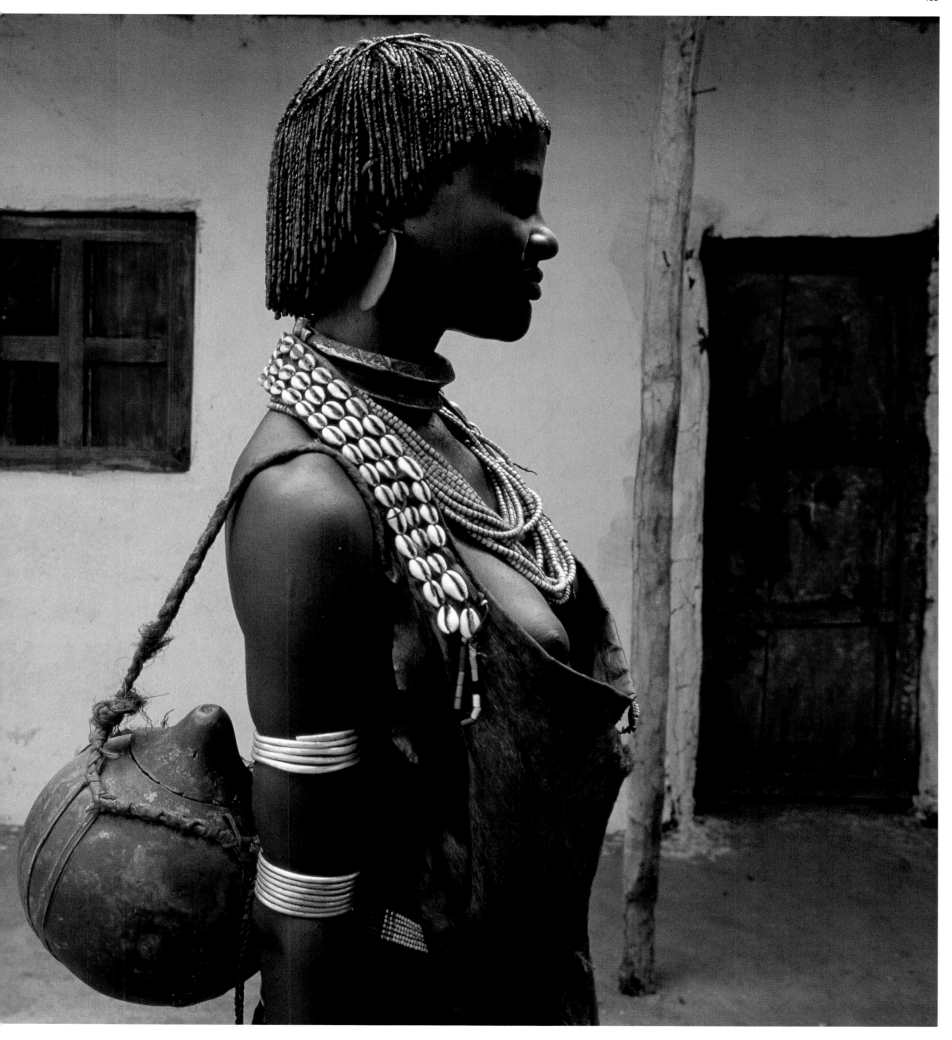

"WHAT ONE IS,
IS NOTHING.
WHAT ONE
SEEMS TO BE,
IS EVERYTHING."

JEAN-JACQUES ROUSSEAU

CHAPTER 3 **TRANSFORMATIONS**

Iya is the adopted daughter of my friend Cynthia, and when Iya was three years old, her grandmother gave her a pink tutu. The combination of a little girl and a pink tutu is enchanting under any circumstance, but this was particularly special, and to understand why you must first know that Iya spent her earliest years in an orphanage in Irkutsk, Siberia. The orphanage was the darkest shade of grim, a place of emotional and physical deprivation. Iya knew little of joy or security or how it felt to be taken care of, and least of all anything about ballet or ballerinas.

The experience left scars not easily erased. Iya, understandably, is not an easy child. Yet, when she put on the cotton-candy-pink circle of tulle, all that evaporated. Lifting the tutu with both hands, she instantly twirled the length of the room with weightless ease and a sureness of self that suggested she had been doing pirouettes all her life. That was more than eight years ago. Iya has long since outgrown the tutu, but it remains a family heirloom. "Something that special I could never throw out," Cynthia says.

Let us speak of the magic of fashion. At its best, adornment celebrates. From the Txikão warrior in Brazil painted in jaguar-like spots to Madonna in her metal bra, humanity revels in the chance to shed its everyday skin and parade as a more powerful, sexy, or, like Iya, joyful being. Men who might ordinarily dismiss the importance of dress are not immune to its power. Boots, the American World War II General George S. Patton observed, can turn an ordinary soldier into a warrior.

All cultures tap into the power, real or imagined, of dress. Slavic tradition holds that wearing a pair of felt boots cures a hangover by allowing the victim to sweat out the effects of over-indulgence. American brides wear something old, something new, something borrowed, something blue to invoke the gods of Happy-Ever-After. The 19th-century Mandan war chief Máto-Tópe wore a necklace made of bear claws as testimony to his courage and the fact that few men were brave enough to hunt the ferocious grizzly. The Queen of England's jeweled crown has its counterpart in the bird-of-paradise feather headdress of a Minj tribesman in Papua New Guinea. So, too, Masai kings and Maya shamans draped themselves in lion and jaguar skin so they might be filled with the spirit of the most sovereign animal in the forest.

In its most powerful guise, fashion has little to do with the practical and much to do with the mystical. In the fairy-tale realm of fantasy and the dream-come-true, clothes can be sheer magic or, at the very least, cause magic to happen. Cinderella's glass slipper served as indisputable proof to Prince Charming that she was the one. Hans Christian Andersen's "Red Shoes" worked a more malevolent charm: his heroine danced herself to death. Superman's red cape and blue leotard, the ultimate power suit, was as indestructible as the Man of Steel himself. And on the fifth floor of the National Museum of American History in Washington, D.C., there is, in a glass case between Michael Jordan's basketball jersey and Minnie Pearl's flowered hat, the ruby slippers that Judy Garland wore as Dorothy in the MGM movie *The Wizard of Oz*. The shoes, which have molted a few sequins, are less ruby-hued and closer to the color of a pack of Big Red cinnamon chewing gum. In the matter of color, style, and shape, as in much else, Hollywood invoked the rule of poetic license. The slippers in L. Frank Baum's book were silver. But silver couldn't do justice to the glory of MGM's new Technicolor process, so the shoes were decorated with 2,300 sequins in camera-ready red.

Clothing can turn us into someone we are not, which is exactly what Hollywood costume designers are paid to do. "I'm a magician, not a designer," Edith Head, costumer to the movie stars, once said. "I can make a woman into anything with my clothes. I can show her how to become a star, catch a rich husband, or get Cary Grant. What I do is a mix of camouflage and magic— the illusion of changing actors into what they are not."

The transformational nature of what we put on can work for better or for worse. Military camouflage can turn an infantryman into a bit of rock or vegetation, a potentially life-preserving deception. In the Old Testament, smooth-skinned Jacob tricked his hirsute brother Esau out of their father Isaac's blessing by wearing the skin of a goat. As intended, Isaac, nearly blind, mistook the goat's rough pelt for Esau's skin. Mascara, used by women to thicken their eyelashes and make them appear longer than they are, comes from the Portuguese word for mask: semantic evidence that looks can deceive.

"I wear jewelry according to my mood," an elegant woman from Jordan tells me. "If I have a meeting to go to I always wear my blue stone." She shows me a small piece of turquoise set in a frame and hung from a silver chain. "It keeps the evil eye away. And when I am going to see_____." —and here she names a high-level bureaucrat she deals with—"I wear a very large blue stone."

Such belief in the power of an ornament is not unlike that of the Dominican friar who, by fingering his rosary, makes prayer his weapon of choice in spiritual battle. The beads are worn on his left side where a knight would have kept his sword. Chhotalal Salvi, a sari maker in Patan, India, has a different talisman. "Silk is the holy cloth. It is what you wear if you want

to touch God," he told Nina Hyde, the fashion writer who wrote about the queen of textiles in NATIONAL GEOGRAPHIC in 1984.

Does God care about clothes? Are there closets in heaven? When an earthquake hit Naples in 1930, several members of the Roman Catholic clergy unhesitatingly suggested that the disaster was "a scourge brandished by the merciful hand of the Almighty" and a divine corrective provoked by "moral disorders and, in particular, shameful fashions."

"All clothing is costume," Katharine Hamnett tells me. Hamnett is a British designer who is known, among other things, for turning clothes into political statements. She was one of the first designers to put slogans on T-shirts and there is a famous photograph of her taken in 1984 with Margaret Thatcher during the Iron Lady's tenure as Prime Minister. Hamnett is wearing white sneakers and a knee-length T-shirt emblazoned with "58 per cent Say No to Pershing missiles," a reference to the controversy then raging against the planned deployment of 166 cruise missiles in Great Britain. "At last, an original," Thatcher was quoted as saying in sporting response.

Hamnett's remark comes up in the context of an interview I'm conducting with her in the kitchen of her home in north London. "The big influence for many British designers was surely the dressing-up box they played with as children," she tells me. "Every home had one." The dressing-up box, she explains, is where old dresses, shoes, hats, even velvet curtains ended up. Children could dress as kings and queens or anything else they could imagine.

"We were encouraged to play with clothing from a very early age," Hamnett remembers. "It was a very liberating influence.

Anything you found was fair game. I discovered my great aunt's leopard coat in the attic, claimed it for the dressing box, and cut off a sleeve to make a quiver. She wasn't exactly pleased."

Dress-up games are not the exclusive property of children. Adults play, too. "A few years ago I bought a Chanel suit," Hamnett says, with a wry smile. "I wore it with irony. It was a *statement*. I fell in love with that suit. I would wear it five days in a row. But I could feel myself becoming someone I was not. I could feel it take over." She clutches her throat. "I was becoming a monster." She pauses for me to absorb this, then says: "I threw it away."

So, too, in gentler ways, we transform ourselves when we put on a prom dress, a wedding gown, a mourning suit. We dress to connect with the parade of humanity and the passage of time. We dress to honor the occasion, much as an Asante woman in Ghana wears a particular hairstyle to honor a daughter who has given birth or a Japanese woman puts on the traditional white kimono for her wedding. We dress to say: *Look at me! This is a moment that matters.*

"We are always being offered wedding dresses," sighs Shelly Foote. Foote is a curator in the Department of Textiles and Costume at the National Museum of American History in Washington, D.C. And there is good cause why this is so. Unlike housedresses, wedding dresses are the only garment everyone saves—to be carefully packed away out of sentiment, or, in some instances, to be worn from generation to generation. (In St. Paul, the Goldstein Museum has a wedding dress that was worn 14 times before a niece decided enough was enough and arranged the donation.)

I am trailing behind Foote as she makes her plaintive comment about the over-abundance of wedding dress donors because there is one particular gown in the museum's collection that was accepted and that I am eager to see. The dress is not particularly fancy or unusual. It is, in fact, modest and ordinary, except for the material. It is the dress worn by Ruth Lengel of Neffs, Pennsylvania, at her wedding to Captain Claude Hensinger on July 19, 1947, and it was sewn from the parachute that saved his life when, returning from a bombing raid over Japan, his B-29 caught fire and he bailed out. The dress is ivory-white with a lace bodice, long sleeves, and a shirred skirt and train. If you look closely near the hem at the back of the dress you will see a small brown smudge which is a bloodstain because Captain Hensinger landed on rocks and injured his knees.

Fortunately, he landed in China, on friendly territory. Captain Hensinger kept his chute and after he returned to base, folded it in a box and sent it to his mother.

"We knew each other from church," Ruth Hensinger says, when I ask how they'd met. "He was tall and handsome with brown hair and blue eyes and we got along well. He never proposed. He just handed me the box with the parachute and said something like, 'Maybe you could make a wedding dress from this.'"

They were married in the same church where they had met. The groom, in the time-honored tradition of the era, wore a tuxedo; the bride wore a wedding dress made from the fabric of the parachute that had saved her husband's life. Although it rained incessantly that summer, that day the sun shone. "Rain wouldn't have mattered anyway, since the dress was made of nylon," she says.

Afterwards, the dress was packed in tissue, then, in later years, unpacked, to be worn by their daughter and daughter-in-law at their weddings. "There's still a lot of parachute material left," she says. "In fact, there's enough for another wedding dress, but I think I'll give the remaining fabric to my grandsons. It would make a great tent."

Does fashion matter? "Always—though not quite as much after death," quips show business personality Joan Rivers. But death has its own rules of dress, and it matters a great deal. "Hung be the heavens with black: yield day to night," writes Shakespeare. In western cultures, we show our grief by wearing black. In India, white is the color of mourning.

White also became the color of mourning for Joan Rivers when her husband, Edgar Rosenberg, overwhelmed by poor health and depression, swallowed an overdose of Valium and died. "It was August when my husband killed himself," Rivers said by phone from her townhouse in New York City, recalling the tragedy of 14 years ago. "I wore white to mark my mourning. After all, white is the absence of color as much as black. I knew I was in mourning and no one else did and no one else needed to know. I didn't have to explain or get in a discussion with anyone. It was just easier. Also, I love to wear black and didn't want to associate it with death."

The conversation drifts to happier associations. She recalls the embroidered dresses her daughter Melissa wore as a baby. "They're such tiny, tiny things," she says, wistfully of the outfits that she keeps in a box. "I think they must be a size two. You look at these clothes; they are so innocent and you wonder what happened to the child who wore them." She remembers the first high-heel shoes she ever owned, a pair of blue suede pumps, and she mentions her mother's brown pocketbook. It's stored in her closet, and every so often she opens it, and a whiff of fragrance conjures her mother's presence in the room.

In the background I hear a small dog yipping. It's about nine o'clock in the morning, and it seems logical to ask Rivers what she happens to be wearing at this moment.

"I'm in an old pink *schmatte*," she says, using the Yiddish word for rag. "It's a robe with a hideous zipper up the front, and I bought it for my honeymoon. Certain things you don't give up."

There is a tenderness to clothes once worn by the dead. Marie-José Lepicard, a French journalist who covers fashion for television, remembers a tiny tunic on display in a Paris museum. It belonged to a prince of some ancient Mediterranean empire, and the prince, who must have been about five years old, had been sent to war in spite of his age. "The garment had been torn and then mended," Lepicard said. "You see, it had been *worn*."

There is unbearable poignancy to the thought of the torn tunic of a five-year-old prince sent off to war, and as she speaks, I think of the unutterably sad ritual of clearing out a closet after a death in the family.

"Max's slippers are in the closet. They still bear the shape of his feet," the wife of a friend wrote me after his death. I was very fond of the man, a well-known allergist in Chicago, and the thought of his brown leather slippers sitting on the closet floor until they would be thrown out or given away filled me with sorrow.

"I remember cleaning out my mother's closet after she died," my friend Mary Jane tells me. "I cried and cried. Ultimately, I kept a couple of things: a beige cardigan of my dad's and a fire-engine red, soft-wool jacket of my mother's. When I wear either one I have a real sense of closeness to them. It is like being hugged. I wear those pieces on cold, gloomy days, when I need something to give me a lift. And they do."

"The garments of the deceased are the nearest things to them," says Valerie Mendes of the Victoria and Albert Museum. "As a dress curator one of the hardest elements of my job is to visit the bereaved and deal with the wardrobes of their loved ones. I well remember one occasion when my assistant, the widower, and myself were all in tears and could hardly see the designer clothes for weeping.

"One of the most poignant features of dealing with clothes that glamorous people have lived in is to catch a waft of expensive perfume when we open one of our storage units, which remains in spite of all that careful museum cleaning."

In dressing to honor the dead, we literally wear our sorrow on our sleeve. These days, the rules have relaxed, but for the Victorians, mourning was a head-to-toe, morning-noon-and-night affair. The well-dressed widow, *Colliers Cyclopedia* pronounced in 1901, should have—among other things—four pairs of black hose, one black, stiff petticoat, a pair of black kid gloves, a parasol deeply trimmed with crepe, and several dozen handkerchiefs bordered in black, the width of the border corresponding to the degree of mourning. In the Museum of American History, Shelly Foote shows me a late 19th-century nightgown dyed black. "I've never seen another like it," she says, unwrapping it from a blanket of tissue paper to show me.

"This woman, whoever she was, felt she had to be dressed in mourning even as she slept."

The beginning of all wisdom is to look fixedly on clothes...till they become transparent," wrote the Victorian essayist Thomas Carlyle in *Sartor Resartus*. Written as satire, *Sartor Resartus*, or *The Tailor Retailored* is actually a spiritual inquiry masquerading as a history of clothing. The fiber Carlyle worried most about was not silk or cotton or wool, but man's moral fiber. In the war between the spiritual and the material, the metaphor of appearance as superficial comes easily to the pen and lips.

"Ordinary clothes seem to drag at all the lofty aspirations of man and at all his finer feelings. They seem to interrupt man's relations with the infinite," writes Anne Hollander, an art historian, who speaks of what she calls the mental indigestibility of taking clothing seriously. We soothe ourselves with clichés. "Pretty is as pretty does," we sigh. "You can't judge a book by its cover," we cluck. But we can and do, and with good reason: How we dress and how we decorate ourselves often really does signal who we are. The dressed state, Hollander tells us, is the best emblem of corporeal existence. "Clothes," she says, "stand for knowledge and language, art and love, time and death—the creative, struggling state of man." Looks deceive, but sometimes what you see is what you see.

Clothes not only make the man; often they *are* the man. But there is another side to fashion that goes beyond a statement of who we are and how much money we have, and it has to do with the pink tutu factor. It has to do with watching a child put on a ballerina skirt and lightly twirl across the room—and it is a magic of the highest order.

One day I open a large envelope with a Paris postmark and out spill a dozen drawings of oval, stylized faces with glyph-like markings. They are from Serge Lutens, a French designer of cosmetics I know and admire. They are drawings he has made of tattoos worn by Berber women who live in the North African desert. The patterns are intricate and decorative, but more than that, they are believed by the wearer to be protective against the forces of evil. I have asked Lutens, a player in the world of fashion, to give me some examples of adornment he has found inspiring or powerful, and he has sent these sketches in response.

Lutens, a cosmetics designer, perfumer, and photographer, understands the magic of self-adornment and decoration better than most. He owns a home in Marrakech, where he became infatuated with the enigmatic tattoos worn by Berber women. He drew them. He photographed them. He began to redesign them, as if by doing so he could deconstruct and understand their primitive power.

"What did you feel when you saw these patterns for the first time?" I ask.

"I don't really know," he answers. "They seemed familiar to me as if they were always inside my memory. They seemed like poetic architecture and writing at the same time; as if they were an indelible alphabet that reflected the dignity of the women who bear them. I would not ask anything more than to admire their beauty."

Fashion is about beauty but it is also about who we are, as well as who we want to be, as well as who we may be in the process of becoming. The transformations engendered by dress range from the trivial to the profound. There are African masks and costumes so powerful they obliterate the wearer's personality and change the wearer into another being entirely. "The man—and it is usually a man—in the ceremonial mask has a spiritual mission," says Herbert M. Cole, Professor of the History of Art at the University of California at Santa Barbara. "The mask allows the superimposition of a completely new character." The ceremonial mask, he suggests, allows the wearer to truly say: "I am not myself."

In our own culture there is the first pair of high-heel shoes that marks the transformation from girl to young woman. There is the first tie and jacket that marks the transformation from boy to young man. There is also the expensive and permanent transformation that is the work of a plastic surgeon. "Body alterations are the makeup of the 21st century," a woman in the fashion industry tells me. "Makeup can only carry you so far." We lift brows, chins, breasts, and jowls as easily as one might lift a sagging hem. The quest for perfection spans centuries and continents. We have been cinching our waists in, pushing our breasts up, padding our shoulders and hips, and increasing our height with elevator shoes since antiquity.

Though self-improvement can spill over into obsession, the desire to dress to look beautiful, powerful, or different is an instinct that binds us all. It can be rooted in ceremonial tradition or it can be sheer self-indulgent pleasure, and there is nothing wrong with any of it.

"It's fun to reinvent yourself," says Ann Marie Gardner, an editor at W magazine, "as long as you don't take it too seriously. Think of the tribesmen in New Guinea in paint and feathers. It's mys-

tical. It's a transformation. That's what we are doing when we go to a salon. We are transforming ourselves."

For the last decade of her life, my grandmother Mollie Spier lived in a condominium in Hallandale, Florida. She dressed elegantly, even if she had nowhere to go but one floor down to a neighbor's apartment for a game of mah-jongg. She kept a "standing," a regular appointment at the beauty salon down the street. Every Friday she would drive, then later be driven, for a shampoo, set, and manicure.

Finally, a few months after turning 100, she confronted her frailty and agreed to move to a nursing home and away from her Friday appointment.

A month before she died, I went to visit. Before I did, I called to ask if she wanted me to make an appointment for her at the salon.

"I could drive you, Grandma. We could take your nurse and wheelchair. Do you think you could handle it?"

"Of course," she replied as if I'd asked the silliest question in the world. "What's the big deal? All I have to do is sit there and let them take care of me."

On a Friday afternoon I picked my grandmother up at the nursing home and drove her to the salon she hadn't visited in more than a year. She insisted the nurses dress her smartly. She wore a pair of crisp white slacks, a bright-red flowered silk blouse, white sandals with wedge-shaped cork soles, and carried a red straw handbag. We drove to the salon and I wheeled her in. Luis, her favorite hairdresser, swept her out of her

wheelchair and onto the salon chair where he washed and combed her fine pewter-gray hair into swirls before settling a fog of hair spray over her head.

When he was finished, Yolanda the manicurist appeared. "Mollie, what color would you like your nails?"

"What's new this year? I want something no one else has," she shot back, as if in impossibly fast company at the Miami Jewish Home for the Aged.

Afterward I drove my grandmother back to the nursing home. She admired her fire-engine-red nails every quarter mile. Glancing in the car mirror, she patted her cloud of curls and radiated happiness.

"Mollie," said the nurse behind the desk when I brought her back. "You look absolutely beautiful."

CHRIS JOHNS **SOUTH AFRICA** 1996
/**page 174**/ A Zulu woman reddens her lips with the help of a small mirror.

CHRIS JOHNS **JAPAN** 1987
/**page 175**/ A geisha-in-training works to eat without touching her lips.

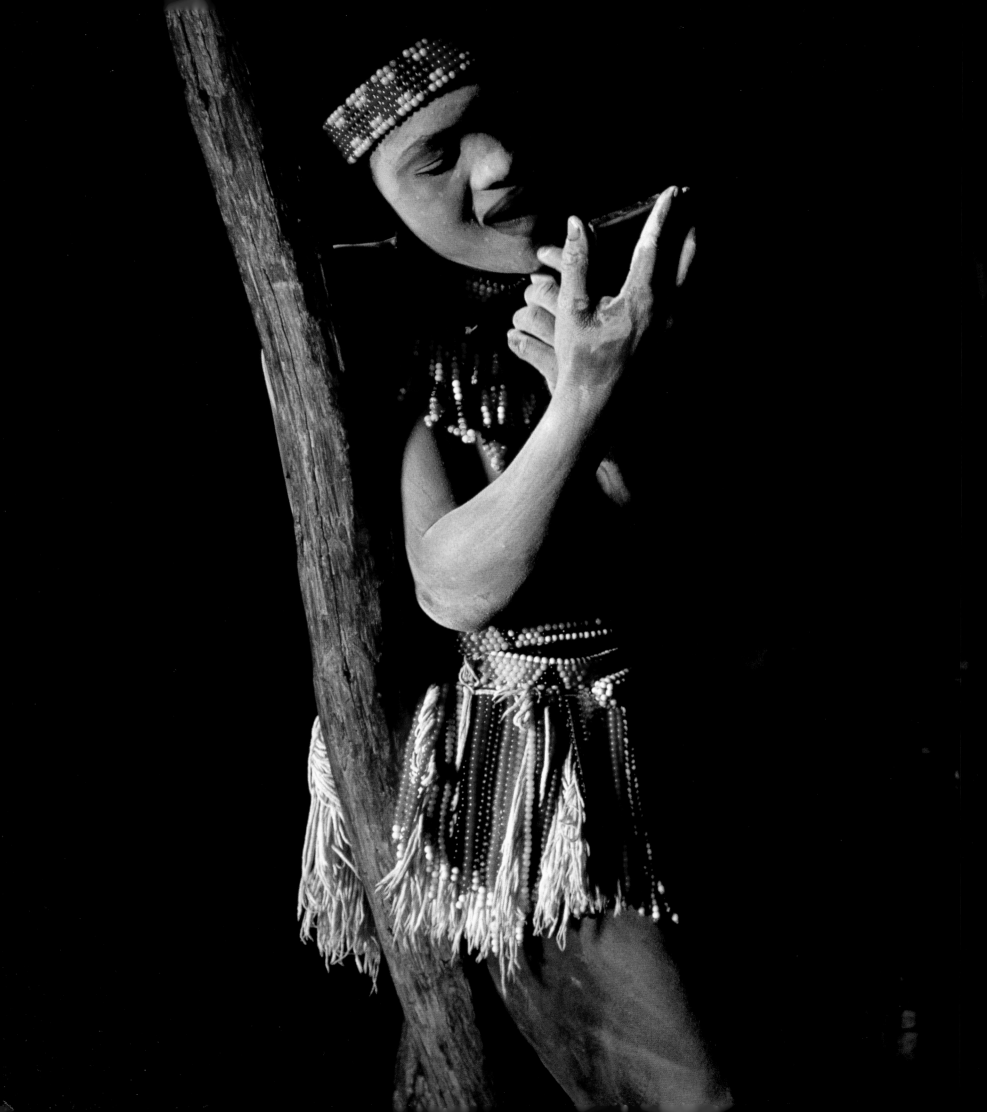

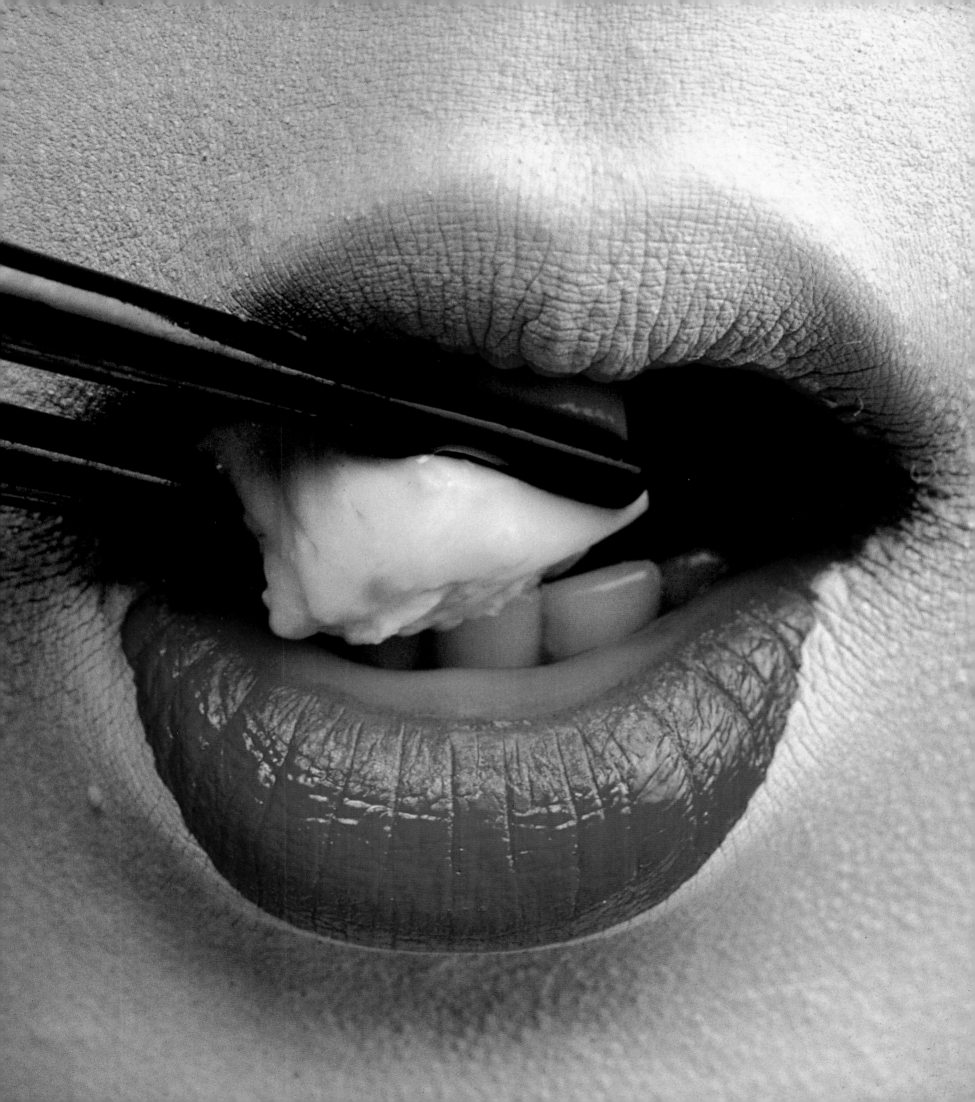

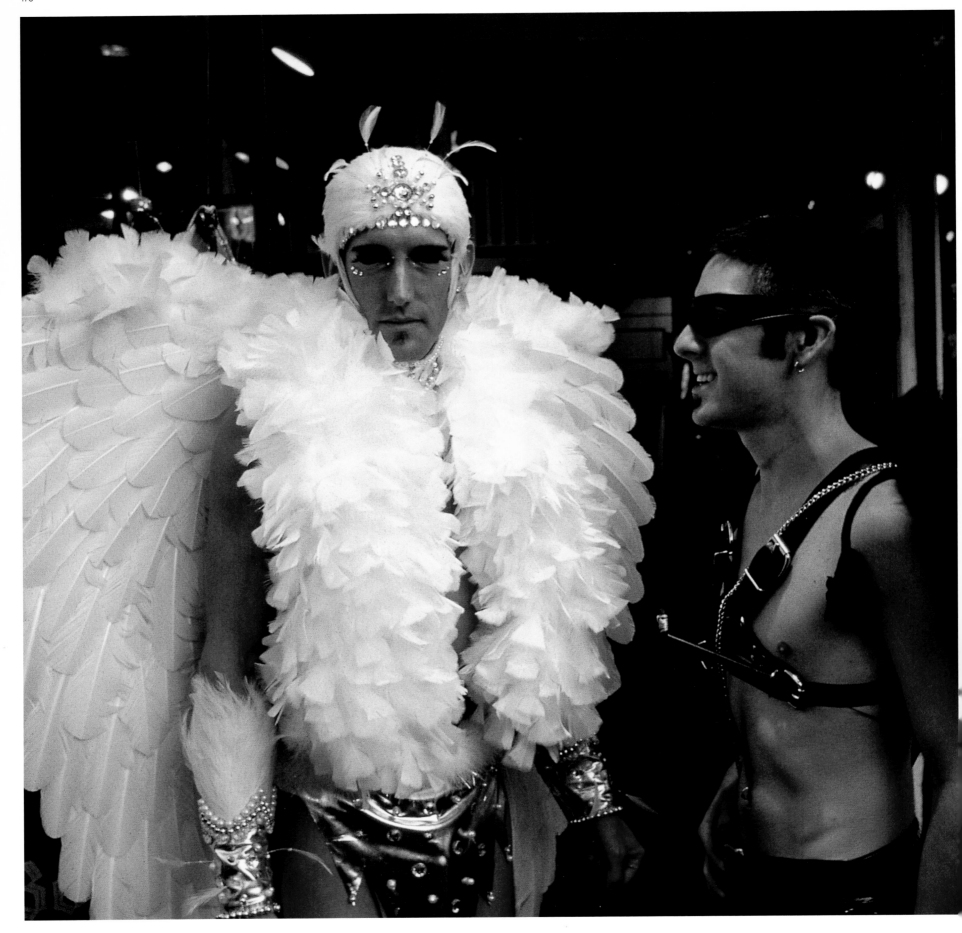

TOMASZ TOMASZEWSKI **UNITED STATES** 1999

Escaping for a few hours their otherwise earthbound existence, a
feathered reveler and his leather-strapped companion in San
Francisco exult in the freedom of fantasy.

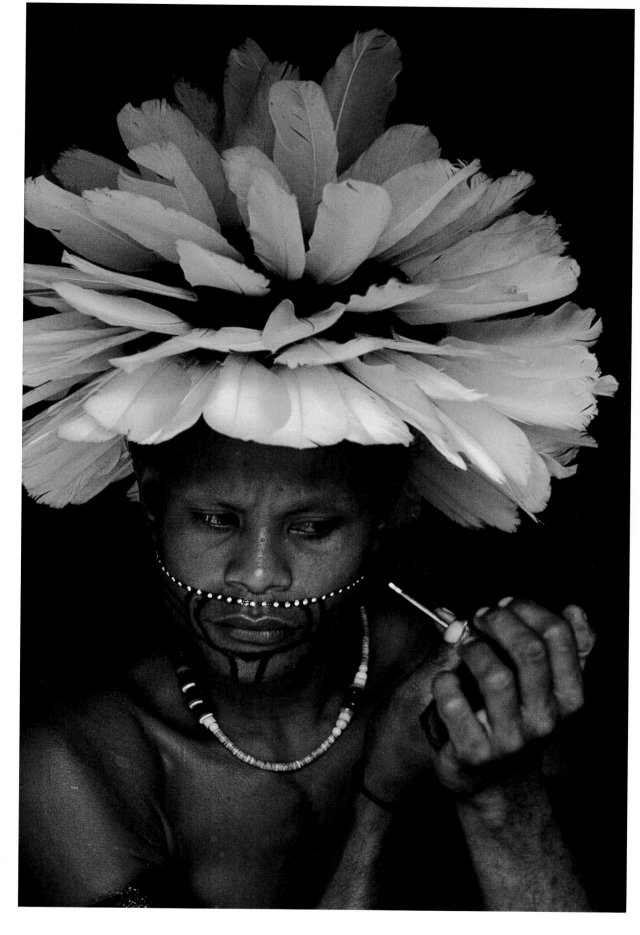

"A MAN IN
A PEARL
NECKLACE IS
MUCH MORE
INTERESTING
THAN A MAN
IN A SKIRT."

VIVIENNE WESTWOOD

PETER ESSICK **PAPUA NEW GUINEA** 1992

Cockatoo feathers crown the head of this dancer from the Trobriand Islands during the celebration of their month-long yam festival. His preparations include painting his face with a mixture of powdered coral and water.

LOREN McINTYRE **BRAZIL** 1972

/page 178/ Giant red-and-black designs painted on the chest and legs of this Waura wrestler from the Amazon emphasize his muscularity. He has girded his biceps to give him strength. His hair is carefully plastered with urucu', the red juice of a local fruit.

CAROL BECKWITH / ANGELA FISHER **ETHIOPIA** 1991

/page 179/ A chalk-and-water snake motif, highlighted by ocher stripes, undulates over the torso of Surma tribesman Ole Regay. The Surma men in southwestern Ethiopia use body paint to attract women and intimidate enemies.

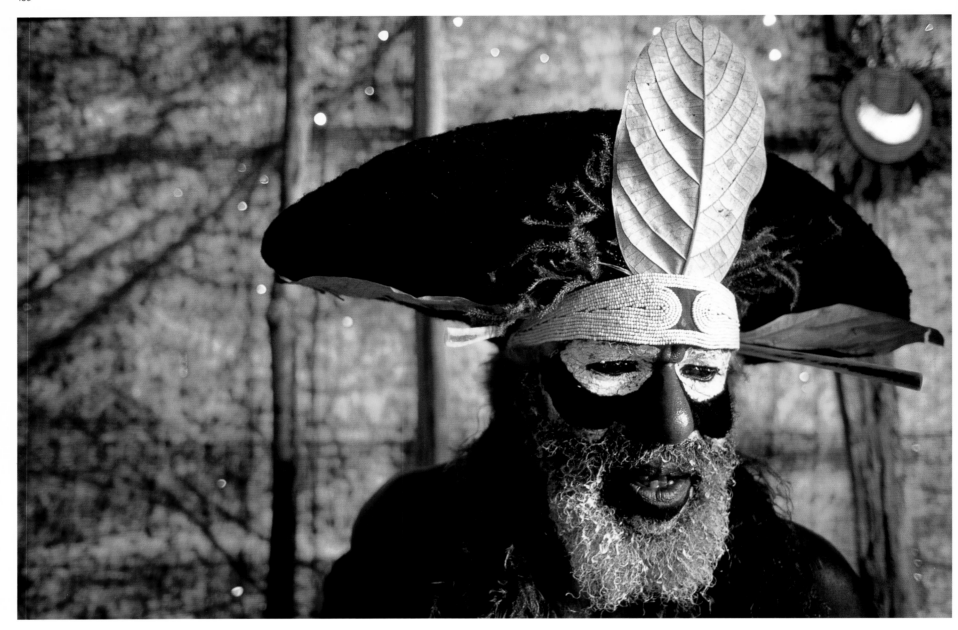

JODI COBB **PAPUA NEW GUINEA** 1998

For annual ceremonial dances that include mimicking the local
birds of paradise, tribesmen from the highlands don headdresses
made from a variety of materials including flowers, leaves, feathers,
and human hair.

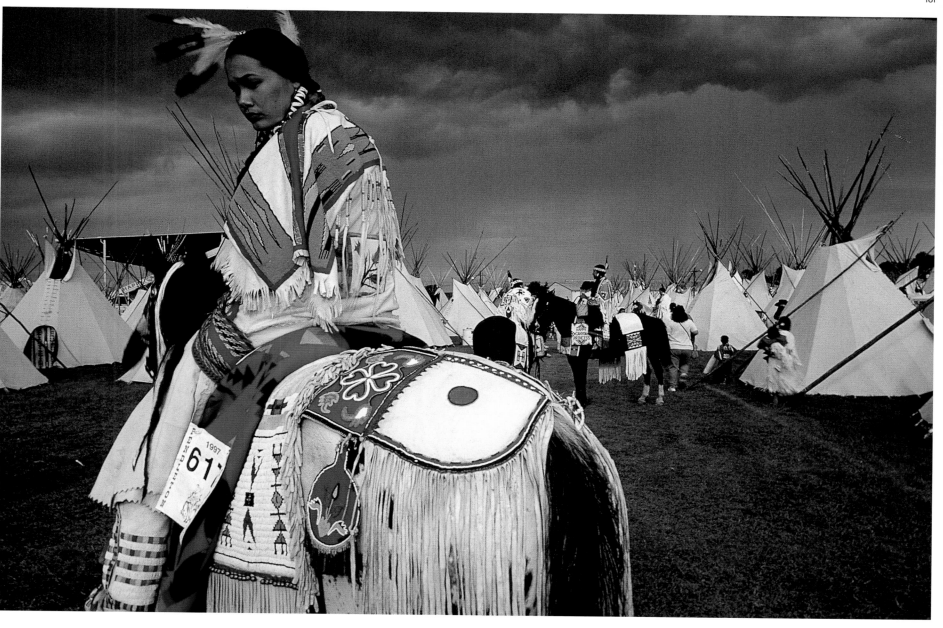

WILLIAM ALBERT ALLARD **UNITED STATES** 1999

After winning the American Indian Beauty Pageant at the Pendleton Round-Up in Oregon, the magnificently beaded Princess Acosia Red Elk waits to join a parade on her equally splendid pony.

WILLIAM ALBERT ALLARD **ITALY** 1995

/**page 183**/ A veil of lace lends mystery to Sicilian actress Benedetta Buccellato as she prepares to take the stage for a modern production of the drama by Aeschylus, *Prometheus Bound*.

"A WOMAN'S
DRESS SHOULD
BE LIKE A
BARBED-WIRE
FENCE: SERVING
ITS PURPOSE
WITHOUT
OBSTRUCTING
THE VIEW."

SOPHIA LOREN

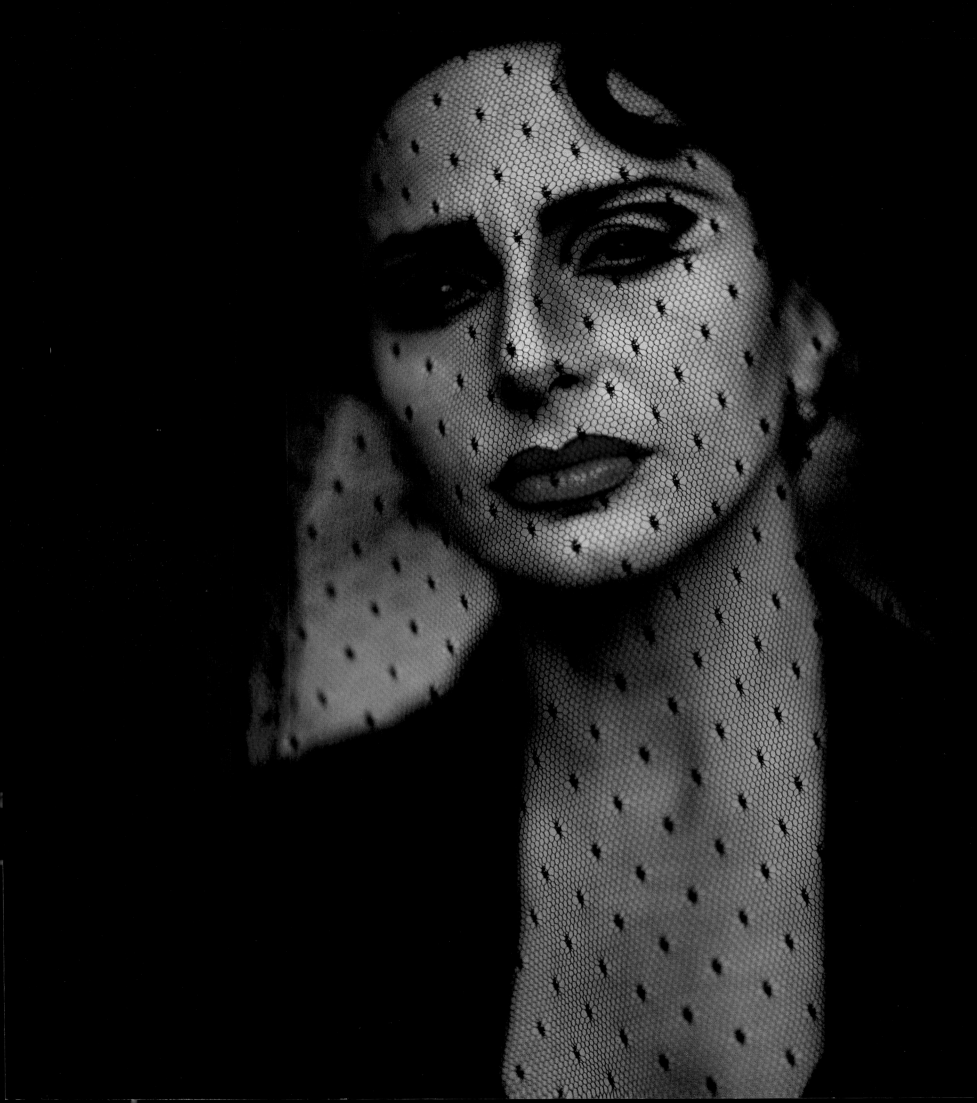

186

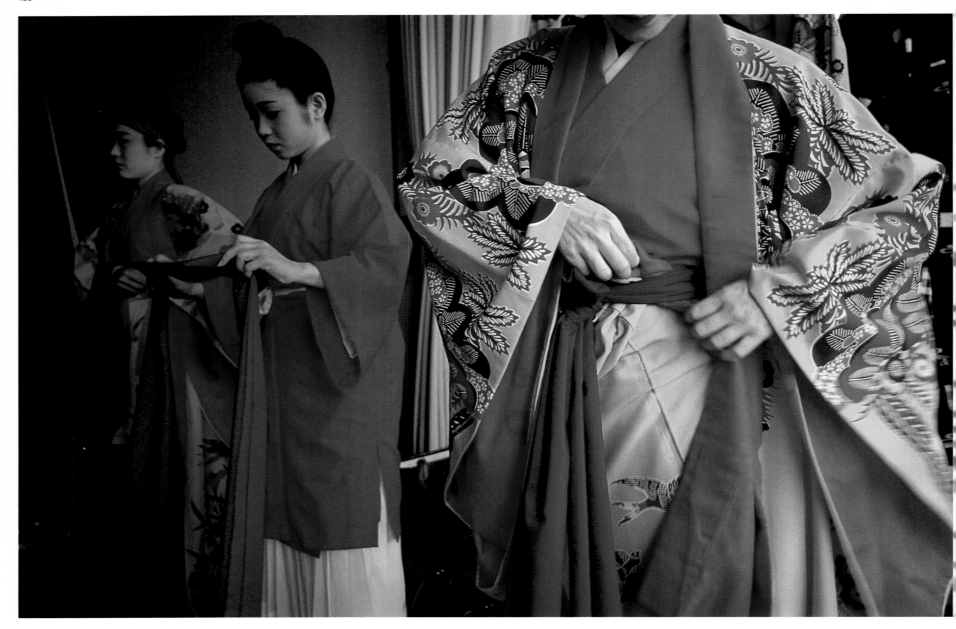

CARY WOLINSKY **INDIA** 1999

/**pages 184–185**/ Drenched in dye mixed with water, women at the Dauji Temple in Uttar Pradesh celebrate at a Hindu festival. They are reenacting a story in which the Hindu god Krishna and his lover Radha are showered with flower petals.

KAREN KASMAUSKI **JAPAN** 1997

Adjusting her costume before going onstage, a dancer from the island of Okinawa prepares to perform Yotsudake, an elegant dance that combines movement, music, and costume from China, Japan, and Southeast Asia.

SAM ABELL **AUSTRALIA** 1991

To honor his ancestors in a corroboree, a festival celebrating
Aboriginal Dreamtime, a native Australian adorns his body with white
pigments and a bright swatch of cloth.

JUSTIN LOCKE · **UNITED STATES** 1949

/**page 189**/ At the Tesuque pueblo in New Mexico, a robe of eagle
feathers and a buffalo-horn headdress—costume for the Eagle
Dance—transform a man into a formidable hunter.

"ORDINARY CLOTHES
SEEM TO DRAG AT
ALL THE LOFTY
ASPIRATIONS OF
MAN AND AT ALL
HIS FINER FEELINGS.
THEY SEEM TO
INTERRUPT MAN'S
RELATIONS WITH
THE INFINITE."

ANNE HOLLANDER

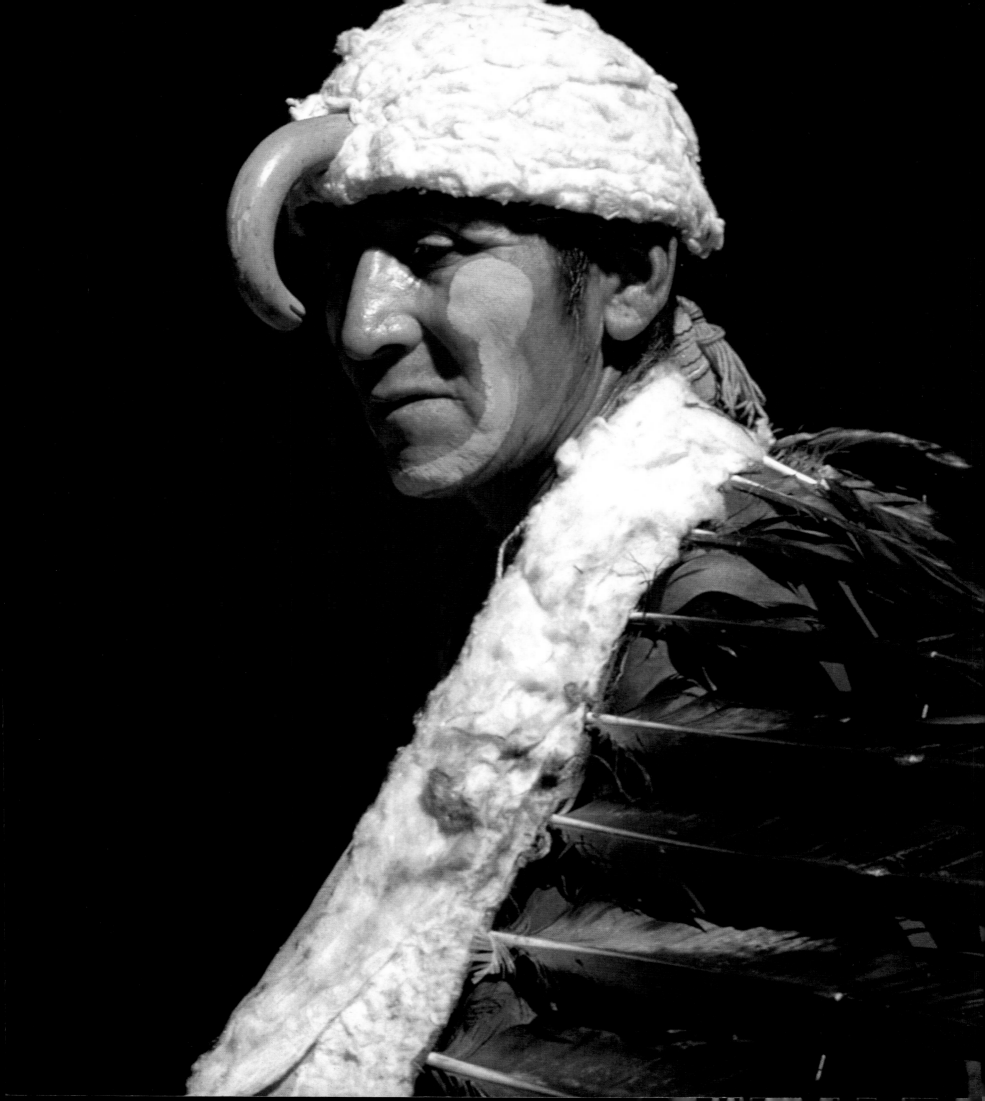

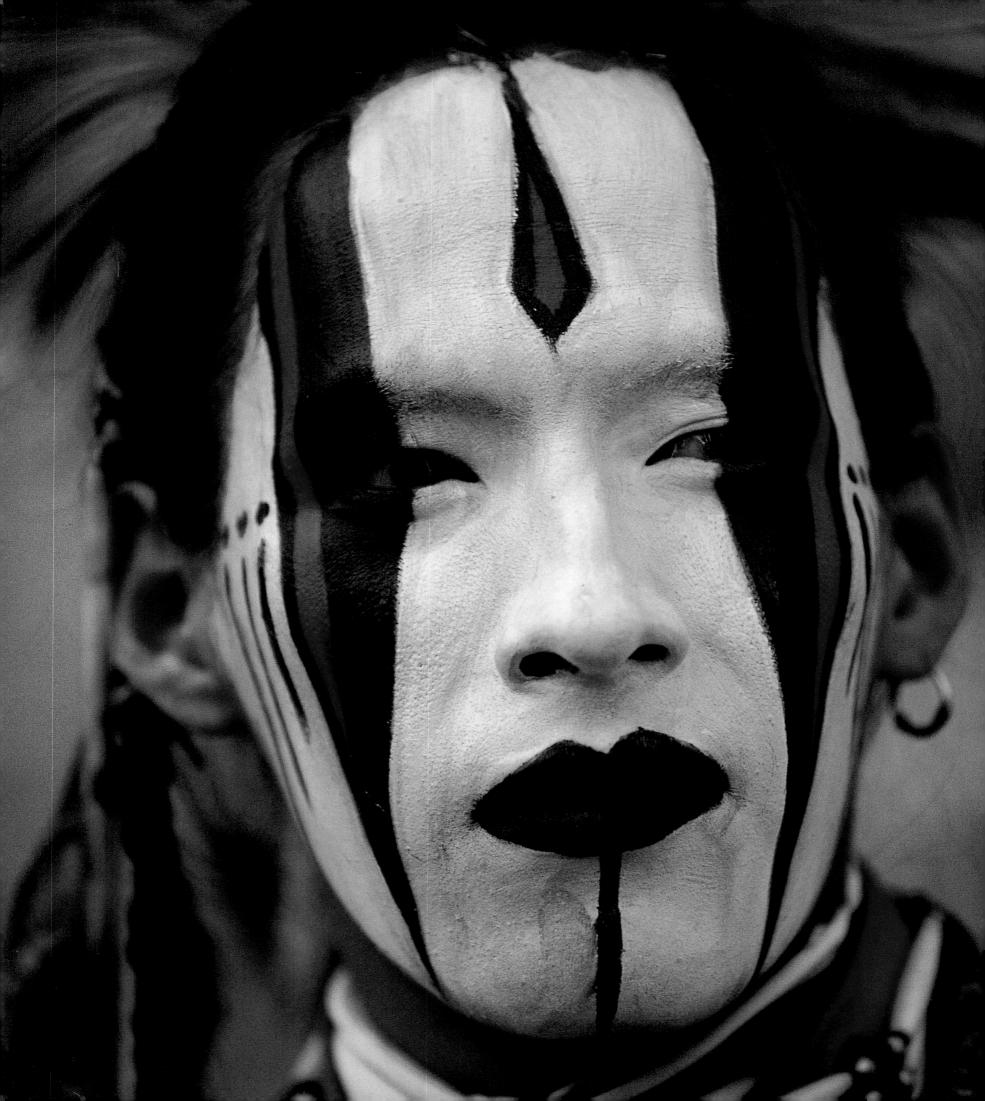

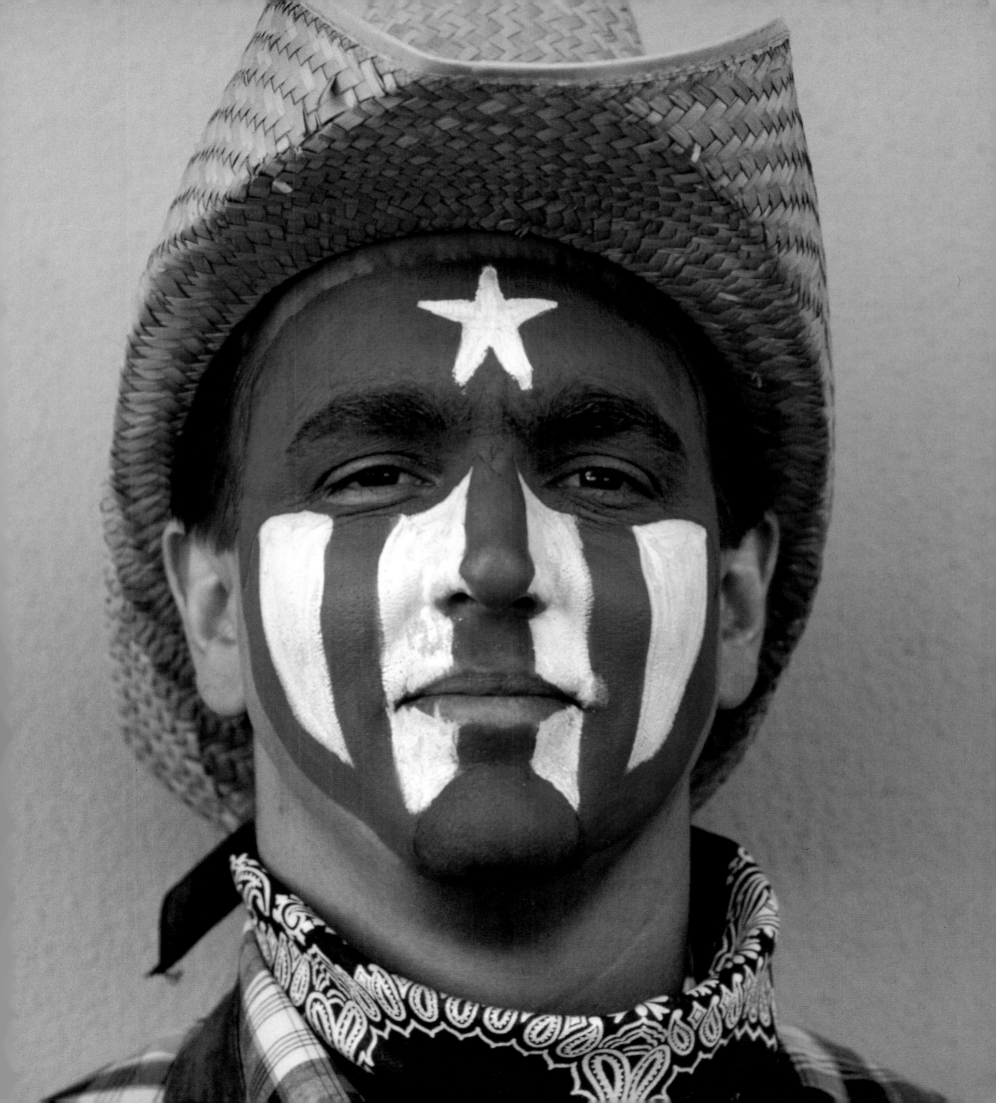

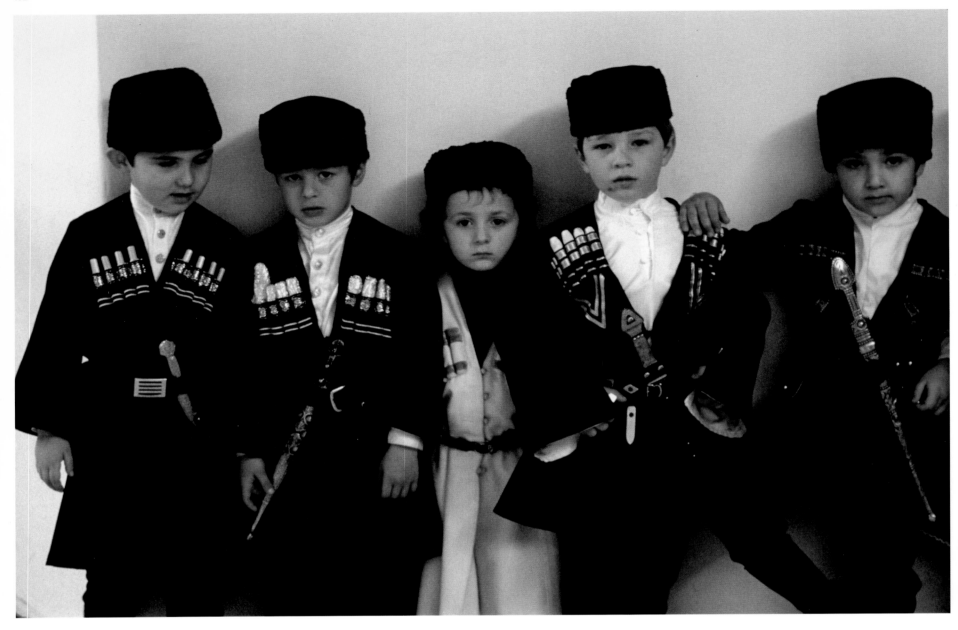

WILLIAM ALBERT ALLARD **CANADA** 1998

/page 190/ An Indian dancer with his face intricately painted for a performance during the Calgary Stampede recalls the days when such paint meant war.

TOMASZ TOMASZEWSKI **UNITED STATES** 1987

/page 191/ At Mardi Gras in New Orleans a patriot expresses his dedication to the American flag by becoming it.

JODI COBB **JORDAN** 1983

Cartridge belts sewn into their jackets and silver daggers in their belts, Circassian boys exhibit the dress of their fighting ancestors from the Caucasus, who resisted Russian domination for decades before emigrating in 1864.

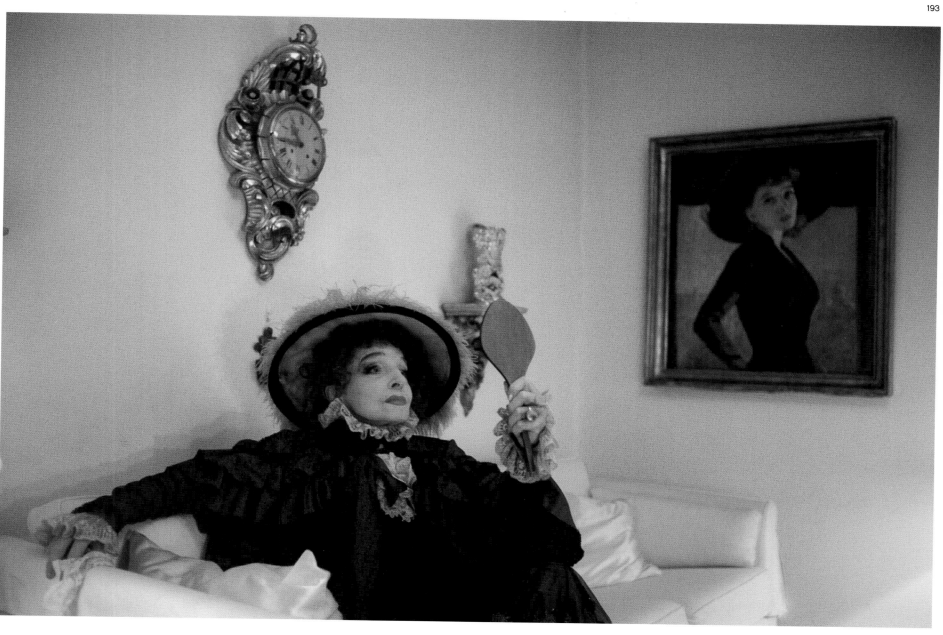

JODI COBB **FINLAND** 1981

Ella Eronen, one of Finland's most beloved actresses, poses in the costume of "Madame," an actress who felt lost unless she had a role to play.

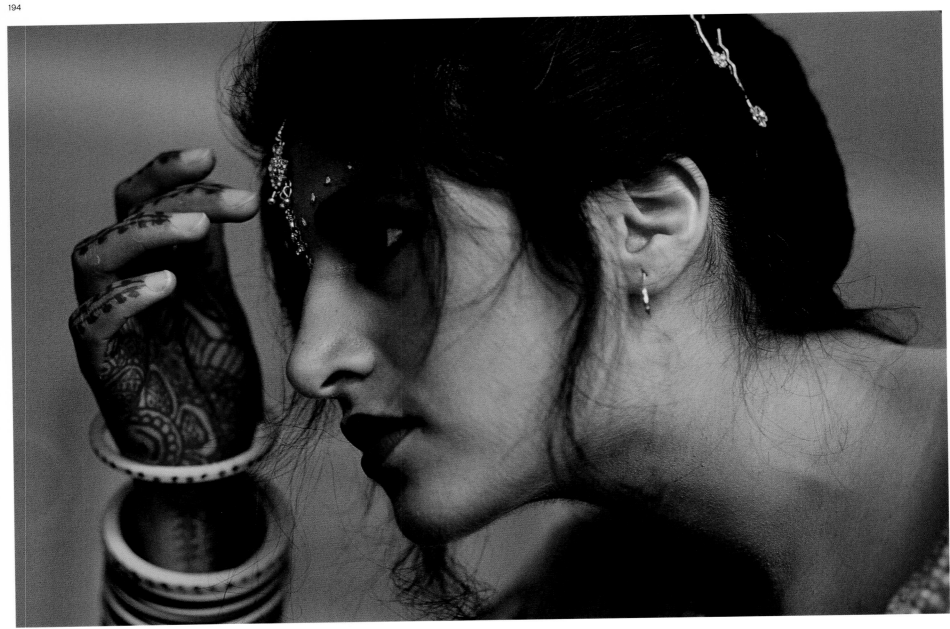

JODI COBB **LONDON** 1999

Her hands decorated with henna designs for beauty, a Hindu bride
dressed for her wedding affixes gold dots called *bindis* to her fore-
head. Symbol of the goddess Parvati, a bindi signifies female energy
and is believed to protect women and their husbands.

JODI COBB **TAIWAN** 1992

The hand of a woman attains the distinctive grace of a bride when adorned in lace, rings, and bracelets. Far from her country's traditional dress, the style nevertheless achieves the goal: beauty and elegance.

CARL J. LOMEN **UNITED STATES** ca 1910

/**pages 196-197**/ Dressed for a ceremonial Wolf Dance, natives of Alaska wear masks made of wolf heads, which transfer to them the spirit, strength, and stealth of that admired hunter.

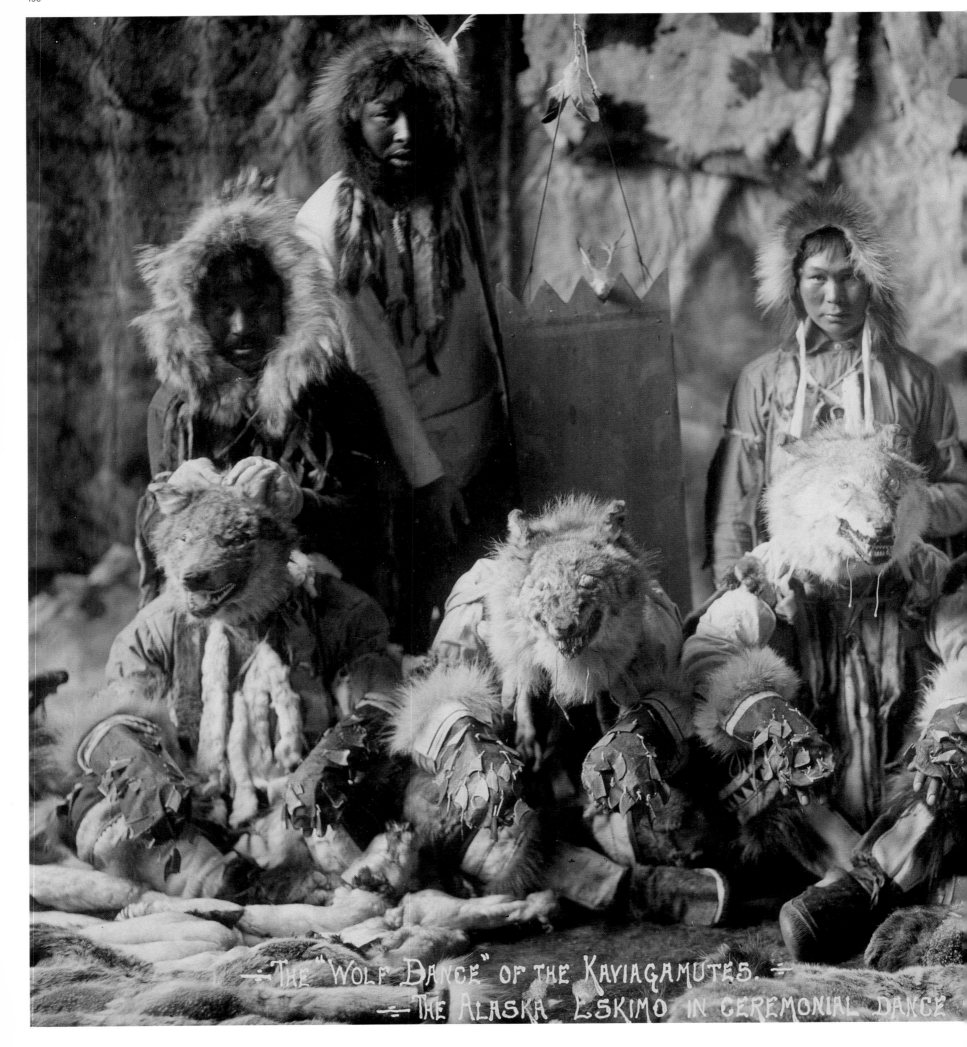

THE "WOLF DANCE" OF THE KAVIAGAMUTES.
THE ALASKA ESKIMO IN CEREMONIAL DANCE

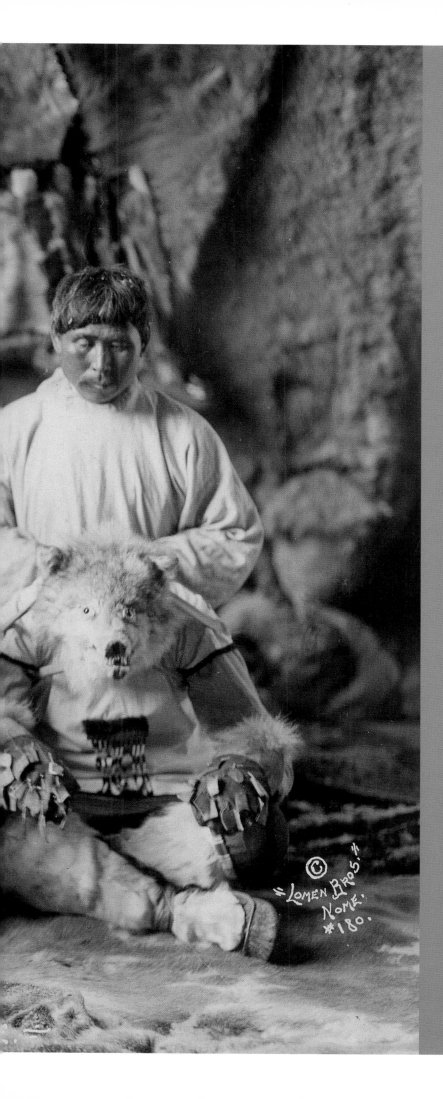

"THE MAN—AND IT IS USUALLY A MAN—IN THE CEREMONIAL MASK HAS A SPIRITUAL MISSION. THE MASK ALLOWS THE SUPERIMPOSITION OF A COMPLETELY NEW CHARACTER. THE CEREMONIAL MASK ALLOWS THE WEARER TO TRULY SAY: 'I AM NOT MYSELF.'"

HERBERT M. COLE

JODI COBB **PAPUA NEW GUINEA** 1998

/**top**/ His face a multicolored canvas accented by a nose spear, a tribesman takes part in the sing-sing, the annual celebration that brings together various clans of Papua New Guinea for music and dance. Each group wears a distinctive hue of face paint.

JODI COBB **PAPUA NEW GUINEA** 1998

The motif of dots is an individual design, but the color yellow marks this sing-sing performer as a member of the Huli tribe, known for wearing wigs of human hair. In Papua New Guinea, men apply colorful makeup, but women do not.

JODI COBB **PAPUA NEW GUINEA** 1998

A Huli wigman takes a break during the sing-sing. His ceremonial wig is woven of human hair grown over an 18-month period by a select group of men in his tribe.

JODI COBB **PAPUA NEW GUINEA** 1998

/**pages 200-201**/ Their bodies slathered with mud and balancing demonic-faced masks, performers called mudmen from the Asaro Valley prepare to enact ritual dances for tourists.

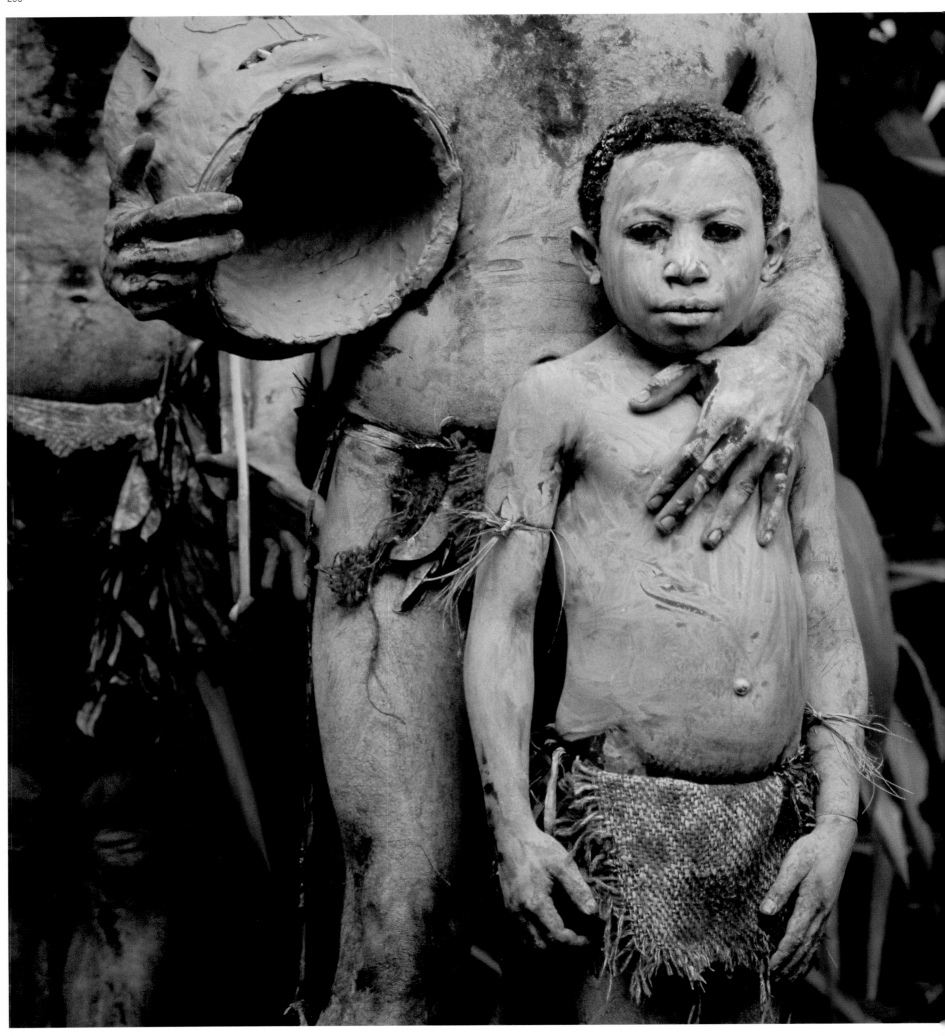

"WE ARE BY NATURE ALL AS ONE, ALL ALIKE, IF YOU SEE US NAKED; LET US WEAR THEIRS AND THEY OUR CLOTHES, AND WHAT IS THE DIFFERENCE?"

ROBERT BURTON

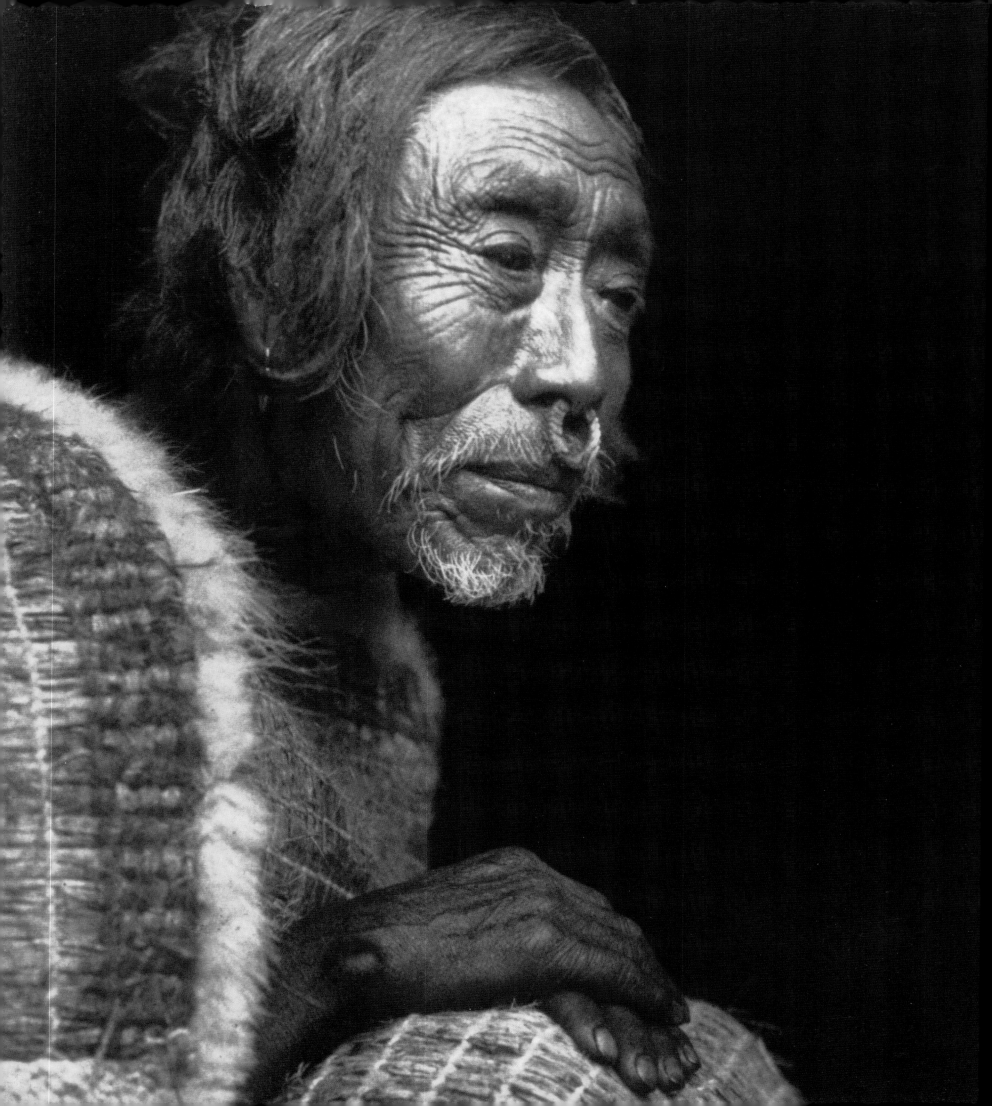

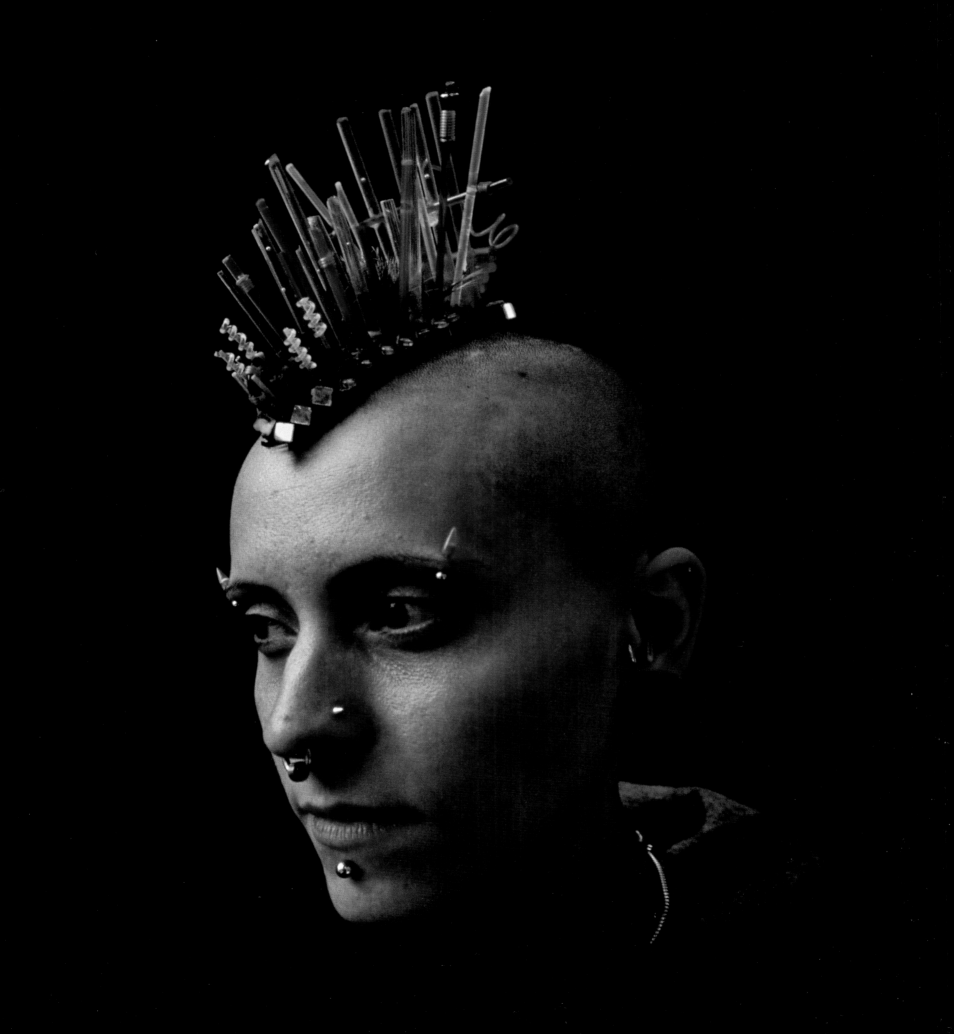

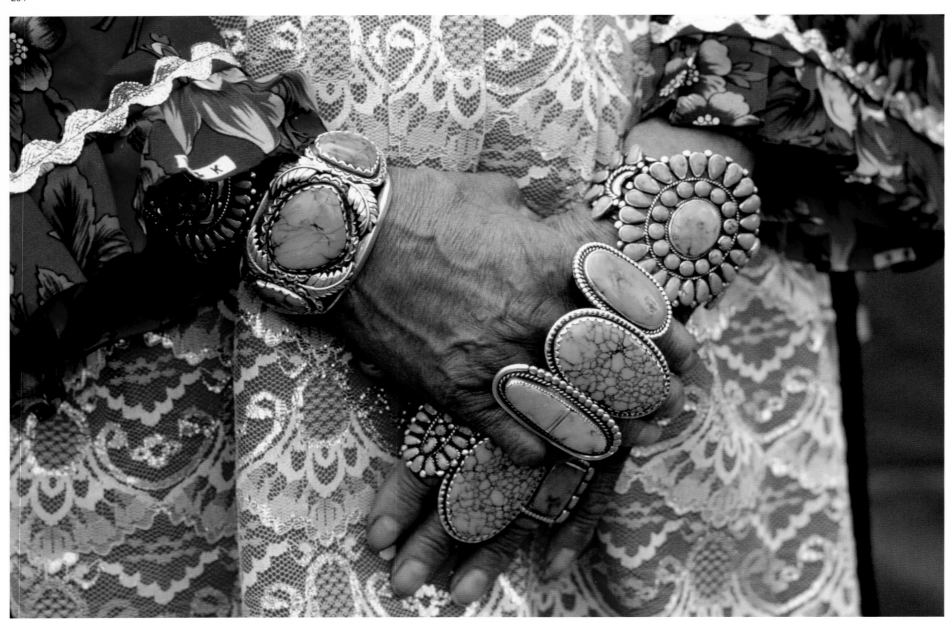

EDWARD S. CURTIS **CANADA** ca 1900

/page 202/ The portrait of a Kwakiutl elder from Vancouver Island reveals a Northwest Coast mark of beauty: a slanted forehead. His head was bound between boards as an infant to achieve the shape.

JODI COBB **UNITED KINGDOM** 1999

/page 203/ His statement of individuality loud and clear, a young Londoner's multiple body piercings accentuate his shaved and spiked head.

JOSEPH H. BAILEY **UNITED STATES** 1987

Heirloom turquoise and silver rings and bracelets adorn the arms and hands of a Zuni woman in Arizona as she attends a tribal celebration.

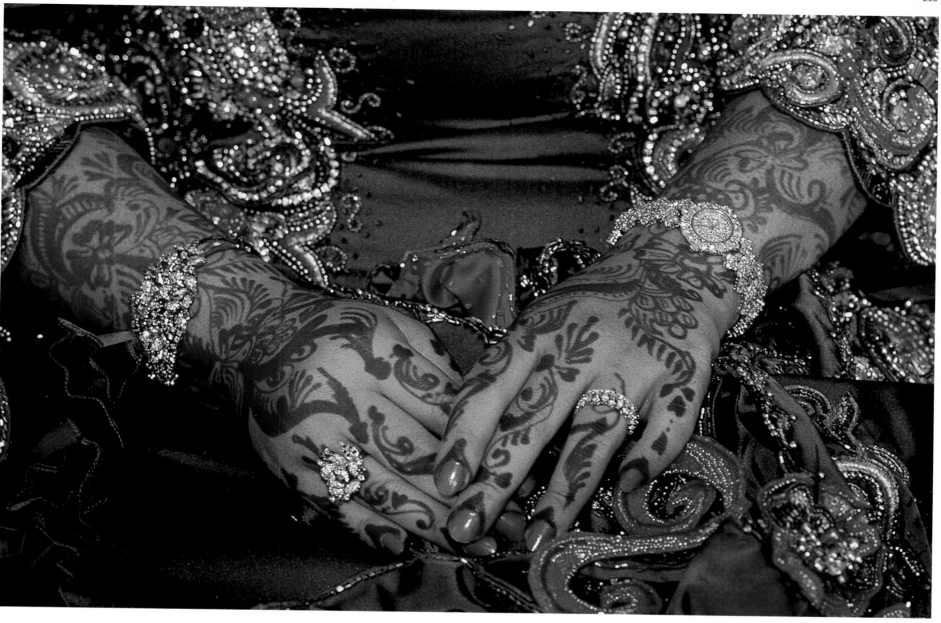

JAMES L. STANFIELD **OMAN** 1995

A bride's hands are resplendent with jewels and designs drawn in henna at a "lailat al henna," a females-only event to honor the bride on the eve of her wedding.

MARIA STENZEL **KENYA** 1999

/pages 206–207/ Wearing layers of beaded necklaces and head-bands, women from the nomadic Ariaal tribe of northern Kenya walk to a wedding. On their way they sing "Meirita ngai nkeera ang!" which means "God bless our children!"

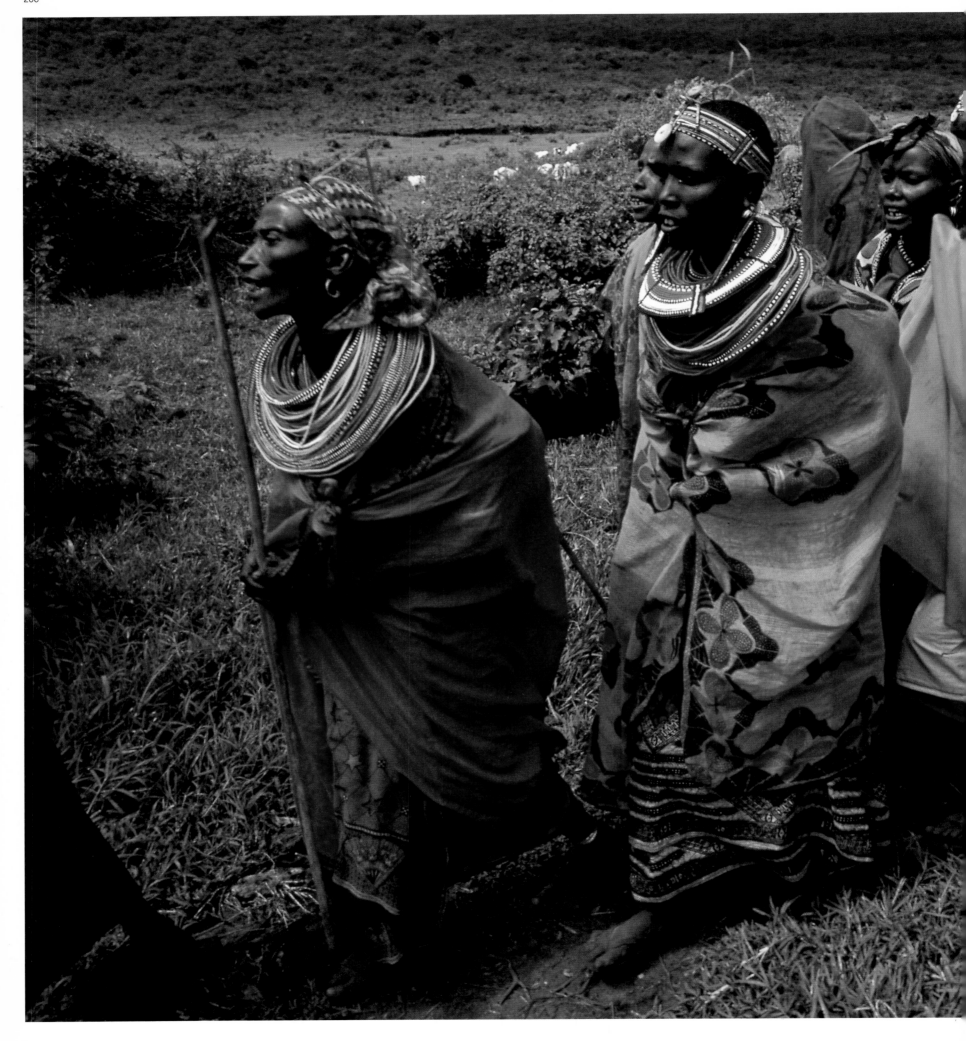

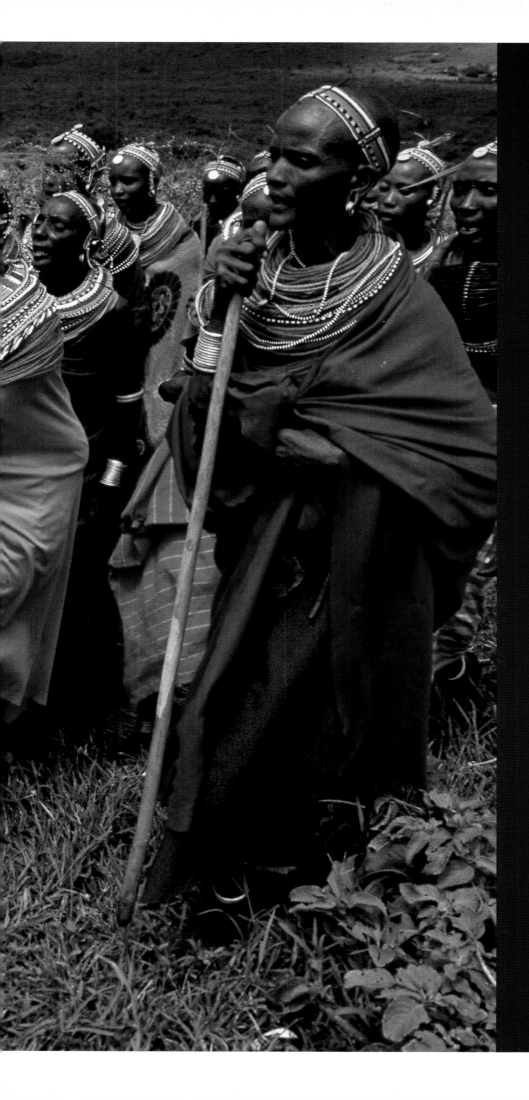

"SHOULD WE BE SILENT AND NOT SPEAK, OUR RAIMENT AND STATE OF BODIES WOULD BEWRAY WHAT LIFE WE HAVE LED."

WILLIAM SHAKESPEARE, FROM *CORIOLANUS*

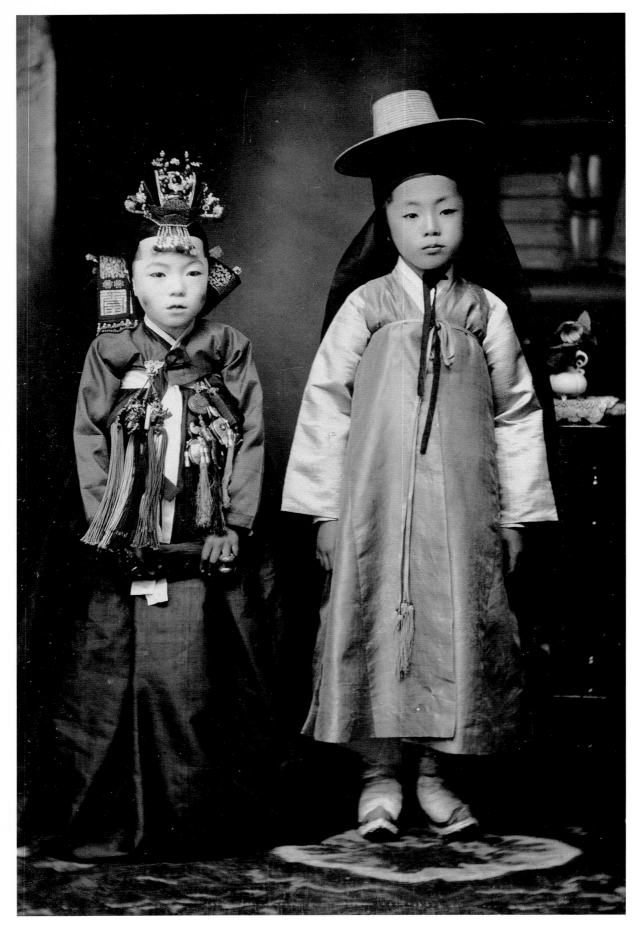

MARY G. LUCAS **KOREA** 1916

With rouged cheeks and an apprehensive expression, a 10-year-old
bride stands with her new husband, age 12. His silk robe and her gold
headdress distinguish the young couple as upper class.

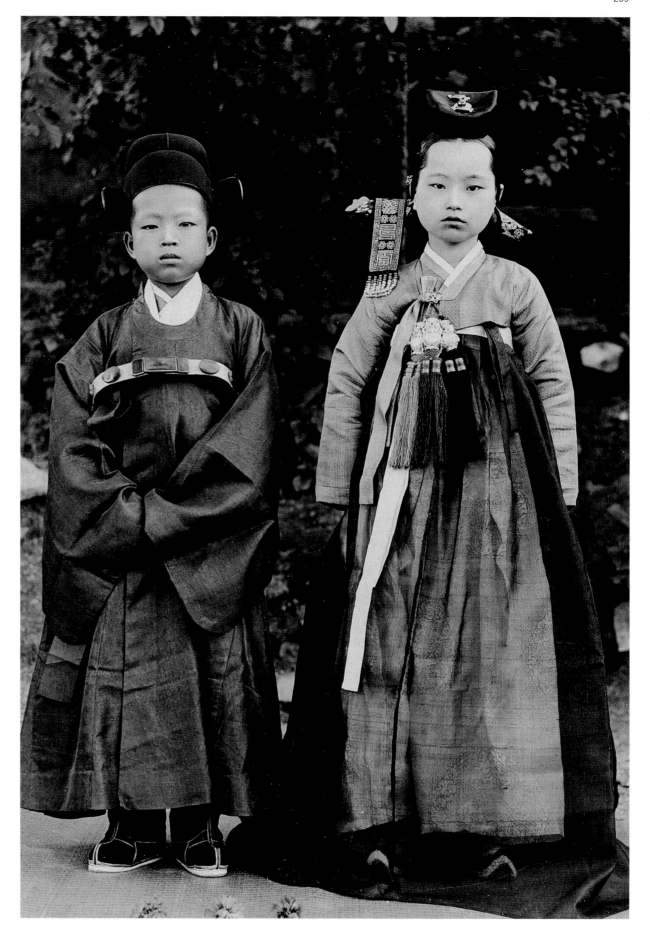

MARY G. LUCAS **KOREA** 1916

The hairstyle of a young bride reflects her position. Before marriage she wore a single braid down her back. From her wedding day on, she will wear her hair gathered at the nape of her neck and fastened with a pin, sometimes of silver and precious stones.

ELIZA R. SCIDMORE **JAPAN** 1918

/**pages 210–211**/ This hand-colored photograph captures the traditional tea ceremony, as much about dress as ritual. Poised and elegant in silk kimonos and ornamented hair, each woman plays a part.

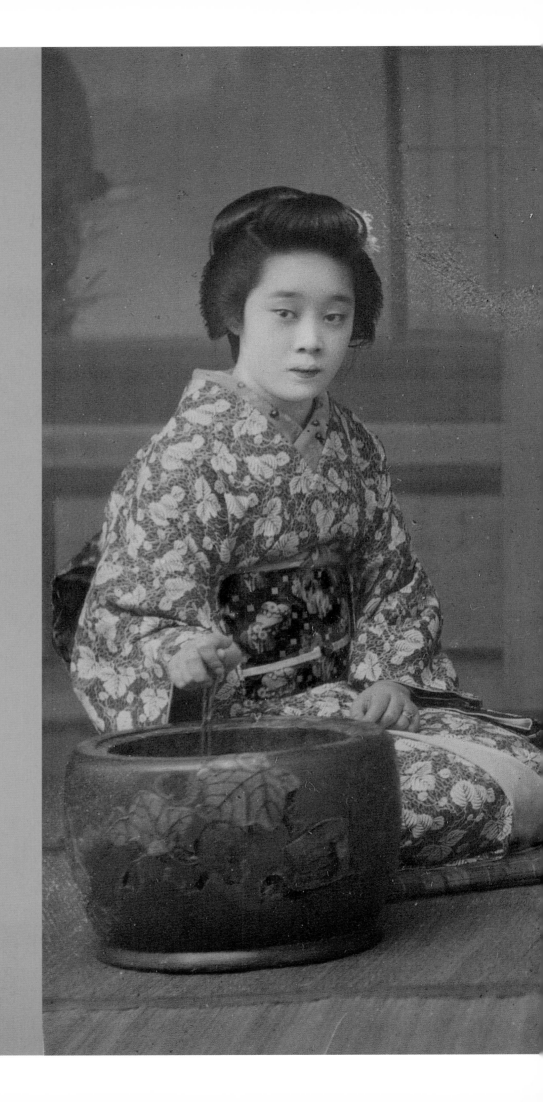

"SHOW ME
THE CLOTHES
OF A COUNTRY
AND I CAN WRITE
ITS HISTORY."

ANATOLE FRANCE

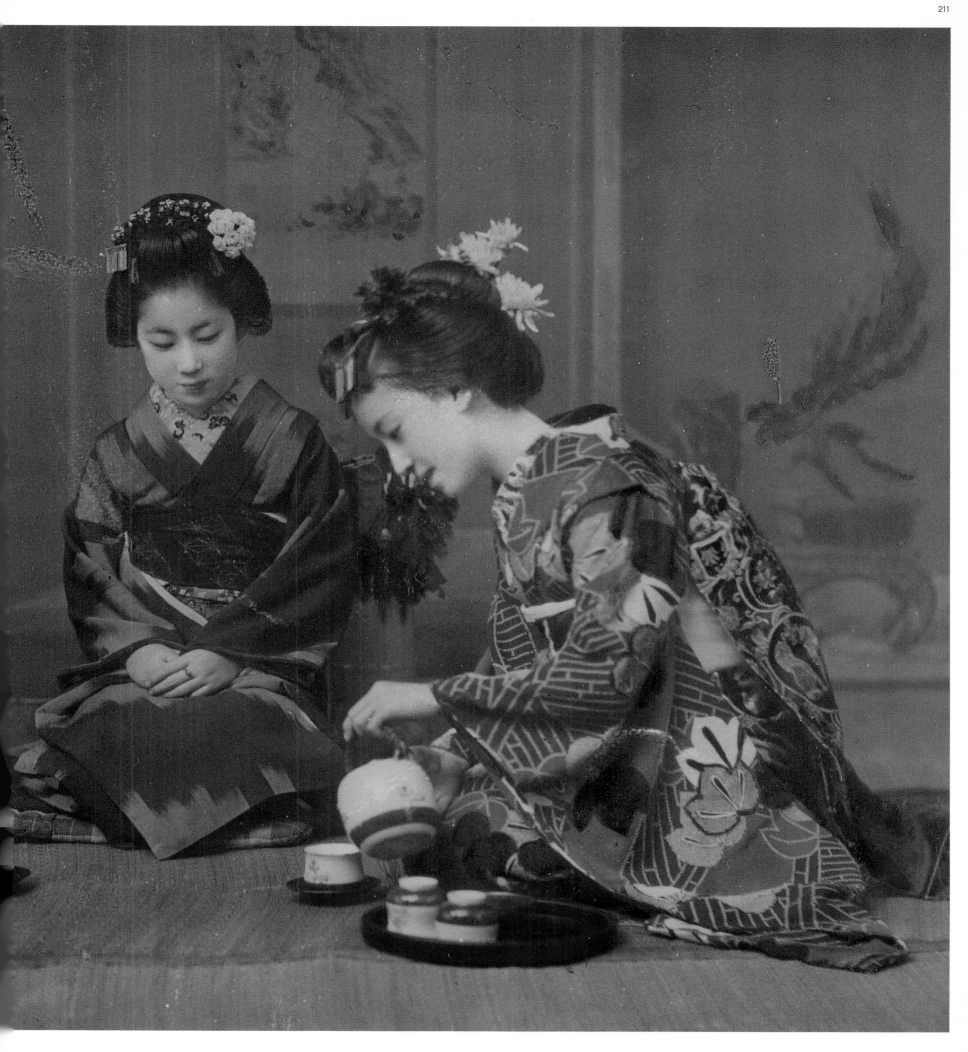

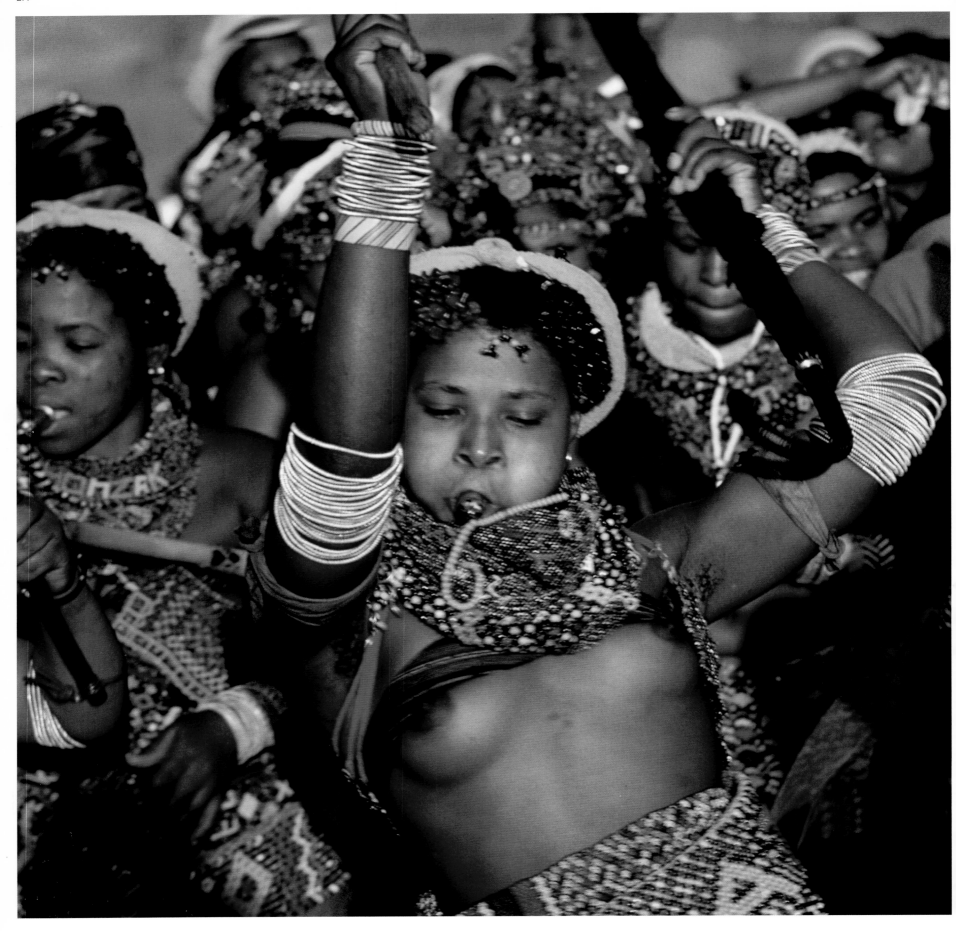

WILLIAM ALBERT ALLARD **ITALY** 1994

/**pages 212–213**/ In a village in Sicily, the dress of a young girl cele-brating the feast of St. Paolo blends with the sea of confetti in the streets.

VOLKMAR WENTZEL **SOUTH AFRICA** 1977

In the hands of this beaded, bangled, and whistle-blowing dancer, a furled umbrella becomes an instrument of rhythm during a frenzied celebration.

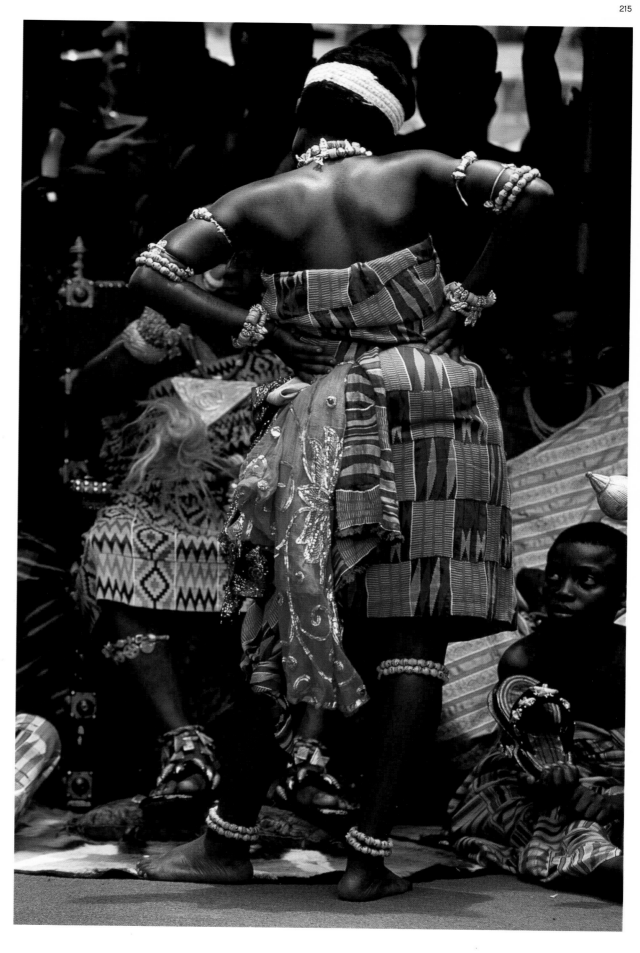

CAROL BECKWITH/ANGELA FISHER **GHANA** 1996

Kente cloth and intricately-worked gold jewelry offset the spirited movements of this Asante royal court member performing a ceremonial dance.

PAUL ALMASY **MADAGASCAR** 1938

/**pages 216–217**/ Shaded from the burning sun, women hawk their wares beneath parasols whose shapes and patterns lend festivity to a regular market day.

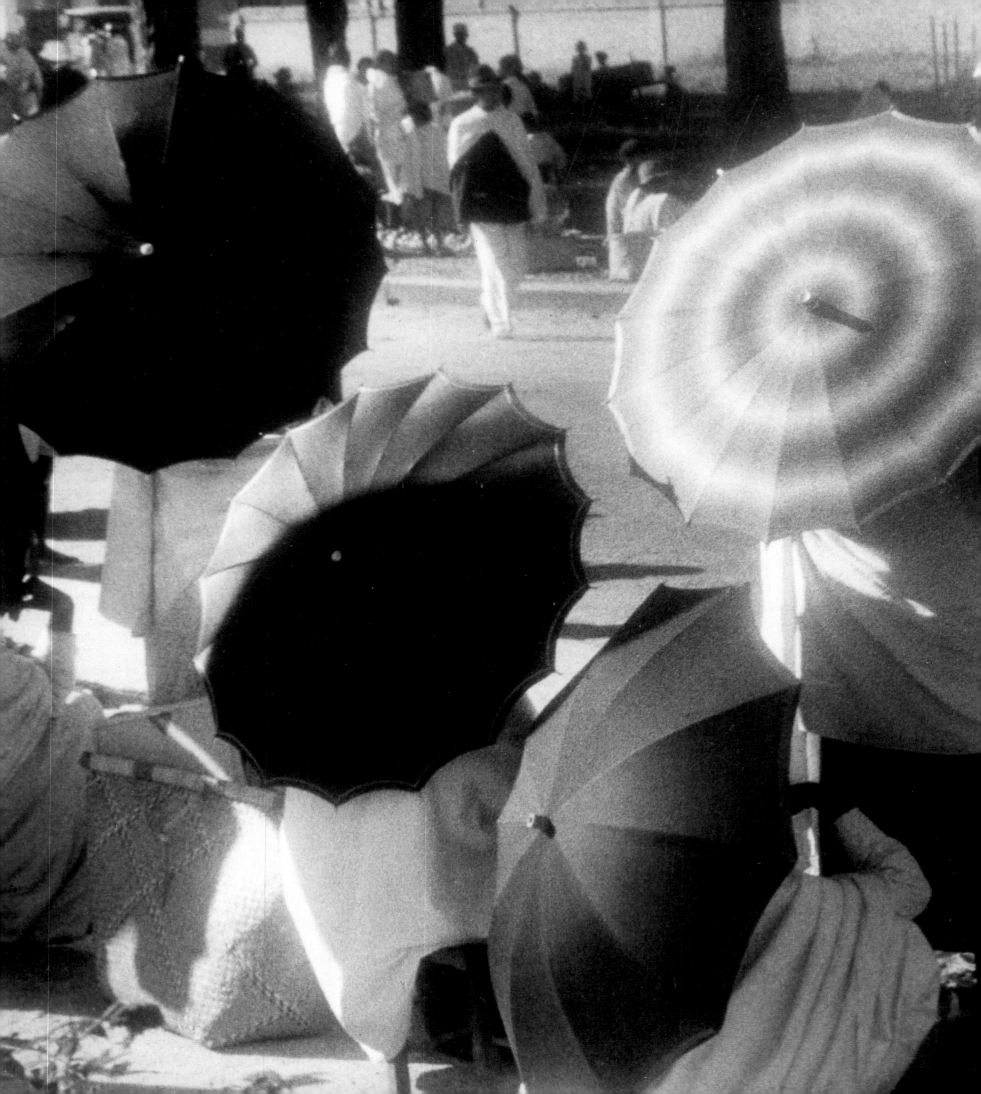

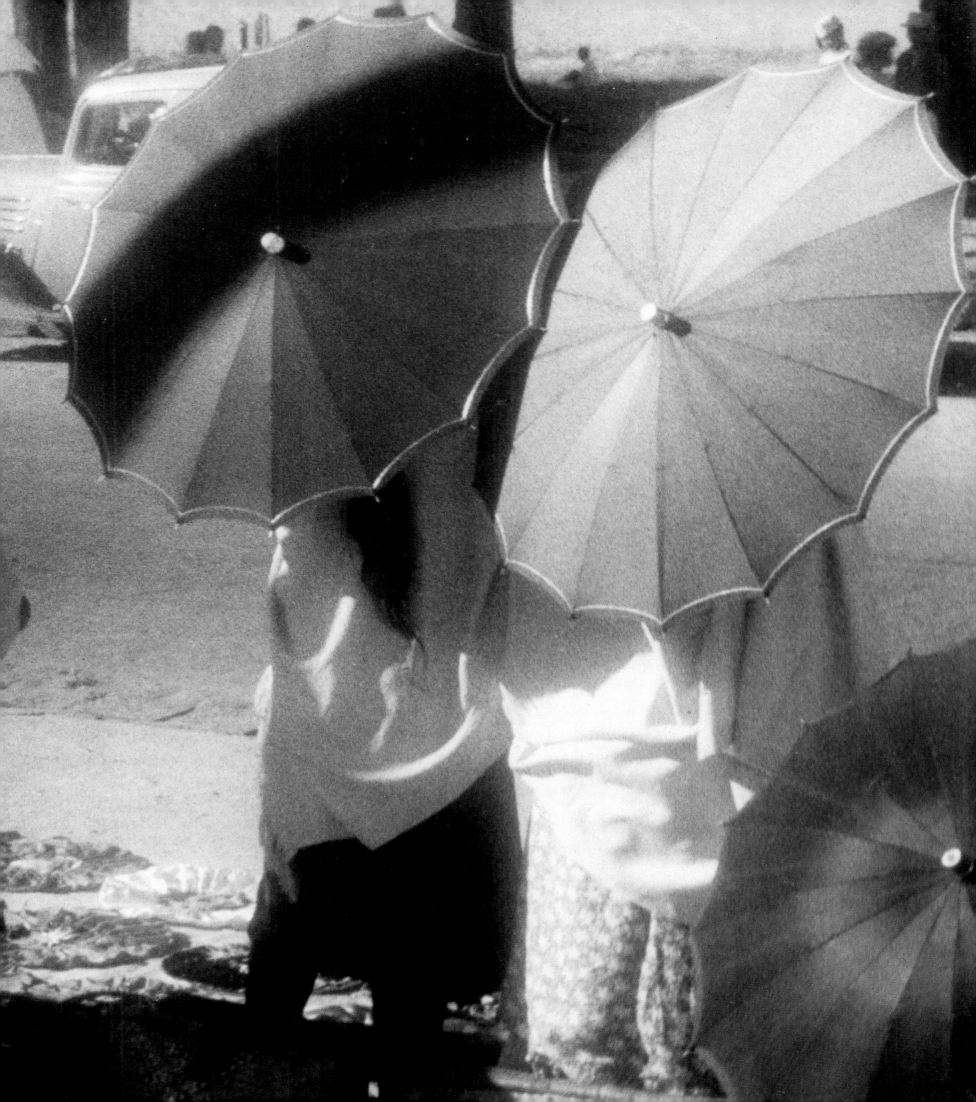

"THE PRINCIPLE
OF FASHION IS...
THE PRINCIPLE
OF THE KALEIDO-
SCOPE. A NEW
YEAR CAN ONLY
BRING US A NEW
COMBINATION OF
THE SAME ELEMENTS;
AND ABOUT ONCE
IN SO OFTEN WE
GO BACK AND
BEGIN AGAIN."

KATHERINE F. GEROULD

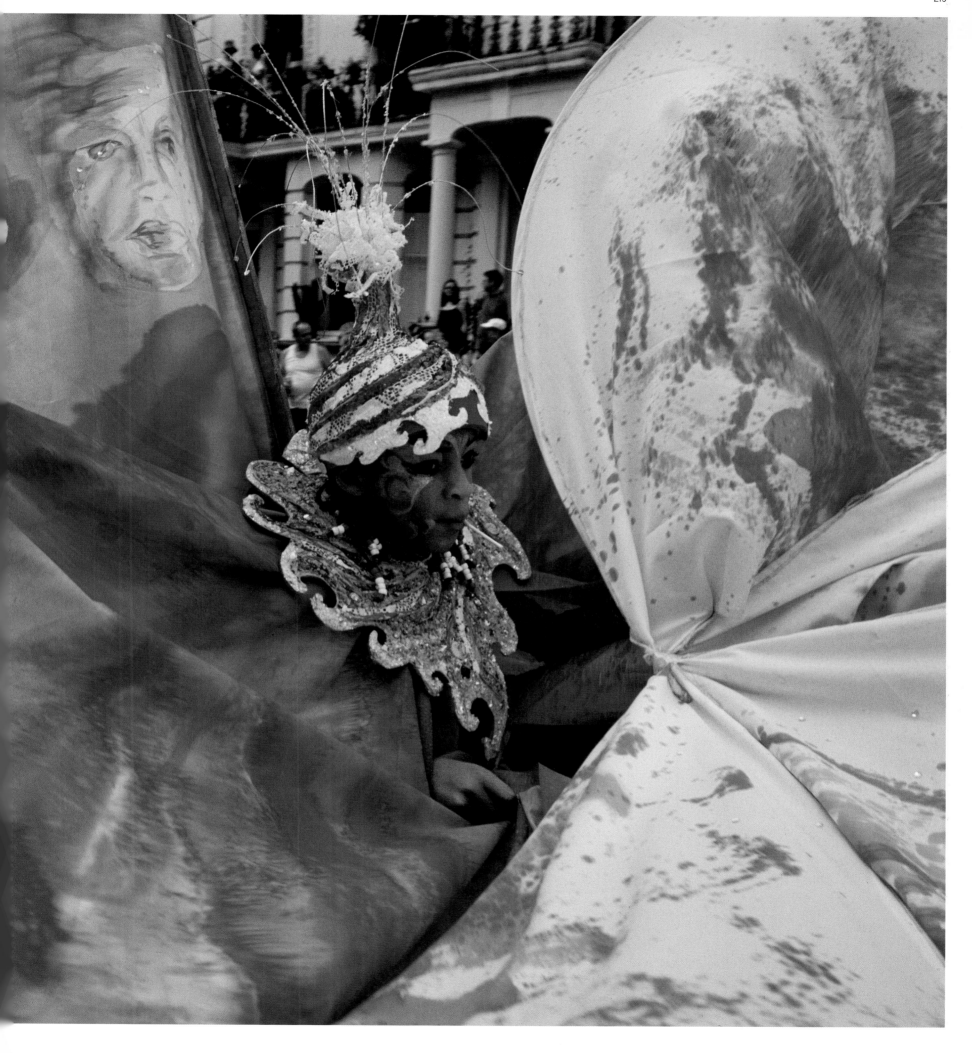

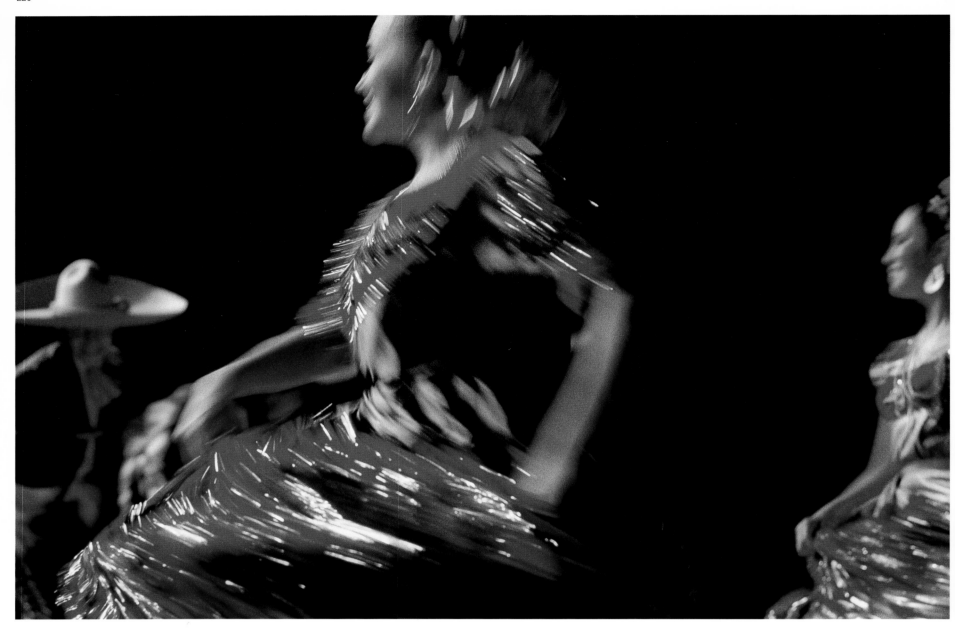

JODI COBB **UNITED KINGDOM** 1999

/pages 218–219/ Billowing fabric with hand-painted designs envelopes this dancer performing at the annual Notting Hill Carnival, one of Europe's largest festivals.

SISSE BRIMBERG **MEXICO** 1989

Following the whirling motions of a dancer, this dazzling costume is part of the performance.

TOMASZ TOMASZEWSKI **UNITED STATES** 2000

Letting the spirit move her, a Gypsy, or Roma, dancer swirls her flowing skirts to emphasize her steps.

DAVID ALAN HARVEY **UNITED STATES** 1993

/**pages 222–223**/ Moving to the beat of a drum, Comanche John Keel wears a fur and feather headdress and a feather bustle in the Men's Traditional Dance competition, in which dancers act out a hunt or a battle, at the Red Earth Festival in Oklahoma City.

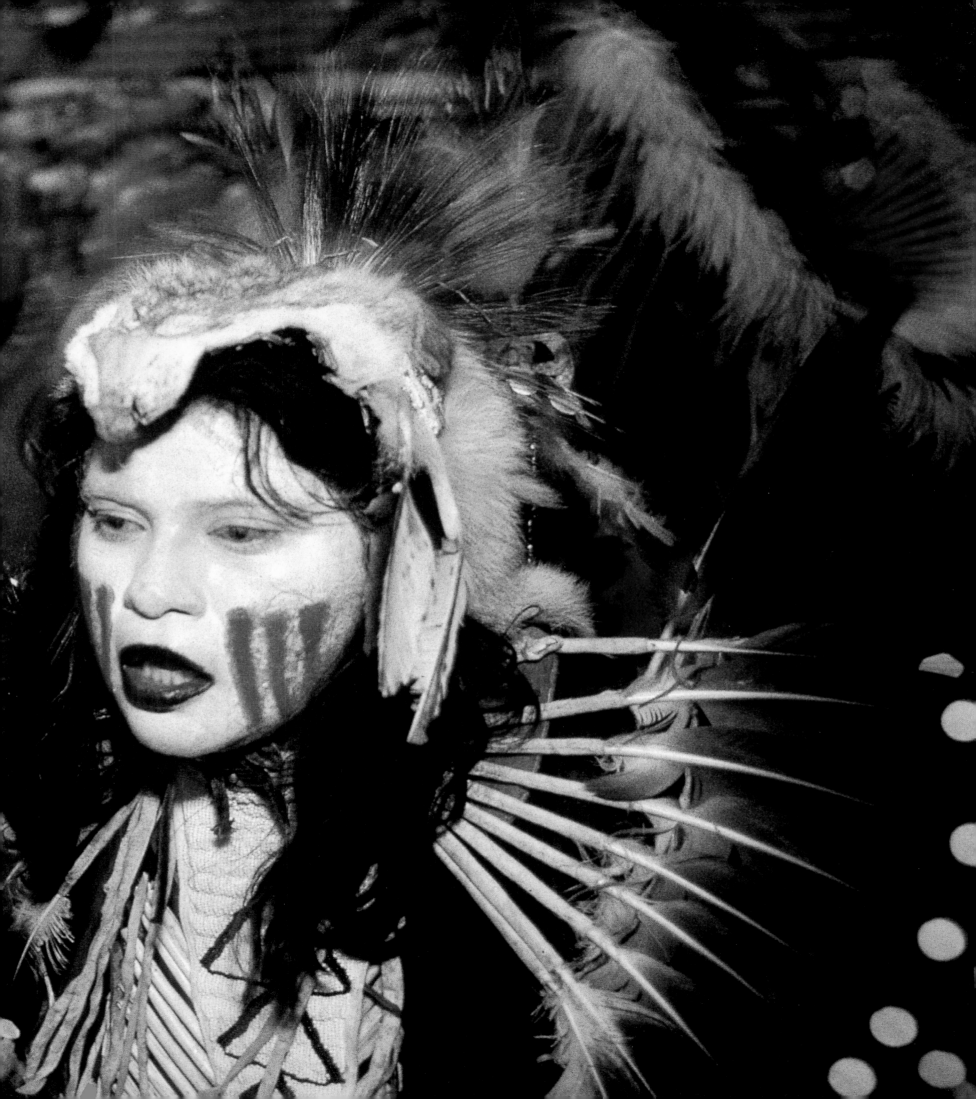

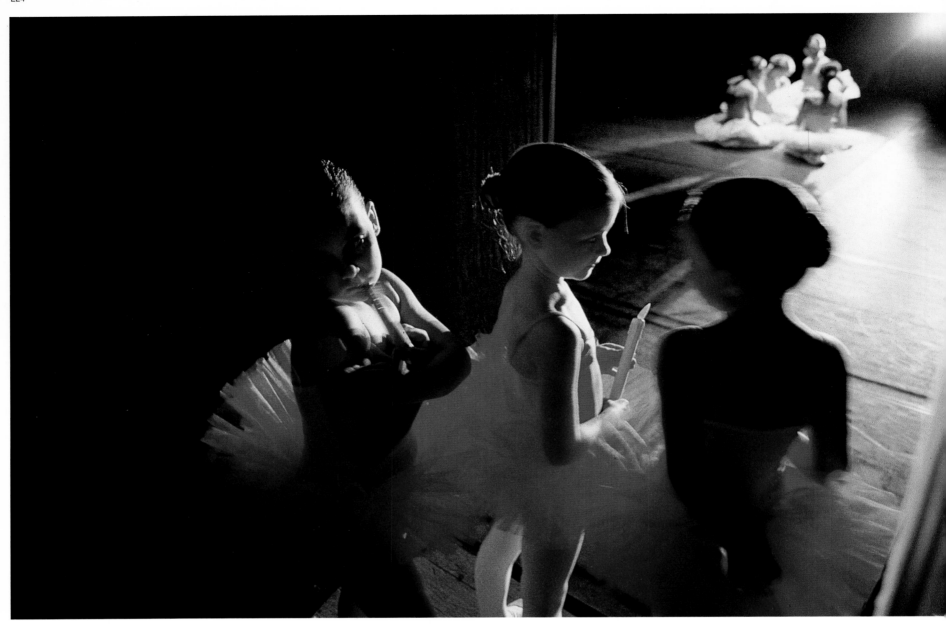

JODI COBB **MONACO** 1996

Junior ballerinas in stiff tulle skirts await their cue backstage during
a performance.

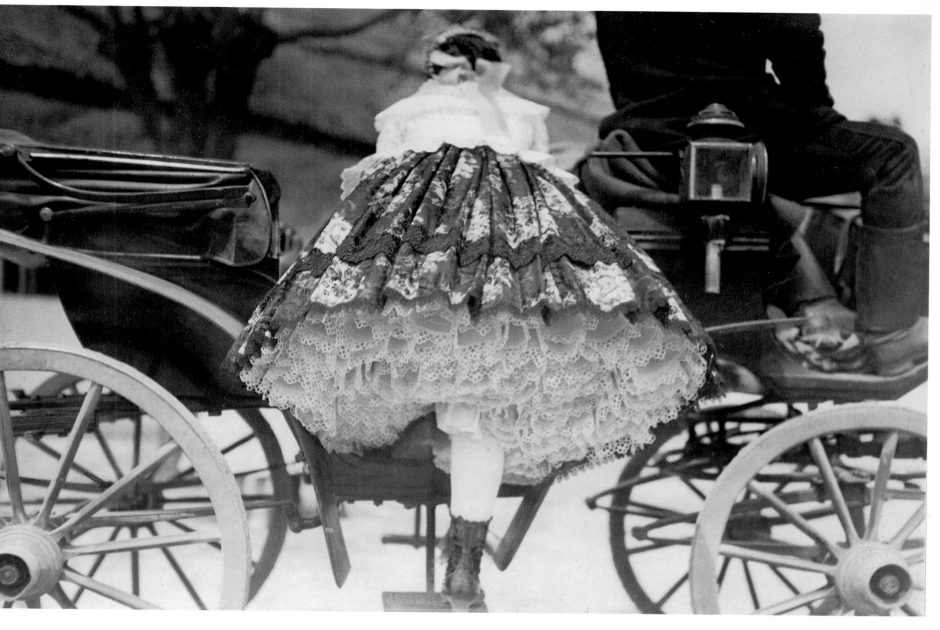

HUNGARIAN PRESS **HUNGARY** 1931

A massive spray of lace denotes the dress of women in Hungary's Alfold region, where seamstresses create richly decorated dresses of silk. They are often worn with multiple petticoats—perhaps 30—even on a daily outing.

RAGHUBIR SINGH **SRI LANKA** 1979

/**pages 226–227**/ Concentric stone pleats cascade down the body of a colossal Buddha at the shrine of Avukana, where saffron-robed monks offer petitions and flower petals, symbols of the impermanence of life.

"SILK IS THE
HOLY CLOTH.
IT IS WHAT
YOU WEAR IF
YOU WANT TO
TOUCH GOD."

CHHOTALAL SALVI

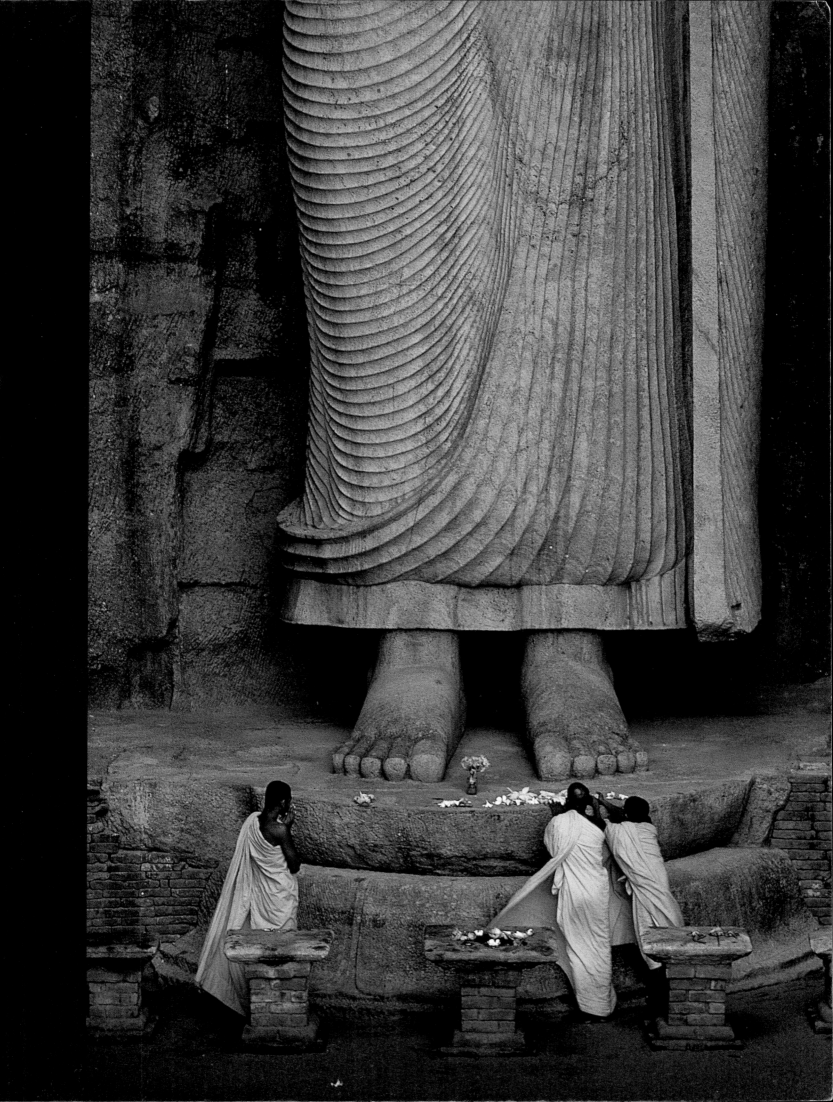

INDEX

SEBAH & JOAILLIER **TURKEY** ca 1880

/pages 234-235/ Two women lounge over a card game. This and other views of life around Constantinople were favorite subjects for the Turkish-born photographer Pascal Sebah.

A NOTE ON THE AUTHORS

CATHY NEWMAN Cathy Newman began her career writing for the Miami News and joined the staff of NATIONAL GEOGRAPHIC magazine in 1978. As a senior staff writer, she has covered such diverse subjects as the Shakers, trout, beauty, the English Channel Tunnel, and Cape York Peninsula, Australia. Her book *Perfume: The Art and Scent of Science* was published by National Geographic in 1998, and *Women Photographers at National Geographic* was published in 2000.

JOANNE B. EICHER Joanne B. Eicher, Regents' Professor in the Department of Design, Housing, and Apparel at the University of Minnesota, specializes in dress as nonverbal communication, especially African and Asian dress, with field work on dress and textiles of the Kalabari people of Nigeria. In association with this, she is also interested in world trade to the Kalabari, which includes Indian and English textiles and Italian beads. Dr. Eicher's M.S. and Ph.D. are in Sociology and Anthropology from Michigan State University and she has been on the faculty at the University of Minnesota since 1977. She has received numerous university and professional organization awards and has published articles, books, and textbooks. These include *Dress and Ethnicity: Change Across Space and Time* (Berg Publishers), 1995; *The Visible Self: Global Perspectives on Dress, Culture, and Society*, 2nd edition, 2000; and *Nigerian Handcrafted Textiles* (University of Ife Press), 1976. She is the Series Editor for "Dress, Body, Culture," an interdisciplinary series of books from Berg Publishers, in Oxford, England, that focuses on the meanings of dress and culture.

VALERIE MENDES Valerie Mendes served as Chief Curator of the Victoria and Albert's world-renowned Dress Department from 1990-2001. She is currently Research Fellow for the museum. After graduating from Leeds University, she began her museum career in 1966 as a Research Assistant in the Textiles Department of Manchester University's Whitworth Art Gallery. In 1970, she became Lecturer in the History of Textiles and Fashion in the History of Art Department at Manchester School of Art. Three years later she was appointed Assistant Keeper at the Victoria and Albert.

Since 1973 Valerie Mendes has specialized in 20th century textiles and fashion with research ranging from investigating the work of 1930s textiles designer Marion Dorn, to 1980s designer denim commissioned by *Blitz* magazine, to high fashion provocatively photographed by Norman Parkinson for the 1987 *Pirelli Calendar.*

Valerie Mendes has also been involved in numerous exhibitions and was a major contributor to Victoria and Albert's groundbreaking Streetstyle exhibition (1994) and The Cutting Edge exhibition (1997).

She is an author of numerous books including *John French, Fashion Photographer* (V&A Publications), 1984; *Salvatore Ferragamo 1927-1960* (V&A/Centro Di), 1987; *Pierre Cardin Past, Present, and Future* (Nishen 1990), and *Modern Fashion in Detail* (V&A), 1991.

In 1999 she completed *Black in Fashion* for V&A Publications and *The Concise History of Twentieth Century Fashion* for Thames and Hudson. She is currently researching the early 1900s work of the couturier Lucile (Lady Duff Gordon).

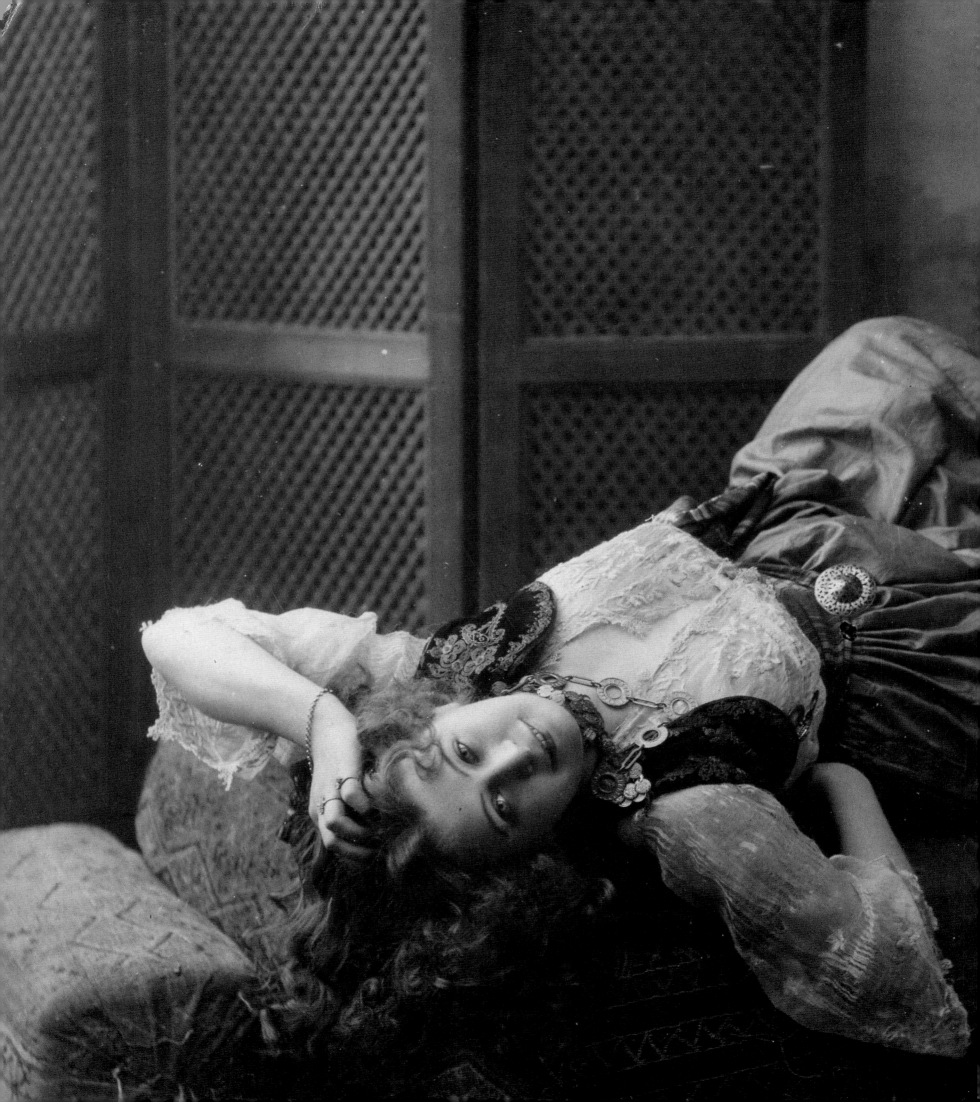

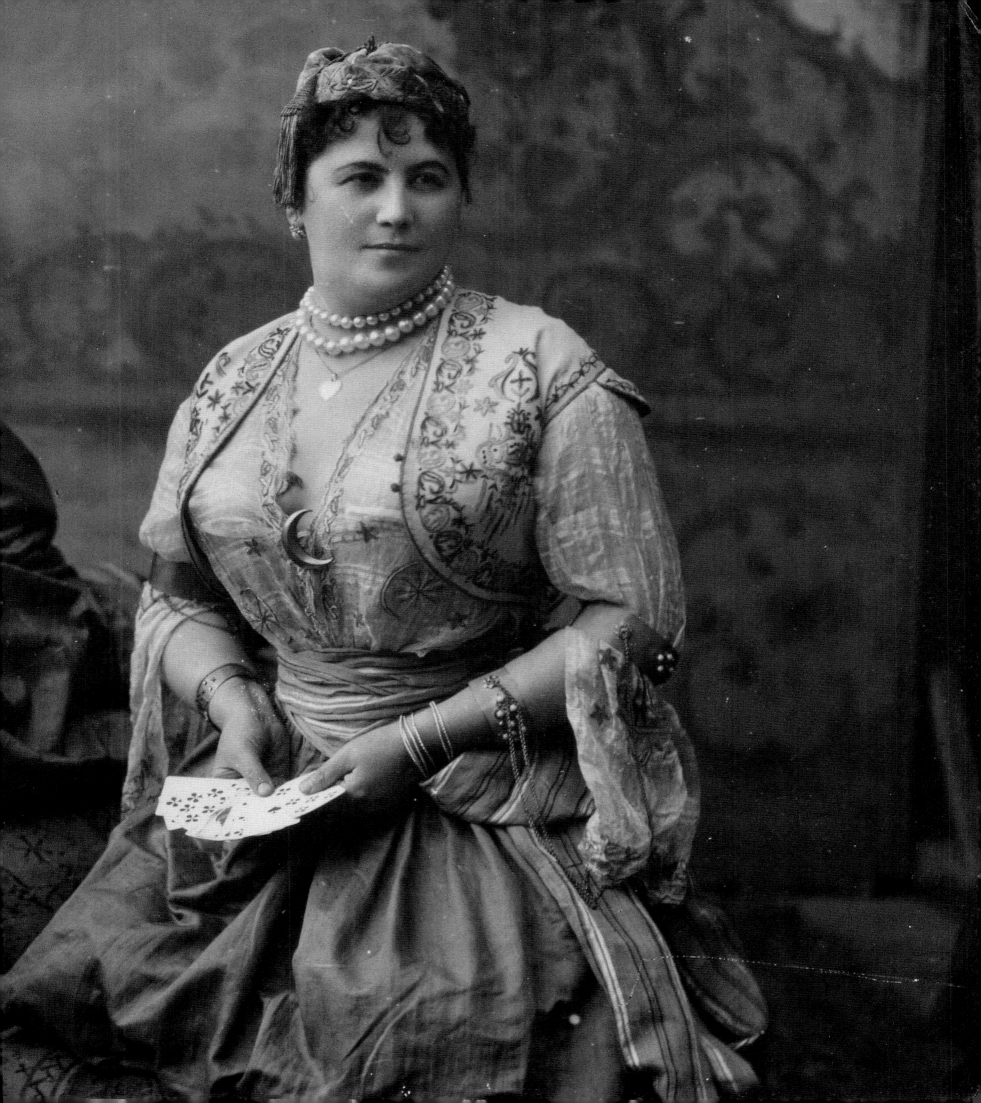

PHOTOGRAPHIC CREDITS

DUST JACKET Front Cover, Reza; Back Flap; back cover Reza. FRONT MATTER 2 Charles O'Rear; p 4 (left to right) David Edwards; Justin Locke; Peter Essick; 6-7 Jodi Cobb, NGS Staff Photographer; 8 Roland W. Reed; 9 N. Zographos; 10-11 William Albert Allard, NGS Staff Photographer; 12 Robert W. Madden; 13 Michael Nichols, NGS Staff Photographer; 14-15 William Albert Allard, NGS Staff Photographer; 24-25 Jodi Cobb, NGS Staff Photographer; 26-27 Alfred I. Hart; 36-37 James L. Amos; 38-39 William Albert Allard, NGS Staff Photographer LOOK AT ME 48 David Edwards; 49 Jodi Cobb, NGS Staff Photographer; 50 Jodi Cobb, NGS Staff Photographer; 51 Cary Wolinsky; 52-53 Yvette Borup Andrews; 54 Hans Hildebrand; 56-57 Dr. Joseph F. Rock; 58 Jodi Cobb, NGS Staff Photographer; 59 Photographer unknown; 60 Horace Brodzky; 61 Edwin L. Wisherd; 62 Steve Raymer; 63 Thomas J. Abercrombie; 65 The Tesla Studios; 66 Eliza R. Scidmore; 67 Lehnert & Landrock; 68-69 Jodi Cobb, NGS Staff Photographer; 70-71 R.R. Sallows; 72 Jodi Cobb, NGS Staff Photographer; 73 William Albert Allard, NGS Staff Photographer; 74 Thomas J. Abercrombie; 75 Edward S. Curtis; 76-77 James L. Stanfield; 78 (left) Jim Brandenburg; 78 (right) George F. Mobley; 79 (left) Otis Imboden; 79 (right) Carole Devillers; 80-81 J. Baylor Roberts; 82 Rosamond Dodson Rhone; 83 Angela Fisher; 84 Dr. Joseph F. Rock; 85 N. Zographos; 86-87 James L. Stanfield; 88-89 Jodi Cobb, NGS Staff Photographer; 90 Jodi Cobb, NGS Staff Photographer; 91 Albert Couturiaux; 92-93 Wilbur E. Garrett; 95 John Sleezer; 96 James L. Amos; 97 Dilip Mehta, Contact Press Images; 98-99 William Albert Allard, NGS Staff Photographer; 101 R. Senz & Co. FRIVOLOUS OR FUNCTIONAL? 112 Eliza R. Scidmore; 113 Barbara Cushman Rowell; 114-115 José Azel, Aurora & Quanta Productions; 116 David Alan Harvey; 117 Maria Stenzel; 118-119 George R. King; 120 Fred Bremner; 121 Harold A. Knutson; 122 George F. Mobley; 123 Photographer unknown; 124-125 J. Baylor Roberts; 126 David Alan Harvey; 127 Henry R. Lemly; 128-129 William Albert Allard, NGS Staff Photographer; 130 Steve Raymer; 131 Fabby K.J. Nielsen; 132 Jonathan Blair; 134 Chris Johns, NGS Staff Photographer; 135 Georg Gerster; 136 J.W. Beattie; 137 Robert E. Peary; 138 Michael Nichols, NGS Staff Photographer; 139 David Alan Harvey; 140 Eliza R. Scidmore; 141 Steve Raymer; 142 (left) J.W. Beattie; 142 (right) Carl J. Lomen; 143 (left) Levasseur; 143 (right) J.W. Beattie; 144-145 Robert Reid; 146-147 John Chao; 148 Maynard Owen Williams; 149 Crété; 150-151 (both) William Albert Allard, NGS Staff Photographer; 152-153 William Albert Allard, NGS Staff Photographer; 154 Thomas Nebbia; 155 Jodi Cobb, NGS Staff Photographer; 156 Richard Nowitz; 157 E.C. Erdis; 158-159 Clifton R. Adams; 160 James L. Stanfield; 161 Flip Schulke; 162 (top) James L. Stanfield; 162 (bottom) George F. Mobley; 163 George F. Mobley; 164-165 Jodi Cobb, NGS Staff Photographer. TRANSFORMATIONS 174-175 (both) Chris Johns, NGS Staff Photographer; 176 Tomasz Tomaszewski; 177 Peter Essick; 178 Loren McIntyre; 179 Carol Beckwith & Angela Fisher; 180 Jodi Cobb, NGS Staff Photographer; 181 William Albert Allard, NGS Staff Photographer; 183 William Albert Allard, NGS Staff Photographer; 184-185 Cary Wolinsky; 186 Karen Kasmauski; 187 Sam Abell, NGS Staff Photographer; 189 Justin Locke; 190 William Albert Allard, NGS Staff Photographer; 191 Tomasz Tomaszewski; 192-193 (both) Jodi Cobb, NGS Staff Photographer; 194-195 (both) Jodi Cobb, NGS Staff Photographer; 196-197 Carl J. Lomen; 198-201 (all) Jodi Cobb, NGS Staff Photographer; 202 Edward S. Curtis; 203 Jodi Cobb, NGS Staff Photographer; 204 Joseph H. Bailey; 205 James L. Stanfield; 206-207 Maria Stenzel; 208-209 (both) Mary G. Lucas; 210-211 Eliza R. Scidmore; 212-213 William Albert Allard, NGS Staff Photographer; 214 Volkmar Wentzel; 215 Carol Beckwith & Angela Fisher; 216-217 Paul Almasy; 218-219 Jodi Cobb, NGS Staff Photographer; 220 Sisse Brimberg; 221 Tomasz Tomaszewski; 222-223 David Alan Harvey; 224 Jodi Cobb, NGS Staff Photographer; 225 Hungarian Press; 226 Raghubir Singh BACK MATTER 234-235 Sebah & Joaillier; 240 Reza.

ADDITIONAL READING

Batterberry, Michael and Ariane. *MIRROR MIRROR: A Social History of Fashion* (New York: Holt, Rinehart and Winston), 1977.

Boucher, François. *20,000 YEARS OF FASHION: The History of Costume and Personal Adornment* (New York: Harry N. Abrams, Inc.), 1987.

Charles-Roux, Edmonde Herbert R. Lottman. Stanley Garfinkel, Nadine Gase, Katell le Bourhis; and Susan Train, ed. *THEATRE DE LA MODE* (New York: Rizzoli), 1991.

Cunningham, Phillis and Catherine Lucas. *COSTUMES FOR BIRTHS, MARRIAGES & DEATHS* (New York: Harper & Row, Inc.), 1972.

DeLano, Sharon and David Rieff. *TEXAS BOOTS* (New York: Viking Press and Penguin Books), 1981.

Edwards, Anne. *THE QUEEN'S CLOTHES* (London: Express Books/ Elm Tree Books), 1977

Eicher, Joanne B. ed., *DRESS AND ETHNICITY: Change Across Space and Time* (Oxford: Berg), 1995.

Eicher, Joanne, B. and Sandra Lee Evenson, Hazel A. Lutz. *THE VISIBLE SELF: Global Perspectives on Dress, Culture, and Society* (New York: Fairchild Publications), 1973

Flügel, J. C. *THE PSYCHOLOGY OF CLOTHES* (London: the Hogarth Press, Ltd.), 1950.

Gidley, Mike. *EDWARD S. CURTIS AND THE NORTH AMERICAN INDIAN, INCORPORATED* (Cambridge, U.K.: Cambridge University Press), 1998.

Gröning, Karl. *BODY DECORATION* (New York: The Vendome Press), 1998.

Hollander, Anne. *SEEING THROUGH CLOTHES* (Berkeley and Los Angeles: University of California Press), 1978.

Kemper, Rachel H. *A HISTORY OF COSTUME* (New York: Newsweek Books), 1977.

Langner, Lawrence. *THE IMPORTANCE OF WEARING CLOTHES* (Los Angeles: Elysium Growth Press), 1991.

Lurie, Alison. *THE LANGUAGE OF CLOTHES* (New York: Henry Holt and Company), 1981.

Haslip, Joan. *MARIE ANTOINETTE* (New York: Weidenfield & Nicolson), 1987.

Kidwell, Claudia B. and Margaret C. Christman. *SUITING EVERYONE: The Democratization of Clothing in America* (Washington, DC: Smithsonian Institution Press), 1974.

Krell, Gene. *VIVIENNE WESTWOOD* (New York: Universe/Vendome), 1997.

Mackay-Smith, Alexander and Jean R. Druesedow, Thomas Ryder. *MAN AND THE HORSE, An Illustrated History of Equestrian Apparel* (New York: the Metropolitan Museum of Art), 1984.

Mendes, Valerie and Amy de la Haye. *20th CENTURY FASHION* (London and New York: Thames & Hudson), 1999.

Museum of London. *VIVIENNE WESTWOOD: A London Fashion* (London: Philip Wilson Publishers), 2000.

Nunn, Joan. *FASHION IN COSTUME*, 1200-1980 (New York: Schocken Books), 1984.

Racinet, Albert. *THE HISTORICAL ENCYCLOPEDIA OF COSTUMES* (New York and Oxford: Facts on File Publications), 1988.

Roach, Mary Ellen and Joanne Bubolz Eicher, eds. *DRESS, ADORNMENT, AND THE SOCIAL ORDER* (New York, London, Sydney: John Wiley & Sons Inc.), 1965.

Squire, Geoffrey. *DRESS AND SOCIETY, 1560-1970* (New York: The Viking Press), 1974.

Steele, Valerie. *FIFTY YEARS OF FASHION* (New Haven & London: Yale University Press), 1997.

Steele, Valerie and John S. Major. *CHINA CHIC* (New Haven & London: Yale University Press), 1999.

Vreeland, Diana. *D.V.* (New York: Da Capo Press), 1997.

ACKNOWLEDGMENTS

Boundless thank-yous and a deep courtesy to Susan Train, Paris Bureau Chief of *Vogue* magazine, who unstintingly shared her experience and wisdom and paved the way with introductions and suggestions too numerous to count. Gratitude also to Marie-José Lepicard, Catherine Join-Dieterle, Melka Treanton, Valerie Mendes, Katharine Hamnett, Joanne B. Eicher, Rebecca Stevens, Elizabeth Ann Coleman, June Weir, Serge Lutens, Christopher Ross, Vera Strubi and Vivienne Westwood, who shared their insight and passion for the subject at hand. Shirley Giovetti and Catherine Disdet pointed me in the right direction. Finally, the late Nina Hyde, fashion editor of the *Washington Post*, was the first to teach me that fashion is far from frivolous. How much she is missed. Special thanks and appreciation to Nina Hoffman for her support and enthusiasm, and to my National Geographic colleagues on the project, Barbara Brownell, Marilyn Terrell, and Annie Griffiths Belt, who helped transform the book from concept to reality; to Caroline Herter, who imagined its existence, and to designer Ben Pham, who dressed it so beautifully.

 —Cathy Newman, Author

My thanks to Bill Bonner, Neil Philip, and Margaret Tulloch-Weir of the National Geographic Image Collection. Their creativity, intuition, and quick work made *Fashion* possible.

 —Annie Griffiths Belt, Illustrations Editor

The Book Division would also like to thank Richard Alford, East Central University, Ada, OK; William Ayrey, ILC Dover, Inc., Frederica, DE; Bill Bonner, National Geographic Society, Washington, DC; Jodi Cobb, National Geographic Society, Washington, D.C.; Herbert M. Cole, University of California, Santa Barbara, CA; Elizbeth Ann Coleman, Museum of Fine Arts, Boston, MA; David Doubilet, Washington, DC; Cynthia Hamilton, Washington, DC; Katharine Hamnett, London, England; Shelly Foote, National Museum of American History, Washington, DC; Ann Marie Gardner, W Magazine, New York, NY; Michelle Guzniczak, ILC Dover, Inc., Frederica, DE; Ruth Hensinger, Neffs, PA; Bonnie Lawrence, Silver Spring, MD; Marie-José Lepicard, Paris, France; Serge Lutens, Paris, France; Valerie Mendes, Victoria and Albert Museum, London, England; Rafael Misher, Washington, DC; Thierry Mugler, Paris, France; Joan Rivers, New York, NY; Noliwe Rooks, Princeton University, Princeton, NJ; Valerie Steele, Fashion Institute of Technology, New York, NY; Rebecca Stevens, Textile Museum, Washington, DC; Susan Train, Vogue Magazine, Paris, France; Melka Treaton, Paris, France.

The world's largest nonprofit scientific and educational organization, the National Geographic Society was founded in 1888 "for the increase and diffusion of geographic knowledge." Since then it has supported scientific exploration and spread information to its more than eight million members worldwide.

The National Geographic Society educates and inspires millions every day through magazines, books, television programs, videos, maps and atlases, research grants, the National Geographic Bee, teacher workshops, and innovative classroom materials.

The Society is supported through membership dues, charitable gifts, and income from the sale of its educational products.

Members receive NATIONAL GEOGRAPHIC magazine—the Society's official journal—discounts on Society products, and other benefits.

For more information about the National Geographic Society, its educational programs, publications, or ways to support its work, please call 1-800-NGS-LINE (647-5463), or write to the following address:

National Geographic Society

1145 17th Street N.W.

Washington, D.C. 20036-4688 U.S.A.

Visit the Society's Web site at www.nationalgeographic.com

Printed in Italy

Library of Congress Cataloging-in-Publication Data

Newman, Cathy.
 National Geographic fashion / by Cathy Newman; introductions by Joanne B Eicher and Valerie Mendes.
 p. cm.
Includes bibliographical references and index.
ISBN 0-7922-6416-9
1. Costume design—Pictorial works. 2. Fashion—Pictorial works. I. National Geographic Society (U.S.) II. Title.
TT506 .N38 2001
779'.9391—dc21 2001032681

Published by the National Geographic Society

JOHN M. FAHEY, JR.	President and Chief Executive Officer
GILBERT M. GROSVENOR	Chairman of the Board
NINA D. HOFFMAN	Executive Vice President

Prepared by the Book Division

Staff for this Book

ANNIE GRIFFITHS BELT	Project Editor, Illustrations Editor
MARIANNE KOSZORUS	Design Director
BARBARA BROWNELL	Text Editor
HERTER STUDIO	Concept and Creative Direction
MARILYN TERRELL	Researcher, Legends Writer
CHARACTER, S.F. CA	Book Design
MELISSA HUNSIKER	Assistant Editor
GARY COLBERT	Production Director
RIC WAIN	Production Project Manager
SHARON BERRY	Illustrations Assistant
MELISSA FARRIS	Design Assistant
BONNIE S. LAWRENCE	Consulting Editor
CONNIE BINDER	Indexer

Manufacturing and Quality Control

GEORGE V. WHITE	Director
JOHN T. DUNN	Associate Director
PHILLIP L. SCHLOSSER	Financial Analyst

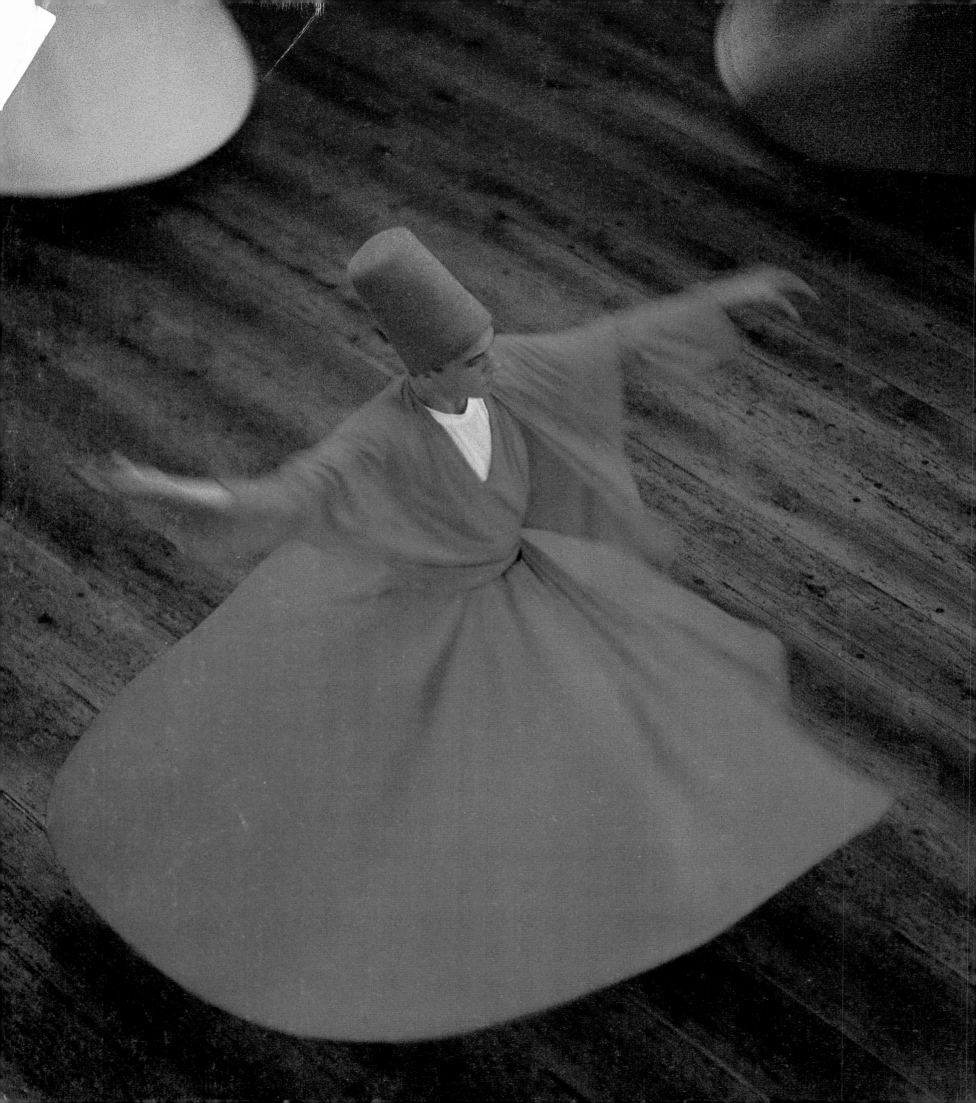